Performance and Cosmopolitics

Studies in International Performance

Published in association with the International Federation of Theatre Research

General Editors: **Janelle Reinelt** and **Brian Singleton**

Culture and performance cross borders constantly, and not just the borders that define nations. In this new series, scholars of performance produce interactions between and among nations and cultures as well as genres, identities and imaginations.

Inter-national in the largest sense, the books collected in the *Studies in International Performance* series display a range of historical, theoretical and critical approaches to the panoply of performances that make up the global surround. The series embraces 'Culture' which is institutional as well as improvised, underground or alternate, and treats 'Performance' as either intercultural or transnational as well as intracultural within nations.

Titles include:

Christopher Balme
PACIFIC PERFORMANCES
Theatricality and Cross-Cultural Encounter in the South Seas

Helen Gilbert and Jacqueline Lo
PERFORMANCE AND COSMOPOLITICS
Cross-Cultural Transactions in Australasia

Judith Hamera
DANCING COMMUNITIES
Performance, Difference, and Connection in the Global City

Joanne Tompkins
UNSETTLING SPACE
Contestations in Contemporary Australian Theatre

Forthcoming titles:

Elaine Aston and Sue-Ellen Case (*editors*)
PERFORMING GLOBAL FEMINISMS

Adrian Kear
THEATRE AND EVENT

Studies in International Performance
Series Standing Order ISBN 1–4039–4435–0 (hardback)
1–4039–4436–9 (paperback)
(*outside North America only*)

You can receive future titles in this series as they are published by placing a standing order. Please contact your bookseller or, in case of difficulty, write to us at the address below with your name and address, the title of the series and the ISBN quoted above.

Customer Services Department, Macmillan Distribution Ltd, Houndmills, Basing-stoke, Hampshire RG21 6XS, England

Performance and Cosmopolitics

Cross-Cultural Transactions in Australasia

Helen Gilbert & Jacqueline Lo

First published 2007 by
PALGRAVE MACMILLAN
Houndmills, Basingstoke, Hampshire RG21 6XS and
175 Fifth Avenue, New York, N.Y. 10010
Companies and representatives throughout the world

PALGRAVE MACMILLAN is the global academic imprint of the Palgrave
Macmillan division of St. Martin's Press, LLC and of Palgrave Macmillan Ltd.
Macmillan® is a registered trademark in the United States, United Kingdom
and other countries. Palgrave is a registered trademark in the European
Union and other countries.

ISBN-13: 978–0–230–00340–8 hardback
ISBN-10: 0–230–00340–0 hardback

This book is printed on paper suitable for recycling and made from fully
managed and sustained forest sources.

A catalogue record for this book is available from the British Library.

Library of Congress Cataloging-in-Publication Data
Gilbert, Helen, 1956–
 Performance and cosmopolitics:cross-cultural transactions in
 Australasia/Helen Gilbert and Jacqueline Lo.
 p. cm.
 Includes bibliographical references and index.
 ISBN-13: 978–0–230–00340–8
 ISBN-10: 0–230–00340–0
 1. Performing arts—Australia. 2. Performing arts—Asia.
 3. Performing arts—Social aspects—Australia. 4. Performing
 arts—Social aspects—Asia. I. Lo, Jacqueline. II. Title.
 PN3011.5.G55 2007
 790.20994—dc22 2006051024

10 9 8 7 6 5 4 3 2
16 15 14 13 12 11 10 09 08 07

Printed and bound in Great Britain by
Antony Rowe Ltd, Chippenham and Eastbourne

Contents

v

List of Illustrations

Series Editors' Preface

In 2003, the current International Federation for Theatre Research President, Janelle Reinelt, pledged the organization to expand the outlets for scholarly publication available to the membership, and to make scholarly achievement one of the main goals and activities of the Federation under her leadership. In 2004, joined by Vice-President for Research and Publications Brian Singleton, she signed a contract with Palgrave Macmillan for a new book series, 'Studies in International Performance.'

Since the inauguration of the series, it has become increasingly urgent for performance scholars to expand their disciplinary horizons to include the comparative study of performances across national, cultural, social and political borders. This is necessary not only in order to avoid the homogenizing tendency to limit performance paradigms to those familiar in our home countries, but also in order to be engaged in creating new performance scholarship that takes account of and embraces the complexities of transnational cultural production, the new media, and the economic and social consequences of increasingly international forms of artistic expression. Comparative studies can value both the specifically local and the broadly conceived global forms of performance practices, histories and social formations. Comparative aesthetics can challenge the limitations of perception and current artistic knowledges. In formalizing the work of the Federation's members through rigorous and innovative scholarship, we hope to contribute to an ever-changing project of knowledge creation.

International Federation for Theatre Research
Fédération Internationale pour la
Recherche Théâtrale

Acknowledgements

We have been doubly fortunate in having the assistance of Emma Cox and Amanda Lynch on this project. Their superb research acumen and incomparable detective and computing skills have played a crucial role in getting this book to production. We also wish to thank Uschi Dauth and Tiffany Urwin for providing extensive research material for the Asian focus of this project, Tina Muir for expert help with proofing and Alyssa Kimball for her valuable assistance in sourcing information about indigenous theatre. All errors and omissions are ours, not theirs.

The seeds of this book were first planted with the assistance of an Australian Research Council Large Grant to study Asian influences in Australian theatre. We are grateful to our institutions: Royal Holloway College (University of London), the Australian National University and the University of Queensland for their administrative and financial support. The British Academy also provided much needed funding in the final stages of the project.

Many scholars and organizations have assisted us in various stages of this book's development. We cannot name them all but wish to acknowledge the generosity of Tom Burvill, Gay McAuley, Aubrey Mellor, Geoffrey Milne, Peta Tait, the Adelaide Festival Office, Australian Council for the Arts, Belvoir Street Theatre, Black Swan Theatre, Malthouse Theatre (formerly Playbox), Melbourne Theatre Company, Marrugeku, Mitchell Library, Performing Lines, Queensland Theatre Company and Sydney Theatre Company. Our series editors, Janelle Reinelt and Brian Singleton, deserve special mention for their enthusiastic encouragement and incisive advice throughout the project. Thanks also to Penny Simmons and the staff at Palgrave Macmillan for their expert production work.

Most of all, for their love and support and for seeing us through yet another marathon, our heartfelt thanks to Cameron Browne, Michael O'Toole, Ashleigh O'Toole, Joan Bolitho, Sandra and James O'Toole and Pat Warner.

Sections of this work have been published previously in *Australasian Drama Studies*, *Theatre Research International*, *Playing Australia* (ed. Elizabeth Schafer and Susan Bradley Smith), *Alter/Asians* (ed. Ien Ang *et al.*), *Siting the Other* (ed. Marc Maufort and Franca Bellarsi) and *Our Australian*

Theatre in the 1990s (ed. Veronica Kelly). We thank all the editors and editorial staff concerned.

Dates given for performances in the main text refer to the premiere productions unless otherwise specified. Performances mentioned in passing, along with ephemera such as unarchived programme notes, are not listed in the bibliography. We have standardized the nomenclatures of key companies and arts festivals, as well as variant spellings of Aboriginal and Asian words. With the exception of Playbox, theatre companies are referenced by their most recent names.

Introduction: Performing Cosmopolitics

> *What is needed educationally is not to learn that we are citizens of*
> *the world, but that we occupy particular niches in an unequal world.*
> (Immanuel Wallerstein, 1996: 124)

On 15 September 2000, Australians from all walks of life joined with
the performing arts community to stage what is undoubtedly the most
spectacular theatrical event in the nation's history: the Opening Cere-
mony of the Sydney Olympic Games. This 'world show stopper',[1] as
one newspaper termed it, was an emphatically global *and* local perform-
ance, designed not only to capture the imagination of a vast media
audience but also to present the nation to itself through popular
and allusive iconographies. In line with the generic template for such
events, the performance explicitly modelled the social values behind
Olympism: global democracy founded on harmony and community
among individuals, cultures and nations. The local script of such demo-
cracy was written as an allegory of postcolonial reconciliation in which
a young white schoolgirl, Nikki Webster, travelled through a potted
version of Australia's history guided by Aboriginal songman, Djakapurra
Munyarryun. Notable segments of the performance included 'Awaken-
ings', an indigenous welcome featuring over 1000 dancers from clans
across the country (see Figure 1); 'Arrivals', a float parade celebrating
immigration from all corners of the world; and 'Eternity', a tribute to
contemporary society in which some 12,000 performers participating
in the ceremony merged in a triumphant finale. Following the tradi-
tional parade of nations, the evening ended when champion Aboriginal
athlete Cathy Freeman, flanked by a group of 'legendary' Australian

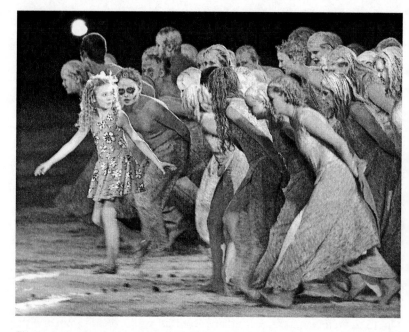

Figure 1 Awakening segment, Olympic Opening Ceremony, Sydney, 2000. (Photo: Amy Sancetta, courtesy EMPICS)

sportswomen, lit the Olympic cauldron in what was widely regarded as a powerful statement of national unity.

In this carefully rehearsed, state-endorsed and media-packaged spectacle, the cultural diversity of the nation was writ large amid more whimsical performances of Australiana. The images projected to the world coalesced into a portrait of a fluid multicultural society with a vibrant indigenous culture – and, judging by the virtuosity of the dancers, acrobats, puppeteers and scenographers, a world-class performing arts industry. Buttressed by the Olympic Spirit, which promotes celebratory notions of a common humanity, this cosmopolitan vision met with enthusiastic approval from games' officials, local media and the general public alike. It was particularly praised for its inclusiveness as well as its international appeal and, critically, for not showing the 'merest smudge' of the cultural cringe that has sometimes revealed Australians' anxiety about their place on the world stage (Gordon, 2000: 4). The sense of a mature, sophisticated nation, at ease in its cross-cultural relations, both internal and external, emerged at various other points in the games proper, notably when Freeman won her major event to the roars of an

ecstatic crowd. For us, however, one of the most resonant expressions of multicultural Australia at the time was a fleeting media image of a volunteer, a young Muslim woman wearing an akubra hat and the official Olympic jacket over her veil and traditional robes. This icono-clastic image seemed to confirm that cosmopolitanism was indeed on the move in twenty-first-century Australia – the utopian vision of the opening extravaganza could not be merely all show.

The 2005 riots at Sydney's Cronulla Beach can be seen as a demotic expression of cultural diversity that challenges the triumphant nature of the first performance. On 11 December, approximately 5000 people gathered to 'reclaim their beach' – an iconic Australian space – from groups euphemistically labelled as being of Middle Eastern and/or Lebanese appearance. The rally, organized following a widely reported series of confrontations between 'locals' and 'outsiders' that had culmin-ated in an assault on three life-savers,[2] started off as a beach party cum demonstration. Participants were mostly young Caucasian men waving national flags, singing patriotic songs and chanting 'Aussie, Aussie, Aussie! Oi, Oi, Oi!' in gestures of solidarity for the affronted life-savers. Many of the protestors sported obscene slogans on their T-shirts or naked torsos vilifying Islam or proclaiming their sense of privileged national belonging with phrases such as 'Ethnic Cleansing Unit' and 'Aussie Pride'. A striking media photograph of a young fair-haired man whose bare chest was inscribed with 'We grew here! You flew here!' encapsulates the performance of a heightened and embodied (masculine) white anxiety about the authority and place of Anglo-Celtic heritage in the national imaginary, expressed in this instance through a discourse of indigeneity and land rights. The celebratory mood, boosted by substantial alcohol intake, rapidly turned vicious as the mob attacked 'Arab-looking' people in the vicinity. The following nights saw incid-ents of retaliatory violence and vandalism in Cronulla and surrounding suburbs, including the razing of a church, allegedly by Lebanese youths.

This civil disorder calls attention to the mundane and embodied aspects of cultural and ethnic diversity in ways that are glossed over by the rhetoric of official multiculturalism in Australia. That the riots were perceived by the authorities as manifestations of a 'race problem', as opposed to a youth and/or masculinity crisis, for example, indexes prevailing concerns about the management of cross-cultural relations in urban Australia. These anxieties were reiterated in the media's asso-ciation of the events with the Paris riots that occurred some months earlier when disaffected youths from migrant African and Muslim back-grounds raged against the establishment. The general reading of the

Cronulla unrest, in the aftermath of the 2005 London bombings and various other acts of global terrorism, dovetails into the narrative of a 'contagion from within' that is presently circulating in Western countries such as Britain, the United States and Australia. The riots' 'glocal' significance was also registered in the government's concern that news of the event would affect Australia's, and specifically Sydney's, international image as stable, tolerant and culturally sophisticated. The local media tracked overseas reportage of Australia's 'multicultural shame' and expressed particular concern about reactions in Asia, as encapsulated by one headline asking, 'What must the neighbours think?' In a region that still remembers Australia's 'Whites only' immigration policy, it was feared that news of racial violence would jeopardize the nation's newly claimed cosmopolitan image. These responses suggest the investment in maintaining multiculturalism as part of the interface between Australia and the rest of the world.

Read in juxtaposition, the Olympics Opening Ceremony and the Cronulla riots capture the central problematic of this book: the tension between the promise of cosmopolitanism as the enactment of universal communitas and its limits as a theory of embodied material praxis. We explore this dilemma by analysing an extensive range of cross-cultural theatre in Australasia, with a sustained focus on Asian and Aboriginal influences on mainstream practice and a specific interest in the interplay of local and global forces.

New cosmopolitanisms

There has been a resurgence of scholarly interest in cosmopolitanism since the early 1990s. Stemming largely from the US academy, the work is characterized by an effort to dislodge the concept from its traditional associations with privilege and with impartiality to the demands of the local. Paul Rabinow's (1986) call to establish a 'critical cosmopolitanism' cognizant of transnational experiences that are particular rather than universal, and coerced as well as voluntary, has been met with a variety of theoretical propositions. These include James Clifford's 'discrepant cosmopolitanism', which refers to actually existing practical stances as opposed to theoretical ideals (1992); Mitchell Cohen's 'rooted cosmopolitanism', grounded in the sociocultural specificities of the nation-state (1992); Benita Parry's 'postcolonial cosmopolitanism', which proclaims multiple cultural detachments and reattachments from within a critique of imperialism (1992); and Pnina Werbner's 'working-class cosmopolitanism', focusing on demotic and popular experiences of

transnationalism (1999). Mostly, these revisionist projects derive from new leftist politics within the United States, embodying middle-path alternatives between ethnocentric nationalism and particularistic multi-culturalism (Vertovec and Cohen, 2002a: 1). The general aim is to remake cosmopolitanism into a more worldly and less elitist concept, an endeavour that includes recuperating 'cosmopolitans from below' – defined along class and racial lines and encompassing refugees, migrants and itinerant workers – and accounting for the recent emergence of a new meritocratic ruling class of transnationals, variously called 'cosmocrats' and 'technocrats'.

For some theorists, cosmopolitanism operates as a prescriptive vision of global democracy and world citizenship while, for others, it offers a theoretical space for articulating hybrid cultural identities. Various scholars also use the term descriptively to address certain social processes and/or individual behaviours and dispositions that demonstrate a capacity to embrace cultural difference. While part of the appeal of cosmopolitanism seems to be its 'nice, high-minded ring' (Himmelfarb, 1996: 77), perhaps its conceptual slipperiness lends itself to these diverse, even contradictory, applications, which attempt to grapple with the ethical, political and intellectual challenges of cross-cultural and transnational encounters in contemporary life. There is a growing body of academic work mapping the history and diversity of new cosmopolitan thinking that we will not attempt to replicate (see Vertovec and Cohen, 2002b; Yeğenoğlu, 2005); the following discussion is conceived as a space-clearing exercise in order to foreground particular conceptual threads relevant to our investigation of cross-cultural transactions within the Australasian theatre sector.

Recent attempts to retool cosmopolitanism can generally be divided into three conceptually overlapping categories: moral/ethical, political and cultural. Moral cosmopolitanism is fundamentally concerned with the individual's 'loyalties to humanity as a whole', which entails an obligation to help fellow human beings to the best of one's abilities (Harvey, 2000: 726). While critiques of cosmopolitanism sometimes refer to the concept's antecedents in classical Greek philosophy, the bulk of new thinking about moral cosmopolitanism derives from the work of Immanuel Kant, who promoted a notion of world citizenship committed to universal codes of rights and justice (see Nussbaum, 1997). For Kant, an ideal 'universal cosmopolitan existence', fuelled by common interests and the spirit of commerce, was to be humanity's 'natural' destination and the preferred path towards forging world peace. Crucially, this cosmopolitanism was dependent upon ancient rights of hospitality

that demanded all persons (regardless of colour, creed or politics) be allowed free access to any part of the world (Pagden, 2000: 16). Kant postulated that the trade and communication facilitated by such hospitality would enable the world's peoples to eventually enter the highest political order, the 'universal community'.

It is easy to see the appeal of Kant's philosophy in a world increasingly subject to the pressures of globalization and ever more fractured by its uneven consequences across different regions and disparate populations. Neo-Kantian cosmopolitanism is distinguished from its older form by a suspicion of the universals associated with Enlightenment epistemology and its attendant history of colonial expansionism. Current advocates of cosmopolitanism have been careful to reformulate their critical apparatus in ways that particularize and pluralize the liberal ideal of detached loyalty to the abstract category of the human. Qualified terms such as Kwame Anthony Appiah's 'universalism plus difference' (2001) and Pheng Cheah's 'polymorphic universal' (1998) reflect attempts to negotiate a situated ethical practice with 'the aspirations of deliberative democracy and internationalist politics' (Amanda Anderson, 2001: 179). Among other things, our study of cross-cultural theatre traffic in Australasia, positioned within the broader context of a globalizing performing arts market, sets out to test the Kantian ideal of universal community and explore new kinds of cosmopolitanism arising from the commercialization and politicization of cultural difference. By focusing on a range of theatrical processes involving embodied encounters between cultural groups, as well as modes of staging cultural alterity, we aim to investigate the complexities of cross-cultural encounters in a field of activity that is characterized historically by asymmetrical power relationships.

The second category of cosmopolitanism is typified by efforts to establish legal and political frameworks and institutions that set forth universal rights and duties that bridge or override the conventional political structures of nation-state systems (Vertovec and Cohen, 2002a: 11). If Kantian philosophy sets up a moral imperative for what Walter Mignolo calls 'planetary conviviality' (2000: 721), political cosmopolitanism aims to regulate and optimize the conditions of its possibility. David Held, among others, has made a strong case for a (qualified) shift away from nation-based governments to multilevel, intricately institutionalized and partially dispersed systems of transnational governance to better cope with the consequences of economic globalization (2003: 469). There are two distinct sites of political activity operating at the transnational level that, ideally, work

towards cosmopolitan democracy. The first functions in the elite domain as a layer of governance that would administer and legislate at global and regional levels to complement national and local government (Held, 2003: 476). Such forms of institutionalization would coexist with an international system of states but could overrule them in clearly defined spheres of activity, particularly those that cross state borders; for instance, pollution and disease control. The United Nations and the European Union exemplify this form of elite governance. The second kind of political cosmopolitanism operates at the demotic level in the form of grassroots social movements and networks concerned with issues such as human rights, labour conditions and refugee resettlement (see Goodman, 2004). The effects of globalization have challenged scholars to theorize political agency and subjectivities in more complex ways. The fact that individuals can continue their roles as national citizens while directly engaging in transnational political activities at both elite and demotic levels underscores the complex and multilayered political interests and modes of engagement mobilized by the cosmopolitan subject (Vertovec and Cohen, 2002a: 12).

A cosmopolitan politics, in this understanding, demands recognition of an 'important democratic principle: the legitimacy of plural loyalties' to different communities and political bodies (Mitchell Cohen, 1992: 482). The idea of multiple (and sometimes contending) allegiances has caused considerable debate in older forms of cosmopolitanism, which pitch the loyalties of the compatriot to the homeland/nation against his/her more abstract ties to humanity in general. There have been many instances in Western history when the term 'cosmopolitan' has been used to vilify nonconformists, including Christians, Jews, aristocrats, merchants, homosexuals and intellectuals (Brennan, 1997: 20). The cosmopolitan's relation to the nation continues to exercise the attention of new cosmopolitan thinkers (see Nussbaum and Cohen, 1996). Some, like Arjun Appadurai, claim that nationalism has been superseded by alternative forms of belonging arising out of the new dynamics of time-space compression afforded by globalization. For Appadurai, terms such as ethnoscapes, finanscapes and mediascapes express new dimensions of transnational social relations that surpass the primacy previously accorded to national affiliations (1996).

The centrality of the nation in cosmopolitan formations has been vigorously defended by critics such as Benedict Anderson (1998), who argues that the nation-state continues as the basic unit of political activity in the global era. Similarly, Timothy Brennan (1997) and Pheng Cheah (1998) call attention to the ways in which nationalism works

in tandem with transnational capitalism to achieve increasing geopolitical influence for specific nation-states. These attempts to rethink the relationship between the nation-state and global capital are matched by more philosophical inquiries into the changing face of nationalism. For example, Appiah asserts that a cosmopolitan perspective can only stem from a strong sense of location; his notion of the 'cosmopolitan patriot' celebrates multiple cultural affiliations while remaining committed to the political culture of a single nation-state (1998). Leela Gandhi also investigates the affective dimensions of cosmopolitanism in order to understand the deep attachment to the nation manifest in many societies previously colonized by the West (2000). She provides a timely warning against the uncritical, celebratory embrace of cosmopolitanism in the field of cultural studies, reminding us of the dangers of assuming an implicit teleology of progress whereby postcolonial cosmopolitanism is perceived as the next stage of development from modernist nationalism. Gandhi's caution has particular resonance for analysing the Australian situation in the early to mid-1990s when the Keating Government advocated republicanism and multiculturalism as part of its nation-building plan. Like Gandhi, we maintain that nationalism and cosmopolitanism as theoretical and political projects must be understood as operating dialogically rather than antithetically.

The third category of cosmopolitanism is arguably the best known and also the most elusive. Cultural cosmopolitanism can be described as an attitude or disposition characterized by openness to divergent cultural influences, *as well as* a practice of navigating across cultural boundaries. For Ulf Hannerz (1996) and Timothy Brennan (1997), this mode of being in the world entails an inclusive stance towards cultural difference that balances some of the more abstract aspects of cosmopolitan moral philosophy. Such a stance accommodates the transnational flow of capital, ideas, products and human bodies that has constituted rapid globalization, and challenges more traditional perceptions of national cultures as integrated and bounded. According to Stuart Hall, cultural cosmopolitanism proposes not a homogenized society 'without culture' but one that 'draws on the traces and residues of many cultural systems, of many ethical systems. ... It means the ability to stand outside of having one's life written and scripted by any one community ... and to draw selectively on a variety of discursive meanings' (2002: 26).

While Hall is attentive to the ethical issues involved in the selective incorporation of other cultures, less rigorous scholars have used cultural cosmopolitanism to mean a simplistic form of 'mix and match' cultural fusion, with the added patina of international sophistication. We

describe such populist concepts as 'thin' cultural cosmopolitanism, which lacks due consideration of either the hierarchies of power subtending cross-cultural engagement or the economic and material conditions that enable it. This usage is ubiquitous in the tourism industry, where the generic cosmopolitian city is presented as a space occupied by an array of highly ethnicized individuals and groups whose differences are visibly embodied in physical attributes and/or particular cultural practices. Such cities are not necessarily made up of cosmopolitan subjects (defined in terms of an international orientation) but those whose cultural specificities add variety to the urban landscape. The delights and/or challenges posed by this cultural diversity tend to vary according to whether it is encountered in our home country or 'abroad'. In the local cosmopolitan city we seek difference – ethnic foods, multicultural arts, a variety of cultural practices – that can be cast as somehow exotic. The foreign cosmopolitan city, on the other hand, must offer not only difference but also sameness, particularly if it is located in the non-Western world. This is what Paul Theroux calls the 'home plus' factor (1986: 133). So, for example, Shanghai or Tehran might be judged to greater or lesser degrees cosmopolitan, depending on how much of the physical, social and cultural landscape can be comfortably negotiated by the implicitly Western visitor. While these invocations of thin cosmopolitanism might be beneficial for cultural tourism, they have little value as analytical tools other than to provoke the question of what constitutes cosmopolitanness as opposed to what is merely inscribed with signs of Otherness.

Thin cosmopolitanism also circulates in the arena of aesthetics where it is associated with exoticism and commoditization, as demonstrated, for example, in the fashion for 'Zen' décor comprising a fusion of oriental and modern European design. According to Anthony D. Smith, this form of naive cosmopolitanism is characterized by pastiche and consumerism and consists 'of standardized mass commodities, images, practices and slogans ... and an interdependence of all these elements across the globe' (1995: 20). This approach to cosmopolitanism is prominent in some areas of the Australasian performing arts circuit and can lead to problematic forms of cross-cultural traffic. Operating on the thesis that cosmopolitanism institutes a certain 'regime of value' in which exotic forms of cultural difference circulate as valuable commodities, we propose that cosmopolitanism is increasingly gaining purchase as a form of sociocultural capital, both domestically and internationally. This is not to imply that 'every act of commodity exchange presupposes a complete cultural sharing of assumptions, but rather that the degree of

value coherence may be highly variable from situation to situation, and from commodity to commodity' (Appadurai, 1986: 15). This book's task is to identify such value coherence across a range of theatrical practices and sites of consumption.

The methodology deployed by *Performance and Cosmopolitics* can be described as a form of 'thick' analysis that endeavours to locate cross-cultural encounters within relevant sociopolitical and historical contexts and reflexive interpretative frameworks. Drawing largely from postcolonial theory, we examine the cultural freighting attached to cosmopolitanism and, in particular, its historical association with imperial privilege. Postcolonial studies has played a major role in exposing cosmopolitanism's historical imbrication in Europe's civilizing mission. Anthony Pagden, among others, maintains that cosmopolitanism cannot escape from its post-Enlightenment lineage and thus cannot be anything other than a reflection of Western liberalism (2000). Similarly, Gandhi calls attention to the ways in which the cross-cultural encounter implicit in the concept is underscored by colonial knowledge systems that encode a fundamental disparity between the West and the rest. Enlightenment cosmopolitanism, she asserts, 'manifest[ed] itself principally as a form of voracious knowledge, or as an epistemological expansion which attempt[ed] frenetically to keep pace with European colonialism and the concomitant growth of imaginative and practical ethnography' (Gandhi, 2004: 45). Other critics are more positive about the potential to reconceive cosmopolitanism from a postcolonial perspective while acknowledging its historical biases, particularly with regard to race. Mignolo, for example, concedes the racism inherent in Kant's deliberations about what constitutes proper 'personhood' – Kant essentially excluded groups such as Amerindians and Negroes – and thus who deserves to receive universal hospitality (2000: 733–4). For Mignolo, the task of critical cosmopolitanism lies in discovering options beyond benevolent recognition and humanitarian pleas for the inclusion of the Other, particularly on issues such as human rights and democracy (2000: 745). In a similar vein, Ackbar Abbas criticizes the celebratory voluntarism implicit in much cosmopolitan-talk and points to colonial situations where different cultural experiences are not chosen but enforced (2000: 771). Such critiques of cosmopolitanism and its valencies play a vital role in reminding us that the terms of cross-cultural engagement are rarely free of power, but rather embedded in asymmetrical relationships dominated by the forces of commerce, imperialism and/or militarism.

It is with this worldliness in mind that we approach a range of theatrical practices and institutional formations in mainstream, festival, avant-garde and community sites in order to investigate the usefulness of cosmopolitanism as a critical apparatus for understanding the complexities of cross-cultural interaction. As appropriate to our focus on cultural praxis, we deploy as a working definition Hannerz's description of cosmopolitanism as 'an intellectual and esthetic openness toward divergent cultural experiences', which generally entails sufficient reflexive cultural competencies to enable manoeuvrability within new meaning systems (1996: 103). The central contention of this book is that there is, inevitably, a politics to the practice of cosmopolitanism – a *cosmopolitics* that is caught up in hybrid spaces, entangled histories and complex human corporeographies.

Theatre matters

Our interest in Australasian cosmopolitics took on a palpably visceral dimension some years ago when we visited the Art Gallery of New South Wales to see the blockbuster exhibition, 'Orientalism: Delacroix to Klee'. As one might expect in a post-Said era, the paintings and sketches featured in the exhibition were acknowledged (in both written captions and verbal explanations on audiotape) as products of an orientalist vision that traded primarily in fantasy and cultural misrecognition. We confess to being somewhat relieved by this curatorial approach; it confirmed that we belonged to a cultured, cosmopolitan society while offering a way of mediating the illicit pleasures presented by the exhibition. Thus, we could gaze at Jean-Léon Gérôme's *The Snake Charmer* – more breathtakingly beautiful than the cover of Edward Said's 1978 book, *Orientalism*, can begin to suggest – while reading or listening to Linda Nochlin's well-known critique of the painting. We left the exhibition hall immensely satisfied, stimulated intellectually and sensorially, until we noticed a photo booth of the kind ubiquitous to theme parks, along the obligatory exit route past the posters, catalogues and postcards. Apparently without irony, the booth's attendant invited us to choose from an array of exotic costumes, step into the makeshift harem and have a snapshot taken as a memento of our visit. Was this photo opportunity to be read as a rather thoughtless concession to commercialism or, waywardly, as a satire of the exhibition's earnest political correctness – or both? We were astonished that the exhibition's curator would approve of such a cheap trick, and that we would be tempted, for even a second, to play along!

Our experience of the exhibition is an uncomfortable reminder of the ways in which specific ideological positions unravel at the point of embodiment – the point of performance. In this case, the discursive frame so carefully constructed to position spectators as *post*-orientalist aesthetes seemed to fracture at the instant we were offered a body-based experience of orientalism itself, particularly since it was unclear how the masquerade operating in the particularized space of the photo booth might articulate with the apparent objectives of the exhibition: to visibly perform/practise/iterate/simulate Sydney's (and beyond that, urban Australia's) cosmopolitanness. This vexed question of embodiment has particular implications not only for a cultural praxis that aims to avoid the pitfalls of exoticism – or other (difference-based) 'isms' of its ilk – but also for one that valorizes concepts of a common humanity and/or global community. One of the main assertions of this study is that it is precisely the process of embodiment that reveals cracks in cosmopolitan philosophy and, in the context of Australia's cultural relations with Asia and the Middle East, connections between the new cosmopolitanism and a not-so-new orientalism.

To insert the problematics of embodiment into cosmopolitanism is to trouble its more nebulous elaborations as a practice of 'thinking and feeling beyond the nation' and being 'at home in the world', to cite the (sub)titles of two influential books in the field (Cheah and Robbins, 1998; Brennan, 1997). While the mode of (apolitical) deterritorialization invoked by these phrases is characterized by critics such as Robbins as an embodied consciousness (1998: 2–3), this form of affective embodiment does not confront the hard questions about representation, about the ways in which particular practices or peoples seen as cosmopolitan (or not) may be implicitly racialized, gendered or ascribed a certain class status by this descriptor. The emphasis on 'thinking and feeling' as the primary constituents of cosmopolitanism can activate individual agency in important ways, but cannot adequately address concerns about how cosmopolitanism may be harnessed to serve broader political and cultural agendas. In this respect, new cosmopolitanism, as an explanatory model of an ever-evolving global citizenship, needs to engage with the more performative, embodied conceptions of the term as it might apply to peoples, groups, cultures and practices.

Theatre, lucidly described by Yan Haiping as 'a humanly animated site where living community and live performance are mutually engendered and the lifeworld at large is writ small with human materiality' (2005: 226), provides an exemplary site through which to examine the limits as well as the potential of cosmopolitan thinking. The materiality of

theatre, manifest at multiple levels, offers practical ways of grounding the abstractions of theory, allowing us to relate ideals and concepts to tangible ways of living in the world. As an aesthetic practice, theatre focuses attention on the ways in which cosmopolitanism is embodied, spatialized and temporalized rather than merely inhering in sentiment and/or consciousness. As a social practice, theatre situates cosmopolitanism within specific cultural, political, geographical and historical contexts that anchor its universalizing impulses. As an economic practice, theatre shows how cosmopolitanism is imbricated in identifiable circuits of production, distribution and consumption that connect with the operations of (trans)national capital. In combination, theatre's material aspects thus enable us to apprehend the contingencies of cosmopolitanism as a form of cross-cultural *praxis* as well as a discourse about cross-cultural engagement. From this perspective, we can also begin to isolate cosmopolitanism's normative and/or evaluative functions as a regime of value that regulates particular practices and their meanings at various times within specific communities.

Within theatre's complex materiality, the cosmopolitics of cross-cultural exchange may be located at the levels of representation, training/rehearsal processes and reception practices, understood in this study as dynamically interactive aspects of any production. To determine how performance articulates (with) cosmopolitanism in Australasia, we examine these three sites with reference to broader cultural trends and political and economic imperatives. In terms of representation, the focus is mainly on encounters between settler Australians, Aboriginals and Asians as enacted through particular dramaturgies and modes of embodiment on stage, though we are also interested in the position(s) of racialized groups within the structures of the performing arts industry. Our analysis of process concentrates on questions about the ethics, as well as the mechanics, of cultural exchange when (predominantly) white artists experiment with Asian and/or Aboriginal performance traditions and physical training regimes. The issue of reception, by comparison, directs our attention to interpretive communities and their variable investments in cross-cultural engagement. In some cases, reception patterns underscore the economic basis of such engagement and the purchase of cosmopolitanism in branding products for particular market constituencies. While our account of these intersecting levels of activity is grounded in a specifically Australasian regional context, it is also designed to serve as a paradigmatic analysis of modes of cross-cultural theatre, an art form that has achieved considerable commercial success and attracted significant

critical attention in international performance studies. In this instance, indigenous performance is foregrounded as a critical axis of exchange to extend and complicate prevailing models of East–West cross-cultural praxis, while speaking to local particularities.

Cosmopolitanism in Australia

Situating the cosmopolitan debate within an Australasian context entails divesting it of some of its US-based cultural and political accretions as well as probing its conceptual lacunae, particularly with reference to indigenous interests. This includes reviewing the ways in which cosmopolitanism has been celebrated as a remedy to problems associated with multiculturalism, notably communalism and the perceived decline of the nation-state as a political entity. Australia and the United States have radically different approaches to managing cultural diversity. In Australia, as in Canada, official multiculturalism has operated since the early 1970s as a 'top-down' strategy implemented by the state to improve the participation of ethnic minorities in the national culture, whereas in the United States, multiculturalism remains largely a community-generated (minoritarian) consciousness that has come to influence state management. For cosmopolitan advocates such as David Hollinger, US multiculturalism is associated with a growing pluralism that rigid-ifies ethnoracial boundaries (1995). His concept of the 'postethnic' subject, inspired by cosmopolitanism's emphasis on 'human' common-alities that cut across particular identities and affiliations, is presented as a solution to the multicultural predicament. Such calls to refortify the nation-state by reinforcing a sense of unity and the pursuit of a common (national) good have escalated since the September 11 terrorist attacks on New York and Washington. It is this covert nationalism, smuggled under the banner of cosmopolitanism, that Brennan (1997) warns against.

In Australia, the backlash against multiculturalism in the last decade has been impelled by domestic cultural politics, also coupled lately with anxieties about global terrorism. While a great number of Australians embrace cultural diversity as part of the nation's contemporary char-acter, multiculturalism as a policy has been disparaged by political leaders and intellectuals alike, charged with the superficial celebration of difference and/or the promotion of cultural and racial enclaves. Since its election in 1996, John Howard's conservative government has gradually eroded official multiculturalism – while building the rhetoric of a 'shared national identity' among different cultures – and persistently attempted

to restrict claims for indigenous land rights. Such actions have accompanied, and enabled, the rise of a populist nationalism, spearheaded by Pauline Hanson and her One Nation Party in the mid- to late 1990s. As a populist movement, Hansonism pitched itself against multiculturalism, which it characterized as the project of a political, economic and cultural elite; it also cast Asian immigration as a source of unemployment for 'ordinary' Australians and the provision of government services to Aboriginal communities as a form of politically correct favouritism (Neilson, 1999: 113). While such antagonisms were undoubtedly present under the previous Labor Government, the Howard administration has tended to legitimize processes of racialization – and racism – by either reiterating (white) anxieties about cultural difference, as evident in current anti-Islamic sentiment, or failing to respond more vigorously to the bigoted views of politicians such as Hanson.

Hanson's selection of Asians and Aboriginals as scapegoats for the economic and social ills of late capitalism in Australia speaks not only to a long history of colonialist anxieties about the (white) nation's specific Others but also to the Keating Government's earlier attempts to reorient Australian culture and commerce towards the nation's own geopolitical region. For our purposes, the critical element of this reorientation was the release in 1994 of Australia's first, and thus far only, national arts policy, *Creative Nation*. Stressing the need to tackle global trade issues and create products for international markets, *Creative Nation* articulated Keating's vision of a culture-led economic and creative future for Australia:

> This cultural policy is also an economic policy. Culture creates wealth ... Culture employs ... Culture adds value ... It is a badge of our industry. The level of our creativity substantially determines our ability to adapt to new economic imperatives. It is a valuable export in itself and an essential accompaniment to the other commodities.[3]

Creative Nation was significant in its dual emphasis on the national imperative to nurture cultural development and the economic potential of cultural activity. In contrast to the access- and equity-based forms of cultural administration in the 1980s, *Creative Nation* shifted the focus towards user-pays and industry-dominated rationales, which included being responsive to changing regional and global economic conditions (Craik, Davis and Sunderland, 2000: 195–6). Asia, as a potentially vast market for Australian cultural products, was central to Keating's policy initiative, though he was aware of the diplomatic work remaining to be

done to counter Asian perceptions of a vestigial White Australia.[4] His foreign minister, Gareth Evans, likewise stressed the need to develop a new 'country brand image' in Asia (quoted in Walker, 1997: 24). Cosmopolitanism was identified as the foundation of this new image through the co-optation of Asianness and Aboriginality. This mobilization of cultural resources from minority and marginalized groups is a form of 'commercial cosmopolitanism' – a market-driven approach to culture that manifests itself in particular forms of consumption and distribution. When Keating lost office, much of his policy was yet to be implemented; however, in the absence of an alternative proffered by the Howard Government, the underlying principles of *Creative Nation* continue to inform arts management today.

Indigeneity and Asianness were also linked, albeit more symbolically, in the republican movement of the 1990s, in which Keating played a leading role. While cultural reorientation towards Asia had been advocated primarily as a way of reviving Australia's flagging economy, for Keating it was also part of a teleology of the nation's movement away from its colonial past and into a cosmopolitan republican future (see Betts, 1999). The new republic, as Keating made clear on a number of occasions, would be premised on reconciliation between indigenous and non-indigenous Australians and a formal recognition of the status of Aborigines as the historically dispossessed first inhabitants of the nation. That the 1999 referendum on whether to change the constitution resulted in a majority ballot for the status quo suggests some of the tensions underlying this republican vision, even if the no-vote was motivated by a diverse range of political investments.[5]

Keating's yoking of cosmopolitanism to government policy initiatives was seen in some sectors as another form of multicultural elitism that devalued Anglo-Celtic heritage and threatened to dictate the terms of 'ordinary' Australians' engagement with other cultures. Yet, resistance to such elitism has not precluded expedient claims to more organic kinds of cosmopolitanism, particularly when Australian culture is presented to an international audience, as in the Olympics ceremonies. Hugh Mackay observes that whereas the term 'multiculturalism' has 'never had a comfortable currency' in Australia, cosmopolitanism retains a sense of flexibility and agency:

> [Multiculturalism] sounds like a bureaucratic invention and social engineering ... It is seen more as a fragmentation of culture, lots of subcultures, without coalescing ... But the word people love is cosmopolitan. It sounds exciting and when you say it people swell up

with pride. Cosmopolitan sounds like something we achieved, not something that was imposed on us.

(quoted in Paul Kelly, 1997: 21)

Clearly, part of the appeal of the popular/thin cosmopolitanism described here is its conceptual detachability from multiculturalism as a strategy of ethnoracial management. In practice, cosmopolitanism and multiculturalism, in their many cultural and political modes, are more ambiguously entwined in Australia, particularly in the performing arts, as various parts of this book suggest.

Locating Australasian theatre

Historically, the term 'Australasia' has referred to the physiography of Australia, Aotearoa/New Zealand and Melanesia (including New Guinea and neighbouring islands north and east of Australia in the Pacific Ocean). In geopolitical terms, Australasia commonly denotes the nation-states of Australia and New Zealand. In the last two decades, however, there has been a gradual change in this conventional understanding as Australia (and, to a lesser extent, New Zealand) attempts to forge stronger relations with the rising economic powers in the Asian region. Australasia is thus sometimes used in an expanded sense to include Asia, particularly when the focus is on region-based cultural, social and polit-ical relations. Our study of cross-cultural transactions in Australasia takes its cue from this emerging sense of the term; we deliberately foreground the position of Aboriginal performance cultures in this regional grid, not only because of their intrinsic importance to our study but also to acknowledge precolonial cartographies and patterns of Asian–Aboriginal cultural trade.

The changing meaning of 'Australasia' is reflected in the development of contemporary Australian theatre in so far as significant segments of the industry have moved to embrace Asian performance forms, methods, products and/or commercial opportunities, as well as to explore the thorny history of cross-cultural relations in the region. This latter project has inevitably involved an extended engagement between indigenous and non-indigenous cultures, played out in both aesthetic and political terms. Keith Gallasch's recent assertion that 'Australian performance resonates with the drumming of the circus, the stamping of Arnhem Land dancers and the stomping of Suzuki Tadashi trained performers' (2001: 38) suggests the pivotal role of Aboriginal and Asian influences in what has been a dramatic shift from the largely monocultural – and

often anxiously nationalist – theatre of the mid-twentieth century to what is now an (arguably) internationalist industry more adept at negotiating cultural specificities, in both product and process, and more attuned to regional and global markets. Gallasch locates evidence of this development not only in a newly manifest cultural pluralism but also in a new style of visceral performativity that registers the 'distinctively Australian' body as 'increasingly complex' and 'multicultural' (2001: 38). This assessment indexes the dual impulses behind what we interpret as the cosmopolitan reorientation of Australian theatre: an energetic commitment to cultural diversity and a simultaneous tendency to incorporate cultural difference into realignments of national identity.

Contemporary Australian theatre has been examined from a range of thematic, aesthetic, sociopolitical and structural perspectives that cannot be catalogued within the scope of this book. Suffice it to say here that the period from the 1970s is generally registered as one marked by an extraordinary diversification of theatrical styles, activities and modes of address; increased politicization of performance and reception processes; and, as Gallasch's (2001) observation suggests, the (partial) decentring of Western naturalism and its associated sociocultural canvass. As historically marginalized groups have demanded their place on the nation's stages, the predominantly nationalist theatre historiography of the 1970s and 1980s has given way to scholarly practices more acutely attuned to the politics of race, class, gender and sexuality.[6] In particular, postcolonial and feminist studies of the field have attempted to rethink its contours to highlight the complex connections between cultural histories and embodied cultural practices. Cross-cultural theatre (broadly defined) has not been entirely neglected in such endeavours, but there has been little attempt to systematically assess its profound impact on the development of Australian performing arts praxis or its signal role in the industry's internationalization. *Performance and Cosmopolitics* aims to address such gaps while (re)locating Australian theatre in a regional context that is (too) often forgotten and/or downplayed.

The bulk of this study is devoted to analysing the ways in which indigenization and Asianization, understood as dynamic cross-cultural processes, have been instrumental in forging Australian theatre's current cosmopolitan credentials. Among other things, these parallel processes have frequently accounted for the distinctiveness of Australian theatre as compared to other Western products circulating in the global arts market. This is especially the case at international festivals, where Aboriginality functions as a metonym for the 'authentic' nation while

(incorporated) signs of Asianness confirm Australia as an urbane and outward-looking society. Within the nation, Australian theatre's cosmopolitan reorientation has worked at multiple and more complex levels and needs to be understood in relation to historical and political as well as market forces. In this arena, non-indigenous engagement with Aboriginal performance has been deeply embedded in a local politics of decolonization and postcolonial reconciliation, while patterns of interest in Asian performance have been shaped by the national investment in multiculturalism[7] and, notably, by Australia's attempts to form closer and more positive regional connections with Asia.

To provide a historical context for our discussion of contemporary work, we begin by tracing early representations of (anti-)cosmopolitanism on the Australian stage. Chapter 1 analyses a number of texts performed in different moments from the 1830s to the 1970s, when cross-cultural theatre work began to develop as a significant force in the nation's performing arts industry. By historicizing theatrical expressions of contact between disparate cultures in Australasia, we situate whiteness, Asianness and Aboriginality – each contested markers of Australia's current cosmopolitan credentials – as foundational elements in the imagined community of the nation. Chapters 2 and 3 outline, respectively, the indigenization and Asianization of Australian theatre in recent decades. We suggest that these trends are manifest through increased visibility of Aboriginal and Asian theatre in fringe and mainstream venues, wider participation by Aboriginal and Asian Australians in various aspects of the performing arts industry, greater investment in collaborative ventures and exchanges, and the valorization of signs of cultural difference in performance. The two processes are treated separately to account for their discrete histories and trajectories as well as their different inflections by specific cultural issues and arts policy initiatives. Chapter 4 builds on this discussion, comparing indigenizing and Asianizing trends as evident in one of the most visible and lucrative sites of cosmopolitan traffic: the international arts festival. Here, we focus specifically on the programming and reception of Aboriginal and Asian performances at the Adelaide Festival in order to elucidate the commercial and social currency (and risks) of cross-cultural theatre positioned within a global performing arts market.

The latter part of the book examines the cosmopolitics of specific productions and practices in more detail. Chapter 5 consists of case studies that attempt to trace the differential meanings attached to cosmopolitanism as it circulates in mainstream and avant-garde circuits. Three modes of cross-cultural work are examined as paradigmatic sites of

cosmopolitan engagement: indigenous stagings of canonical European texts; the Asianization of an Australian 'classic', *The Floating World*; and the bodily incorporation of Suzuki Tadashi's actor training method by two physical theatre companies. Chapter 6 interrogates the concept of 'hybridity', which is often associated with (thin) cosmopolitanism and said to characterize Asian Australian cultural production and identities. This section focuses on key performance texts that explore the embodiment of racial/ethnic difference beyond the prevailing forms of exotic commoditization. Our concern with the ethics and politics of embodiment is further developed in Chapter 7, where we investigate performances dramatizing the experiences of asylum seekers within the nation's detention system. Ironically, such theatre may constitute one of the more efficacious cosmopolitan projects in contemporary Australian arts, despite constraints to cross-cultural engagement occasioned by government policies.

Across its various parts, *Performance and Cosmopolitics* aims not only to apprehend the complexities of cross-cultural theatre, but also to calibrate the ways in which specific racialized communities negotiate and change particular cosmopolitan formations. By anchoring the cosmopolitical dilemma to the very material processes of theatre within the Australasian region, we hope to arrive at a new – and nuanced – understanding of cosmopolitanism that is in dialogue with international debates.

1
(Anti-)Cosmopolitan Encounters

> *[L]et us not say that Aboriginality is our past and Asia is our future. It is one of the hallmarks of nationalist thought to see the Other as displaced in time.*
>
> (Stephen Muecke, 1994: 5)

Aboriginals and Asians on the colonial stage

A commonly held perception is that Australian theatre had only European and American models on which to draw as it gradually developed from an import-dominated enterprise in the convict era into a home-grown arts industry that, by the early 1970s, seemed ready to engage with the diverse range of non-Western performance practices becoming more accessible with the nation's turn towards multiculturalism. In fact, colonial audiences – and presumably aspiring practitioners – did have some opportunities to observe specific kinds of Aboriginal, Maori, Chinese and Japanese performance, if not necessarily in establishment venues. Their responses, often marked by incomprehension and even distaste, nevertheless reveal a deep fascination with aestheticized displays of cultural difference. Such events, we argue, constitute the beginnings of an Australasian theatrical cosmopolitanism, albeit one marked by racism and a sense of cultural incommensurability.

Aboriginal corroborees were the earliest public entertainments available to settler/invader populations in some parts of the fledgling colony. The *Perth Gazette* documents a well-attended corroboree organized by

Noongar leader, Yagan, and performed by local tribesmen in 1833, just four years after white settlement commenced in Western Australia:

> Captain Ellis was induced to allow the Swan River and King George's men to hold a corroboree in Mr Purkis's yard ... which attracted an overflowing audience. His Honour the Lieutenant-Governor Captain Irwin honoured the natives with his presence and we observed nearly the whole of the respectable inhabitants of Perth, including several ladies, all of whom seemed highly entertained. Yagen [*sic*] was master of ceremonies and acquitted himself with infinite grace and dignity. The ceremony of preparation for the performance was accompanied by a hurdy gurdy chaunt chorused by the party.
>
> (quoted in Rees, 1978: 17)

While Leslie Rees commented much later than the event itself that it was 'amusing to read about a primitive tribal dance described in terms of a court ballet' (1978: 17), the journalist on the spot seems to have discerned some of the artistry displayed by the Noongar performers and the gravity of their ritual. Whether this kind of cross-cultural transaction mitigated tensions between settlers and indigenous groups remains a moot point. Only a few weeks after the corroboree, the Governor declared Yagan an outlaw for his alleged role in the retaliatory killing of two white men; he was promptly shot and beheaded. As a much more grisly form of 'entertainment', his smoked, preserved head was sent to the Liverpool Royal Institution, where it seems to have been exhibited.

A later account of a corroboree witnessed by actor Joseph Jefferson in the Murray River region around 1862, suggests the limits of cultural transmissibility at a colonial frontier that had been forged through racial conflict and genocide. Jefferson is able to read some elements of the performance through the codes and conventions of Western theatre. He notes that the few white spectators present paid the Aboriginals a token sum for their 'artistic display', and that a row of blazing sticks served as 'footlights' to illuminate the performance area (Jefferson, 1889: 243). However, he seems at a loss to position the performance itself, except in terms of the uncanny. After remarking that the dancers' black bodies had been painted with white earth or chalk to resemble 'hideous' skeletons, he catalogues their movements:

> At some mysterious signal ... every alternate skeleton begins to move slowly, the others remaining rigid, then they jerk violently and spasmodically, and suddenly stopping, they become rigid; then the

alternate skeletons ... go through the same fantastic actions. Now they all screech and dance together, and suddenly, turning their backs, plunge into the deep woods and disappear. The spectators seem to breathe more freely after they are gone, and, looking around on one another, exclaim that it is the strangest sight they have ever witnessed.

(Jefferson, 1889: 244)

This account conveys both the aesthetic appeal of the corroboree as an exotic spectacle and its power to unsettle viewers lacking the requisite cultural knowledge to appreciate its function and meaning within Aboriginal societies.

Not surprisingly, corroborees – or rather simulated fragments of them – were rapidly incorporated into settler theatre to suggest a range of traits (physicality, primitivism, aggression, sexuality) typically ascribed to indigenous peoples, not only in Australia but also in other parts of the British and European Empires. David Burn's *The Bushrangers*, the very first play to be written directly out of Australian experience, though performed only in Edinburgh at the time, included a grotesquely drawn movement piece executed by white actors playing Aboriginal characters. Similarly domesticated versions of Aboriginal corroborees were to become familiar theatrical fare in forms as diverse as pantomime, melodrama, bush realism and, much later, Aboriginal theatre itself, which has tended to reappropriate corroboree dance forms as part of a larger project of cultural recuperation.

Another type of spectacular, non-Western performance witnessed in colonial Australia was Chinese opera, though its circulation seems to have been largely restricted to goldfields with substantial Chinese populations, particularly in Victoria. From the mid-1850s until the early 1870s, gold-rush towns such as Ballarat and Bendigo received regular seasons of Chinese theatre presented in canvas tents by travelling companies comprising up to 50 members. The performances, featuring acrobatics, dance, musical interludes and what colonial observers called 'regular opera', were staged nightly and often lasted into the small hours (see Love, 1985). These theatricals were generally patronized by Chinese audiences, but did attract some white visitors and newspaper reviewers, whose responses ranged from admiration to contempt. The Chinese performers' physical skills, particularly the vaulting and tumbling, elicited great praise, and critics report that 'the stage action [was] elaborately studied, and highly expressive' with every gesture seeming 'accurately rehearsed' (quoted in Love, 1985: 60). An 1860 *Argus*

article also commends the ornate costumes and elaborate make-up: 'The dresses are some of them exceedingly costly, the art of "making up" is brought to perfection, and the faces of some of the performers are painted with a skill to which our best artists can scarcely boast to have attained.'[1]

Other spectators were more equivocal about the operas' visual aesthetics. An 1863 report asserts that the Chinese theatre 'displayed a high degree of barbaric taste' even though it expressed 'the uncouth ideas of a wrongly civilized people' (quoted in Love, 1985: 65). On the whole, reviewers tended to be unimpressed by the narrative dramaturgy and utterly appalled by the music and singing. Harold Love details an instance of 'editorial outrage' about the 'hideous discords and cater-waulings' emanating from a Chinese company in Castlemaine in 1859: 'the instruments were of the rudest kind, and the enthusiasm of the performers only made the effect more ear-splitting. The performances consisted of inexplicable dumb show and noise, to Europeans, at least' (quoted in Love, 1985: 51). This kind of ethnocentrism constitutes the more benign edge of the cultural arrogance with which European settlers in colonial Australia regarded other races. Chinese settlers, initially migrating in the late 1840s in small numbers as indentured labourers to work in the pastoral industry, and shortly afterwards in larger numbers to the gold diggings, 'were not regarded as fellow immigrants and colon-ists but rather as outsiders with no rights to the wealth of the colony' (Curthoys, 2003: 18). They were not permitted to hold gold-mining leases and were frequently objects of hostility and physical violence. As the century wore on, Chinese immigration was progressively restricted and then effectively halted in 1888 by laws passed in all Australian colonies except Tasmania (Curthoys, 2003: 29–30). This legislation was the forerunner of the White Australia Policy.

The distinctly anti-cosmopolitan bent of government policy, together with the hostility of many white settlers towards Chinese immigrants, no doubt contributed to a general ghettoization of Chinese opera. Love argues that its mixture of high art (dialogue sung to music) with acro-batic mime and other low art forms also presented a stumbling block to cross-cultural engagement (1985: 73). Apparently, spectator interest in the acrobatic segments of the operas reflected a larger public enthusiasm for circus performance, which was one of the more lucrative compon-ents of a highly viable colonial touring circuit operating in the latter half of the nineteenth century. While American companies such as the famous Cooper and Bailey's Great International Circus dominated circus performance within this circuit, Australian-based troupes, notably

Harmston's, FitzGerald Brothers and Filli's Circuses, not only toured Australia but also regularly visited India, the Dutch Indies and Singapore (Waterhouse, 1999: 23). Unlike the twentieth-century version of Australian cultural engagement with Asia, this older form of theatrical commerce can be described as colonial cosmopolitanism as it operated within established colonial trade routes that traversed North America, England, India and Australasia.

There was a visible Asian presence in many of these circus performances, along with Aboriginal input from performers such as Harry Cardella and Mongo Mongo. The Chinese acrobat, Chin Foo Lam Boo, appeared with Ashton's Circus in 1861, and Japanese circus groups and individual performers came to Australia from as early as 1867. Lenton and Smith's Great Dragon Troupe expanded while on tour in Asia to include a group of 12 Japanese performers from Yokohama, notably top spinner and juggler Gengero (Genjirō), and subsequently performed in Hong Kong, the Philippines, Penang, Singapore, Java and Calcutta before arriving back in Australia in 1867 (see Figure 2). It then toured the major Australian cities and towns on the east coast and continued to Aotearoa/New Zealand in 1869 (Sissons, 1999: 75–6). Japanese troupes were usually managed by English and Australian entrepreneurs, although some individuals, such as 'Sacaranawa Decenoski' (Sakuragawa Rikinosuke), eventually formed their own touring groups (Sissons, 1999: 73–4). Aside from the usual circus acts – acrobatics, juggling, tight-rope walking – the Japanese troupes were also known to perform excerpts from kabuki plays with sword-fights and live shamisen music. According to one newspaper report, these 'expressive pantomimes' were warmly received by the audience and perceived to conform to imperial standards: there was 'a great deal of gesticulation, a considerable amount of tumbling by the performers, and some terrific sword combats in very much of the style ... so much in vogue in London transpontine theatres' (Sissons, 1999: 79–80). Many of these Japanese performers remained in Australia, married and integrated into Australian society. Some, like Bungaro (Bunjirō) from the pioneering Great Dragon Troupe, went on to train Caucasian performers such as the world-famous equestrienne, May Wirth (Sissons, 1999: 98). The relative ease with which Japanese circus acts entered local repertoires in colonial Australia is undoubtedly linked to the fact that their particular artistic form was congruent with the local product. In all likelihood, the vastly smaller numbers of Japanese immigrants (compared to the Chinese) also contributed to their acceptability at this time.

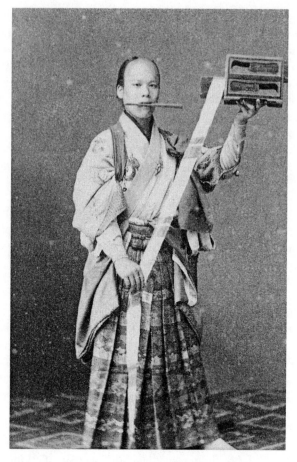

Figure 2 Unidentified top spinner, possibly Gengero (Genjirō) of the Lenton and Smith Troupe. (Photo: Courtesy Mitchell Library)

Staging Otherness

Although the existence of Aboriginal, Chinese and Japanese theatrical forms complicates notions of Australian theatre's Euro-American genealogy, as these brief examples demonstrate, their impact on representations of cultural difference on the colony's stages was dwarfed by highly coded images of indigenous and Asian characters, fashioned in accordance with popular stereotypes to fit transplanted Western entertainment genres. Mostly, such characters were played by white

actors, whose efforts to portray their non-white Others formed part of a larger imperial practice of racial (and racist) impersonation that was entrenched in structures of white privilege. Blackface minstrelsy, for instance, constituted one of the earliest and most pervasive mass-entertainment forms to influence the development of what was to become the typical nineteenth-century stage Aboriginal. From 1850, when minstrel troupes from America began touring in the Australian colonies, locally formed companies began to adapt this particularly versatile genre to speak to their own specific contexts. Although it is difficult to determine what precise images of Aboriginal peoples were included in Australian minstrel shows, there is little doubt that black-face minstrelsy instituted an iconography of racial difference that could flexibly encompass indigenous groups. As part of that iconography, minstrelsy normalized the process of 'blacking up' to play Aboriginal characters, which, to some extent, were styled after the stage Negro in popular theatre for some decades after the first spectacles of this sort.

While blackface minstrelsy presented a (limited) range of caricatured types that could easily migrate into other kinds of colonial theatre, notably pantomime and melodrama, their stock features were modified by the generic conventions of these forms, combined with the specific mythopoeic impulses of an Anglo-Celtic settler community attempting to forge a distinctive culture in a usurped land. In Garnet Walch's panto-mime, *Australia Felix – or Harlequin Laughing Jackass and the Magic Bat* (1873), Aborigines are co-opted into a cast of native characters (mostly animals) to help young Australia Felix triumph over the forces of English gloom in a contest for colonial rule that is allegorized as a fiercely competitive cricket match. Various other pantomimes featured Abori-ginal characters, similarly naturalized as part of the colony's exotic fauna, to construct specific Australian mythologies, but melodrama was the more enduring popular theatre genre to shape representations of Aboriginals – and also Asians of various types.

Margaret Williams argues that melodrama offered a special niche for Aboriginal characters in its comic by-play, traditionally executed by farcical servant figures whose resourcefulness delivers the hero and heroine from penultimate evil (1983: 267). Countless examples support Williams's thesis but a few will suffice to convey the flavour of these indigenized roles: faithful Warrigal drags the injured Captain Starlight away from the final shootout and nurses him back to health in Alfred Dampier and Garnet Walch's renowned bushranger play, *Robbery Under Arms* (1890); Nardoo, in E. W. O'Sullivan's *Coo-ee* (1906), thwarts a blackmailing villain by pulling the hero from under a wool press in

a blazing shed; and Nulla Nulla vaults nimbly onto a horse at the bushrangers' lair to rescue her prostrate mistress in Bert Bailey and Edmund Duggan's smash hit, *The Squatter's Daughter* (1907). Stage Aboriginals were by no means at the bottom of the precise hierarchy of stock characters that populated such bush melodramas; instead, they were shown as superior in wit and appeal to the inept new chum – typically dramatized as an English fop or his dour spinster equivalent – and always more trustworthy than Asians. The Aboriginal's 'generous share of colonial impudence' also gave him/her 'an affinity' with iconic white Australian characters (Margaret Williams, 1983: 267), whereas racially marked immigrants remained indubitably Other. This differentiation and hierarchization of races subtended a much broader process of nation-building in Australia, as our later discussion shows.

In rare instances, indigenous groups performed in melodramas in scenes staged for local colour – *The Australian Bunyips* (1857), for example, featured a corroboree danced by 'genuine' Aboriginals – but individuated character roles were invariably assigned to white actors (male and female), many of whose reputations gained a boost from their comic execution of these blackface parts. Actress Dora Mostyn, who played Cooee in W. C. Cooper's *Foiled* in 1896, is a noteworthy example, receiving plaudits from *Table Talk* for her winning rendition of the character's 'swift, noiseless appearances, his demoniac love of mischief, and his evident delight in existence'.[2] Sam Poole, likewise, is said to have 'stolen the show' with his impersonation of an old Aboriginal named Charley in Julian Thomas's *No Mercy* (1882):

> [I]t is the best representation of a blackfellow we have ever had upon the Melbourne stage. Most stage aboriginals have been modified negroes, but this aboriginal is like what many of us have seen. To be sure, he is not habited in a blanket nor an opossum rug, and he carries neither spear, waddy, nor boomerang; but he is a real native for all that, and for all that he has undergone the process of civilisation, and wears a trooper's dress, and swears like any white man.
>
> (quoted in Margaret Williams, 1983: 137)

Such examples show both the currency of Aboriginal roles in the colony's nascent theatre industry and the extent to which the cultural specificities of Aboriginal performance, as expressed in the ritual corroborees that both fascinated and unnerved white settlers, had been domesticated or suppressed. Notwithstanding occasional textual acknowledgements of Aboriginal dispossession – Eva's admission in

Coo-ee that the squatters have simply taken black territory is a case in point[3] – Australian melodrama's conspicuous interest in Aboriginal characters did not originate from a cosmopolitan impulse to engage with other (autochthonous) cultures, but rather from a provincial imperative to indigenize this tremendously popular entertainment form in ways that would appeal to local audiences. The contours of staged Aboriginality, as etched by that particular colonial transposition, would influence theatrical representations of indigenous Australians until well into the 1970s, when Aboriginal theatre became a significant force in the nation's performing arts industry.

If melodrama was the signature form to author the stage Aboriginal, it also offered ready-made plots, roles and settings through which to present settler images of Asia and Asians, infused, in this case, with the fabulous narrative and scenographic conventions of a stage orientalism that reached its zenith across the Western theatre world in the early decades of the twentieth century. Brian Singleton asserts that this orientalism came in two distinct types: a pictorialist variety, suited to popular entertainment, that 'subjected the Orient to fantasy in exotic spectaculars', and a modernist variety (as espoused by Yeats, Craig and Artaud) interested in 'high-ideal aesthetics or tribal primitivism' (2004: 14–15). Whereas recent (neo)orientalist theatre in Australia has tended to duplicate the modernist preoccupation with Asian performance aesthetics, as our later chapters show, the pictorialist form of orientalism held sway in colonial Australia, inspired and largely maintained by touring productions from Britain and, to a lesser extent, the United States.

One of the earliest productions in this exotic mode was *Sardanapulus*, staged by G. V. Brooke at the Theatre Royal in Melbourne in 1857. Following Charles Kean's 1853 London revival of the play, Brooke used sumptuous archaeologically inspired costumes and scenery to dramatize Byron's romanticized account of the political and social order of ancient Assyria. Later, Gilbert and Sullivan's hugely popular mock-orientalist operetta, *The Mikado*, introduced Australians to an equally fabricated, if iconically different, view of the Far East when it toured to large audiences in the 1880s.[4] The most magnificent orientalist extravaganzas, however, were mounted by Australia's expatriate son, Oscar Asche. Fresh from successful runs in London, Asche's productions of *Kismet* (by Edward Knoblock) and his own dramas, *Cairo* and *Chu Chin Chow*, toured to Australia across a decade beginning in 1912. His generically hybrid creations – part pageant, part musical comedy, part pantomime – were suffused with fantastical images of an alluring but dangerous Orient

of precisely the kind Said identifies in *Orientalism* (1978). Like the European travel literature and visual art that Said critiques, these shows conveyed the apparent sexual licentiousness, cruelty, sartorial excess, mystery, beauty, greed and corruption of the Orient, itself a generalized and homogenized formation, through attention to décor, costume and colour in a pseudo-realist style that functioned to authenticate the myths thus engendered. Such productions were immensely popular, though not immune to critical scepticism (Veronica Kelly, 1993: 40–1).

Theatrical orientalism, like blackface minstrelsy, functioned in the late-nineteenth and early-twentieth centuries as a representational apparatus through which a variety of concerns about racial and cultural difference could be figured. In this respect, both the generic conventions of minstrelsy and the stylistic innovations of orientalism (as applied to forms as diverse as high opera, melodrama, Shakespearian tragedy, pantomime and burlesque) were symptomatic of an era of territorial expansion that inevitably brought white colonists across the European Empires into real and imagined contact with other races. This confront-ation with alterity was played out not only at the colonial frontier but also, and most powerfully, in the imperial centres of Europe. Pictorialist stage orientalism of the kind exported to the colonies provided a way of commoditizing and consuming difference. While this fetish licensed certain types of racism, it also betrayed a deep Western fascination with Otherness and an appreciation of its value in commercial and aesthetic, if not epistemological or ethical, terms. Such theatre is arguably cosmo-politan in orientation but still colonial in attitude and practice. It did not demand – or exhibit – a culturally open disposition, or a commit-ment to continued East–West engagement, but instead supported what Said has termed the West's 'flexible *positional* superiority' over a largely manufactured Orient (1978: 7).

Various scholars have critiqued Said's contention that orientalism provided a totalizing and internally congruent technology by which 'European culture was able to manage – and even produce – the Orient politically, sociologically, militarily, ideologically, scientifically, and imaginatively' (1978: 3). Lisa Lowe, among others, argues for a more particularist critical concept: 'Orientalism facilitates the inscrip-tion of many different kinds of differences as oriental otherness, and the use of oriental figures at one moment may be distinct from their use in another historical period, in another set of texts, or even at another moment in the same body of work' (1991: 8). For our purposes, this raises questions about how stage orientalism was taken up in early Australian texts and how it operated as a local apparatus for

colonial self-fashioning, especially in relation to Asian peoples and cultures. Veronica Kelly locates one strand of Australian orientalism in an aesthetic register following Asche's use of 'light, kinesics, and colour', which, she argues, was readily appreciated and mobilized for local purposes (1993: 34–5). Her focus on the fit between the brilliant hues of pictorialist orientalism and a 'nationally-identified colour palette' offers a persuasive aesthetic model for interpreting the look of some Australian productions (1993: 35) but largely circumvents issues of cross-cultural representation. Colonial Australians' acutely-felt proximity to Southeast and East Asia, their sense of insecurity and isolation as an outpost of European 'civilization' in a non-Western region, and their general hostility towards Chinese settlers (who formed a numerically significant minority) all worked to produce an orientalism that, by the early years of the twentieth century, was obsessively concerned with racial and cultural Otherness. Whereas the British stage attuned itself to the exotic interests of a population geographically and imaginatively distant from the Orient (in its many guises), Australian dramatists spoke to the fantasies of a white settler community more threatened than seduced by so-called oriental cultures. Thus emerged the specific local stereotypes of a debauched (Chinese) and dangerously powerful (Japanese) Orient, both reflective of a racial politics particular to the time and place.

Chinese men were initially the most prominent Asian characters to appear in locally authored texts, occupying minor, usually comic, roles as cooks, gardeners, scheming merchants, gold fossickers or opium-addicted low-life. The paradigmatic example in this mode is Alfred Dampier and J. H. Wrangham's *Marvellous Melbourne* (1889), a satirical portrait of urban life that indexes topical debates about Chinese immigration through its larrikin 'revolutionary', Ledger, who blames the Chinese for spoiling the economic chances of the 'wukkin' class'. His resentment is chiefly directed at Hang Hi, a market gardener whose speech impediment and apparently artless cunning provides much of the play's stock comedy. This cultural stereotype is augmented by sketches of other Chinese settlers chattering secretively and incomprehensibly among themselves, and notably, by a portrait of the Chinese as abject Others in a scene set in a dirty, smoky opium den. That the gamblers, excepting Hang Hi, seem to have been played by Chinese extras in the Sydney production of the play (renamed *Slaves of Sydney*) likely helped to naturalize the stereotypes presented.

While *Marvellous Melbourne* could hardly be called culturally inclusive in outlook, it does present a vision of an increasingly diverse urban

community, however riven with racial tensions, that is accepted by at least some of the white Australian characters as normal. Ledger's sister, for instance, argues that a 'chinaman' has as much right to be in the country as an Englishman; moreover, the play's parody is directed as much at the new chum and the Irish constable as at the Chinese. Aboriginals are included in this urban melange but only as shadowy passers-by in the opening scene set at the city's main railway station. This rollicking portrait of colonial society would soon develop into a much more paranoid vision of cross-cultural (dis)engagement, as conveyed in a number of early-twentieth-century invasion dramas in which Aboriginals often played a key role in helping Whites to defend the nation from invading Asians. Such dramas formed part of a broader category of Asian invasion narratives that began in Australia in the late 1880s in literature, print media, cartoons and political tracts and intensified in the period after federation in 1901, as the fledgling nation began to define its cultural, political and economic position within the Asia-Pacific region. Theatrical versions of this trope are notable for the ways in which they stage whiteness, Aboriginality and Asianness as agonistic elements in the constitutive field of Australian nationalism.

White Australia or piebald possibilities?

Narratives about Asian invasion were symptomatic of the inherently racialized process by which the five separate Australian colonies federated to become an independent (white) nation. Ien Ang (following David Walker) argues that the discrimination undergirding the federation project had a distinct spatial as well as a racial dimension, linked to a general perception of an 'awakening Asia' with territorial designs on Australia (2003: 54–7). This 'threat ethos', which continues to inform Australia's obsessions about national security, was strengthened at the time by Japan's emergence as a significant world industrial and trading power and its victory in the Sino-Japanese War of 1893–95. That European settlers in the federation era were outnumbered in northern Australia by Asians (including Chinese, Japanese, Malays, Indians, Afghanis and Filipinos) working in agricultural, pearling, fishery and transport industries contributed to white Australians' racial/spatial anxieties. Asian invasion fantasies were also stoked by broader international discourses on race and degeneration connected with the incipient decline of the European Empires. Collectively, these particular factors led Australia, at its constitutional inception, to define itself *against* a generic Asia. In Ang's terms, this process amounted to 'a self-protective

parochialism, and a determined commitment to provincialism and anti-cosmopolitanism' as cornerstones of white Australian culture (2003: 58).

The anti-cosmopolitanism built into Australia's constitution as a nation did not overtly reference Aboriginal peoples; nevertheless, anti-Asian and anti-Aboriginal racisms 'were conceptually unified by their unshakeable belief in European superiority, reflected in a common, colour-bound lexicon' (Edwards and Shen, 2003: 6). Both groups were implicated in white Australian fears about miscegenation, elliptically expressed by the phrase, 'the crimson thread of kinship',[5] which was emblazoned as a motto on the commemorative citizens' arch erected in Melbourne for the federation ceremonies. The crimson thread of kinship conveyed the idea of a common bond between the people of the Australian colonies, based on a shared British ancestry. This metaphor powerfully fused the concept of race with kinship to imagine the newly federated Australian nation as an extended family with strong attachments to the mother country. But even at this very point of self-styled white triumphalism, the image of the solitary crimson thread exposed unease about maintaining the purity of the bloodline, and about the dangers of racial contamination. Clearly, the preservation of white kinship would be dependent not only on the regulation of Others (Aboriginal and Asian) but also, and more tellingly, on self-regulation and restraint in terms of cross-racial desire. This emphasis on whiteness adds a biological dimension to the history of Australian cosmopolitics: whereas cosmpolitanism today tends to be seen as the precinct of those Whites who are versed in the ways of other cultures, to be white in 'White Australia' was categorically *not* to be cosmopolitan.

We offer this brief cultural history as a way of anchoring the character constructions and narrative trajectories – and some of the ontological contradictions – evident in the typical Asian invasion play. An early precursor of the form was J. C. Williamson and Bert Royle's pantomime, *Djin Djin, or the Japanese Bogeyman*, first staged in 1895 and then updated for a federation performance in 1901. Couched in an orientalist vision of 'old' Japan, as conveyed via costumes, characters and setting, the narrative registers a shift in the locus of the perceived Asian menace from Chinese immigration to Japanese military aggression, but stops short of suggesting that Australia is at risk of being attacked (see Fantasia, 1996: 115–17). Instead, the pantomime Prince (Eucalyptus) and his supporters invade Djin Djin's temple, battling demon warriors in order to rescue the imprisoned Japanese princess (styled somewhat in the manner of a geisha) who will become the hero's bride. Later plays were much more blatant in figuring Japan's imperial intentions towards

Australia, instituting a plot (in both senses of the term) that would recur periodically in the nation's theatre throughout the twentieth century, albeit in very different phases and guises.

A fascinating example is Randolph Bedford's sensation melodrama, *White Australia, or The Empty North*, which presents a telling portrait of colonial anxieties about establishing and maintaining a robust Anglo-Australian society in a seemingly hostile geopolitical region. First performed in 1909, *White Australia* dramatizes attempts by a squatter and an engineer to repel an invasion by 'a confederation of coloured races' that has declared war on Australia (Bedford, 1909: 21). This confederation is led by an English-educated Japanese spy who is assisted by a few of his own countrymen, various slavish Chinese supporters and a traitorous Anglophile Australian whose bravery and loyalty have clearly been eroded by too many years spent in Britain. Most of the action is set in the so-called 'empty north' even though more populous areas such as Sydney are the targets of the Japanese naval invasion that forms the spectacular climax of the play. The setting reflects strong contemporary concerns that the vast, sparsely populated areas of northern Australia were an open invitation to millions of Asians who might usurp land that white Australians had failed to develop.

Bedford uses a familiar array of stereotypes to convey the moral battle between good and evil that is well recognized as one of the hallmarks of melodrama. The Japanese villain, Yamamoto, is cast as a ruthless, duplicitous tyrant bent on annihilating Australians and stealing their land; he is also aristocratic and dangerously well-versed in the white man's ways, almost admirable, provided he remains in his own country. The Chinese, on the other hand, are portrayed as lascivious, dirty, servile nuisances, threatening in numbers but individually lacking in the tactics to plan a successful assault. Pitted against these 'yellow' villains are two main kinds of white Australians: affable but lazy, gambling drunkards too complacent to guard against attack; and resourceful, virtuous and energetic patriots whose valour and ingenuity eventually save the day when they bomb the Japanese fleet in Sydney Harbour from the vantage of a revolutionary airship balloon. In the finest of Australian melodrama traditions, the winning side's glorious victory is only made possible by the intervention of two comic Aborigines, who rescue the 'goodies' from certain death after they have been captured by their foes.

There is much in this script that invites, indeed compels, deconstructive analysis. In particular, it should be noted that the narrative uses carefully differentiated manipulations of racial Otherness to demonize Asians and yet commend Aborigines, while displacing them from the

imaginary space of the nation. Yet, what is perhaps more remarkable than the virulence of the text's racism is the strenuousness of some of its characters' claims to whiteness, which are anxiously reiterated throughout the dialogue to form a racial metadiscourse of sorts. This raises the question of whether Bedford's play may have functioned not only to normalize Anglo-Australian versions of national identity, but also, and in a perverse way, to denaturalize notions of an organically white Australia. It is possible, though counter-intuitive, we admit, to consider that *White Australia* 'alienates' whiteness in at least two ways. First, what we are claiming as an accidental Brechtian *Verfremdungseffekt* occurs through the extraordinary focus on what Richard Dyer has called 'extreme whiteness', a form distinct from the unmarked whiteness that generally underpins the hegemony of Anglo-Australia. For Dyer, the whiteness of most people is ordinary, unspectacular or plain and this is what allows whiteness to imagine that it is able to speak on everyone's behalf – to be broadly representative. In his formulation, '[e]xtreme whiteness coexists with ordinary whiteness [but] it is exceptional, excessive, marked. It is what whiteness aspires to and also ... fears' (Dyer, 1997: 222). Thus extreme whiteness leaves a residue through which whiteness becomes visible as a racial marker rather than simply passing as an invisible, disinterested and normative category.

In Bedford's play, the mode of excess in representations of whiteness begins in the first few moments with an audience aside by Kate, one of the heroines, as she reveals her distrust of Yamamoto: 'I don't like that man ... Green's my eye but white's my colour' (1909: 3). This kind of obvious racial self-fashioning is adopted time and again by virtually all of the other Anglo-Australian characters, though it has different inflections according to gender and circumstance. The women are, of course, paragons of virtue whose whiteness is rhetorically intensified as they prove their allegiances to the national ideal of racial purity. Ironically, Victoria, the romantic heroine, is even willing to endure sexual violation rather than reveal strategic military secrets to the Japanese, though, predictably, this threat of inter-racial rape is averted at the eleventh hour. The paradox here is that the promised submission to racial contamination actually makes Victoria whiter since she would lose her virtue to protect White Australia. Extreme whiteness thus constitutes itself in the field of racial Otherness, deriving ontological power from the threat of that which is 'not white'. The already fallen white prostitute, Pawpaw Sal, provides an even more overt example of the improbable power of extreme whiteness when she manages to reclaim her sense of racial belonging after being found, mad and dissolute, in the opium dens

of the Port Darwin Chinese community. Spurred by her countryman's recognition of her whiteness, she stabs her pimp, exclaiming, 'White's my colour, yer yeller dog', then dies uttering the refrain: 'I'm all white again, god forgimme, all white, all white' (Bedford, 1909: 32). Here the anxious repetition of a reappropriated whiteness suggests it is less an essence than an aspiration (Hage, 1998: 20), something that, to a certain point, can be accumulated.

The play's versions of Australian masculinity are similarly punctuated by numerous vocal iterations of whiteness, delivered either as a form of self-reference or as a way of interpellating Others into the dominant discourse. From playful, approving expressions such as 'Ah mate, you're a white man' (Bedford, 1909: 18), to assertions like 'I'll show that I'm white when I'm wanted' (p. 16), to the jubilant battle cry of 'First blood to the white man' (p. 16), the sense of whiteness is intensified to the point of radical excess. It is represented as the organizing principle of colonial Australian society and the moral touchstone of its male patriots. In an elegant paradox, Australian masculinity draws on Englishness as a form of white patrimony but also defines itself against the emasculating Englishness that Cedric, the traitor, has accumulated.

Another important way in which whiteness registers in Bedford's melodrama as a constructed rather than natural category is through a comic set piece where Terribit and Minimie, the two Aboriginal characters, play at being their white masters. Using a surcingle (corset) and stays, along with affected upper-class manners, Minimie fashions herself as 'White Mary' and then demands all the privileges, including the vote, that her new status is supposed to afford. Terribit, meanwhile, takes on the role of the white suitor, albeit somewhat reluctantly because he fears it will compromise his own masculinity. After a considerable amount of stage business, they discard their disguises and resume Aboriginal modes of behaviour as Minimie paints Terribit with ochre to prepare him for war. This kind of cross-cultural transvestism, overtly staged as a self-reflexive performance, seems to perfectly fulfil Brecht's demand for a historicized treatment of social relations. Terribit's comment, 'White's the best trick of all but I'll back black against yeller till the cows come home' (Bedford, 1909: 50), shows that he is fully aware of the ways in which Aborigines are positioned relative to Asians and Anglo-Australians in the social hierarchy. The blackface conventions of the time further stress the possibilities for a wayward signification of whiteness in Bedford's play.

In making whiteness noticeable as a racial category in these ways, Bedford reveals its constructedness – and its tenuousness – as the

ontological basis of postcolonial nation-building. We are not suggesting here that *White Australia* was deliberately written to engage critically with the racist discourses of the time, but rather that both the text and its dramaturgy opened up possibilities for such a project. Support for this stance is evident in reviews of the premiere performance, since at least one commentator (from the nationalist *Bulletin* magazine) complained that the 'talk of White Australia from the word "go"' strained credibility and that the political purpose of such 'verbiage' was 'too glaringly obvious'.⁶ *Table Talk* added caustically that '[t]he house cheered the national sentiments', but ultimately appeared to agree with Terribit that 'there was "too much yabber"' (quoted in Margaret Williams, 1983: 242).

Not all invasion melodramas were as perniciously racist as Bedford's. Jo Smith's *Girl of the Never Never* (1912) similarly thematizes white imperatives to keep the country from becoming racially 'piebald', but in fact stages a vision of northern Australian society as already multiethnic, and not always regrettably so. Set in the Gulf of Carpentaria, the play is peopled with various Anglo-European settlers who must share the stage – and the imagined space of the nation – with an array of non-white Others, some central to the drama, some incidental. Among the indigenous contingent are numerous black station-hands and children, plus a teenage girl, Cinders, who plays the leading role in foiling an attempt to steal the hero's gold lease. These Aboriginals intermix with the villain's sidekick, a Japanese pearl diver, and sundry Chinese, notably a cook who is continually put upon by the 'lubras'. (Curiously, the cook speaks pigeon English with a distinct Aboriginal inflection.) Other such figures exist just outside the visible world of the play, mentioned by various characters but not embodied on stage. These include Malay traders, a Chinese carpenter and parties of raiding Blacks who make nuisances of themselves by rustling stock. The overall impression is not so much of a white garrison under siege (though this is one of the metaphors invoked) as of a working micro-economy, complete with its rogue elements. This image of a multiracial Australia in which indigenous and Asian groups interacted on a daily basis – and not just according to the contingencies of the plot, as in Bedford's play – is significant for its rarity at a time when the two groups were located in very different symbolic sites in the national imaginary and consequently separated in public and intellectual debate. Annette Hamilton has schematized this process as a cartography of racial segregation in which a white centre mediated between Asians, who threatened the 'fragile boundaries' of the continent, and Aboriginals, who occupied its 'empty heart' (1990: 18).

As well as suggesting the fluidity of the racial map of northern Australia, *Girl of the Never Never* also reveals slippages in the discourse of whiteness. The early scenes celebrate and centralize whiteness through devices such as the claptrap, a 'jingoistic line designed to appeal to nationalist sentiments' (Singleton, 2004: 69), but the obsession with an exclusively white Australia wavers as the narrative develops. The romantic hero seems particularly prone to contradiction: he proclaims at the outset, 'What comes first is our determination to keep this country white. It's our heritage, our pride, our religion' (Jo Smith, 1912: 35); yet, towards the end, he deems the Australian villain 'only white on the outside' when the latter declares he has 'no room for the coloured races' (p. 78). By contrast, the heroine, Pearl, is consistently unperturbed by the racial admixture and repulsed by the thought of racially motivated cruelty. Thus, she reacts angrily to the suggestion that the injured Japanese traitor should be left to die because he simply does not count: 'There's not a house in the Territory that would close its doors to a sick man or a hungry one be he black white or yellow' (p. 78). The play also acknowledges Cinders's claim to native title, if not in today's terms. When she asserts, 'Wommera: my country – all belonga my people' (p. 60), she is not contradicted. In fact, Pearl affirms the Aboriginal girl's birthright – and her trustworthiness. Such incidents not only rupture the hegemony of whiteness but also hint at a nascent cosmopolitan consciousness, at least on behalf of some of the characters.

If invasion plays such as *White Australia* and *Girl of the Never Never* revealed cracks in the anti-cosmopolitan foundations of the nation, it was partly because the generic modalities of melodrama – the mode of excess, the overt polarization of moral categories, the comic performativity – offered a ready template for staging a cast of characters and a series of situations seen as compromising the racial future envisioned at federation. In this respect, the invasion dramas discussed and others of their kind synthesize anxieties connected with the sedimentation of the White Australia Policy as a form of racial/spatial management. Their featured transactions between Aboriginal and Asian characters did not find a place in the roughly contemporaneous extravaganzas staged by Asche – though Singleton unearths a suggestive example of Aboriginals being recruited to perform as Nubian slaves in Asche's lavish, orientalized version of *Antony and Cleopatra* in 1913 (2004: 44) – and such cross-cultural transactions would also be largely absent from the social realist drama that developed from the 1920s after the decline of popular theatre. Only recently have Aboriginal and Asian characters begun to reappear together on the nation's stages, now in much more

complex triangulations with white Australia, as sketched in this book's conclusion.

Miscegenation and its discontents

Although Australian popular theatre seems to have been animated by fears of racial contamination in ways specific to the nation's colonial history and regional positioning, it was rarely explicit about cross-racial desire or its possible outcomes: miscegenation and mixed-blood offspring. These issues, largely unspeakable in colonial society, became the focus of a significant number of mid-twentieth-century plays that deal with cross-cultural encounters between Aboriginals and Whites. By this time, interest in Asia and Asians as theatrical subjects had diminished dramatically, possibly because immigration restrictions and local population growth had altered racial demographics in favour of a 'whiter' Australia in many parts of the country, particularly urban areas. The obsession with national self-definition continued, increasingly artic-ulated as a (white) postcolonial identity politics that involved renego-tiating cultural ties with Britain and finding local modes of national belonging. Like the other arts, theatre participated in such processes with varying degrees of success. In cosmopolitical terms, it can be described as inward-looking but not necessarily insular. A number of dramatists writing from the early 1930s were connected with international socialist theatre movements and drew inspiration from them in their treatment of social justice issues, including discrimination against Aboriginals. Their interest in miscegenation and the so-called 'half-caste problem' reflected a concern with the practical consequences of government policy, which moved from a segregationist to an assimilationist model over the decades from the 1920s to the 1960s. Assimilation worked around two key modes described by the indigenous critic, Ian Anderson, as 'fuck 'em white [and/or] train 'em right' (1995: 33). The former relates to the biological policy to breed the 'colour' out of Aboriginals through intermarriage with Whites, and the latter refers to the sociocultural policy of ensuring that Aboriginals lost their distinctiveness through cultural integration into white communities. The removal of children of mixed-race descent – later named the Stolen Generations – was among the more infamous assimilationist methods enforced by the authorities.

One of the most controversial portraits of miscegenation occurs in Katharine Susannah Prichard's *Brumby Innes*, considered too shocking to stage when it was written in 1927 even though it won that year's Triad Prize promising a full professional production. The play was the first to

expose white men's callous sexual exploitation of Aboriginal women, and to present indigenous cultures as subjects of dramatic interest in their own right. A drought-stricken cattle station provides the setting for what is essentially a realist vision of outback life, particularly in terms of race and gender hierarchies. With her story of a young indigenous woman, Wylba, who is taken from her community and forced to become Brumby's mistress, Prichard suggests that sex is the primary commerce between black and white Australians. In such transactions, women and Aboriginals are denied desire, and miscegenation is shown to be a white, male prerogative. The hypocritical, racist Brumby seems specifically created to incite our disgust, yet the play's critique of colonial relations is couched in a broader vision of natural (male) sexuality that tends to dilute moral censure. Although Wylba is treated sympathetically and given some degree of agency at the end, her rape is normalized by the metaphor of a stud brumby driven to service his 'brood mares'. Prichard's (mis)use of Aboriginal ritual in a long corroboree that frames the narrative further licenses Brumby's actions because it sets up a parallel between him and the Narloo, a mythical figure associated with both sexual threat *and* creativity whose bad behaviour would not be seen as exceptional in some Aboriginal contexts. When the play finally reached the stage in 1972, co-produced in Melbourne by the Australian Performing Group and the Nindethana Company, some of its problematic ambiguities seem to have been addressed by the input of the Aboriginal participants.

Just a few years after Prichard penned *Brumby Innes*, George Landen Dann's much more positive account of black–white sexual liaisons, *In Beauty It Is Finished*, amply demonstrated the risks of staging dramas that undermined White Australia's myths of racial purity. This work centres on a reformed white prostitute, who falls in love and eventually elopes with a part-Aboriginal fisherman, torn between black and white worlds. Described as 'filthy' and dubbed a 'sordid drama of miscegenation' by one magazine, the play created a scandal when it was first rehearsed in Brisbane in 1931 after winning a competition sponsored by the local repertory theatre (quoted in Connie Healy, 2000: 45). There was strong pressure from several quarters, including the churches, to abandon the production and virulent criticism when it went ahead. A report from the *Patriot* is indicative:

> [I]t was a pity that the half-caste in question should be placed in the limelight … This is a country advocating a White Australia policy, and reference to our darker tragedies not only accentuates certain

conditions in the minority of Australia's progress, but is a bad advertisement abroad ... not one woman in five thousand would be in any way attracted to a half-caste.

(quoted in Connie Healy, 2000: 45–6)

Such comments point to the white establishment's need to suppress a troubling history of miscegenation, and also reveal its anxious disavowal of white women's interracial desire. Whereas other plays such as Henrietta Drake-Brockman's *Men Without Wives* (1938) could be explicit about white men's relations with Aboriginal women – in this case as part of a cautionary tale about the need to balance race/gender demographics in the outback – white women's attraction to Aboriginal men was simply unthinkable to some spectators. Nevertheless, *In Beauty It Is Finished* did garner enough positive criticism to vindicate its daring production.

Because dramas about miscegenation were part of a response, mostly by leftist artists and intellectuals, to White Australia's unacknowledged brutalization of indigenous peoples, they did not consider cross-racial relationships that fell outside the black–white dyad. Mona Brand's *Here Under Heaven* (1948) is the major exception here. It dramatizes an upper-class rural family's prejudice towards their eldest son's bride: a Chinese woman, Lola, whom he met and married in Singapore before being killed during the Pacific War. Initial amateur runs of the play in Australia were well received and it was later staged in Sydney in 1961 after having had productions in Hungary, Czechoslovakia, the Soviet Union and East Germany; however, one Melbourne professional theatre company rejected the script as 'irrelevant' on the grounds that there was 'no colour problem in Australia' (Pfisterer, 1999: xviii). This kind of response masks continuing unease about the issue of miscegenation, which Brand uses as a device to interrogate the social order of a sheep-grazing community, a metonym for rural Australia. The dramatic scenario turns on the fact that two of the Hamilton family's sons have ignored the social prohibition on interracial sex – one with an Asian the other with an Aboriginal – transgressions that cannot be overlooked since each has, or will result in, hybrid offspring, as confirmed by Peter's illegitimate daughter and Lola's pregnancy. At a symbolic level, the hypothetical Eurasian and the bastard 'half-caste' thus stand as citizens to be included in a refigured nation. Nonetheless, this play's potential intervention in the hegemonic nation-building process is somewhat weakened by the absence of assertively visible signs of such hybridity. The figure of the Eurasian is only anticipated at some point in the narrative future and the unnamed part-Aboriginal child haunts the margins of the stage, appearing briefly as a

mute and virtually lifeless form obscured by the blanket in which she is wrapped.

Brand's incorporation of class issues into the story gives her leverage in dislodging the power of whiteness to determine racial relations. The Hamilton family's full access to white nationhood as a privileged social space is shown to depend not only on their visible racial features but also on their upper-class attributes. This aligns with Ghassan Hage's argument that markers of class capital such as economic riches, education, manners, accent and religion, function to signal whiteness in so far as they allow their possessors to claim certain forms of dominant national belonging (1998: 56). The family's class capital is in danger of being eroded, both by the drought that threatens their livelihood and by a historical weakening of class barriers, which Lola seems to exacerbate. That she is cultured, highly articulate and clearly more knowledgeable about world affairs than the parochial Australians unsettles the fixity of class/race hierarchies. Moreover, it is Lola who deliberately transgresses social boundaries by bringing the sick Aboriginal child to the homestead so that she can tend her. This particular juxtaposition of racial subjects signals an oppositional social orientation whereby the Asian migrant seeks to establish national belonging in reference to Aboriginal rather than Anglo-Celtic society. Such orientation represents a signal moment in the national imaginary, even though in the world of the play that moment can only be fleeting since Aboriginals are ultimately figured as a dying race.

Not surprisingly, the figure of the half-caste appeared on mid-century Australian stages as part of the broader engagement with race relations that many social realist playwrights included in their canvas. This (usually tragic) figure emblematized the incompatible pulls of white and black worlds and, particularly, the difficulties faced by Aboriginals trying to integrate into white communities. The general taboo against miscegenation, which continued despite the move to breed out Aboriginality in the assimilation process, had been formalized early in Australia's colonial history through government policies confining Aboriginals to reserves and fringe settlements. It was based on nineteenth-century racial science, which worked according to a double logic throughout the European Empires, enforcing and policing differences between Whites and non-Whites, but at the same time focusing fetishistically on the product of interracial coupling. Within this racialized sexual economy, the Black is constituted by his/her absolute difference from the White. The mixed-race subject, on the other hand, reveals that this absolute difference (which forms the ontological basis of whiteness) is 'tenuous

and permeable, dramatizing *in the flesh*, as it were, the impossibility of its permanent maintenance' (Sexton, 2003: 252).

George Landen Dann's *Fountains Beyond* (1942) illustrates the ambiguities presented by the half-caste as an embodied stage character created by non-Aboriginal dramatists, particularly when performed by white actors in face paint, as was still the custom at this time. The play dramatizes the efforts of a part-Aboriginal man, Vic Filmer, to prevent his people's land from being appropriated by the expanding white community of the small Australian town in which they live. He is pressured to stage a corroboree for the benefit of a visiting 'lady' travel writer and a white-run town council that plans to use the proceeds of the event to build a playground on the site of an Aboriginal shanty settlement. He refuses and will not be bribed but is undermined by his wife Peggy's opportunistic lover, whose hastily arranged corroboree descends into drunken mayhem, violating the ritual. In the aftermath, Vic accidentally shoots Peggy during an argument and is forced to flee his community. Dann's play was controversial in its time, precisely because it focused on Aboriginal issues and critiqued white racism; nevertheless, it received productions in a number of (mainly fringe) venues across Australia in the 1940s–50s, as well as in England and Wales. Recently, it was restaged by Brisbane Aboriginal theatre company Kooemba Jdarra in a stunning modern adaptation (see Gilbert, 2003: 683–4).

Despite Dann's obvious sympathy for the plight of the dispossessed fringe-dweller, his portrayal of the Aboriginal characters reveals the extent to which social Darwinism and eugenics still dominated conceptions of race in the first half of the twentieth century. Both Peggy and her lover are described as 'full-blood' Aboriginals and presented as stereotypically naive, greedy and deceitful. Vic, on the other hand, is depicted as 'a man of about 30 – pleasant features, pleasant voice, quietly mannered. Though he is not a full-blooded aborigine, there is more of the black-man about him than there is of the white. And though he does not speak grammatically he talks intelligently' (Dann, 1949: 17). These stage directions make explicit the racial taxonomy of the time and, more importantly, suggest the ways in which Vic's racial difference from either the white norm or the full-blood Aboriginal is signalled in performance through the body. The emphasis on physical mannerisms and corporeal behaviour is in keeping with a broader shift from racial science to more cultural explanations for racial difference in which posture, speech, movement and other bodily features became symbolic markers to differentiate one social group from another. Culturalist conceptions of race potentially complicated the semiotics of

mixed-race roles, even while facilitating their enactment. The almost-but-not-quite whiteness of the half-caste, as embodied by the white actor, threatens to undermine the idea of absolute racial difference on which whiteness is predicated. Hence, it is not surprising that the play's character synopsis emphasizes Vic's 'black' side; this serves to remove any ambiguity that might bedevil the embodiment of prevailing racial typologies.

Unlike popular theatre, which tended not to discriminate between degrees of (im)purity in its caricatures of racial Others, culturalist representations of Aboriginality, particularly by empathetic artists such as Dann, began to develop interiority in their characters. The half-caste comes to an awareness of his/her own hybridity, and perceives this as problematic. In *Fountains Beyond*, Vic is self-reflexive about his mixed ancestry; his choice to identify as a black man is not purely voluntary, but clearly circumscribed by white racism. There are also signs of an internal psychological battle representing his warring black and white bloodlines when he discovers Peggy's infidelity and is torn between venting his anger and letting her be. At the play's end, he leaves the settlement with Henry, a full-blood elder, intending to return Peggy's body to her ancestral island. The plangent wail that closes the final scene suggests they are doomed never to reach their destination. Hence, miscegenation, as embodied in this text by the figure of the mixed-race Aboriginal, signifies the tragic loss of pure origins and, ultimately, the extinction of Aboriginality.

The 'doomed race' thesis evident in Dann's play and others of its time constructs a tragic vision of Aboriginal culture as unable to survive the ravages of white colonization. Oriel Gray's *Had We But World Enough* (1950), which dramatizes tensions arising in a small town over a teacher's decision to cast a black girl as Mary in the school nativity play, also belongs to this genre. In so far as they demonstrate how racial prejudices get in the way of humane cross-cultural interaction, such texts engage in a particular strand of moral cosmopolitanism that stresses overarching principles of rights and justice, but does not necessarily entail intellectual or aesthetic openness toward cultural difference. Assessed in both political and artistic terms, the social realist plays left a mixed legacy. On the one hand, they demanded acknowledgement of occulted histories of Aboriginal genocide, miscegenation and forced assimilation, thus challenging normative myths of Australia's progress towards mature nationhood. They also suggested that aspects of Aboriginal performance culture had both intrinsic value and dramaturgical scope, beyond the appeal of exoticism. More equivocally, the gaps and

contradictions that often characterized such texts opened up possibilities for later indigenous productions, as in the cases of *Brumby Innes* and *Fountains Beyond*. On the other hand, this liberal humanist drama could not imagine a future for Aboriginal societies, nor their ongoing representation on stage, except in reified images of loss/absence. And, inadvertently, it often supported pre-existing racial and cultural stereotypes – and thus prejudices – by drawing on previously constructed theatrical images of Otherness, especially as embodied by white actors in black or 'coloured' roles.

While the perspectives and performance modes of social realism combined to form an essentially white theatrical landscape, even when Aboriginal issues were the primary focus, an alternative model of cross-cultural engagement did surface in Jim Crawford's *Rocket Range* (1947), which deserves mention here as a remarkable departure from the norm. This short sketch presents European colonization in Australia through the eyes of Aboriginals; its revolutionary aim is to provoke white audiences to consider themselves as the Others of their Others. The play's political target was a government proposal to sequester tribal hunting grounds for a rocket testing site, though this is only referenced in passing. The action centres on a debate among tribesmen to decide on an appropriate response to a white intruder, sent as a scout for the rocket range project. While the plot is basic, Crawford was years ahead of his time in his depiction of indigenous peoples, especially in having them speak standard English to discuss the situation at hand while reserving pidgin, the accepted vernacular of Aboriginal stage characters, for moments when they repeat the white man's dialogue. The white pariah never appears on stage; instead, in a canny reversal, his actions are refracted through the Aboriginals' account of contact, which presents him – and, metonymically, his community – as cruel, lascivious, ignorant and a threat to the natural environment. As to be expected, the play was attacked in some circles and dismissed as 'ideological propaganda', though it received a number of productions over the next decade in socialist-leaning New Theatres across the country, including one in Brisbane that featured Aboriginal elder Bob Anderson as a tribesman (Connie Healy, 2000: 151–4). Jim Crawford went on to write material that would be included in the first contemporary Aboriginal theatre piece, *Jack Charles Is Up and Fighting*, performed by the Nindethana Company in 1972. This history seems to vindicate Angela O'Brien's claim that *Rocket Range* constituted an early example of intercultural theatre (1997: 217).

What is potentially subversive about Crawford's script is that it did not depend on the discourse of white tolerance that underpinned other plays of its time, and which was to remain the prevailing sentiment in Australian theatre about cross-cultural relations until a critical mass of texts and productions by marginalized groups could shift the performance terrain. This process, which grew from tentative beginnings in the 1970s, will be discussed in detail in the following chapters. The proposition that tolerance will lead to a genuinely democratic nation now appears naive in political terms, even if it seemed a significant step in addressing Australia's anti-cosmopolitan foundations. According to Hage, racial tolerance can function as the flip side to racism in so far as it is 'never a passive acceptance, a kind of "letting be"', but rather an action that presupposes control over an object of tolerance (1998: 89). In the Australian context, he insists, multicultural tolerance has become 'a strategy aimed at reproducing and disguising relationships of power in society ... a form of symbolic violence in which a mode of domination is presented as a form of egalitarianism' (Hage, 1998: 87). Hage's arguments ring true in relation to much of the theatre discussed in this chapter if we acknowledge that it tends to situate white Australians as empowered subjects and managers of national space, and Aboriginals and Asians as objectified Others to be tolerated or not tolerated according to the imperatives of a race-based society. In this respect, the politically committed drama of the mid-twentieth century may not depart so radically from the popular forms that preceded it. For many dramatists and theatre practitioners working across the periods discussed, confrontations with cultural difference produced both opportunities and quandaries – but few instances of genuine dialogue.

2
Indigenizing Australian Theatre

After the 'silence' is broken, after the Other is acknowledged, after historical memory and 'the consequences' are admitted, after the double-ness of colonialism's impact on black and white is recognised, comes the moment when Aboriginality becomes part of heritage, a material and potent component of history in the present.

(Chris Healy, 2001: 287)

Few local observers would debate the claim that Australian theatre has now confidently outgrown its anti-cosmopolitan foundations, although some might argue about the extent to which historical patterns of cross-cultural engagement continue to impact upon performing arts praxis within and beyond the nation. The vital role played by indigenous products and practices in reorienting an industry currently defining itself as distinctive, culturally hybrid, innovative and entrepreneurial is indicated by recent claims that Aboriginal theatre constitutes one of the 'emergent "sexy" experimental forms' energizing the national repertoire (Veronica Kelly, 2001: 5) and that it projects the Australian voice that 'will, in due course, be the most widely heard in other countries' (Brisbane, 1995). Since its tentative beginnings in the civil-rights protest movements of the 1960s, contemporary Aboriginal theatre has burgeoned during a period when cultural diversity generally and Aboriginality specifically – each with their complex impacts on Australian identity formations – have been on the national agenda as never before. Hence, this theatre, like other indigenous art forms, has necessarily served at least two constituencies: its own indigenous community and the broader postcolonizing society, from which audiences are mostly drawn. The vested interests of both Aboriginal practitioners

wanting a visible platform for their work and the non-Aboriginal arts community wanting to engage with indigenous cultures have facilitated a pronounced, if uneven, shift not only in Australian theatre's image and profile, but also in its cultural and political functions. How Aboriginal performance has negotiated a place in an industry governed by the conventions and fashions of a largely Anglo-Celtic mainstream and how that mainstream has absorbed Aboriginality, in its many guises, are the subjects of this chapter.

A snapshot of Aboriginal theatre today suggests the depth of a praxis that has become increasingly difficult to delimit. Indigenous commentators cite storytelling as its signal characteristic, indicating the centrality of the performer–audience relationship to a body of work that includes among its styles and forms musical theatre, agitprop, stand-up comedy, dance theatre, naturalism, multimedia performance, docudrama and autobiographical monologue. The thematic concerns of Aboriginal theatre are equally various, ranging from critiques of colonization and engagements with current cultural politics – at local, national and international levels – to redefinitions of indigenous gender roles and individual and communal identities. Such issues have been explored primarily through newly created Aboriginal and/or cross-cultural works, but also via reinterpretations of European classics and, to a lesser extent, Australian canonical dramas. Aboriginal theatre has simultaneously 'evolved a strategy of multiple audience address (Aboriginal, white Australian and now non-Australian)' (Veronica Kelly, 2001: 8), as its possible sites of production have expanded to include festival, avant-garde, mainstream, fringe, outdoor, community and mass-entertainment venues.

Not only has there been a vast increase in the number and type of performances which might be termed 'Aboriginal' over the last three decades, but also a concerted effort to put in place industry structures that will ensure the continued visibility of Aboriginal theatre and Aborigines *in* theatre, whether in acting, directing or production roles. One of the most important infrastructural advances has been the emergence of amateur and professional groups – including Ilbijerri Aboriginal and Torres Strait Islander Theatre Co-operative (1991), Kooemba Jdarra Indigenous Performing Arts (1993) and Yirra Yaakin Noongar Theatre (1993) – with a specific mission to create and produce indigenous performance events and, crucially, to ensure indigenous control over those processes. The work of such groups has been supported by various one-off projects and, in some instances, by the active commitment of established companies to Aboriginal content and/or

non-traditional casting choices. Perth's Black Swan Theatre Company, Sydney's Company B at Belvoir Street and Playbox Theatre in Melbourne have been pioneers in this respect, joined more recently by state flagship institutions such as Sydney Theatre Company, Queensland Theatre Company and Melbourne Theatre Company. At the community and grass-roots level, companies committed to intercultural work and site-based projects – notably Sidetrack Performance Group and Urban Theatre Projects in Sydney, along with Melbourne Workers Theatre – have played a significant role in fostering indigenous performance and developing audience bases.

In terms of professional training beyond the on-the-job skills acquisition that often happens in many of these companies, institutions and bodies such as the Aboriginal Centre for the Performing Arts and the National Aboriginal and Islander Skills Development Association have been formed to cater for the specific needs of indigenous groups, preparing them for pathways into the performing arts industries and further training. Some mainstream institutions extend or complement this work through vocational courses, while Aboriginal artists and practitioners have organized playwrights' conferences and networks such as Blakstage Alliance to develop and advertise their work. At the wider political level, government support in the form of policy initiatives and funding has contributed to the establishment of what now seems to be a permanent Aboriginal element in the nation's theatrical culture. The Aboriginal and Torres Strait Islander Arts Board of the Australia Council plays a major role in funding and promoting indigenous performance, both traditional and contemporary, while varying levels of support for this endeavour are built into local and state governance. In addition, indigenous artists avail themselves of publicity vehicles developed for the broader industry, notably OzArts Online, an internet showcase of 'export-ready' contemporary arts that profiles individual artists and companies, and the Australian Performing Arts Market, which is held biennially in conjunction with the Adelaide Festival to facilitate arts trade.

As this snapshot suggests, Aboriginal theatre currently participates in an intricate web of performance, management and marketing structures, which, in turn, are enmeshed in the changing cultural politics of the nation, particularly as they influence relations between different racial and ethnic communities. Broadly speaking, the issues of recognition and reconciliation, both central to postcolonial Australia's wider cultural landscape, have been very much at the heart of transactions between indigenous and non-indigenous performing arts practitioners, even if

efforts to collaborate have sometime been fraught with difficulties. In this context, what we are calling the indigenization of Australian theatre refers not so much to the rapid growth of modern Aboriginal performance as a distinctive set of practices, though this has been of vital importance in enabling cross-cultural work, but rather to the significant, if still partial and uneven, integration of Aboriginal practitioners and products into the nation's performing arts industry, with a concomitant valorization of (selected) markers of Aboriginality in political, aesthetic and/or commercial terms. This trend is part of a wider national interest and investment in Aboriginal cultural production – especially in heritage and arts industries – seen by some critics as a manifestation of 'Australia's desire to know itself' through its indigenous Others (Batty, 1998). While the performing arts may well participate in such neo-colonial regimes of identification, we maintain that indigenization in this sector has been a highly complex and variable process involving not only instances of opportunism and cultural exploitation but also successful efforts at cross-cultural rapprochement, and, crucially, productive negotiation. In this respect, indigenization, however riven with contradictions, complicates current ways of thinking about Australian – and Australasian – cosmopolitan formations.

Bicentennial blues

In a perverse way, Australia's official Bicentenary in 1988 proved to be an initial catalyst for indigenization in so far as it mobilized an ethics of dissent – embraced by many non-indigenous as well as indigenous artists – targeted at nationalist celebrations of European settlement/invasion. Beforehand, Aboriginal theatre had progressed in a series of fits and starts, mainly in Perth, Melbourne and Sydney, the general history of which is now well documented (see Enoch, 2000; Casey, 2004). Suffice it to note here, by way of summary, that this sector of the performing arts industry was characterized in its fledgling years by innovative if sporadic productions, important but unfortunately short-lived companies, and ongoing struggles to secure funding. Although some Aboriginal plays, notably Jack Davis's pioneering accounts of Noongar history (developed with input from 'Wedjella' (whitefella) director Andrew Ross), played in state festivals and on the main stage, most were produced in fringe venues accommodating smallish audiences. This fringe activity did often involve black–white collaborations, particularly at the level of production, but such cross-cultural work tends not to be foregrounded in histories of either Aboriginal

or white Australian theatre during the 1970s–80s. Moreover, while Aboriginal performance can legitimately be classified as part of the period's 'new-wave' theatre movement in its attempts to tell quintessentially Australian stories and forge distinctively Australian performance styles, it is rarely positioned within this paradigm. A more visible, if perhaps superficial, cross-cultural engagement continued during this time in white-authored texts concentrating on Aboriginal themes, many of which were yet to depart significantly from the liberal humanist approach to race relations discussed in the previous chapter (see Brisbane, 1995). Black actors increasingly played the Aboriginal roles in such texts, the egregious practice of blackface performance rapidly becoming a thing of the past.

By the time the bicentennial year started, Aboriginal theatre had consolidated to some extent, partly due to Davis's increasing profile as a dramatist and events such as the First National Black Playwrights' Conference in 1987. During its relatively short existence, this theatre practice had been animated by the themes of Aboriginal resistance (to discrimination) and persistence (in the face of dispossession), which in tandem signalled its inherently critical stance towards the colonial history to be memorialized during Australia's 'birthday'. Ironically, the Bicentenary provided an apt target for strategic interventions in (white) nationalist mythologizing, not just in the arts but in a range of social and cultural domains. It was vulnerable to attack precisely because of its drive towards modes of historicity that were becoming untenable as indigenous cultural struggles gained public recognition, and other minority groups increasingly demanded an equal place in their officially multicultural nation. Bob Hodge and Vijay Mishra argue that underlying the year-long 'celebration of a nation' (as one of the bicentennial slogans put it) was an 'acute anxiety at the core of the national self-image and an obsession with the issue of legitimacy' (1991: x), an observation that can be amply supported by a study of Australian culture in 1988.

Whereas earlier political gains for Aboriginals had often been achieved through legislation aimed at inclusion, notably the 1967 amendments deleting race-specific clauses from the federal constitution,[1] counter-bicentennial protests were designed to enact a revolution of sorts by attacking not just official histories but also the heritage industry itself. The carefully planned and orchestrated Aboriginal boycott of bicentennial celebrations formed an overarching framework for such protests, many of which were inherently theatrical events supported by a considerable contingent of non-indigenous Australians. Most prominent was

the Sydney march on Australia Day – variously dubbed 'Invasion Day' and 'Survival Day' by Aboriginal groups – to demonstrate against the re-enactment of the First Fleet's landing in Sydney Cove.[2] Quite apart from its obvious aim of throwing focus onto the historical omissions embedded in the Bicentenary, this protest had special meaning in performance terms as a reclamation of indigenous agency that had been taken away when a group of mission Aboriginals was forced to act in a similar imperial pageant during the 1938 Sesquicentenary of European invasion. Tens of thousands from all walks of life took part in the Sydney rally, which gained both national and international coverage, and others like it across the nation. In no uncertain terms, non-Aboriginals participating in these events publicly acknowledged colonization – probably uncomfortably – as part of their heritage and indicated their willingness to engage (at least in limited terms) with Aboriginal culture. Broadly speaking, then, the counter-bicentennial protests performed the ideological work of indigenizing heritage, where heritage is understood as 'the mobilisation of historical understanding or social memory in *institutional* and *citizenly* terms' (Chris Healy, 2001: 279).

In the theatre proper during 1988, indigenous work made considerable inroads, marked by the production and touring of unprecedented numbers of texts by Aboriginals and the profiling of Aboriginal performance at festivals, notably the World Expo in Brisbane. Critical responses to most shows were sympathetic with numerous reviewers taking the opportunity to reflect on the connections between the production at hand and the politics of the Bicentenary. Highlights included the mainstream staging of Davis's *First Born Trilogy* in Melbourne, the export of *No Sugar* (the trilogy's best known play) to the Riverside Studios in London, and the presentation of a multimedia performance, *The Rainbow Serpent*, by Oodgeroo Noonuccal and Vivian Walker, as a leading part of the Australian Pavilion's exhibit at the Expo. A number of smaller local projects – notably premieres of Bob Maza's *The Keepers* and Eva Johnson's *Murras* – consolidated the Aboriginal content of the year's theatre in various regions. The Bicentennial Authority supported some Aboriginal works, directly or indirectly, as part of its arts programme, which openly declared its commitment to cultural exchange and cultural pluralism under the banner of 'living together', another of the official slogans for the year.

The mounting and reception of the *First Born Trilogy* amply illustrate the ways in which the Bicentenary facilitated Aboriginal theatre's mainstreaming. The sheer logistics of putting together this epic production in the Fitzroy Town Hall (floors of which were covered with

truckloads of red sand as part of the set) and coordinating its numerous black and white participants required an occasion worthy of the effort. The production involved collaboration between Davis's own company Marli Biyol, expressly created to produce the trilogy's final play, *Barungin*, in Perth earlier in the year, and three major organizations: the Western Australian Theatre Company, which had previously fostered some of Davis's work; the Melbourne Theatre Company, whose inclusion of the plays in their subscriber season very likely boosted audiences; and the Elizabethan Theatre Trust in a management role. Publicity suggests that the producers relied on the Bicentenary's memorializing functions to sell what was essentially a risky venture for the organizations involved; reviewers, in turn, stressed the special significance of the trilogy's 'honest' and 'moving' chronicle of Aboriginal life over the previous 60 years as a vital corrective to the historical amnesia of the official bicentennial celebrations.[3] Most commentators duly noted the production's direct engagement with the politics of the moment – particularly the symbolic reclamation of the Town Hall as Aboriginal space and *Barungin*'s use of death as a savagely ironic symbol of the nation's birthday – and many expressed, in response, an ethical acknowledgement of their own complicity in Australia's 'black' past (in both senses of the term). Leonard Radic concludes, for example: 'It was not just *their* story being acted out. It was ours as well' (1988: 14).

The 'white' theatre establishment's contribution to the counter-bicentennial protest was also highly significant in strengthening the industry's engagement with Aboriginality. Belvoir Street Theatre hosted a well-attended revue, *Not the 1988 Party*, comprised of satirical sketches performed by prominent Aboriginal actors and personalities, along with various non-Aboriginal supporters; and the internationally renowned Circus Oz included a biting interactive parody of the First Fleet re-enactment in its touring extravaganza, *Maximus*, accompanied by a programme featuring the Aboriginal flag colours and the quip: 'What exactly are we saying Happy Birthday to with such gusto?' (Martin Kelly, 1988: 23). On a more serious note, three of the nation's best known dramatists, Michael Gow, Stephen Sewell and Louis Nowra, penned new works – all of them featured as part of the official arts programme and staged at major venues – that shared the revisionist project of Davis's trilogy, albeit in very different ways (see Gilbert, 1998a: 99–114). While Gow's *1841* and Sewell's *Hate* each presented confronting allegories of Australian settlement and alluded to the brutal colonization of indigenous peoples as one of the root sources of contemporary society's dystopia, Nowra dealt

more directly with race relations in his commissioned adaptation of Xavier Herbert's sprawling mid-century novel, *Capricornia*.

Company B's production of *Capricornia* indicates the extent to which the indigenizing process – effected in this case through a focus on Aboriginality *and* whiteness – had begun to reshape mainstream Australian theatre. The company was able to assemble what was then an unusually diverse cast, including Aboriginal, Asian and white Australians, to stage Nowra's epic portrait of northern life in the 1930s (see Figure 3). Detailing one man's journey to discover his Aboriginal roots, the play sets up a dialogue with the narrative tropes and performance conventions of earlier Australian drama, specifically targeting the figure of the half-caste, the trope of miscegenation, and the fear of invasion by non-white races, all of which had been implicated in White Australia's anti-cosmopolitan foundations. That Aboriginal and Asian characters were not situated primarily as objects of a plea for racial tolerance, despite the constraints of Herbert's original story, suggests the distance Australian theatre had travelled in the intervening years. The performative virtuosity of a multiracial cast playing across (and with) a spectrum of racialized roles contributed to this feat,

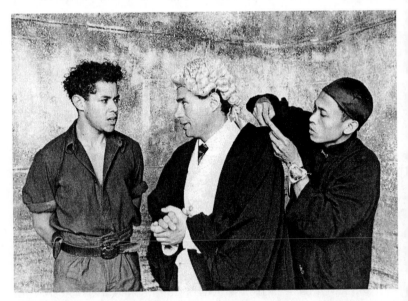

Figure 3 Laurence Clifford, George Spartels and Yul Sastrawan in Company B's production of *Capricornia*, Belvoir Street Theatre, 1988. (Photo: William Yang)

along with the production's strategic costuming codes, embodied visual ironies, racial slippages and self-conscious character constructions. In production, the text thus foregrounded hybridity and celebrated miscegenation – as a performative *and* corporeal concept – to the point of dislodging racism as the play's central subject. *Capricornia* was hailed as a 'landmark' in Australian theatre and toured nationally to considerable acclaim.

The script isolates and critiques mechanisms of racial privilege by making visible the rhetorical strategies through which the concept of White Australia maintained its purchase. A key tactic of this counter-discursive project is to dramatize the feared decline of the white races that the invasion narrative, as discussed previously, attempted to avert. Hence, the stage abounds with abject or degraded forms of whiteness embodied in characters who use addictive drugs, 'go combo', commit violent crimes or simply succumb to the tropical heat. Nowra juxtaposes all these images of acutely visible whiteness to a chaotic transitional society where signs of Asian and particularly Aboriginal national belonging are increasingly the norm. At one point, Norman, the 'half-caste' protagonist is left to run a formerly white-owned cattle station with the help of Tocky, his part-Aboriginal lover, a handful of black stockmen and a Chinese cook. While Tocky's pregnancy briefly signals a hopeful future for those previously positioned as the underclasses of imperial modernity's progress in Australia, the fact that she dies before her baby can be born suggests that the historical moment depicted in the play was not ripe for the acceptance of a re-racialized northern society where negotiations between Asian and Aboriginal Australians could be more pivotal than those anchored by the white mainstream. Nowra's cosmopolitan vision, however, was meant to be taken seriously as a contemporary model of the nation post-1988, not only in broader cultural terms but also in the more specific context of Australian theatre. This dialogic project continued with Aboriginal director Wesley Enoch's revival of *Capricornia* at Belvoir Street Theatre in 2006, an event that lived up to its billing as 'raucous, big, rich, violent, bloody and thrilling'.

Although the Bicentenary provided an occasion for white Australian theatre to declare its dissident postcoloniality, Nowra was one of the few who expressed this rejection of hegemonic nationalism in terms that engaged with Asian as well as Aboriginal histories.[4] His pluralist approach to indigenizing heritage was all the more significant given that representations of Asianness circulating elsewhere in the mainstream that year were largely 'exotic' festival imports that positioned Asian cultures as external to the nation. That most of those

who quarreled with the exhortation to celebrate did so in reference only to black–white relations reflects the strength of the separatisms that have structured contemporary Australia. As Chris Healy observes, even though 'inclusiveness and pluralism were [its] key organizing principles', the Bicentenary as a whole actually 'made apparent some of the tensions and limits' inhering in its multicultural vision of 'living together' (2001: 281).

Reconciliation: a bran nue dae?

In the 'wake' of the Bicentenary, increasing numbers of Australians admitted the need for some kind of process by which to publicly recognize and redress the historical causes of Aboriginal disadvantage. Bob Hawke's Labor Government initially pledged a 'compact' in response to long-standing Aboriginal demands for a treaty to be negotiated through the mechanisms of international law. In 1991, this promised compact, the terms of which had never been clearly projected, evolved into a ten-year programme of 'reconciliation' when it became apparent that land-rights legislation remained a contentious issue among state Labor factions. Reconciliation had been mentioned in various circles since at least 1988 and was featured in the specific recommendations of the 1991 report released by the Royal Commission into Aboriginal Deaths in Custody.[5] As a formal process of cultural rapprochement following traumatic conflict, reconciliation was also part of an emerging transnational ideoscape – to use Arjun Appadurai's term (1996) – in countries struggling with the legacies of Euro-colonialism. Australia's Council for Aboriginal Reconciliation, chaired by a series of indigenous leaders during its decade in existence, was set up as a statutory authority whose main brief was to foster cooperative action aimed at addressing inequities and increasing understanding and appreciation of indigenous cultures. Council membership included indigenous and non-indigenous representatives drawn from widely bipartisan backgrounds.

The waxing and waning importance of reconciliation to successive governments and various community stakeholders over the past 15 years has led to much scrutiny of the principles behind its conception and implementation. Fiona Nicoll, among others, notes a tension between the word's two primary meanings – to settle differences or to become resigned to a situation – and argues that the 'political rhetoric of being reconciled *with*' has been regularly 'translated into policies of reconciliation *to*', especially in relation to land-rights issues (1998: 168). In this respect, indigenous groups maintain that recognition of

native title remains inextricable from reconciliation, whereas the two are an anathema for the conservative forces of the current government (Nicoll, 1998: 173). While there is general agreement that reconciliation has functioned as a nation-building exercise, opinions vary as to the efficacy and desirability of that project, and the kind of nation it might authorize, with indigenous reservations perhaps best summed up in the question, 'reconciliation on whose terms?' (Lucashenko, 2000: 114). This is an issue Aboriginal theatre has broached in a variety of ways since the early 1990s and one that continues to both plague and dynamize cross-cultural transactions in the performing arts industry.

Jimmy Chi and Kuckles's hit musical, *Bran Nue Dae*, which toured nationally to critical acclaim and packed houses between 1990 and 1993, provides a fascinating example of the ways in which reconciliation in its early years as a social and political project boosted the indigenization of Australian theatre while raising thorny questions about the intricacies of that process. Originating in the songs, stories and performance practices of the remote Western Australian town of Broome, *Bran Nue Dae* charts the picaresque journey of an Aboriginal youth and his odd-ball travelling companions in search of a physical and spiritual homeland in the 'melting pot' of northern Australia. It was developed initially as a collaborative local effort, with some assistance from various national Aboriginal arts bodies, as well as encouragement from non-indigenous supporters in Hobart and Perth. When the script had been sufficiently polished, Bran Nue Dae Productions, the company formed to stage it, approached Andrew Ross to direct; the show was then rehearsed in Broome with a cast of mainly local actors for its premiere, co-produced with the Western Australian Theatre Company, at the 1990 Perth Festival. This history, elaborated in detail in the published text (Chi and Kuckles, 1991: vi–viii), situates *Bran Nue Dae* as very much a community project – and one deeply embedded in the multiracial town from which it arose – yet its initial critical reception (first in Perth then Adelaide, Canberra, Brisbane and Sydney) suggests it was quickly enlisted as an expression of hope for improved black–white relations, and indeed a demonstration of that possibility. While most reviews specifically noted Chi's Chinese, Japanese, Aboriginal and Scottish ancestry, and many drew parallels between his personal history and the text's narrative, they insistently cast the show as exclusively and quintessentially Aboriginal, and Broome as merely an exotic outpost rather than a complex multiracial community. This essentialist manoeuvre elided the Asianness of the town, the text, the band (Kuckles), and many of the production's mixed-race cast and crew, despite

the text's strong emphasis on hybridity in its themes, musical routines, movement idioms, costumes and scenography.

We have argued elsewhere that *Bran Nue Dae*'s hybrid vision of Aboriginal life and art specifically aims to subvert the discourses of authenticity that tend to attach to indigenous cultural products (Gilbert, 1998a: 77–81; Lo, 2005). That many reviewers nonetheless registered its Aboriginality in essentialist terms suggests the usefulness of this paradigm for consonant claims about the show's significance within (white) Australian culture in the 1990s. Almost instantly, Australia's 'first Aboriginal musical' became an icon, initially for Western Australia and then the nation. Duncan Graham's comments on the Perth premiere illustrate the beginning of this process: 'At last, uplifting and original news from Western Australia. The state of corporate chicanery, racism and hedonism has produced something worthwhile. And, irony of ironies, the saviors are the state's outcasts, the Aborigines' (1990: 14). Subsequently, critics in other state capitals stressed the production's significance as an 'upbeat', 'conciliatory', 'and 'liberating' account of black–white relations in Australia, and praised the writer and director alike for not provoking guilt. Several commentators also claimed *Bran Nue Dae*'s importance to Australian theatre as a rollicking, homegrown show that made foreign imports look 'tired'. The play's serious political undertones – as evident in lyrics about genocide, Aboriginal deaths in custody, dispossession and cultural disintegration – attracted only the odd comment, and the explicit call for land rights in Uncle Tadpole's final recitative introducing the title song seemed to slip quietly out of hearing:

> This fella song all about the Aboriginal people, coloured people, black people longa Australia. Us people want our land back, we want 'em rights, we want 'em fair deal, all same longa white man. Now this fella longa Canberra, he bin talkin' about a Bran Nue Dae – us people bin waiting for dijwun for 200 years now.
>
> (Chi and Kuckles, 1991: 84)

Chi's summary of *Bran Nue Dae* in the production's programme notes as 'a play to ease the pain' undoubtedly helped its incorporation into a project of racial harmonizing, yet responses in rural townships, where predominantly Aboriginal audiences packed makeshift theatres to standing capacity, suggests this phrase might be read with a different emphasis. In these regional venues, the production returned to its roots as a community show, often ending in communal dancing.

Bran Nue Dae's second national tour in 1993, in a slicker, expanded version with some new cast members, consolidated its status as an exemplary contribution to reconciliation, now formalized as a national project. The programme notes for this production carried an endorsement from none other than Prime Minister Paul Keating, who had confirmed his government's commitment to reconciliation in his much quoted 'Redfern Park Speech', delivered a year after he took office in 1992. By this time, the nation's High Court had delivered its historic Mabo judgement (1992), effectively voiding the declaration of *terra nullius* that had legitimized British colonization of Australia, and paving the way for the Native Title Act in 1993.[6] This substantial step towards (limited) land rights for Aboriginal peoples had caused some public unease, requiring vigorous government campaigns to sell reconciliation as a *common* good. In this context, Keating's public endorsement of *Bran Nue Dae* can be seen as equally serving the play and the politics of the moment: 'A landmark in Aboriginal theatre. And, no less significantly, a landmark on the road to a relationship between Aboriginal and non-Aboriginal ... built on a sense of shared experience' (quoted in Johnston, 2004: 170). Thus, the musical, which does stage (small 'r') reconciliation between a variety of characters and cultures, was primed to be read as enacting (large 'R') Reconciliation between black and white Australia. Reviews of the Melbourne production confirm this trend.

Perceived as doing the cultural work of reconciliation, *Bran Nue Dae* could offer its non-Aboriginal viewers something more than absolution for the sins of colonization: a sense of 'indigenous' national belonging. This 'gift' emerges with the story's closure when the various characters, including the 'white' hippies, (re)discover their Aboriginal relations and embrace their lost 'black' heritage/homeland. While this scene may be read in a number of ways that are not mutually exclusive – for instance, as a send-up of new-age claims to 'native' spirituality, as a parody of the extensive Aboriginal kinship system, as a liberal humanist recognition of common humanity, or as a reflection of the historical effects of miscegenation – the 'semantic territory' of Aboriginality that encompasses the cast at this point 'seems also to close around the audience' (Lawe Davies, 1993: 58). Reconfigured thus, Aboriginality becomes a site of 'shared experience' and, through the logics of the narrative, a conduit to the land as homeland.

We are not suggesting, as a few critics have, that *Bran Nue Dae* was/is politically naive or that its creators sold out to the forces of commercialism. In fact, the modes of sharing and belonging it dramatizes are

contingent upon the audience's recognition of indigenous sovereignty, but this is never taken for granted, as confirmed by the ironic refrain: 'There's nothing I would rather be/ than be an Aborigine/ and watch you take my precious land away' (Chi and Kuckles, 1991: 15). Hence, *Bran Nue Dae* seemed to problematize indigenization even as it participated in that process, navigating 'a deft political route through a landscape of happy sponsors [and spectators] and the driving anger of the land rights issue' (Romney, 1993: 61). And while the text's message may have been co-opted to some extent in the service of nation-building, the material effects of the production, with its mass audience appeal, constitute a significant interpolation of (modern) Aboriginality into mainstream Australian culture, particularly in the performing arts. In industrial terms, *Bran Nue Dae* was the first 'commercial' entertainment substantially under indigenous control and, with more than 15 Aboriginal and mixed-race performers and musicians, it made a breakthough in providing sustained employment for the cast. Besides functioning as a career launching-pad for actors such as Josie Ningali Lawford, Leah Purcell, Stephen Baamba Albert and Trevor Jamieson, the show's success also contributed to the establishment of a course in musical theatre for Aboriginal students at the Western Australian Academy of Performing Arts. As proof of the versatility and viability of Aboriginal musical theatre, *Bran Nue Dae* also paved the way for future experiments in this genre, a recent example being Tony Briggs's soul/Motown show, *The Sapphires* (2004), about an all-Aboriginal girl-band on tour in the 1960s in war-torn Vietnam.

Sharing histories and sorry business

Although *Bran Nue Dae* had seemed to herald a new dawn for both Aboriginal theatre and Australian cultural politics, it soon became clear that the work of building bridges between indigenous and non-indigenous cultures was only just beginning, and that it would involve complex negotiations at a number of levels. As the 1990s progressed, two main strategies emerged in Aboriginal performing arts for contesting *and* advancing the reconciliation process, particularly as framed within the Council's guidelines, which stressed the need for all Australians to develop a 'shared ownership of our history'.[7] One approach was to perform stories (in various media) that called on non-Aboriginal audiences to acknowledge and validate Aboriginal histories and cultural practices; the other was to collaborate *with* non-Aboriginal practitioners (and audiences) to explore differences and commonalities in the

history-making process itself. Wesley Enoch and Deborah Mailman's monodrama, *The 7 Stages of Grieving* (1994), and *Bidenjarreb Pinjarra* (1994), an improvised theatre piece by Noongars Trevor Parfitt and Kelton Pell and Wedjellas Geoff Kelso and Phil Thomson, respectively illustrate these two modes. Both works were essentially intimate fringe events and each toured extensively, though across somewhat different territories. *The 7 Stages of Grieving*, in various incarnations performed by Mailman and initially directed by Enoch, played in state capitals across the nation and at festivals in Zurich and London, while *Bidenjarreb Pinjarra* toured to regional towns and Aboriginal communities in a number of states, as well as having seasons in Perth, Adelaide and Brisbane. Both plays were included in the Festival of the Dreaming, the first of the major pre-Olympic performing arts events in Sydney in 1997.

At the beginning of the published script, *The 7 Stages of Grieving* is introduced as 'a contemporary indigenous performance text from the highly acclaimed Kooemba Jdarra' (n.p.). The preamble acknowledges the company's input in developing the play and also locates Enoch and Mailman in the broader Murri community represented by Kooemba Jdarra as an arts organization. In *The 7 Stages of Grieving*, Enoch and Mailman apply their community's concern with agency in cross-cultural relationships to their critique of reconciliation to suggest that a shared vision of Australia's future can only be realized after the personal and cultural losses precipitated by European colonization have been publicly mourned. The performance centres on an indigenous 'everywoman' who details such losses with the intimacy of autobiography in a poetic and, at times, surprisingly funny collage of stories, images and songs. Her discontinuous narrative attaches different aspects of grieving to an Aboriginal history schematized into seven phases – dreaming, invasion, genocide, protection, assimilation, self-determination and reconciliation – which are communicated through sketches of family and communal life. Towards the end of the play, the solo performer broaches the topic of national harmonizing, initially parodied as 'Wreck, Con, Silly, Nation' (Enoch and Mailman, 1996: 71–2). The four words, projected so as to fleetingly inscribe the woman's body as she moves through the space, morph into different shapes and sizes then settle as RECONCILIATION – writ large on upstage screens – while she addresses the audience: 'It isn't something you read or write. It's something that you do' (p. 72). To clear up the semantic 'mess' caused by this (premature) discourse, the woman packs the now shrunken word in an old suitcase, which she locks then places at the feet of the audience with a plea: 'These are my stories. These are my people's stories, they need to

be told' (p. 73). Metaphorically, this finale invites an ethical dialogue between Aboriginal and non-Aboriginal communities: reconciliation is extended as a promise stowed amid the (hi)stories of a past that must be jointly – and painstakingly – excavated for real progress towards cross-cultural understanding. Here, the key to this past remains firmly in the hands of the Aboriginal storyteller/archaeologist and it is incumbent upon listeners to respect that authority.

Whereas Enoch and Mailman effectively produced an interracial script for (as well as about) reconciliation, the creators of *Bidenjarreb Pinjarra* insisted on the malleability of that process. When asked for a copy of the script on one occasion after a performance, Phil Thomson rummaged through his pockets then held up a single crumpled sheet of paper with the scenes listed in approximate running order. A programme note explains how the performers worked with the specific goal of sharing ownership of their product, an account of the Pinjarra massacre in Western Australia in 1834:

> There is no 'written' script because the four of us made a conscious decision to develop the play and then perform it as spontaneously as possible combining Aboriginal and non-Aboriginal traditions of story telling. Rather than producing an evening of unremitting guilt and horror, we choose to tell the story in a style which contributes to reconciliation by demonstrating the humour, respect and trust which is the basis of our own relationships with each other.

The programme also stresses that the performers researched both Wedjella and Noongar sources about the massacre and that they trialled their work-in-progress in the Pinjarra community to ensure that the official owners of the Noongar stories were satisfied with their interpretations. On stage, conflicting 'memories' of the event are interleaved with accounts of present-day black–white relations, often improvised from scenarios solicited from the audience. The four actors play across a range of racialized roles, divesting some characters of their ascribed traits by dint of colour-blind casting and insisting on the racial specificity of others. The 'truth' about the massacre – reported by colonial authorities at the time as a skirmish accidentally killing 15 'natives' whereas Aboriginals' stories record a raid decimating hundreds – is not the issue in this text, which presents history as ultimately unknowable in empirical terms. Instead, the focus is on the fundamental absurdities of racism and their epistemological consequences for historiography, as demonstrated in one ridiculous, but unnerving scene where the performers act out

the concept of an 'accidental massacre', casting the audience as their imaginary victims to underscore their point that the discursive apparatus through which we understand the past must be constantly held up to scrutiny.

In their own ways, *The 7 Stages of Grieving* and *Bidenjarreb Pinjarra* tackled problems inherent in the idea that a reconciled nation depended on the development of a shared historical narrative that both Aboriginal and settler Australians could embrace. Bain Attwood makes the useful distinction between 'shared history' and 'sharing histories', arguing that whereas the former necessarily smoothes over contradictions and conflicting perspectives, the latter acknowledges divergent views of the past and 'assumes that any future "reconciliation" process will depend on a recognition and acceptance of ongoing difference' (2005: 249). Both performances eschewed the concept of a shared history even while they insisted that the horrors of the past be *communally* recognized, accepted and grieved via the act of sharing histories. *The 7 Stages of Grieving* conceives settler Australians' role in this process primarily in terms of ethical listening that does not seek closure in the more conventional historical or theatrical terms. The demand for this kind of listening can be unsettling, as one review suggests – 'where is the line between catharsis that allows one to move on and the repeated resurrection of grief that brooks no resolution?' (Gough, 1995: 93) – but it also sets up the conditions for reconciliation to be modelled as/through compromise rather than consensus. In a different way but to similar effect, *Bidenjarreb Pinjarra* foregrounds the dialogic aspects of history-making and thus opens up culturally determined narratives about the past to experiment and improvisation. The sharing of histories, as enacted in these and various other performances tackling the complexities of reconciliation,[8] constitutes a particular mode of indigenization that aims to preserve and respect cultural differences, on stage and in broader social praxis, despite the political push for a unitary, reconciled nation. In so far as non-Aboriginal participants (including audiences) involved in such cross-cultural transactions make efforts to engage with Aboriginality on its own terms, they help to move the thin cosmopolitanism of 'sympathetic' support for cultural diversity in the arts beyond a politics of humanitarian inclusion and towards the complex territory of mutual accommodation.

Ethical engagement with Aboriginal histories became an even more urgent project for cross-cultural work in Australian theatre with the 1997 release of *Bringing Them Home*, the findings of the inquiry by the Human Rights and Equal Opportunity Commission into the forced removal of

Aboriginal and Torres Strait Islander children from their families during the era of government mandated assimilation, which continued in some states until the 1970s. Since the tabling of the report,[9] which includes extensive testimony from members of the Stolen Generations, many of whom were subjected to physical, sexual and psychological abuse in their new homes, the removal of Aboriginal children has been Australia's most publicly discussed atrocity and, for many intellectuals on both sides of the racial divide, a kind of flash-point signalling an ongoing crisis in black–white relations. As critics have noted, the narrative style of *Bringing Them Home*, its use of verbatim reports from individuals not previously given the opportunity to speak and be heard in a bureaucratic forum, made a claim upon the nation to listen and called for appropriate symbolic responses, both official and personal (Gooder and Jacobs, 2000: 238). The Howard Government's refusal to issue a suitable apology for this atrocity on behalf of the nation led to a proliferation of public apologies by church leaders, police, state governments, welfare agencies, members of the judiciary and 'ordinary' Australians, the latter through mechanisms such as National Sorry Day and the Sorry Books, public registers that have reportedly collected more than a million signatures and personal expressions of sorrow, shame and sympathy. While such an investment in apologizing may be part of an attempt to reclaim a sense of settler belonging in the face of brutalities (and denials) that indicate an improperly formed postcolonial nation, as Haydie Gooder and Jane Jacobs argue (2000: 242–3), the focus on the 'sorry business' of the prime minister's failure to utter the precise words demanded in this context nonetheless created a receptive climate for the circulation of texts by and about the Stolen Generations.

Among many recent texts that speak to the enduring effects of the child removal policies,[10] Jane Harrison's *Stolen* (1998) best illustrates the power of performance to elicit the affective responses on which the cross-cultural work of reconciliation is premised. The play was first staged professionally at the 1998 Melbourne Festival in a co-production by Ilbijerri and Playbox, which subsequently toured to various parts of Australia as well as to London, Dublin and Hong Kong. Although the premiere occurred after the *Bringing Them Home* report was tabled, script development had begun some five years earlier with a commission by Ilbijerri that involved Harrison, as writer, working with a researcher and various members of the Koori community to record and dramatize first-hand accounts of child removal. The resultant fictional drama draws from real life stories but, for the most part, does not re-enact testimony as such; instead, narratives of pain and loss are conveyed through an almost dizzying progression of non-chronological vignettes that sketch

the experiences of five Aboriginals stolen from their families as children. Further fragmenting the individual character portraits are occasional dream/nightmare sequences, sections of documentary footage and two storytelling scenes that allegorize the figure of the white child-snatcher within an Aboriginal oral history/mythology. Five old iron institutional beds arranged across the stage establish the main setting as a children's home, which, with the aid of a few functional props, easily morphs into other spaces: a prison cell, a mental institution, a girl's bedroom.

After the play proper ends, the stage is repositioned as a place for formal witnessing when the Aboriginal actors step out of their roles and speak directly to the audience, giving unscripted personal responses to the stories they have dramatized. In most performances, the actors talked about their own lives, about their ancestry, about the children they had or will have. One, Pauline Whyman, revealed during this epilogue on many occasions that she and ten of her 14 siblings were all stolen. In what is a fairly representative response from reviewers, Jo Litson, writing for *The Australian*, described this moment as a 'blow to the solar plexus' when 'your heart goes out to her while guilt curdles your stomach' (2000: R16). What seems to be happening here is a complex moment of witnessing that fulfils Harrison's claim that her play works towards 'healing the rift between black and white Australia' (quoted in Hart, 2000: 67). The actor's embodied role as the character Shirley and her real-life testimonial as Pauline Whyman are both registered as authentic in this finale, although perhaps in different ways. Having followed the staged narratives of the Stolen Generations, the spectator is ideally positioned to become the 'second person' implied in all testimonial transactions. In Gillian Whitlock's formulation, drawn from scholarship on holocaust testimony, the second person, the addressee, 'is called upon to witness her own complicity and implication in the loss and suffering which is finally being spoken' (2001: 209). This is a necessary part of reconciliation which 'demands from the second person an ethical performance of civic virtue that is cast in a particular discursive framework, and which is understood to be an engagement with emotion, and a recognition of shame' (Whitlock, 2001: 210). Litson's review manifests exactly this response, and seems to speak for much of the wider audience, judging by the media coverage in various venues. In this respect, *Stolen* provided a platform not only for sharing histories but also for registering shame – for enacting 'sorry business' in the Aboriginal sense of the term: the activities performed when a community deals with tragic events. Director Wesley Enoch, assessing the play's impact in retrospect, sees this kind of 'business' as a way of transforming the

'intellectual concept' of reconciliation into an 'emotional reality': 'That moment hammered home what theatre is really about for me because what came out of it was a real communion, a sense of truth, a sense of exchange' (2001: 10).

Awakenings: indigenous arts showcased

If the dissemination of the Stolen Generations narratives represented a decisive step in installing Aboriginality at the centre of public consciousness in the late 1990s, the Festival of the Dreaming, staged just months after *Bringing Them Home* was released, demonstrated the distinctive and valuable contribution indigenous Australians were making to the nation's cultural industries. Curated by Koori performer and director Rhoda Roberts, the three-week Sydney festival, Australia's largest ever indigenous arts showcase, featured dance, film, literature, music, storytelling, theatre and visual arts drawn from a variety of regions and linguistic groups across the nation as well as from other first peoples in Papua New Guinea, the Pacific Islands, Aotearoa/New Zealand, Canada, the United States, Korea and Greenland. The performing arts programme constituted a particularly strong segment of the overall festival and received considerable media coverage with many critics praising its depth and diversity. Among the large-cast productions were Roger Bennett's *Up the Ladder*, an exploration of racism in the carnivalesque subculture of 1940s sideshow alleys; Julie Janson's *Black Mary*, the story of Aboriginal bushranger Maryanne Ward, lover of the famous Captain Thunderbolt; Bangarra Dance Theatre's *Fish*, celebrating Aboriginal relationships with the waters of the land; and an indigenous version of Shakespeare's *A Midsummer Night's Dream*, directed by Noel Tovey. Wimmin's Business, a more intimate cluster of works judged by several critics to be the 'jewel' of the festival, consisted of seven monodramas about Aboriginal, Maori and Native American women's lives. Along with Deborah Mailman in *The 7 Stages of Grieving*, the local performers in this programme were Ningali Lawford in *Ningali*, Leah Purcell in *Box the Pony* and Deborah Cheetham in *White Baptist Abba Fan*, all of whom worked with non-Aboriginal writers and/or directors to produce their shows. *Bidenjarreb Pinjarra* and *Ngundalelah Gototgai*, a Bundjalung translation of Beckett's *Waiting for Godot*, extended the range of cross-cultural work. Outdoor events included a high-profile Awakening Ceremony to open the festival; street performances by Koori Klowns, Oogadee Boogadees; and the Marrugeku Company's rendition of a Kunwinjku creation story, *Mimi*, featuring stilt work and acrobatics (see Figure 4).

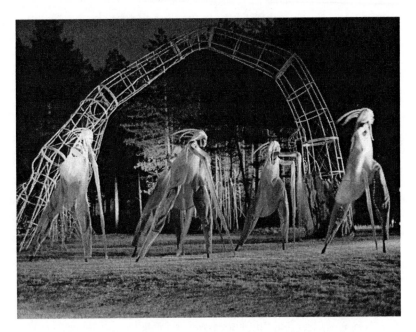

Figure 4 Stilt spirits, *Mimi*, by Marrugeku, 1997. (Photo: Henry Krul)

Many of these events were produced in collaboration with established theatre companies, notably Company B, Sydney Theatre Company and Melbourne Workers Theatre, and performances were staged at a wide range of mainstream and fringe venues such that, geographically, Aboriginal performing arts penetrated much of urban Sydney during the festival period.

As a major national event functioning partly to herald the Sydney 2000 Olympic Games, the Festival of the Dreaming played a complex role in the indigenization process that concerns us here. In keeping with the goals of federal cultural policy as outlined in *Creative Nation*, the yearly Olympic Arts Festivals from 1997–2000 were specifically designed to increase cultural tourism, boost creative industries and advertise Australia's unique heritage and contemporary cultures to the rest of the world.[11] These goals meshed particularly well with the general brief of the Olympic Cultural Programmes: 'to promote the arts and culture of the host city and the host nation while embracing an international cultural dimension; and to provide a dynamic and high profile context for promoting Olympism and the Olympic Games'.[12] In this context, it is not surprising that

Aboriginal arts practitioners were invited to inaugurate the four-year programme celebrating Australian cultural achievements. Indigenous arts and cultural expression had been recognized by then as playing a significant role in 'shaping the cultural landscape of the nation', generating tourist income and, perhaps more importantly, defining and profiling Australianness abroad (Stevenson, 2000: 154). While this environment may have augmented the conditions for tokenism and/or appropriation, especially in connection with global events such as the Olympics, it was mediated by corresponding policies released by the Aboriginal and Torres Strait Islander Commission (ATSIC) to highlight issues such as cultural development, management and protection, and to engender respect for indigenous cultural beliefs and practices (Stevenson, 2000: 156).

There is much evidence to suggest that the Festival of the Dreaming managed to fulfil its brief as an Olympic event while also serving the interests of indigenous peoples. Because Aboriginal art/performance had already been called upon to undertake the work of reconciliation in both symbolic and practical ways, indigenous communities could exercise considerable purchase in negotiating the terms of their involvement in this new nation-building endeavour, especially since it was critical to the government, and to much of the general populace, that the upcoming Games not be marred by an Aboriginal boycott or otherwise visible instances of racial conflict. Roberts accepted the commission as Festival Director only on the condition that the event would remain under indigenous control, and her team is widely credited with using this unprecedented platform strategically to address ignorance about Aboriginal cultures, build bridges with mainstream companies and enhance future opportunities for Aboriginal employment in the arts. In programming the festival, Roberts aimed to break down stereotypical representations – including marketable ones – that have historically circumscribed Aboriginal identities across evolving formations of the imagined nation. She thus avoided iconic forms of advertising in both the festival slogan, 'Intimate, Contemporary and True', and the poster design, which, she stressed, contained 'not one dot painting or boomerang or didgeridoo' (quoted in Dunne, 1997: 8). While the festival offerings did include art and performance drawn from so-called traditional communities, these were presented as dynamic practices rather than static, reified products. Several performances fused traditional and contemporary forms – as evident, for instance, in the mixed modes of storytelling in the Wimmin's Business programme and in the kinetic styles of *Mimi* and *Fish* – while others conveyed their interests

and concerns through Western dramaturgy and, on occasion, European canonical texts. This diverse fare, chosen with a view to getting 'the right mix of art and politics' (Roberts, quoted in Burchall, 1997: C5), thereby proffered a complex and heterogeneous portrait of Aboriginality that acknowledged and celebrated local specificities while also building a strong sense of community.

Roberts was clear from the outset that her demand for indigenous control of the festival did not preclude joint ventures with non-indigenous groups and companies, and the final programme, which featured numerous cross-cultural works, reflected that policy. To ease difficulties potentially arising from cultural differences and misunder-standings, her team produced a protocol manual addressing issues of importance to remote, urban and rural Aboriginal communities; they also consulted extensively with community elders and cultural advisors and made contingency plans to accommodate 'sorry business' occur-ring during the festival (Roberts, 1998: 8–10). While it is unlikely that the overall approach to cross-cultural performance diffused all signi-ficant conflict, it seems to have provided a solid framework for building respectful relationships in most cases. Commenting on the festival shortly after its conclusion, Roberts reiterated the importance of collab-oration in both artistic and political terms, reserving particular praise for the Marrugeku Company – comprised of settler Australians from the Sydney physical theatre troupe, Stalker; urban Aboriginal performers and choreographers; and musicians, dancers and storytellers from the Kunwinjku people of western Arnhem Land – for their ongoing efforts to engage with each other's cultures and languages (Roberts, 1998: 10).

In simple industry terms, the significance of the Festival of the Dreaming seems fairly clear: the event involved approximately 700 indi-genous arts workers, many of whom continued in employment after-wards in various touring shows; it set up collaborations and producer relationships, commissions of new work and new seasons of existing work; it gave lesser known artists and performers much needed visibility; and it also provided opportunities for indigenous Australians to liaise with other first peoples from abroad. Roberts's success in securing main-stream venues – including the Opera House and the Wharf Theatre – guaranteed a public profile for the festival and her call to reviewers 'not to go soft on Aboriginal products' seems to have piqued critical interest (Waites, 1997b: 15). Although lauded in most quarters as a critical and box-office triumph, the festival was not without its detractors, with some concerned that it was merely pandering to white, middle-class audiences and others noting the discrepancy between the opportunities offered

to a few indigenous arts workers and the disadvantages suffered by the many indigenous citizens nationwide. One angry letter to *The Koori Mail* pointed out that the festival constituted a particularly cynical public relations exercise given the backlash in some sectors against Aboriginal advances in land-rights legislation and the Howard Government's move to water down the effects of the High Court's 1996 Wik decision allowing Aboriginal title to coexist with pastoral leases (Reyburn, 1997: 6).

In this charged political climate, the Festival of the Dreaming was expected to continue the fraught domestic work of reconciliation while presenting Australia as a cosmopolitan society that modelled the social values behind Olympism. Not surprisingly, the different sociopolitical and corporate agendas facilitated different readings of the festival. It can be argued, for instance, that the performance programme exhibited one kind of (Aboriginal) cosmopolitanism – inhering in cross-cultural open-ness and demonstrated competencies at navigating between cultures – which was interpreted as another kind of (Australian) cosmopolitanism, anchored by an investment in cultural diversity made visible on this occasion by the indigenization of the nation's performing arts. This subtle transvaluation of Aboriginality is evident in a number of reviews and also underwrites the assessment of the event in the official report: 'The Festival of the Dreaming gave the nation a song cycle with a message of collaboration between white and black, of Reconciliation and of the landscape of Australia. The Olympic Arts Festival showed that Australia's indigenous culture is fresh, contemporary and, above all, relevant as we head into the new millennium.'[13] In a related discourse, several critics also remarked on the festival's importance in giving the nation's arts a new image, a sentiment best summed up in a glowing review by James Waites: 'to experience our Aboriginal brothers and sisters bringing fresh life to so many of Western culture's largely moribund traditions is like witnessing a life-saving blood transfusion' (1997b: 15).

That Aboriginal performance was harnessed in these highly symbolic ways to enhance the nation's efforts to project a distinct cultural identity within the universalism of the Olympic movement suggests the perils of events organized under the auspices of global capital, despite Roberts's apparent success in securing indigenous control of the festival's plan-ning, marketing and production. Lisa Meekison addresses this issue in a detailed analysis of the Awakening Ceremony that opened the festival, arguing that there were numerous points of local agency even within the event's powerful Olympic framework (2000b: 183). She notes, for instance, that the welcome speech given by the officiating Olympics

minister was itself (re)framed by its insertion between various Aboriginal presentations: an initial ceremonial performance by various dancers, an indigenous welcome to Koori land and, following the minister's speech, Roberts's own welcome in Bundjalung together with her account of how Aboriginal–European contact history infused the very site of the ceremony (Meekison, 2000b: 186–7). Meekison also observes that the indigenous participants in the performance saw it as a bona fide ceremony to cleanse the site and connect Aboriginal people and places, even if the minister used the occasion to link times and events to generate international interest in the Olympic Games (2000b: 192). She concludes that the indigenous producers/participants and the officialdom each had their own ideas about what the ceremony could mean and more or less pursued their agendas independently (p. 190).

The potential variance between locally and globally scripted performances – and interpretations – of indigeneity was, of course, more limited in the Sydney Olympic Games proper. By this time, the official reconciliation process seemed irretrievably stalled, following the Howard Government's dilution of native title legislation (1998), its tacit approval of 'soft' versions of Hansonite race politics, and the prime minister's dismissal of the Stolen Generations' moral claim to state recognition (via a formal apology) as 'black armband history'. Nevertheless, there was a substantial groundswell of public support for reconciliation, strengthened despite (and because of) the government's retreat from that project and emphatically expressed in performances of solidarity such as the Sydney Harbour Bridge Walk on 26 May 2000, attended by more than a quarter of a million people from various political and cultural backgrounds.[14] In the context of this unsettling polarization of opinion about the ways in which past and future race relations might be approached, indigenous involvement in the Olympics was susceptible to being incorporated into a narrative of reconciliation that would redeem the nation's vexed self-image and enact a 'national catharsis' of sorts (Neilson, 2002: 20).

In indigenous terms, the Awakenings segment of the Opening Ceremony, choreographed by Bangarra's artistic director, Stephen Page, called together the tribes to welcome the world to the Olympic site and cleanse the land on which the contests would be held. Page explicitly states that his intention was 'not to send a glamorous postcard to the world, but to try to give a sense of the real spiritual experience of ceremony'.[15] Presented as part of the larger cosmopolitan vision of multicultural Australia, this representation of indigeneity could be read as amply projecting the Olympic ideal of communitas as well as the

national spirit of reconciliation.[16] The performance was roundly praised by most media commentators and deemed to have symbolically enacted the cultural harmony that was proving so elusive in the realm of national realpolitik. Representatives of Aboriginal peak bodies were also quick to express their approval; for instance, Geoff Clark, then Chairperson of ATSIC, considered the ceremony 'a powerful healing statement for Aboriginal Australia', a celebration of survival and 'a milestone on the road to reconciliation' (2000: 36). This is not to suggest that indigenous and settler Australians interpreted reconciliation in the same way. Page explains, for example, that the real magic of the occasion for him was in bringing black clans together as if in a huge corroboree and being trusted by elders to amalgamate their stories at that particular site.[17] He locates reconciliation in Djakapurra Munyarryun's performance as the 'link' between each of the nine segments of the Opening Ceremony, but notes that this tended to be edited out in the televised versions, resulting in a rather token coverage (2003: 125). Since the Olympics, there has been considerable debate in academic circles about the ways in which local and global interests were played out in this event across the terrain of highly mediatized images of Aboriginality. One thing is clear amid the complexities of this discussion: by giving its imprimatur and its aura, so to speak, to the world's premier global spectacle, the Awakenings segment cemented the indigenization of Australian performing arts even while generating a store of images of pride and success specifically for the Aboriginal community.

Indigeneity and commodity culture

The spectacular media packaging of Aboriginality as part of a suite of iconic images of Australian culture in broadcasts of the Olympics raises questions about whether (and how) indigenous performance can escape exoticism, as a mode of aesthetic perception, once it enters international commodity circuits. Melissa Lucashenko suggests the extent to which Aboriginality has been harnessed as a consumer brand for the nation when she asks, wryly, 'What the bloody hell did Australians give their overseas relations before Aboriginal Australiana was invented?' (2000: 113). This branding is not limited to low-brow products but also operates in business and government; Aboriginal fine art, in particular, has become something of an official style in decorating corporate boardrooms of local mining companies and Australian consulate offices around the world. The Department of Foreign Affairs and Trade regularly uses Aboriginal arts, including performance, at trade fairs and events

profiling Australian diplomatic efforts. One especially ironic example is the exhibiting of paintings and photographs of the Kunwinjku people at a Geneva celebration of Australia's presidency of the United Nations' Commission of Human Rights in 2004.[18] Performances that incorporate aspects of 'traditional' culture are most susceptible to this kind of commoditization, as suggested by Bangarra's recent international touring schedule, which included performances in an ambassadorial role at events such as the 1999 World Economic Forum in Switzerland and the 2005 World Expo in Japan. Since 1990, Bangarra has performed abroad extensively, both in Western regions such as the United States and Europe and in Asian countries, including Japan, Indonesia, China, India, Korea and Taiwan, and it remains, for most foreign theatre enthusiasts, *the* flagship Aboriginal Australian performance company. Quite apart from its members' considerable talent, it is likely that Bangarra's success in tapping into the global market owes something to the ease with which its fusion of Western and Yirrkala choreography, visual design and bodily styles of presentation can be recognized as tribal/traditional, a conduit of sorts to the mystical Otherness of the world's most ancient culture. What this instant recognition mechanism tends to occlude are not only Bangarra's Euro-American influences but also the nature of the company's ongoing engagement with the eastern Arnhem Land Yirrkala community, a process that has involved complex cross-cultural negotiations of its own. One critic's labelling of Yirrkala lead dancer Djakapurra Munyarryun as Bangarra's 'cultural designer' (Sykes, 1997: 18), together with reviewers' general tendency to concentrate on the authentic (traditional) aspects of the company's work, suggests the limitations of this exoticist response (see Gilbert, 1998b: 74–5).

Aboriginal performing arts practitioners are clearly aware of both the market value and the pitfalls of exoticism. Several Aboriginal speakers at the Indigenous Briefing Session for the 2002 Australian Performing Arts Market (APAM) stressed the need for critical approaches to self-representation and for vigilant awareness of the ways in which Aboriginal products are already 'pigeon-holed by international markets that continue to look for something indigenous from Australia'.[19] Nevertheless, pitch presentations for specific indigenous shows at this kind of trade fair regularly stress marketable aspects of cultural difference, again resorting to the semiotics of tradition and authenticity to capture the appeal of their offerings. Publicity for the 2006 APAM Spotlight Live Showcase programme, which featured six indigenous works (including one Samoan performance) out of a total of 23 in the theatre and

cross-artform category, supports this observation, notably in the case of the one-man show, *Nerrpu Dhawu Rrurrambuwuy*: 'Rrurrambu is a thoroughly engaging storyteller who demonstrates the mastery of Yolngu dance and song with the haunting authenticity of his tribal upbringing. He brings to the stage a living tradition of dance that beats with the heart and soul of ancient Australia.'[20]

Obviously, such blurbs are bound to some extent by the stock-in-trade discourse of the market, as evident in APAM's self-generated profile as a 'one-stop opportunity for the world's program-makers to experience the very best of new works from the Australian region',[21] or in the description of the 2003 Indigenous Arts Showcase in Perth, which again features packaged Aboriginality: 'High quality cultural product, ready for the international and national markets, will be presented in a boutique style designed to highlight the diverse artistic scope of Western Australia's Indigenous peoples.'[22] While a comprehensive response to the pressures of the global market is yet to be formulated by indigenous practitioners, most argue the need to remain connected to grass-roots communities – urban and rural – while developing ethical working processes in cross-cultural situations. Rhoda Roberts's 2002 keynote address to APAM suggests some of the challenges involved in this task:

> What we need to address, I suppose, is global and local context. And we have to be very careful that we don't become the organ grinder, the token, the mediocre, and we have to set industry standards and benchmarks. They need to be challenged, as there's a risk of reducing cultural concerns to protecting what can be bought and sold, neglecting community culture and tradition.
>
> (n.p.)

Roberts also intimates that only with vigorous efforts to ensure that Aboriginals maintain agency can their own creative works and cross-cultural collaborations properly fulfil their potential to indigenize Australian theatre in productive ways, 'giving the arts of the new millennium a distinctive character that places Aboriginal culture as the uniqueness of Australian culture' (2002).

Judging by the critical reception of Aboriginal plays that have toured to Britain in the last five years, it seems indigenous practitioners have found strategies not only to manage the deleterious effects of commodity relations in the global marketplace, but also to mobilize market interest in indigeneity to garner international support for Aboriginal political and social struggles. The HeadsUp Festival of Australian arts in London in 2000, organized to mark the centenary of the British Parliament's

passing of the Australian Constitution Act, proved to be a powerful platform in this respect. As a forerunner to the extensive cultural programme curated in Australia to celebrate the nation's Centenary of Federation in 2001, HeadsUp, funded by the Australia Council and scheduled in conjunction with a prime ministerial visit to London, was designed, at least on the official level, 'with ambassadorial goals in mind' (Bradley Smith, 2003: 204). The festival brochure presented Australian arts practice as drawing from many traditions and societies to create its trademark 'cultural soul' as 'a collision of ancient cultures and contemporary edginess' (quoted in Bradley Smith, 2003: 204). This implicitly cosmopolitan profiling of Australian arts seems to speak to the festival's need to make a mark in one of the world's renowned cultural capitals, while demonstrating Australia's cultural sophistication to the mother country. Not surprisingly, Aboriginal theatre featured prominently in the performing arts segment of the HeadsUp programme amid several other imports, mostly in dance and physical theatre, though the choice of indigenous plays may have raised a few official eyebrows since all three – *Box the Pony*, *Stolen* and *White Baptist Abba Fan* (also about the Stolen Generations) – offered damning portraits of Australian society. These works played at major venues (the Tricycle and the Barbican) with near sell-out seasons and generated a good deal of media interest that operated, in important ways, as a counterdiscourse to the press coverage of the Howard Government's official visit.

Shortly before the festival began, an article about *Stolen*, titled 'Black play may upstage Howard's London visit', appeared in the headline pages of *The Australian*; it included excerpts from an interview with Wesley Enoch lamenting the lack of space for 'moral arguments' in Australian politics and expressing the hope that 'British performances [of the play] would increase pressure on the Government to address the issue of reconciliation' (quoted in Collins, 2000: 4). While there is no evidence of any such shift – in fact, reconciliation has slipped even lower on the Howard Government's agenda in the face of current anxieties about global terrorism and border security – *Stolen*, together with the other two plays, did stimulate considerable debate in London arts circles, and possibly beyond that realm, about Australian cultural politics. Susan Bradley Smith observes that the festival's Aboriginal fare generated something of a media buzz and that critics took the opportunity to explain 'black–white relations in Australia' and reveal 'the flawed nature of reconciliation politics' (2003: 207). Some noted Howard's refusal to apologize to the Stolen Generations and discussed the meaning of the Sorry Books available for signing at the Tricycle;

others stressed the importance of airing such Aboriginal stories in Britain as a corrective to the stereotypical (white) Australianness expressed by imported television soaps. In a lengthy article for the *Guardian*, Michael Billington mentioned a meeting between the British and Australian prime ministers early that week to discuss the repatriation of the remains of more than 2000 Aborigines and suggested Mr Blair and the museum bosses could visit plays such as *Stolen* to learn about the 'historical wrongs' endured by indigenous Australians. While the review gave the play all-round praise, pronouncing that 'good theatre is the best way of recording social injustice', what seems to have moved Billington most is the 'authenticity of experience' with which its stories were told (2000: 6). This is not the same kind of reified authenticity that so easily attaches to indigeneity as exotic product, though, as Enoch himself notes, it is possible that part of the appeal of plays such as *Stolen* in Britain is that audiences can hear 'hard luck stories' without having to confront guilt (2004: 43).[23]

Whatever the accuracy of Enoch's conjecture, contemporary Aboriginal performance has clearly found an enthusiastic market in Britain as well as in other European countries. Among such works touring to this region in the last few years, *Stolen* had a return season in London in 2001 and also played in Dublin; Marrugeku's *Crying Baby* was staged in Ireland, Holland and Belgium; Kooemba Jdarra's production of Kevin Gilbert's 1968 play, *The Cherry Pickers*, enjoyed a regional tour in England; and Trevor Jamieson and Scott Rankin's *The Career Highlights of Mamu* was performed in Germany. In 2006, three Aboriginal plays – David Milroy's *Windmill Baby*, a celebration of Aboriginal women's roles in the cattle industry; Andrea James's multimedia performance, *Yanagai! Yanagai!*, which deals with the land-rights struggles of the Yorta Yorta people; and Richard Frankland's *Conversations with the Dead*, a harrowing account of the inquiry into Aboriginal deaths in custody – were translated into French for staged readings at the Louvre in Paris to celebrate Pacific writers. *Yanagai! Yanagai!* subsequently toured to several venues in Britain, supported by Undergrowth Australian Arts UK. This two-year programme has sponsored a range of events including an Aboriginal Culture Showcase at the 2006 Salisbury Arts Festival, which featured *Windmill Baby* and David Page's hit autobiographical cabaret, *Page 8*, written in collaboration with Louis Nowra. Markets for indigenous Australian theatre in the United States are also beginning to expand, aided by the development and publicity work of the New York-based Australian Aboriginal Theatre Initiative, which presents plays by established and emerging playwrights to American audiences.

Apart from Bangarra's extensive touring, Aboriginal performance has been much less successful at crossing cultures into Asian markets for the obvious reasons of language and cultural differences, though it is important to recognize the innovative cross-cultural performance work occurring between Aboriginal and Asian practitioners in northern Australian communities such as Broome and Darwin. The significant exports have been to Japan, initiated by translator and Australian theatre specialist Keiji Sawada working in tandem with director Wada Yoshio, whose Rakutendan theatre in Tokyo is the sole Japanese company to tackle issues concerning the nation's own indigenous minority, the Ainu. For both Wada and Sawada, Aboriginal theatre seems to contain the possibility of being able to raise consciousness about Japan's imperial history and mainstream Japanese society's continued marginalization of Ainu and Korean subcultures. So far, this interest in Aboriginal work has resulted in Japanese productions of *The 7 Stages of Grieving* and *Stolen* in 2002, *Up the Ladder* in 2003, and *Radiance* and *The Dreamers* in 2005. Rakutendan also produced Wesley Enoch's award-winning new play, *The Story of Miracles at Cookie's Table*, written and directed by Enoch, for the 2006 Australia–Japan Year of Exchange programme. As well as being enthusiastically supported by the Australian government (in line with trade objectives), these performance projects have been facilitated by bodies such as the Japan Foundation.

From the beginning of their experiments with Aboriginal theatre, Wada and Sawada have been anxious to set up some kind of cross-cultural exchange rather than merely importing plays to be performed in a vastly different context. They were instrumental in bringing the original Ilbjerri–Playbox production of *Stolen* to the 2002 Tokyo International Festival and linked Rakutendan's rendition of the play to this event, encouraging audiences to see both versions; they also scheduled post-performance discussions of their own work with Enoch and Jane Harrison as special guests. Enoch attended a similar forum the following year in conjunction with *Up the Ladder*, which involved Aboriginal actor/dancer Kirk Page working with Ainu composer Ikabe Futoshi in addition to the Japanese cast. In the initial stages of what now seems to be an ongoing (if sporadic) collaboration, Enoch expressed reservations about the Sawada–Wada initiative, stating that he remained 'on alert' about the politics of Japanese actors playing roles expressly written for Aboriginals and that Aboriginal 'ownership of the story' was critical to him (quoted in Sawada, 2005: 243). In response to Wada's production of *Stolen*, he praised the 'intensity and clarity of the relationships' conveyed, but 'was reminded that the performers were at least two steps

removed from their understanding of the material', not having experienced Aboriginal social realities and not living in Australia in contact with the play's everyday reference points (quoted in Sawada, 2005: 237). How such issues are being resolved as further projects unfold remains unclear, though Enoch appears to have negotiated a more powerful role as director of the 2006 Rakutendan Aboriginal venture rather than merely cultural advisor and commentator. In terms of reception, Sawada admits that Tokyo audiences had trouble understanding *Stolen* and *The 7 Stages of Grieving* other than as educative portraits of a very unfamiliar world, and that the intended parallels between indigenous groups in the two countries may have been difficult to grasp because Japanese spectators are schooled to recognize Ainu (and Aboriginal) cultures only in their traditional guises (2005: 241–2). Thus, the ethics and politics of reconciliation, so central to both of these plays in their Australian context, seemed to slip into the realm of cultural incommensurability despite, and because of, Wada's embrace of universality as a way of finding cross-cultural common ground or 'contemporaneousness' (quoted in Sawada, 2005: 243).

One of the most valuable aspects of this Japanese engagement with Aboriginal theatre may, in fact, be its potential to clarify issues concerning the transferability of indigenous cultural products to/within international markets. While exportability is increasingly one of the factors that gives Australian performances of any kind a longer 'shelf life' and the opportunity to evolve over time, the protocols of cross-cultural interaction so critical to indigenous practitioners are less likely to be respected – or even understood – in circuits of exchange driven primarily by commodity values. The dilution of indigenous theatre's cultural matrix within the global marketplace affects both representation and reception, despite all best intentions, particularly in instances where performances are developed in a specific community context that remains integral to the work. As one of the very few community-based cross-cultural companies to tour extensively overseas, Marrugeku has faced particular challenges in this respect. The company's creative process is typically long and often difficult, involving deep social and cultural negotiations, not only among the diverse group members but also with the traditional custodians of the sites in which they work as part of an effort to explore relationships between landscape, community and story. Artistic director Rachel Swain explains that, in these circumstances, the resultant performances are inherently fragile and vulnerable and that efforts to package them for a festival audience dispense with much of their uniqueness (2006: 36). The real value of Marrugeku's

work, she argues, lies in living/practising reconciliation as an everyday part of the performance process: 'The stories we translated or created for the show *Mimi* were not just our interpretation of Kunwinjku mythology in contemporary performance form; they became a deep processing of the shock and conflict of our difference and our stumbling steps towards understanding each other and, as such, understanding life together in Australia' (Swain, 2006: 33). Similarly, *Crying Baby*, which took three years in the making, encodes, for its creators, the complicated process of bringing together settler and indigenous experiences of dislocation under the metaphorical sign of the lost/orphaned child figure around whom the story revolves. As Swain acknowledges, however, it is difficult to craft a performance that reaches from remote indigenous communities to international arts festivals, and there is no simple mechanism by which to extend the 'cultural exchange and inquiry' at the core of Marrugeku's practice to a 'relationship between the company and a host country' (2006: 26).

The rapid expansion of an international performing arts market in which the interpretive repertoires for engaging with Aboriginality tend to be limited while its commodity value is at a premium has no doubt strengthened the indigenization of Australian theatre, yet in a substantially different way to the processes activated by the politics of reconciliation. Although overseas interest in Aboriginal performance has clearly provided important opportunities for various practitioners and companies and, in some instances, encouraged mainstream industry investment in Aboriginal and/or collaborative ventures, the major effect of this market trend for the wider Australian performing arts industry has been in terms of profile. That Aboriginal participation in the global market is dependent to a considerable extent on funding from the Australian government – which continues to support the development of Aboriginal cultural exports despite its reluctance to address domestic issues of importance to indigenous groups – has produced an uneasy coalition of sorts in which Aboriginality as commodity is made available, through performance, to be renegotiated in terms of Australianness. This state appropriation of Aboriginality can be understood, in Attwood's formulation, as a way of 'making good [the] deficit' of 'a distinctive sense of nationality in an age of deepening globalisation' (2005: 245). For arts promoters and consumers in general, indigenized Australianness immediately brands Australian works amid the supposed homogeneity of Western produce by linking them with an internal (non-Western) cultural tradition. Applied to the Australian performing arts industry as a whole, such branding is often part of a composite cosmopolitan

profile that enlists Asianness in a complementary role to mark the nation's concomitant external cultural orientation. Aboriginal practitioners should never be seen as mere pawns in this process; clearly, any alliance between indigenous groups and government bodies is mobile and contingent, often driven by different vested interests and not necessarily preventing indigenous theatre makers from forming other artistic and political coalitions, as the example of the HeadsUp Festival demonstrates. In this respect, Aboriginality as enacted in/through performance seems less imbricated in the commercial structures of the global market than other indigenous cultural products, notably visual art, which is often brokered by non-indigenous intermediaries with minimal input by the artists themselves.

The emphasis in government circles and among some reviewers on the commercial facets of indigenization – that is, the ability of Aboriginal performance to energize, demarcate, represent and authenticate Australian theatre in marketable ways – has tended to obscure the deeper processes of cross-cultural negotiation that have occurred among indigenous and non-indigenous practitioners and that might be seen as more properly constituting a cosmopolitan performing arts praxis. This autochthonous cosmopolitanism, grounded in Aboriginal challenges to the hegemony of settler cultures within the nation and played out in Aboriginal and non-Aboriginal aesthetic, political, philosophical and corporeal engagements with difference across unstable cultural barriers, has generally been omitted from Australian cosmopolitical thinking, in the arts and more broadly, despite the aesthetic purchase of Aboriginality in a range of cultural domains. For the most part, the indigenization process we have discussed, particularly as it relates to reconciliation, has been characterized by self-reflexive and metacultural approaches to artistic exchange, which casts cosmopolitanism as neither the consequence of cultural diversity nor the prerogative of Western liberalism, but rather the practice of striving toward ethical interconnectedness. Within this practice, indigenization has recognized, and generally respected, limits, especially as applied to issues of embodiment. Cross-race casting of non-indigenous actors in roles expressly written for Aboriginals is virtually unthinkable in political and ethical terms in most areas of Australian performing arts, unless as part of a joint effort to deconstruct the epistemological biases of racial fashioning. Likewise, prohibitions and/or strict protocols apply to the performance of specific corporeal forms such as traditional Aboriginal dance, the transmission of which is regulated by clans according to customs of ownership and sharing attached to particular dance-stories and movement sequences.

In these circumstances, indigenization is rarely manifest in a codified style of physical performance adopted by non-indigenous practitioners, as in instances of Asianization to be discussed in Chapter 3; instead, the bodily praxis of indigenization might be said to inhere in a deep consciousness of historical constraints to cross-cultural exchange and a lived commitment to accommodation – rather than incorporation – of difference.

3
Asianizing Australian Theatre

The simple truth for Australia is that unless we succeed in Asia, we succeed nowhere.

(Paul Keating, quoted in Willox, 1995: 8)

While recent Aboriginal incursions into mainstream Australian theatre are strongly associated with the cultural politics of reconciliation and, indeed, perceived in some quarters as exemplary of the commitment to cultural rapprochement found lacking in the present conservative government, the Asian influence is closely connected to public policy and the arts establishment. As noted in Chapter 1, Asia has figured periodically in the national theatrical imaginary as a site of both desire and disavowal since the mid-1800s. This ambivalence continued to inform cross-cultural theatrical activities in the region in complex and sometimes contradictory ways as Asian themes and art forms became highly visible on the main stage in the latter part of the twentieth century, a trend facilitated by the government-led campaign for cultural and economic (re)alignment with the Asian region. The Asianizing process in theatre has occurred less through the emergence of a distinct body of works and practices by/about Australians of Asian descent, although this is an important aspect of the phenomenon (see Chapter 6), than through the incorporation and valorization of (selected) elements of Asianness in the performing arts industry, in a range of political, aesthetic and commercial sites. While there is some evidence to support a reading of this process as a form of neo-orientalist cosmopolitanism, we contend that Asianization, like indigenization, is a multifaceted and dynamic process that presents opportunities for exploitation and commoditization *as well as* prospects for mutually productive and sustained cross-cultural engagement.

The 'Asian turn' has played a crucial role in Australia's postcolonial identity formation in the last 50 years as the fears about Asian invasion that characterized early twentieth-century nationalism have transformed into a more ready acceptance of the need to forge closer and more positive regional connections. This shift has been aided by the demise of the White Australia Policy in the late 1950s, a steady rise in non-European immigration over the last several decades, and ever-expanding trade with Asian economies. While orientalist stereotypes of Asia/Asians persisted in Australia in the years following World War II, these were challenged by a gradual disaggregation of a monolithic concept of Asia and an increasing appreciation of the diverse cultures, traditions and histories in the region. The impact of the Pacific and Vietnam Wars also contributed to a re-examination of national identity and regional politics within the context of an increasingly global world order.

The Asian presence in modern Australian theatre in the lead up to the 1990s Asian turn can be conceived in two distinct modes: representation and performance aesthetics. As subjects of representation, Asia and Asians essentially disappeared from the Australian stage in the 1920s with the decline of melodrama as a form of popular entertainment, and only re-emerged in significant ways in dramas about the Vietnam War in the late 1960s. In such texts, Asia was often depicted as a site of repressed trauma and unresolved conflict, reflecting Australia's anxieties about both Asian communism and American neo-imperial intervention in the region (see Gilbert, 1998a: 186–204; Perkins, 1998). With the notable exception of Alan Hopgood's *Private Yuk Objects* (1966), which proffered Vietnamese perspectives on the war, plays in this genre were marked by the relative absence of Asian characters. John Romeril's attempt in *The Floating World* (1974) to present a more nuanced picture of Australian–Asian regional relations represents an important turning-point; however, the play's intervention into racial representation was circumscribed, in the final analysis, by its focus on white nationalist masculinity. This kind of representational impasse leads to Peter Fitzpatrick's 1985 observation that although the previous decade's theatre had shown an acute awareness of the ways in which the age-old topic of Australian attitudes towards Asia and Asians had intensified in political sensitivity, most playwrights seemed content to merely demonstrate the intractability of problems concerning representation of their cultural Others. Fitzpatrick relates this shortcoming in part to a preference for naturalistic dramaturgy, concluding, hopefully, that the concern with cultural difference might

eventually encourage the development of more diverse (non-verbal) forms of theatre by which to reflect the nation's openness to the cultural influences of its neighbours (1985: 46). This chapter details Australia's engagement with such aesthetic forms – and their associated modes of staging cultural difference – a process enabled over the following decades by significant developments in the areas of cultural politics and theatrical praxis.

Australian experimentation with Asian performing traditions across the middle decades of the twentieth century was strongly influenced by the Western modernist avant-garde movement and, in some arenas, preceded the resurgence of interest in Asian themes. Dancer Louise Lightfoot was a pioneer in this respect, studying Indian classical forms in the 1930s and incorporating elements of their choreography into performances by her company, the Australian Ballet. In theatre, one of the first Asian-styled productions in the contemporary era was the Performance Syndicate's 1973 Sydney adaptation of Hans Christian Anderson's tale, *The Marsh King's Daughter*. Katharine Brisbane described the performance as 'roughly Indian', distinguished by 'the occasional use of the Hindu dance gesture' and the actors' Indian costumes (1973: 17). She was adamant, however, that the performers were not trying to reproduce another culture's aesthetics, but rather seeking to 'convey in purified form, by their use of gesture and expression to musical accompaniment', aspects of 'Oriental theatre' that enhanced the Western narrative (1973: 17). Brisbane's description captures both the attraction and danger of cultural borrowing; although the Indian-inspired staging broke new ground by enabling innovative ways of communicating with the audience, it can also be read as an ethnocentric practice that synthesized and reified cultural difference rather than respecting its distinctiveness.

The establishment of international arts festivals in Perth (1953), Adelaide (1960) and Sydney (1976) played a crucial role in introducing a wider range of Asian performance styles to the Australian public and theatre community. There were also a number of showcase tours organized during this period, including by the Guangzhou Acrobatic Company (1972, 1978 and 1980) and the Jiangsu Peking Opera (1983). The dominance of dance, puppetry and circus acts continued the popular nineteenth-century tradition of staging spectacular Asian performances and contributed to the stereotyping of Asian theatre as 'all that non-verbal ... stuff' (Musa, 1995: 1). Interest in cross-cultural experimentation with Asian forms clearly corresponded with the public's increasing exposure to, and demand for, Asian performing arts. In

contrast to the nineteenth-century circus tours that featured Asian performers playing to city, town and rural audiences, the trade in Asian theatre in the latter half of the twentieth century has largely concentrated in the major cities. And whereas Asian performance had a popular audience base in colonial Australia, it is now intended for the urban sophisticate. Knowledge about Asia and Asian culture became a signifier of class and social ascendancy in the 1970s and 1980s, a trend that has become even more pronounced in later decades.

Eastward ho!

Theatrical interest in Asia as both a subject of representation and a site/source of cross-cultural trade reached its peak in the 1990s under the Keating Government's so-called Asia enmeshment campaign. Keating presented the economic benefits of forging closer regional relations as the strongest rationale for the move to privilege Australia's geographic location over its historical ties with Europe. The rhetoric of enmeshment had first circulated in the mid-1980s when the Hawke Government propagated an image of an economically depressed Australia and touted the opportunities available in the rapidly expanding Asian economies. The dominant ideology of economic rationalism gained further credence under the Keating regime, which justified the government's Asian turn in terms of its potential to resolve the nation's economic crisis and thereby maintain current living standards. Stephen Frost makes the astute observation that for all its fine sounding rhetoric, enmeshment was merely 'a version of "protecting our way of life"…a new way of remaining the same' (1994: 27). The dominant view at the time was that the major impediment to forging closer links with Asia was a lack of understanding about Asian cultures and histories; hence, the government established an array of programmes to promote 'Asia literacy'. This effort to change the cultural imagination of Australia was implemented through courses to sensitize business people to the cultural diversity within the region, increased emphasis on teaching Asian languages and cultures in schools and universities, and strategies to heighten 'Asia-mindedness' among the general population using the media and other forms of entertainment. As Ien Ang and Jon Stratton put it, there was a 'clear desire among the national leadership to bring about not only economic "Asianisation", but also a *cultural* "Asianisation" of sorts' (1998: 19). The symbiotic relationship between trade and culture as represented by the prevailing Asia enmeshment discourse had significant repercussions on the production of specific types of knowledge

about Asia: it endorsed the utilitarian perception that understanding cultural differences was desirable because it enabled economic and political leverage in the encounter with Asia.

The arts sector was drafted by the government to assist in the enmeshment project: funding was made available to develop pro-Asia initiatives such as the Asia-Pacific Triennial visual arts exhibition in Brisbane, the Asialink Centre at the University of Melbourne, and the annual Asia-Pacific Film Festival in Sydney. The Performing Arts Board of the Australia Council for the Arts devoted up to half of its international arts funding budget to works related to the Asia-Pacific region in the early to mid-1990s. Cross-cultural exchange programmes were encouraged by enabling Australia to host Asian artists and arts administrators, and funding was made available for Australians to develop non-Western performance skills in Asia. According to Carrillo Gantner, then Chair of the Board and long-time advocate of Asian arts, the aim of introducing Asian art forms to Australian practitioners was to challenge and extend the Eurocentric foundations of Australian theatre:

> As Australians we need to do this because increasingly our position in the world is to be a sort of bridge between a European past and an Asian future. ... [Theatre] offers opportunities to do this in a way that ... helps the wider Australian community come to term with these changes. The arts generally do this better than anyone or anything else. They're non-threatening, they show the excitement of cultural exchange ... the diversity and quality of other cultures, [and] the intelligence and traditions of the people who have created those cultures.
>
> (Gantner, 1999: 35)

While Gantner's aim to reorient Australian theatre practices is laudable, his statement reveals the extent to which the cultural elite was actively implicated in the enmeshment project. Theatre served as a form of cultural diplomacy on at least two fronts: to persuade the international community of Australia's cosmopolitan sophistication and to convince the nation's own citizenry of the viability and desirability of 'Asianization'. The increased funding and support for projects serving these agendas had a marked effect on theatrical production. Until the 1990s, Asia-related work was generally relegated to the margins, but with the advent of the enmeshment policy 'Asianists' found themselves in the mainstream, enjoying the recognition of both the theatre establishment and the government. While the bold initiatives of the

Keating Government did much to challenge the residual image of White Australia, Nicholas Jose suggests that they also resulted in some highly opportunistic ventures, with some Australia Council grant applicants suddenly claiming to be 'Asianists' beckoned 'Eastward Ho!' (1992: 46). Not surprisingly, Australia's Asian ambitions invoked mixed reactions from countries in the region; while there were welcoming arms, many leaders and opinion makers were highly sceptical of Australia's motives. Leading Thai artist and academic Apinan Poshyananda declared that Australia had, until then, seen itself as 'an agent of the Anglo-Saxon world' and that its move to use the arts as part of a regional enmeshment strategy was a form of 'seduction' designed to shift the nation's position from 'the edge of Asia to the centre of attention' (quoted in Broinowski, 1994: 24).

The economic thrust driving the Asian cultural turn was given added force with the 1994 launch of *Creative Nation*. As noted in our introduction, this national arts policy transformed the cultural sector into a service industry that had to be attentive to changing regional and global economic forces. The policy endorsed belief in the viability of Asia as an important market for Australian arts and resulted in the injection of an additional $2.5 million in federal government funding for the international activities of the Australian Council. While funding overseas programmes involving Australian artists was seen as a way of actively promoting domestic cultural production, the principal reason for exporting arts under the auspices of the Department of Foreign Affairs and Trade was 'to enhance [Australia's] national image at critical times or to support particular goals'.[1] This pragmatic approach to culture, coupled with the promise of financial gains to be made from engaging with Asia, exacerbated the tendency to commoditize Asia-related performance products.

The altered value of Asianness was also affected by the discourse of multiculturalism under the Keating Government. The critique of state-sanctioned multiculturalism, as a form of ethno-racial management that reinforces the centrality of white Australian subjectivity, is well established (Perera and Pugliese, 1994; Stratton, 1998). For Ghassan Hage, 'white multiculturalism' also produces a particular kind of cosmopolitan subject, an urban (and urbane) person who is defined by modes of consumption: the 'cosmopolite' is 'a class figure...capable of appreciating and consuming "high quality" commodities and cultures, including "ethnic" culture' (1998: 201). The commercially motivated turn to Asia was reinforced by domestic conditions that heightened propensities for aestheticizing and reifying cultural difference. Asia and

Asian cultures were not just 'sexy' or economically lucrative during this period, they were also signifiers of cultural capital within the context of state-led cosmopolitanism. The consumption of Asianness signalled ideological differences between contending groups in Australia: the upwardly mobile consumers of Asian cultural capital versus Australians who viewed Asia through an outdated prism of fear and hostility (Naomi Smith, 2004: 2). The competing interests between 'new' and 'old' Australia came to a head in the late 1990s with the reactionary politics of Pauline Hanson's One Nation Party.

The Asian turn resulted in increasing numbers of Asia-themed plays being produced for the main stage in the early 1990s, including Michael Gurr's *Sex Diary of an Infidel* (1992), which explores Australia's involvement in the Philippines' sex industry; Anna Broinowski's *The Gap* (1993), a portrait of friendship between a young Australian woman and her Japanese counterpart; and Nicholas Jose's political thriller, *Dead City* (1994), set in Shanghai. It was also the catalyst for the formation of new performance groups, such as Zen Zen Zo, with an Asian aesthetic orientation, as well as new Asian Australian companies such as Theatre 4a. These initiatives were preceded by a shift in orientation at more established mainstream institutions, such as Playbox,[2] towards a praxis that reflected the cultural diversity of Australia and placed its performing arts within the Asia-Pacific region. By the 1990s, Playbox had developed strong regional links through a varied programme of exchange, touring and Asia-themed production work. The company initially focused on establishing relations with China and Japan, through tours by groups such as the Fujian Puppet Theatre in 1979, and on mounting texts that experimented with Asian theatrical forms. Roger Pulvers's *Yamashita* (1977) and John Lee's *The Propitious Kidnapping of the Cultured Daughter* (1978) are among early examples. In later years, under the stewardship of Carrillo Gantner and Aubrey Mellor, Playbox became the nation's premier pro-Asia company, producing Asian plays such as Filipino dramatist Tony Perez's *On the North Diversion Road* (1994), and co/hosting tours by leading Asian companies, including the Peking Opera Troupe of China (1988) and the Suzuki Company of Toga (1989). Playbox also conducted some very successful residency programmes in Asia, and hosted visits by Asia's leading artists and administrators. It has a strong record of touring Australian productions to Asia and initiated one of the country's best-known cross-cultural experiments, Suzuki Tadashi's *The Chronicle of Macbeth* (1992). From 1995–2003, Playbox, in association with Asialink, also ran a biennial playwriting competition that focused on Australian–Asian relations. Many of the winning

plays went on to receive mainstage productions, including Duong Le Quy's *Meat Party* (2000), a depiction of the Vietnam War from the lesser-known perspective of the north Vietnamese, and Nöelle Janaczewska's *Songket* (2003), a courtroom drama that explores different cultural notions of love and how the law struggles to accommodate cultural diversity.

Another institution that played a major role in the Asian turn was Belvoir Street Theatre, which hosted the annual Sydney Asian Theatre Festival from 1994–98 under the direction of Cheryl Yin-Lo.[3] The festival broke new ground by drawing attention to the experiences of Asians *in* Australia as opposed to their conventional siting outside the national boundaries. It provided crucial opportunities for hitherto marginalized Asian Australian writers and performers, and encouraged the development of text-based Asian Australian theatre that challenged the assumption that Asian performances were largely movement-based spectacles. Asian Australian productions at the festival include David Zhu's *Black Eyes* (1993), which depicted the struggles of Chinese students residing in Australia in the aftermath of the Tiananmen massacre; Binh Duy Ta's *The Return* (1994), a poetic exploration of the migrant sensibility; and Merlinda Bobis's *Ms. Serena Serenata* (1997), a dramatization of the embodied memory of war. The cultural and infrastructural transformations initiated by Playbox and Belvoir Street were supported by another crucial player in the Asianizing process: the Asialink Centre. Asialink was closely aligned with the economic enmeshment drive and continues to perceive its mission as that of growing, in the words of its promotional material, a generation of 'Asia-skilled Australians'.[4] The centre supports an ambitious programme that places Australian artists, writers and arts administrators in residencies in the Asian region, and also hosts their Asian counterparts in Australian locations. It works closely with government agencies and the arts sector to support touring productions, exhibitions and associated Asian-related cultural activities.

Staging Asia

Notwithstanding the increase in narrative accounts of regional relations over the last 30 years, the Asianization of Australian theatre has occurred primarily at the level of stylistics and involves the incorporation and reinterpretation of Asian performance forms within a Western aesthetic paradigm and bodily praxis. Unlike indigenization, which has been grounded in an overt politics of negotiation and reconciliation, the Asianizing process has been subtended by a long history of theatrical

orientalism that naturalizes Western interest in Asian performance traditions. This calls attention to the ways in which Australian artists navigate between the faultlines of appropriation, assimilation and respectful adaptation, within a context of a global arts market in which signifiers of Asianness are often unhinged from traditional/conventional sources.

Among the modes for incorporating Asian performance styles into Australian theatre, the most visible and arguably most influential is the capital city festival loop, as discussed in Chapter 4. In this arena, specific Asian productions are imported as 'total' packages, their form unassimilated by the Australian context even though aspects of their mise-en-scène may be crafted to suit the target culture.[5] A related – and potentially more problematic – packaging practice has occurred in some Australian practitioners' use of the richly evocative presentational styles of Asian theatre to index thematic concerns and/or enliven realist dramaturgy. For example, Jill Shearer's *Shimada* (1987) drew inspiration from noh theatre in its presentation of geisha and samurai figures to signify Australian suspicions of, and fascination with, Japanese culture. The play also used a hanamichi[6] and framed a transvestite performance by a young Australian soldier within the kabuki tradition of the onnagata.[7] Similarly, Jim Sharman's *Shadow and Splendour* (1992) employed noh-style masks and movement vocabularies to punctuate its dramatization of a real-life story about a Soviet espionage ring operating in 1940s Japan. In this instance, the meshing of Western and Asian staging techniques was not as successful, with reviewers perceiving the experiment as 'simply a display of cultural credentials' (Morley, 1992: 35).

Such productions, uninformed by sustained engagement with the performance traditions at issue, risk replicating the tendency in orientalist melodrama to reduce 'Asia' to mere spectacle. At its most extreme, this opportunistic approach treats Asian theatre as a source of raw materials with which to invigorate Australian cultural commerce:

> Australia has long been a country whose principal exports have been raw materials rather than manufactured goods; value has been added ... further downstream – overseas, by their importers. ... [O]ur visual and, more recently, physical theatre has become a value-added export in its own right. We have imported the raw materials (such as Bunraku, black theatre and educational philosophies) and refined them, incorporating them into original stories which can be exported as 'manufactured' products.
>
> (Wilson and Milne, 2004: 91)

While such commercial cosmopolitanism was undoubtedly implicated in the Asian turn, it also resulted in innovative ways of incorporating and circulating Asian theatre forms that were less assimilatory and that transformed both the performance vocabularies and the cultural landscape of Australia's theatre industry. These more reflexive engagements with Asian performance traditions can be delineated into two specific (interactive) modes of operation: staging (the application of specific Asian technologies of representation) and embodiment (the bodily incorporation of Asian expressive techniques through training). While such modes vary across a range of cross-cultural projects, our focus is restricted to paradigmatic examples: puppetry to assess the impact of Asian staging on visual theatre in Australia, and circus and physical theatre to examine Australian ways of embodying Asian performance techniques.

Puppetry, as a complex dialectic between the animate, the inanimate and the animated, offers a rich site through which to unpack the intricate relationships inherent in cross-cultural practice. Although forms such as Indonesian wayang kulit and Chinese finger puppetry have found their way into contemporary Australian theatre, the single most influential source of Asian puppetry has been the bunraku (Wilson and Milne, 2004: 89). Bunraku, a traditional Japanese form accompanied by chanting and live shamisen music, was first introduced to Australia at the 1972 Adelaide Festival. One of the earliest local practitioners of the form was Peter Lyndon Wilson, whose 1974 work, *The North Wind and the Sun*, juxtaposed actors with bunraku-style rod-puppets. The Japanese influence in Australian puppetry strengthened when Noriko Nishimoto joined Wilson's company, Spare Parts Theatre, as a master puppeteer in 1982. Her Asian-inspired productions, including *Kaguyahime* (1988), which dramatized an ancient Japanese folktale about the Moon Queen, and *The Emperor's Nightingale* (1989), based on a Chinese legend, have been instrumental in developing cross-cultural puppetry in Australia. Over the last three decades, bunraku techniques have been widely assimilated into mainstream puppetry for adult audiences. The traditional presentational style featuring a fully visible master puppeteer who only works on the head and right arm while masked apprentices operate the left arm and legs is eschewed in favour of more collaborative animation processes (Wilson and Milne, 2004: 90). Most reviews of puppet/visual theatre today do not distinguish particular elements in productions as specifically drawing from bunraku; rather, the Japanese influence has been digested and naturalized as part of contemporary Australian puppetry.

The 1987 production of Daniel Keene's *Cho Cho San* is distinguished as one of Australian theatre's most arresting bunraku experiments.[8] A contemporary adaptation of Verdi's *Madam Butterfly* drawing on an eclectic selection of music ranging from rock to cabaret, *Cho Cho San* staged a dynamic interaction between live actors, puppets and puppeteers. The production employed some innovative doubling, and even tripling, strategies to unsettle the orientalist power relations encoded in the *Madam Butterfly* narrative. A youthful and virginal Butterfly, represented by a life-size puppet, shared the stage with an older, more disillusioned Cho Cho San, played by a non-Asian actor. This dialectical merging of characters, performance styles and dramatic time frames produced some highly complex theatrical moments, giving a reflexive edge to the narrative. Cho Cho San's 'Asianness' was signified by geisha-like white face paint, red lips, black lacquered hair and a colourful, lavishly patterned kimono. She appeared to be the stereotypical embodiment of the orientalist tropes that inhere in the *Madam Butterfly* story and its long history of operatic productions featuring similarly attired Westerners in the lead role. The Butterfly puppet, dressed in a simple ivory kimono with stylized 'Asian' facial features, including 'slanted' eyelids, served to reinforce the presentation of Japanese exotica and erotica. However, this conventional, gendered portrayal of Asian Otherness was complicated by the presence of the male puppeteer, dressed in robes almost identical to those of Cho Cho San. Effectively, the puppeteer functioned as an uncanny double for both Butterfly (as her operator) and also Cho Cho San (through the costume replication). The impact of this strategy can be seen, for example, in a flashback scene when Butterfly is disrobed by her 'Yankee God', Pinkerton. Pinkerton does not touch Butterfly at all; rather, it is the puppeteer and by extension, Cho Cho San, who performs the act, witnessed by the 'live' Cho Cho San who hovers in the background of the play's present, supervises the re-enactment and participates in the scene by singing Butterfly's song. While Butterfly's disrobing at the hands of the puppeteer 'takes on the image of dismemberment as the puppet Butterfly is laid on the ground, in pieces' (Milne, 1988: 94), Cho Cho San's 'direction' of this highly theatricalized scene challenges the traditional portrait of the oriental woman as victim. Yet, notwithstanding such subversive moments, *Cho Cho San*'s capacity to critique orientalism's entrenched gender and racial ideologies seems to have been limited by the *Madam Butterfly* metanarrative. This impression is borne out by reviews typically describing the production as 'an ageless story' of the 'clash of the cultures and values between East and West' (Barnes, 1987: 112).

John Romeril's play *Love Suicides* (1997) also uses the doubling effect of the live actor and bunraku puppet to extend a narrative exploration of the perceived differences between Japan and Australia. While Keene's play reworks a canonical Western ur-text, *Love Suicides* references a classical Japanese genre, the double-suicide, pioneered by Chikamatsu Monzaemon in the early eighteenth century. Dubbed the Shakespeare of Japan, Chikatmatsu developed the genre for the then emerging bunraku puppet theatre. Romeril uses it to depict the doomed love between Ohatsu, a tourist from Osaka who is unhappily locked into an arranged marriage, and Mark Paris, a failed businessman from Perth facing criminal charges. Through a layered, visually stunning performance that includes doublings and inversions, *Love Suicides* works to dismantle cultural and gender stereotypes. The binaries of East/West and male/female are deconstructed in the play through the use of half-sized Ohatsu and Paris puppets who occupy the same theatrical space as the live characters. While *Cho Cho San* struggled to address the difficulties of representing Asianness with a non-Asian cast of performers and puppeteers, *Love Suicides* featured actors of Japanese and Caucasian descent performing their respective racial roles. The faces of the Ohatsu and Paris puppets, by contrast, closely resembled 'neutral masks'. Although there were subtle differences between Japanese and Caucasian features, the most obvious point of distinction was gender rather than race, with Paris's face defined by prominent masculine features compared to the delicate visage of Ohatsu (see Figure 5).

The original plan for the Paris puppet to be manipulated by Noriko Nishimoto did not eventuate and male puppeteers operated both Ohatsu and Paris in the 1997 production. While the envisaged gender dynamic between puppet and puppeteer might have strengthened the multiplicity of relations staged, the (in)distinctions between Asians and Caucasians in their respective roles and their puppet doubles were highly effective in foregrounding both racial and cultural specificities and commonalities. A strong dialectical relationship between animated characters and live performers heightened the production's appeal: the actors playing Paris and Ohatsu, in particular, functioned as actors, as narrators whose stories animated the puppets, and even as puppets themselves when they fell under the influence of other characters. Produced nearly a decade after Keene's play, *Love Suicides* demonstrated a keener awareness of the politics of staging racial difference. This can be attributed to Romeril's long-term and in-depth engagement with Japanese culture and performing traditions, the absence of an orientalist metatext to be circumvented, the increased availability of Asian Australian performers

Figure 5 Paris and Ohatsu puppets, *Love Suicides*, Playbox, 1997. (Photo: Jeff Busby)

to play Asian roles, and the general enhancement of Asia-awareness in the arts community as a result of public policy.

Among other Asian forms of animation making important contributions to Australian theatre's internationalization, Vietnamese water puppetry has been extremely popular with Australian audiences. It made its Australian debut at the 1988 Adelaide Festival, and has since become a regular feature at international arts festivals in various parts of the country. Traditional water puppetry uses a pool as the stage; the puppets appear on the water's surface and are manipulated with underwater rods by puppeteers who stand waist-deep behind a screen. Unlike bunraku, which has been modified and incorporated into mainstream puppet practice, water puppetry has maintained its cultural distinctiveness. Australian productions featuring this form have been staged in cross-cultural collaborations with either Vietnamese-Australian communities or visiting Vietnamese artists. Peter Copeman's *Hearts and Minds* (1992) exemplifies the first approach: based on extensive research among Australian veterans of the Vietnam War as well as Vietnamese refugees who have settled in Australia, the bilingual production used

a combination of water puppetry and actor-based realism to chart the war's impact on the romance between the children of a veteran and a refugee. *Water Stories* (1997), on the other hand, was a major collaboration between the Song Ngoc Vietnamese Water Puppetry Troupe and the Canberra Youth Theatre, with music by the Canberra Youth Wind Ensemble. The Vietnamese troupe operated the water puppets while marionettes and hand puppets were manipulated by the multicultural Australian cast, which included Vietnamese-Australians and indigenous performers. Comprising a series of vignettes depicting everyday activities in Vietnamese villages and rural and urban Australia, the production included scenarios of a camera-wielding kangaroo touring Vietnam, and a dog saving a picnicker from a shark. In a scene titled 'An Australian Mythology', a young indigenous performer crouched by the water to witness the successive arrival of migrants from Europe and Asia. As one reviewer pointed out, this segment 'was a timely reminder in these less tolerant times that we are largely a nation of migrants' (Morgan, 1997: 9).

Like *Hearts and Minds, Water Stories* did not attempt to disguise the difficulties of cross-cultural work. Some critics noted the different levels of puppetry competence between the Vietnamese visitors and the young cast members. Such tensions and disjunctions mark both productions as process – rather than product – driven. As *Water Stories* director Roland Manderson puts it: 'The combination of the traditional [Vietnamese] forms with the Australian eclectic approach is fascinating ... But it's not just the production that is important, it is the whole activity embedded in it. It's about dealing with difficulties and bringing together different worlds' (quoted in Kay Dixon, 1997: 3). The development of both *Hearts and Minds* and *Water Stories* as community-based productions with considerable input from Vietnamese-Australians contrasts markedly to the ways in which bunraku has been taken up by mainstream commercial theatre (which, tellingly, has not perceived a need for similar consultative protocols with the Japanese-Australian community). The primary factor for this discrepancy may be that water puppetry is less portable and adaptable; it may also be the case that, generally speaking, Vietnamese culture has less cosmopolitan currency for Australia. While Vietnamese puppetry is largely seen as traditional/folk art, bunraku's international status has allowed the form to disengage from its specific cultural moorings and become more easily incorporated into contemporary practice without accusations of cultural pillaging.

Like water puppetry, wayang kulit is closely associated with the traditions and mythologies of its source culture. Although this Indonesian

form had been circulating in theatrical circles and Asian studies courses in Australia for some time, its aesthetic cachet was amplified when the Adelaide Festival staged a large-scale imported production of wayang kulit and its sister form, wayang golek (three-dimensional puppets) in 1994. The all-night performances were enthusiastically reviewed by critics, but failed to draw large audiences. The most extensive cross-cultural wayang kulit collaboration in the region has been *The Theft of Sita*, which was commissioned by the 2000 Adelaide Festival. Marketed as an Australian product, this international project was directed by Nigel Jamieson, designed by Julian Crouch from Britain, with music composed by notable Australian and Balinese artists. The puppetry directors, Peter J. Wilson and Dalang I Made Sidia, also performed in the show. The production drew on the *Ramayana* as the ur-text to tell the story of the costs of environmental destruction as the result of economic globalization. Despite the specifically Indonesian focus, Jamieson was eager to point out that such degradation is also a problem in Australia, and that cross-cultural collaborations of this ilk could contribute to the nation's realignment with its geographic region (2000).

The Theft of Sita received rave reviews for its jazz-infused gamelan music and the ingenious puppetry, which drew on both Western and Indonesian traditions. In the show, Sita is associated with the natural, mythical and traditional world; her peaceful life in the idyllic forest setting is violently disrupted when she is abducted by Ravanna and taken to the evil city of Lanka. In a marked contrast to the use of traditional gamelan music in the forestscape, the Lanka scenes are punctuated by Western music suggestive of the decadence of capitalism and urban life. Depictions of forests transformed into golf courses for Western tourists augment the critique of economic globalization and its cost to the environment (Wilson and Milne, 2004: 92). Prince Rama is forced to go to war in Lanka to save Sita and the kingdom from further destruction. The allegorical relations set up between, on the one hand, capitalism, modernity and Westernization, and on the other, nature, tradition and Asianness are potentially problematic. The primacy of the *Ramayana* myth demands that Sita's/Indonesia's honour be defended, which notionally recapitulates older binaries of East and West. This allegory was complicated, however, by dynamic interactions between the puppetry and other visual technologies. The intricacies of the wayang kulit were enhanced through the use of both rear and front projections on various screens, which enabled the audience to experience different kinds of visual images and apprehend their collaborative creation by the Australian and Indonesian puppeteers. Film, slide

projection, newsreel footage and digital video imagery added to the visual complexity of the production. Thus, it could be said that the so-called first-world technology was utilized in such a way as to complement rather than assimilate the older visual technology of the wayang kulit.

Since its Adelaide premiere, *The Theft of Sita* has received international acclaim at major arts festivals in Zurich, Aarhus, Berlin, Rotterdam, New York and London. There is clearly a market for these high-profile cosmopolitan productions that are accessible to a non-Asian audience. According to Peter J. Wilson and Geoffrey Milne, Jamieson's project 'took raw materials (of form and content) from abroad, refined them and with great inventiveness, resourcefulness and canny international collaboration, welded them into a brand new product to export to the world ... as an *Australian* production' (2004: 92). This reading undermines the complexities of the cross-cultural work undertaken in *The Theft of Sita*. Representing such collaborations as a manufacturing process elides questions about the specific ways in which Asian forms have been integrated into the Australian theatre industry and about the long-term implications of this process. While cross-cultural work in puppetry has generally been sensitive to issues of appropriation, as many of our examples suggest, modes of staging Asia in contemporary performance continue to be complicated at both aesthetic and political levels.

Embodying Asia

The process of Asianization becomes even more complex – and potentially fraught with political challenges – when elements of Asian theatre are integrated into the bodily expressive praxis of a typically non-Asian and non-Aboriginal Australian performer. Keith Gallasch's claim that an increasingly 'multicultural body' has emerged on the national stage (2001: 38) suggests the importance of Asian training techniques but belies the fractures inherent in this development. While many Australian performers have enthusiastically adopted aspects of tai chi, silat, kathakali, randai and butoh to enhance their physical capabilities and performance vocabularies, this eagerness to partake of Asia can also be perfunctory and cosmetic, amounting to nothing more, in some cases, than a performance of cultural drag. Sally Sussman, a long-term practitioner of Peking opera reminds us that Asian performance techniques are not culturally neutral and cautions fellow artists to consider the 'applicability' of the chosen form to 'a particular culturally specific

body' (Sussman and Day, 1997: 132). It is beyond the scope of this study to cover the range of cross-cultural embodiments occurring in recent Australian theatre; we will therefore foreground key sites where the influence of Asian body-based techniques is most apparent: the circus and physical theatre.

As mentioned earlier, interest in Asian circus skills were reignited in the 1970s through a number of high-profile touring groups from China. A seminal event in the development of Australian circus and physical theatre was an exchange programme with the Nanjing Acrobatic Troupe organized by Gantner and Playbox in 1983. Nanjing I was the inaugural international training programme for the Albury-Wodonga-based children's company, the Flying Fruit Fly Circus, and the participants included many older artists who took advantage of the three-month-long project to broaden their skills base in acrobatics, juggling, aerial work and gymnastics. The intensive training led to the development of a shared understanding of circus arts for the Australian sector as a whole and a common acrobatic language based on the classical Chinese style. The exchange programme was so successful that Nanjing II was conducted in 1985–86 and attracted even more circus performers from around Australia. The Chinese connection has remained a significant part of the Flying Fruit Fly's operation: in 1987 some Fruit Flies trained in China for three months with the Guangzhou Acrobatic Troupe, and the company collaborated with the Shanghai Acrobatic Troupe to create a new show, *Fusion*, for the 2000 Olympic Arts Festival.

While some of the stylized acrobatic forms introduced by the Chinese have been adapted and transformed by the circus community into acts that are more 'organically' Australian, particularly in the light of subsequent training influences from Russia and France, there is little doubt that the Chinese input contributed significantly to the professionalization of the industry. According to Ollie Black, 'the international training opportunities offered by the Flying Fruit Fly Circus have influenced style, content and skill levels' across the country (2001: 42). Graduates from the Circus have gone on to perform in some of the leading physical theatre and circus companies within Australia and abroad, including Legs on the Wall, Circus Oz and Cirque du Soleil, and many of these artists are also training the next generation of performers. The Australian–Chinese exchange has also stirred circus interest in Australia's own Asian history; for example, a 1993 Circus Oz show directed by Sue Broadway explored the little-known story of Sam Poo, a Chinese bushranger who lived around the inland town of Mudgee in the 1860s (Tait, 1998: 217). The performance utilized the skills of Lu Guang

Rong, a former member of the Nanjing Troupe who was invited back to Australia after the second training programme as Training Director of the Flying Fruit Fly Circus. Chinese skills continue to play a significant role in Australian circus: Lu is presently Director of Circus Training at the newly established National Institute of Circus Arts at Swinburne University.

In asserting the influence of Chinese skills on Australian circus and physical theatre, we are not suggesting that 'pure' Chinese tradition has been adopted; the skills taught by the visiting trainers were hybridized to suit the different body types, cultural mores and abilities of the Australian performers. For example, the Chinese hoop diving act, traditionally reserved for men, had to be modified to become more gender-inclusive for the Australian milieu. Rosemary Farrell argues that such 'invented traditions' have since become reified; their alleged authenticity as *Chinese* circus acts functions to maintain a hierarchy of acrobatic knowledge, which seems to block change in their execution at the Flying Fruit Fly Circus (2005: 11). Farrell's assertion supports our contention that within the cosmopolitan discourse of Asianization, knowledge about Asia can function as a form of cultural capital to distinguish between social groups. One of the first mainstream theatre productions to fuse the newly internationalized circus skills with actor-based realism was Therese Radic's *Madame Mao*, which uses 'invented traditions' to lend authority to the representation of Asianness. Based on the life of Mao Zedong's wife, Jiang Qing, *Madame Mao* was staged by Playbox in association with Circus Oz in 1986. The production used a highly physical presentational style consisting of acrobatics, Chinese opera, kung fu, tai chi and Brechtian agit-prop to suggest the intimate connection between the theatre and Jiang Qing's life. The non-Asian ensemble cast, which consisted of both trained actors and members of Circus Oz, was costumed to invoke both the country and the period. A striking set featured red, white and black as its dominant colours, while the faces of the actors playing the Red Guards were painted in a style that resembled those of Chinese opera performers. Despite these exotic visual cues of 'Chineseness', most critics pointed to the circus elements as the authenticating factors in locating the play's cultural referent, claiming that they provided the 'Chinese connection'. In this respect, the embodiment of physical techniques from 'real' Chinese sources seemed to legitimize the representation of Chineseness on stage, though, at this nascent stage of Asianization, there was uncertainty about how to interpret the embodiment of Asia in performances by (non-Asian) Australian artists.

The influence of Asian circus training has also contributed to the development of physical theatre through the hybrid works of companies such as Legs on the Wall, renowned for its integration of text, acrobatic skills and aerial imagery; Strange Fruit, which specializes in large-scale outdoor performances using flexible poles; and ERTH Visual and Physical Inc., distinguished for its deployment of puppetry, pyrotechnics, abseiling and other site-specific technologies. Contemporary circus and physical theatre have been promoted as distinctly Australian contributions to the international performing arts market. Jennifer Bott, the chief executive officer of the Australia Council, claims that '[o]ur artists draw on rich circus and vaudeville traditions, absorb new and traditional influences from Asia and indigenous Australia, and importantly, build on a physicality deeply ingrained in the culture' (2001: 2). Practitioners seeking to develop this bold physicality have also been attracted to Japanese avant-garde practices such as butoh and the Suzuki Method of actor training, possibly because both are perceived as already circulating within a (Western) postmodern performance aesthetic and have hybrid ancestry in European as well as Japanese theatre/dance practices. Butoh developed as a postwar reaction to traditional Japanese culture and society; its grotesque physicality is said to derive from German expressionism, though critics such as Vicki Sanders assert that butoh aesthetics are contiguous with those of traditional Japanese performance forms in terms of body poses and thematic interest in human metamorphosis (1988). Suzuki, for his part, draws not only from noh and kabuki, but also from Western-style surrealism and, possibly, from the Japanese shingeki form, itself modelled after naturalism (Carruthers, 1995a: 12–13). That butoh and the Suzuki Method have been widely disseminated in the United States and Europe over the past two decades also adds to their accessibility and ease of adaptability for Australian practitioners. According to Peter Eckersall, the basic appeal of the genres is very telling: 'Not requiring language ability in their replication of physical form, both also respond to a perceived need in Australian theatre culture to develop and expand on physical vocabularies, spatial sensibilities and body-focused *mise en scène*' (2004: 35).

Like many other Asian theatre practices, butoh entered Australia through the festival circuit with performances by butoh pioneer, Kazuo Ohno (1986), and key companies such as Tanaka Min's Maijuku Performance Company (1982), Sankai Juku (1988) and Dairakudakan (1991). By the mid-1980s, butoh was a well-established art form on the international arts market and increasing numbers of Australian performers were going to Japan for training. Some, like Melissa Lovric,

gained sufficient expertise to be invited to join elite Japanese companies (Dairakudakan, in this case). Australian interest in butoh has been so pronounced that it has provided work opportunities for migrant Japanese artists such as Yumi Umiumare, who is based in Melbourne. Umiumare first visited Australia as part of the Dairakudakan tour and is now widely recognized as one of the leading physical theatre performers in the country. The butoh vogue reached its peak in the mid-1990s when it took on an almost cultish status that ignored the historical and political context associated with the art form's emergence. According to Eckersall, the nudity and sexualized images in butoh have 'a context in Japan that makes available subversive and anti-status quo interpretations. Such work has explored oppressive forms of social orientation, inhibition and sexuality. There is danger, however, that these bodies come to be read through a notion of availability and erotics when they are sensationally depicted in the West' (2004: 34). Chapel of Change's *The Descent* (1996) illustrates this approach. Devised by Rainsford and Mary Salem, the production garnered Chris Boyd's praise as 'a work of superb craft and profound beauty'. His comment that it was 'one of the best examples of Sankai Juku-style Butoh [he] has ever seen by a local company' suggests the degree to which a particular style of butoh had permeated the industry (1996: 92). This mythic narrative about the grief-crazed widow of a fisherman slowly renewing her commitment to life featured Salem in a diaphanous 'Middle-Eastern' dress with a spangled bodice while Rainsford adopted the (androgynous) butoh look with his white body paint and shaven head. The performers used an array of physical movement styles, including belly dance, tango and butoh, accompanied by a score ranging from ecumenical religious chants to gypsy music in an evocatively lit and incense-infused set. Such staged ritualism clearly conjured the Orient as a site of mysticism and sensuality.

Fortunately, not all attempts at incorporating butoh are so sensationalist. Nigel Kellaway was one of the earliest Australians to study with both Suzuki Tadashi and Tanaka Min in the mid-1980s. The Japanese training developed his physical and mental stamina and has meshed with his other training influences to such an extent that it is no longer discernibly foreign. His innovative performances as part of the now defunct Sydney Front, and solo works such as *This Most Wicked Body* (1994), demonstrate the enhanced physical lexicon facilitated, in part, by this exposure to Asian physical training. Tess de Quincey, a dancer with Tanaka Min's company (1985–91) has adapted butoh to an Australian landscape and body praxis. Her work, based on

Tanaka's Body Weather training method and philosophy, draws from Western and Asian dance and theatre practice and martial arts to maintain an ongoing exploration of the body: 'It proposes the body as an environment reflecting a greater environment and aims to generate a conscious relation to the constant state of change – inside and outside' (de Quincey). De Quincey has conducted extensive Body Weather investigations and performances, often with students, academics and fellow artists in various parts of Australia, including a three-year interdisciplinary laboratory, the Triple Alice project (1999–2001), exploring the deserts of Central Australia. Her solo performances, notably *Nerve 9* (2001), are much admired for their 'depth and lucidity' and seen as 'immensely readable and challenging': 'She seems to work with ideas, particularly internalized and embodied, rather than with overt and consciously planned movement' (Brickhill, 2001: 35). Like Kellaway's recent work, de Quincey's practice is not received by mainstream theatre reviewers as being Asia-influenced, despite her stated emphasis on the centrality of Body Weather to her art. Without the formulaic signifiers of butoh, such as white body paint and slow, tortured movement, it is not surprising that there is rarely any mention of her Japanese association in reviews of her solo work. Clearly de Quincey has translated and even 'indigenized' the technique as part of her ongoing embodied negotiation with the Australian environment, which raises the pertinent question of what constitutes a recognizably 'multicultural' and 'Asianized' body in contemporary physical theatre today.

Australians were introduced to Suzuki Tadashi's work through his widely admired touring productions, *The Trojan Women* (1988) and *The Bachae* (1989), which were followed in 1992 by the now well-documented Playbox–Suzuki project, *The Chronicle of Macbeth* (see Carruthers, 1995b). Suzuki's influential method of actor training has been taken up in various circles in Australia and has sometimes elicited problematic forms of Asian embodiment that expose much about the risks of cross-cultural performance. We will analyse this issue in some detail in Chapter 5; here, we focus on individuals such as Mémé Thorne and companies such as NYID (Not Yet It's Difficult), who demonstrate a more self-reflexive and localized approach to the Suzuki Method in their practice. Thorne was tutored by Nigel Kellaway in the Suzuki Method in Sydney in the late-1980s, and became an accredited teacher of the form after completing training with the master himself in the early 1990s. While the Suzuki Method has informed a significant part of her work with Sidetrack Performance Group since the early-1990s, Thorne also draws on a range of other physical training techniques

including tai chi, Western contemporary dance forms and yoga. Her solo work, *Burying Mother*, premiered at the Belvoir Street Sydney Asian Theatre Festival in 1996. Yana Taylor argues in response to the production that the 'enhanced corporeal capacities' Thorne gained from her Suzuki training contributed specific physical 'actions adapted and reconfigured in performance' as well as an 'altered dimension of time use' and an 'extremely high degree of segmentation and fragmentation of action' (1998: 50). While Taylor offers an insightful analysis of the aesthetic effects of Thorne's art form, she does not consider the impact that cross-cultural and mixed-race identity politics play in the performance text. *Burying Mother* is framed within an Asian Australian diasporic experience whereby the Self is caught ambivalently between a home culture (signified by the monstrous Chinese mother) and the Australian host culture. This is most powerfully communicated when the daughter transforms into her mother in a moment of simultaneous identification and disavowal. The performance becomes a ritual that enables the daughter to exorcize the authority of the mother/home culture and its associated demands of cultural purity in favour of a more negotiated and hybridized identity (see Lo, 1998). Thorne's use of the Suzuki Method is not merely for exotic display; rather it is firmly grounded in a process of reappraisal and recontextualization of cultural influences to produce a highly localized exploration of contemporary Australian identity politics mediated through the specific history of a 'Eurasian' migrant. The deconstruction of the Suzukian vocabulary is motivated by an analytical and critical reassessment of the historical and sociocultural synergy between the foreign/Asian and the target/Australian cultures and eventually leads to the creation of an original performance text that navigates between and around cultural boundaries without fetishizing Japanese aesthetic forms.

The work of the Melbourne-based group, NYID, exemplifies a long-term approach to cross-cultural engagement as process. The company's founding director, David Pledger, trained with Suzuki in Japan and was part of the cast of *The Chronicle of Macbeth*. NYID developed out of an extensive series of workshops led by Pledger in the Suzuki Method in the early 1990s. According to the company's promotional materials, a training process was developed to help articulate performers' physical sensibilities, and specifically, to explore 'Australian spatial reality' in performance. Evidently, even at this early stage of development, a concern with the Australian habitus informed the company's practice. NYID members are highly conscious of the cultural history of the techniques they incorporate into their work; they recognize that Suzuki's

method comes out of the avant-garde tradition in Japanese theatre and carries strong political associations. Hence, although the company feels free to transform the genre, care is nonetheless taken to engage with its sociocultural specificity within an Australian context. NYID's first public performance, *Taking Tiger Mountain by Strategy* (1995), adapted the Peking opera Model Play to critique hegemonic political and social institutions in Australia. Aside from the Suzuki Method, the production also drew from a range of other physical techniques, including Vietnamese martial arts and classical ballet. These distinctive performance styles were integrated into appropriate scenes; for instance, the end of the show featured the company marching in Suzuki formation as the Red Army, singing revolutionary songs. *Taking Tiger Mountain by Strategy* employed its Asian and specifically Suzukian influences in a relatively formalist way in comparison to a later NYID work, *The Austral/Asian Post-Cartoon: Sports Edition* (1997). One of the major themes in this production was the issue of racism, particularly against Asian Australians, and one segment of the performance explored the violent bashing of a Vietnamese Australian by the sports team/company members at the behest of the sports coach. In this production, the Asian techniques, including the physicality derived from Suzuki training, were deconstructed and absorbed into the entire fabric of the performance rather than pigeonholed as self-contained styles in appropriate scenes.

While the initial development of its performance idiom was highly influenced by the Suzuki Method, NYID has successfully disrupted 'the integrity of this system while enhancing the effects of its discipline' (Scheer, 2004: 58). The company has been careful to politicize its own processes of cross-cultural adaptation and transformation, as evident in a three-year collaborative project with the Tokyo-based, Gekidan Kaitaisha (Theatre of Deconstruction) from 1999–2002. Gekidan Kaitaisha shares with NYID an interest in experimental physical theatre and deconstructionist politics while drawing inspiration from the Western avant-garde. In contrast to the product-oriented approach that dominates most cross-cultural experimentations, the *Journey to Con-Fusion* project was determinedly process-oriented. Established as an investigation into cross-cultural theatre praxis within the context of globalization, the project aimed to resist the kinds of commoditization found in international festival circuits. According to Eckersall, '[t]he accumulation and transference of forms and practices observable in the ... project was a measure of its success. ... [O]ne could see the ways that each group began to address and apply the other's styles and concerns' (2004: 48).

This did not necessarily lead to an aesthetic fusion, however, as one reviewer noted in relation to the final workshop performance: 'Instead of attempting to reconcile their contrasting body vocabularies they are, rather, observed' so that ultimately 'there is an undeniable sense that the performers are trapped, hostages to the space, their bodies and their cultures' (Rowell, 2002). The self-reflexivity manifest at the level of bodily transference and dis/location points to a deeper awareness of the politics of embodying Asian physical training. This project paves the way for the creation of more 'genuine' hybrid works when Asian-trained Australian bodies feed back into the development of performance vocabularies in Asia.

Trading (with) Asia

While cross-cultural production in community, popular entertainment and avant-garde sectors points to the depth and diversity of Asian influences in Australian theatre, it is, arguably, the area of elite performance that best reveals the confluence of economic, political and cultural interests inherent in the Asianizing campaign. Cross-cultural theatre increasingly functions as a signifier of the cosmopolitan credentials of international arts festivals. Australian audiences have experienced many of the festival circuit's 'canonical' East–West productions, including Peter Brook's *The Mahabharata* (1988), Robert Lepage's *The Seven Streams of the River Ota* (1998) and *The Dragons' Trilogy* (2006), and Ong Keng Sen's *Lear* (1999) and *Desdemona* (2000). Building on nearly a decade of local experimentations with Asian performance styles and training regimes, Australia has reached a point where it is now able to produce and export large-scale East–West performances for the international festival circuit. The cultural and commercial significance of this market is demonstrated by the Australia Council's 1996 establishment of the Major Festivals Initiative (MFI) to support the commissioning, development and showcasing of large-scale festival productions. The high cost of developing such works has meant that most of them have been commissioned by a consortium of international festivals with the support of the MFI. Suzuki's *The Chronicle of Macbeth* was the forerunner of later works such as Mary Moore's *Masterkey* (1998) and Jamieson's *The Theft of Sita*, which have received acclaim in both Asia and the West. These major productions usually draw their cast and crew from a number of countries, and trade on the international status of at least one major Asian artist to validate their claims as elite cross-cultural and transnational collaborations.

A recent example of this kind of festival-based work is *Sandakan Threnody* (2004), which was developed by Singaporean director Ong Keng Sen and Australian composer Jonathan Mills in response to a joint commission from the Melbourne Festival, the Brisbane Festival and the Singapore Arts Festival. Described as 'hybrid documentary multimedia music theatre' (Gallasch, 2004b: 46), the production explores contemporary attitudes to war by focusing on the infamous Sandakan marches which left only six survivors of the 24,000 prisoners forced by the Japanese to undertake the horrendous trek through Borneo during the Pacific War. In order to explore the turbulence of war and its legacy beyond nationalist frameworks, Ong presented multiple accounts of the marches from Singaporean, Australian and Japanese viewpoints. This transnational treatment was enhanced by the diverse performance styles of the multicultural cast which included Australian Matthew Crosby (who was also involved in Suzuki's *Macbeth*), Singaporean performance artist Rizman Putra, kabuki actor Gojo Masanosuke and butoh dancer Kota Yamazaki. Critical reception was mixed with some reviewers praising the production's textured vision and aesthetic splendour (Slavin, 2004) and others criticizing its overt self-consciousness and abstraction (Banks, 2004). One Malaysian commentator even labelled the show 'an exercise in grief aestheticisation' (Pang, 2004). A more moderate view is offered by Rosemary Duffy, who wrote that while there 'is no denying the potency of *Sandakan Threnody*', there were times when she felt that 'Ong did not trust the intrinsic power of the story to speak for itself and there was a tendency to overload the dramaturgy' (2004). *Sandakan Threnody* is one of the many fruits to emerge from the enmeshment campaign: an Australian-based cross-cultural collaboration with one of Asia's most lauded directors that is exported back to Asia via an elite festival circuit represents one of the crowning achievements of the Asian turn. According to Keith Gallasch, Ong claimed in a post-show forum in Singapore that many people in his region had perceived the Pacific War as 'a war between empires' in which they and their countries were 'trapped', and that Southeast Asians were only just 'beginning to appreciate the role of Australians [in this conflict] and the complexities of responsibility' (2004b: 46). It could thus be argued that *Sandakan Threnody* contributed to the politically sanctioned image of the new Australia as a nation willing to relinquish its colonial ties and embrace its regional identity.

While the most visible signs of the Asian turn in Australian theatre have occurred at the level of performance, there has also been significant progress in forging closer commercial links with the region. The

international projection of Australian culture to Asia (and elsewhere) is funded through specific initiatives by the Department of Foreign Affairs and Trade (DFAT), the Australia Council, state governments, festival organizations and corporate sponsors. DFAT, which has played an instrumental role in promoting Australian arts overseas and sponsoring visits by Asian artists and administrators to Australia, established the Australian International Cultural Council (AICC) in 1998 to market the nation's culture in more coordinated and targeted ways by working with sponsors and government and cultural organizations such as the Australia Council and Austrade.[9] That three of the five priority market areas nominated by the AICC are Asian demonstrates the importance of this region. Foremost among DFAT schemes have been the Performing Arts and Arts Management Residencies in Asia programmes, which are organized in association with Asialink, the Australia Council and various local government arts initiatives. The key rationale for the department's interest in the arts lies in their potential to project 'an image of Australia as a stable, sophisticated, tolerant nation with a rich and diverse culture'.[10] This cosmopolitan image is held to advance Australian foreign and trade policies, and to enhance the export of cultural products. Accordingly, the performing arts have played a significant role in 'cultural packages' produced for targeted overseas markets where plays and exhibitions are often linked with specific trade events to deliver maximum impact and media exposure. Cultural showcases incorporating a range of art works are also increasingly used to attract foreign investors: faced with 'a range of cultural forms, the foreign investor can visualize contemporary Australia in a high-impact environment. The arts motivate and captivate interest, resulting in tangible economic returns for the government' (Radbourne and Fraser, 1996: 254). The Ancient Future – Australian Arts Festival Japan held in Tokyo in 2003 exemplifies this kind of showcasing, exhibiting contemporary and indigenous works across a number of art forms including theatre, dance, music, film and visual arts.

The Australia Council also supports Asia-related activities as part of its brief to develop new markets for Australian works. Among the major issues confronting the Australian arts sector's push into Asia is the need for improved understanding of arts networks and cultural infrastructure in Asian countries, and for more cohesive and long-term audience development and marketing strategies. Recent measures taken to address these challenges include the creation of a market development position with the Australian Embassy in Tokyo, triennial funding for Asialink for its residency and touring programmes, and the involvement of

Southeast Asian artists and funding agencies in the Australian Performing Arts Market (APAM) (Brown, 2002). The latter is another key initiative for exporting works to Asia, via potential buyers such as the Tokyo Performing Arts Market and the Singapore-based Esplanade – Theatres on the Bay. Official statistics confirm that Asia is one of the leading touring destinations for artists and companies involved in APAM showcases (Australia Council, 2002: 4). More recently, the organization has enabled Asian performance groups such as Singapore's Wild Rice Company to penetrate the Australian market. Production companies such as Export Oz and Performing Lines also develop, produce and tour Australian performance works internationally.

This brief overview of some of the central Australian organizations involved in brokering the regional market suggests that Australia's turn to Asia has entered a new phase in the twenty-first century. Building on the cross-cultural experimentations that characterized theatre in the 1990s, the current phase is marked by attempts to formalize artistic, institutional and commercial networks that will result in a new Australasian performing arts circuit. In contrast to the nineteenth-century colonial market which was largely driven by Western entre-preneurs supplying limited theatrical products to the region, the global economic order of the twenty-first century has meant that Asian theat-rical establishments and entrepreneurs play a significant role in determining both the terms and conditions for trade. Globalization has also meant that Asian countries are increasingly strengthening intra-regional trade and cultural relations, and Western nations such as Australia and Aotearoa/New Zealand have to actively strategize and collaborate with Asian partners to maintain a presence in these lucrative markets.

This new trading paradigm has created increasing opportunities for Australian artists to perform in Asia in the past decade, particularly in festival events. It is not surprising, given language differences, that dance and physical theatre, as well as multimedia visual productions, have been the most popular exports. Groups such as Chunky Move Dance Company have performed at the Hong Kong and Singapore Arts Festivals as well Seoul's International Modern Dance Festival in recent years, while Arena Theatre toured to Singapore and Taipei in 2000 with its multimedia performance installation, *Eat Your Young*. As discussed in the previous chapter, indigenous performances have attracted significant attention in the region, along with more popular forms of entertainment such as the dance extravaganza, *Tap Dogs*. Australian work has been espe-cially prominent at the Singapore Arts Festival, largely due to a Cultural Memorandum of Understanding between the National Arts Council

of Singapore and Arts Victoria. First signed in 1998 for a three-year term, the memorandum has been renewed twice, most recently in 2004. The renewed agreement has widened in scope to cover areas like arts education, cultural tourism, and technical and administrative expertise exchange (Chow and Oon, 2004). The partners are keen to develop more collaborative projects like *Sandakan Threnody* rather than merely focusing on programme imports/exports. Thus far, the memorandum has resulted in more than 20 major arts projects staged in Melbourne and Singapore. Australia's strategic relations with Singapore also extend to developing a strong presence in the latter's recently established Asian Arts Market.

While there is mounting recognition of Australia's theatrical exports to Asia, the growing trade in technical and artistic expertise and inform-ation networks has escaped general notice. A consequence of the increas-ingly commercialized Australasian arts market has been the demand for skilled Australian technical and administrative personnel and arts educators in Asia. A striking example of this demand is the relocation, within a period of less than 18 months, of six staff from the Western Australian Academy of Performing Arts to the LaSalle-SIA (Singapore International Airlines) College of the Arts. Bell Shakespeare Company is one organization intent on breaking into this new market; it has extended its national education programme in Australia by setting up an office in Singapore to run acting workshops and masterclasses. The increasing Australasian traffic in personnel, artistic knowledge and cultural production has led to the formation of a number of profes-sional associations and networks that aim to formalize intra-regional cooperation. Australia played an instrumental role in the 1996 forma-tion of the Association of Asia Pacific Performing Arts Centres, whose secretariat was based in Sydney for eight years before relocating to Singapore in 2004. Established as a society committed to the exchange of information and experiences, the association's present membership includes major performing organizations such as the Shanghai Grand Theatre, the Hong Kong Cultural Centre, the New National Theatre in Japan, the Adelaide Festival and the Sydney Opera House. A more recent network is the Association of Asian Performing Arts Festivals which was formed in 2004 between member Asian festivals to share resources and to co-produce works for the Australasian circuit. The four founding members were the Singapore Arts Festival, Hong Kong Arts Festival, Jakarta International Arts Festival and the Shanghai International Arts Festival. Australia has associate membership in this body through the Confederation of Australian International Arts Festivals.[11]

The strengthening of the Australasian touring circuit and networks for the exchange of information, resources and expertise points to the increasing commercial value of cultural production in the region. Australia's strong presence in this market is based on the infrastructure and cultural shifts initiated by the Asian turn in the early 1990s. While the Howard Government has not displayed the same degree of enthusiasm for cultural rapprochement with Asia, it has supported the commercial drive to infiltrate the Asian market. Contrary to the perception of the Asian turn as an officially decreed operation, our analysis demonstrates that this shift is also linked more broadly to the globalization of the arts market and the emergence of the Asian arts sector as a significant constituent of this market. While our attention has largely focused on Australia's engagement with Asia, such transactions do not constitute one-way traffic: Asian countries such as Singapore and Japan are major collaborators in the arts trade. Japan has been one of Australia's main trading partners since the 1970s and the Japanese government has invested considerable resources to strengthen relations with Australia through its cultural diplomacy arm, the Japan Foundation. The Sydney office of the Japan Foundation offers a wide range of activities to promote Japanese arts, culture, language and society: it funds exchange programmes for artists, arts administrators and academics in Japan as well as sponsoring Japan-related theatrical productions and associated cultural activities in Australia. The Australian and Japanese governments have designated 2006 as the Australia–Japan Year of Exchange to commemorate the thirtieth anniversary of the signing of the Nara Treaty of Friendship and Cooperation. This year-long focus on bilateral exchange includes 'Dramatic Australia', an umbrella festival showcasing performances of Australian (including indigenous) works in Japanese as well as collaborative productions between Japanese and Australian artists. The Japanese government's proactive support of regional and international artistic ventures partly accounts for the strong interest in Japan-related texts and cross-cultural experimentations in Australian theatre today.

Taken together, the influence of a global arts market, the cross-border mobility and the intersecting points of interest evident in the Australasian regional arts circuit complicate the conventional representation of Australia as a Western nation and Asia as the Orient. The Asianizing of the Australian theatre industry demonstrates the extent to which the Australian nation-state is 'an integral part of an always already Westernized (if not 'Western') Asian region' (Ang and Stratton, 1996: 20). The aesthetic and infrastructural transformations in the theatre

sector also challenge the view of the Asian turn as merely an elitist form of cosmopolitan consumption. Naomi Smith, for example, perceives the uptake of Asianness as 'a technology employed by groups to signify cultural capital or distinction. ... It is above all predicated on access to a disposition, education or habitus ... [and] affords an ability to act as a connoisseur, an assured collector of difference' (2004: 2). While we acknowledge that there are clearly elements of commoditization operating within the theatre industry, we would argue for a more nuanced understanding of the impact of the Asian turn on cultural production. Despite the widespread commercial impulse, the Asianizing process has resulted in the potential for deeper processes of cross-cultural exchange and collaboration between Australian artists and their Asian counterparts, as well as creating new mainstage opportunities for Australians of Asian descent. While this 'reorientation' does not, of course, nullify the possibility of exoticization, it may point the way to what Hannerz calls 'a more genuine cosmopolitanism' that is not only about a willingness to engage with the Other, but also involves a particular kind of competence. This competence entails 'a state of readiness ... to make one's way into other cultures' as well as 'a built-up skill in maneuvering more or less expertly with a particular system of meanings' (Hannerz, 1996: 103). We suggest that the groundwork spanning more than 20 years of regional engagement has resulted in the development of a range of competencies in cross-cultural theatre praxis, as well as regional marketing, among Australian artists, administrators and cultural organizations. Such expertise is vastly different from the kind of 'quick fix' Asia literacy promoted by earlier advocates of the enmeshment campaign. In this context of sustained, long-term engagement, Asia is increasingly recognized as a vital partner in the production and projection of Australian culture and identity on the international stage.

4
Marketing Difference at the Adelaide Festival

> *Gaining visibility for the politically under-represented without scrutinizing the power of who is required to display what to whom is an impoverished political agenda.*
>
> (Peggy Phelan, 1993: 26)

Comedian Barry Humphries is reputed to have said that arts festivals are 'good for Australians' because 'they allow us to get a year's worth of culture over and done with in a couple of weeks' (quoted in Waites, 1987: 2). As well as satirizing the 'typical' (sports-loving) Australian's apparent lack of sustained interest in the arts, this quip, made nearly two decades ago, indexes a mode of cultural exposure/consumption that has become increasingly prevalent within many parts of the nation. All Australian state and territory capitals now host annual or biennial international arts festivals, which, in combination, draw a considerable segment of the total audience for major performing arts events and demand an ever-increasing slice of the industry's funding pie. While this trend is undoubtedly linked to the marked expansion of the international festival circuit in response to the globalization of national cultural economies, the growing emphasis on festival culture in Australia, seemingly among the most pronounced in the Western world, can also be traced to specific local interests and state imperatives, not least of which is the desire to develop and project cosmopolitan tastes/identities. This chapter examines the cosmopolitics of marketing and consuming Aboriginal and Asian performances at the Adelaide International Festival, widely acknowledged as the nation's premier arts event. Focusing mainly on the Asia-themed 1994 Festival, and the 2002 and 2004 Festivals, which both emphasized Aboriginal arts, we analyse the ways in which cultural difference has been framed within the panoramic logic of the

festival, a logic generic to this kind of high-profile international event and one that tends to stress the overview or snapshot rather than the details, to present the discrete indiscriminately and to assume a spectatorial norm of mobile visuality. As part of this analysis, we also interrogate the curatorial imaginary – the complex of explicit and implicit curatorial assumptions – behind each festival's positioning of Asian and Aboriginal cultures and suggest its relation to broader political and cultural movements.

As events that trade in cultural difference, international festivals seem ready exemplars of Kant's market-initiated cosmopolitanism; yet, without an accompanying ethics of cross-cultural engagement, such events risk incorporating cultural specificities into a totalizing vision of global diversity in which difference becomes merely another marketable commodity. According to Ric Knowles:

> At both the major festivals and their fringes ... the mechanics of 'exchange' tend to be modelled more on international diplomacy, intercultural tourism, and transnational trade than potentially disruptive or genuinely interdiscursive interculturalism. Cultural differences, in these contexts, tend to either be packaged for consumption as exotic or charming ... or, as in high modernist formalism, to be treated as energizing but fundamentally incidental local variants on a (therefore more important) universalist or transcendent humanism.
>
> (2004: 187)

These commercial and political functions are typically strengthened by hierarchical organizational structures. In this respect, Peter Timms describes arts festivals as 'top-down events, conceived by politicians and business interests, assembled by high-profile entrepreneurs and pulled into operation by committees' (2003: 19). The danger of such corporatization is that it can position audiences as simply consumers of arts products rather than active cultural negotiators. Yet, notwithstanding the strictures of the international festival model of arts production and reception, individual festivals do accommodate, and even initiate, cultural change and innovation, whether in response to internal or external pressures. They are thus potential sites of intangible but significant cultural exchange as well as particularly charged arenas for performing representations of Self and Other. And while they are enmeshed in larger economic, political and cultural systems, flagship festivals tend to remain sensitive to local issues because, above all, they

are site-specific, time-limited events consumed largely on the ground and in the moment of their immediate constituencies. It is the contradictory nature of such festivals – the tension between being international and local, regular and yet exceptional – that makes their variously inflected processes of cross-cultural interaction especially relevant to the study of specific cosmopolitan formations.

The Adelaide Festival, inaugurated in 1960 under the patronage of the Queen Mother, was modelled on the Edinburgh Festival and initially conceived as a challenge to the provincialism of the former Australian colony, as well as a way 'to overcome the tyranny of distance in bringing to South Australia the culture which art-lovers in other countries experienced'.[1] From the start, the festival was ambitious in its international reach, securing visits by renowned artists and programming performances drawn from a range of cultural mileux. Its resounding success in both economic and popular terms led to a perception of Adelaide's instant (if temporary) transformation, celebrated by critics and media alike, from a cultural desert into a cosmopolitan city. An indicative example of this discourse, as expressed in the early years, is Shirley Stott's claim that the 1962 Festival generated 'wide-eyed surprise at the success of so sophisticated a venture in a place [critics] expected to find culturally naive' (quoted in Whitelock, 1980: 41). That the myth of Adelaide's cosmopolitan origins is still regularly evoked by festival organizers and local and visiting commentators suggests a degree of uncertainty about the city's cultural sophistication and hints at entrenched colonialist assumptions of Australia's apparent cultural paucity. Yet, in line with its early aspirations, the Adelaide Festival is now recognized as one of the international arts circuit's leading events, despite its relative distance (in Euro-American terms) from the key Western hubs of metropolitan arts culture. Over the years, it has presented distinct biennial offerings reflecting the vision, tastes and networks of a range of very different artistic directors. This general policy of bringing in new directors (who are recruited from abroad and locally) has given the festival a certain critical edge within Australia as well as helping it to remain competitive in global terms.

While internationalism and cosmopolitanism may be central to the Adelaide Festival's brief, a cursory analysis of the programming of Asian and Aboriginal events in the first three decades demonstrates the extent to which such concepts have been situated historically within Eurocentric frames of reference by arts administrators and critics alike. Since its second year of operation, the festival has featured Asian works in all but one programme, albeit usually as an adjunct to the more prominent

European and American imports. Until the mid-1970s, such perform-
ances consisted mainly of traditional music and dance, notably from the
Philippines, India and Thailand, and occasional puppetry. Understand-
ably, non-text-based works were chosen to facilitate smoother cross-
cultural communication, yet it is nonetheless instructive to consider
how these selections were presented. Interpretative glosses – in brochure
essays, publicity blurbs, press statements, reviews and interviews – drew
from the well-worn vocabularies of pictorial orientalism to contex-
tualize the works and their cultures. Asian art forms are routinely
described in festival brochures, for instance, as exciting, spectacular,
ancient, graceful, mysterious and timeless. Thus, the 'glittering and
beautiful' Royal Thai Ballet costumes have apparently 'undergone *little
change* since the Ramakhien, the ancient epic about the god-king Rama,
was adopted by the Thais some 800 years ago', while the Balinese
Dance Company, presenting one of the 'oldest and most fascinating
forms of dance', comes to its audience '*straight from the village square*'.[2]
Such descriptions position the performances, and the cultures they are
presumed to represent, in what seems to be an unmediated relationship
to the Australian audience. This strategic representation of the Other as
authentic and uncontaminated by (Western) modernity reveals the colo-
nial impetus in such displays of cultural (in)difference. The curatorial
eye/I is rendered invisible to facilitate the seemingly neutral activity of
cross-cultural consumption.

Whereas the earlier festivals betrayed their historical biases in the
overtly orientalist framing of Asian works, the strategies of interpretation
deployed by later festivals also included assimilation, by which we mean
that the cultural differences inhering in the foreign art forms were either
downplayed and re-presented in terms of the familiar – that is, in terms
of Western cultural models – or explained in depth so as to reduce their
seeming incomprehensibility. In 1986, for instance, detailed contex-
tual guides were made available for a number of Asian performances,
including *Dead Sea* by legendary butoh founder Kazuo Ohno. Such
decoders, which explained the texts in interpretive units and included
artist biographies and statements of intention, were not routinely
prepared for other foreign productions at the festival. Major intercul-
tural productions such as Peter Brook's version of *The Mahabharata*, the
feature presentation of the 1988 Festival, have also played their part in
domesticating Asian theatre forms for Australian audiences by incorpor-
ating cultural difference into a mythic universalism.

Not surprisingly, given White Australia's belated recognition of indi-
genous cultures, Aboriginal content featured less frequently than Asian

content in the festival's earlier years. Aboriginal performers made their first major appearance in the 1976 Festival, which programmed the Bulyan Players' revue production of *Basically Black* and performances by the Woomera Aboriginal Dancers alongside black theatre from South Africa and the United States. Over the next decade, there were a number of non-Aboriginal productions that focused on the general theme of white oppression of indigenous groups but very little in the category of indigenous performance itself. Aboriginal visual artists only began participating in the festival in 1986 via a programme designed to complement the first public display of the South Australian Museum's collection of Toas (indigenous artefacts from the Lake Eyre region). The 1988 Festival built on these efforts by including Jack Davis's anti-Bicentennial protest play, *Barungin*, and a devised performance directed by Robyn Archer, *Akwanso – Fly South*, portraying the life-stories of four black women from Jamaica, Ghana, the United States and Australia respectively. Throughout the early years of the festival, Aboriginal dance and didgeridoo displays were also incorporated as 'local colour' to authenticate the Australian/South Australian location. These 'folk' shows did not receive attention as legitimate works of art and there is no critical mention of them in the mainstream press during this time.

The 1994 Festival is regarded as Adelaide's most culturally diverse and one of its riskiest. Under the supervision of English director, Christopher Hunt, the festival broke away from its tradition of presenting Western showcase events supplemented by local offerings and high-quality works touring the international arts circuit. Instead, Hunt assembled a radical programme that emphasized Australia's geographic location within the Asia-Pacific region and aimed to speak to the nation's increasing cultural diversity. In the *Festival Guide*, he claimed that the confident Eurocentrism of Australia's founders had been superseded by a new vision melding 'East and West in a new Australian-ness: Mahabharata and Ramayana alongside the Bible and the Iliad; schoolyards with Australian children of Asian, Aboriginal and European origin alike' (Hunt, 1994: 1). Hunt's programming reflected this cultural mix: approximately 50 per cent of the festival's content was comprised of works from East Asia and the Western Pacific, and 25 per cent each from Australia and Europe/North America respectively. Of the 16 nations represented in the performing arts programme, 12 came from the Asia-Pacific region. It is little wonder, then, that the overall event was quickly dubbed the 'Asia Festival'.

Hunt declared that his objective was to confirm the Adelaide Festival's international standing by foregrounding Australia's regional identity

and locality. This was a decisive shift in the conceptualization of the festival, which had hitherto associated notions of internationalism with Euro-Americanism. His stress on regionalism as the key to internationalism must be read within the context of the prevailing Asia enmeshment policy. Hunt maintained that the festival's focus was not motivated by the need to be politically correct or the impulse to jump on the Asian bandwagon: 'The future must involve Asia and the Pacific for Australia; to go on living ostrich-like with connections only to a past that has changed enormously would be crazy' (quoted in Stenberg, 1993: 12). Having claimed the inevitability of Australia's future in the region, however, Hunt had to be careful not to alienate critics of the pro-Asia campaign, of which there were many.[3] Foreign Minister Gareth Evans's contribution to the festival brochure indicates the extent to which cultural production was imbricated in broader economic and political movements[4] and reveals the tight-rope act necessary to promote Asia enmeshment while reassuring (white) Australians that they were not in danger of being Asianized. While much of his essay endorses Australia's economic and trade relations with Asia, Evans is quick to clarify the nation's geopolitical orientation: 'Geographically we are not so much in Asia, but alongside it. What we are unequivocally part of is the Asia-Pacific region – embracing East Asia, Oceania, North America (and perhaps the Pacific coast of Latin America as well)' (1994: 6). This strategic identification with the non-Asian parts of the (redefined) region is followed by an assertion that, demographically, Australia is 'overwhelmingly more European than Asian' and its racial status quo will remain largely unchanged despite increased trade and cultural links with Asian countries and a high percentage intake of Asian immigrants (Evans, 1994: 6). With this kind of official framing, the festival was positioned as a site for simultaneously projecting and mediating a new multicultural landscape.

Hunt clearly saw indigeneity as fundamental to this landscape and was careful to present indigenous culture as part of Australia's present and future, not as something traditional and consigned to the past. His introduction in the *Festival Guide* begins with an acknowledgement of the Aboriginal foundations of the nation and goes on to locate Australia's future in the synergy between Aboriginal, European and Asian influences. An essay focusing on the diversity and vitality of Aboriginal culture follows his introduction and chronicles indigenous contributions to Australian arts. To give this kind of prominence to Aboriginality was unprecedented in the festival's history at that time. Similarly, the opening event, a departure from the traditional black-tie

and champagne gatherings for the elite, broke new ground by emphas-
izing the primacy of Aboriginal culture. This popular event, which
progressed from Elder Park to the Amphitheatre and finished in the
Open Roof, consisted of a Jukurrpa Dreaming ceremony by the Warlpiri
people, traditional and contemporary dance by Bangarra, and songs
and stories by young performers from the Adnyamathanha tribe of the
Flinders Ranges. Such ceremonial openings, which explicitly recognize
prior indigenous habitation of Australia, have now become common-
place in arts festivals across the country and major international sporting
events, including, most recently, the 2006 Commonwealth Games.

The Frankfurt Ballet and Mark Morris Dance Group provided the 1994
Festival's headlining performances in accordance with Hunt's vision that
the 'old links with Europe and America [would be] fewer but strong'
(1994: 1). Non-indigenous Australian content included physical theatre
and multimedia performances, along with plays by Italo-Australian
group Doppio Theatro and well-established dramatists such as Patrick
White and Michael Gow. The Asian and Pacific components of the
performing arts programme consisted of an eclectic blend of traditional
and avant-garde works. The latter were drawn almost exclusively from
Japan and targeted a younger audience, whereas the traditional perform-
ances included Vietnamese water puppetry, Chinese acrobatics, Thai and
Cambodian classical dances, Korean drumming, Indonesian wayang and
Western Samoan dance theatre. Most of these were held outdoors at the
Amphitheatre and the specially constructed Open Roof space in response
to the perceived Asian tradition of outdoor performance and Australians'
apparent affinity with the outdoors. A flyer presented the Open Roof
and Amphitheatre segment of the programme as a 'world of music
and dance' presented in a relaxed atmosphere 'at ease on the grass ...
where art and entertainment and ritual are inextricably intertwined'.
Stilt/aerial acrobatics by Stalker along with dance and storytelling by
various Aboriginal artists also featured in this programme. An avant-
garde piece, *Dumbtype: S/N* (a multimedia exploration of identity and
sexuality), *The Braggart Samurai* (a kyogen adaptation of *The Merry Wives
of Windsor*) and several bunraku plays were held indoors. As in previous
festivals, text-based modern theatre was absent from the Asian show-
case, which confirms the general curatorial interest in visually codified
forms of difference.

In a move consistent with the federal government's efforts to inculcate
'Asia literacy', the 1994 Festival brochure and associated publications
provided extensive information to enable Australians to understand
Asia. This material included short essays by experts about specific

countries/regions and their art forms and detailed synopses of the performances, as well as the usual biographical material. The assumption was that information about and exposure *to* Asia would be sufficient as points of entry *into* Asia and its market. What seems to have slipped consideration is that the panoramic logic of the international festival model readily lends itself to the objectification and fetishization of cultural difference rather than engagement with cultural specificities. In Hunt's festival, the abundant array of visibly different theatre forms presented for specular consumption by implicitly Western viewers risked authorizing the image of Asia as *spectacle*. Reviews of the Asian performances confirm the predominance of this kind of interpretive response. While critics used superlatives such as 'exquisite', 'mesmerizing' and 'magical' to describe many of the shows and, as in previous festivals, lauded the complexity and finesse of Asian performing cultures, they largely confined their comments to matters of synaesthetic – particularly visual – appeal. Pamela Payne argues that these works were a privilege to witness and evoked 'wonderment and awe' but elicited a form of passive consumption 'from an elite distance'. For Payne, watching kyogen was not dissimilar to observing 'a particularly illuminating demonstration-lecture': 'But so inaccessible are its cultural cues that as a piece of theatre it is never wholly engaging'. Similarly, she describes the wayang kulit as 'entrancing' but argues that poor deployment of the space for watching the dalang behind the screen emphasized the audience's role 'as observer of artistic tradition rather than as participant in living art' (Payne, 1994: 119). Thus, it appears that however laudable the intention, exposure to Asia per se was not sufficient for genuine cross-cultural engagement when the festival model lent itself to a form of cultural apprehension that, at best, amounted to a lesson in 'Asia literacy' and, at worse, reignited orientalism. Such orientalism also found expression in vehemently negative assessments of the festival as conveyed by critics such as Peter Goers: '[It] will sink without a trace. It was a bonsai festival; stunted, spindly, flimsy, rooted, retentive' (1994b: 11).

Not surprisingly, Asian reviewers sent to cover the festival were primarily interested in Asian Australian and indigenous works rather than the imported fare. Koh Buck Song reported to Singaporean readers that '[p]erhaps the most privately revealing of the *Asian* performances [was] *Sadness*, a monologue with slides by Australian Chinese William Yang' (1994: 5; emphasis added). It is pertinent that *Sadness* registered in this context as an Asian rather than an Australian, or better yet, Asian Australian performance. The absence of any reference to diaspora or transnationalism points to a certain conceptual paucity in the festival's

curatorial approach. Such concepts would have created a richer inter-
pretive foundation for reviewers and audiences alike, not only for enga-
ging with the works of Asian Australians as 'cultural bridges'[5] but also
for articulating more complex forms of cross-cultural relations between
Asia and Australia.

In his promotion of marginalized cultures from Aboriginal Australia
and the Asian-Pacific region, Hunt may have managed, on one level,
to fulfil his aim of creating a festival 'against prejudice of any kind'
(quoted in Bob Evans, 1993: 19). Ironically, the event nevertheless high-
lighted local prejudices, certainly against change and, in some cases,
against the perceived Asianization of Australia's festival culture. One
spectator complained, for instance, that the programme consisted of
'esoteric and generally incomprehensible items' and that 'the exag-
gerated accent on Asian content [had] arrogantly ignored the artistic
preferences of the many thousands who are more comfortable with a
Western/classical orientation' (Bisazza, 1994: 14). Although measures
were taken to enable non-traditional audiences (especially those from
non-Anglo-Celtic backgrounds) to access the arts – these included free
performances at various venues, balloted $10-tickets for the opening
session and allocations of low-cost seats at all events – attendances fell
considerably short of targets, reflecting the general reluctance of the
Adelaide public to embrace Hunt's pro-Asia vision. The resistance to
the festival from factions within the cultural elite, the media and the
community at large suggests that such 'top-down' approaches are not
the most effective way of implementing cultural change. While Hunt
may have been right in partly attributing low attendances to latent
racism,[6] he was also remiss in failing to develop points of access from
which the predominantly Anglo-Celtic audience could enter into a more
active engagement with the festival's particular version of internation-
alism. Clearly, saturating publications and the media with information
about the cultures represented was inadequate.

With hindsight, it is easy to identify aspects that Hunt should have
managed better. Grouping the Asian, Pacific and Aboriginal shows
together in the Open Roof and Amphitheatre programme resulted in
a cultural showcase resembling those produced for the tourist market;
this panorama of evanescent performances was not conducive to deeper
forms of cross-cultural communication. Despite his attempts at demo-
cratizing culture by bringing aesthetic forms perceived as foreign and/or
elitist to a wider audience, Hunt failed to consider community agency
and to develop effective outreach strategies such as mobilizing the
interest and support of local Asian Australians and/or Aborigines. The

festival did not encourage a sense of communal ownership and/or readiness to venture into unfamiliar cultural terrain and there were no events to encourage wide participation. This lack of groundwork in preparing the audience to engage with cultural difference led, in the most extreme case, to the blanket disavowal of the festival as being too 'heavy on the Soy sauce' (Goers, 1994a: 143).

Inevitably, the 1994 Festival revealed some of the complexities involved in Australian efforts to claim a place in the Asia-Pacific region by importing Asian-Pacific culture. Notwithstanding its strong pedagogical intent, the festival's representation of distinct cultures and art forms was communicated as an act of transparent assemblage. Francis Marravillas argues that it is precisely the invisibility of the curatorial subject behind such exhibitions that allows them to (re)produce and naturalize certain kinds of cross-cultural knowledge and, simultaneously, to obscure hierarchies of power and privilege subtending ideas about cultural difference (2004: 2). In this respect, the festival could not address one of the key hindrances to cross-cultural dialogue within the Asia-Pacific region: the (buried) colonial histories and current neo-imperial relations among its various constituents. In so far as Hunt's experiment demonstrated the possibilities and pitfalls of marketing cosmopolitanism within the panoramic logic of the festival model, perhaps its most salient lesson is that cross-cultural engagement takes time to develop and cannot be decreed by either political fiat or commercial forces.

It is significant that Hunt's successor for the 1996 Festival was the avant-garde Australian director, Barrie Kosky, who steered the event away from what he called 'geographic' concerns and returned it to its traditional 'international' foundations of largely well-known Euro-American works. Indigenous productions were noticeably absent from Kosky's programme and Asian content consisted largely of traditional musical performances, an avant-garde Japanese visual design piece by Molecular Theatre, and an intercultural Japanese–Australian production on environmental themes, *Red Sun – Red Earth*, written by John Romeril. That the overall programme was very well received in contrast to Hunt's 1994 effort suggests that a dose of 'soy' is acceptable so long as it does not dominate and *racialize* the flagship of Australian festival culture. Asian and Aboriginal contributions figured more prominently in the 1998 and 2000 Festivals under Robyn Archer's direction, though the overall focus remained decidedly Western. Along with the staple fare of traditional Asian performances, Archer programmed a select number of East–West and intra-Asian cross-cultural productions. The 2000 Festival

received special funding for the inclusion of international collaborations and new commissions, which led to productions such as Nigel Jamieson's *The Theft of Sita* and Ong Keng Sen's *Desdemona*, each in its own way specifically designed for the cosmopolitan audiences of the festival circuit.

The appointment of eminent American theatre and opera director Peter Sellars to head the 2002 Festival was hailed as an inspired choice by the media since his international reputation would surely enhance the event's status as a major player in the global arts market. Sellars took an innovative approach, aiming to internationalize the festival by focusing on indigenous and community arts, areas often marginalized in high-arts festivals. As his chief executive officer, and later replacement, Sue Nattrass claimed, '[i]n the past, the Festival brought the unattainable to our shores This Festival is set to reverse old trends, taking indigenous art to Australians, then outside Australia' (quoted in Owens, 2002: 41). This was a radical change in direction for the festival and entailed a completely different form of management based on the principles of collaboration and power sharing.[7] Sellars developed a programme that addressed the themes of 'Right to Cultural Diversity', 'Truth and Reconciliation' and 'Ecological Sustainability'. Of the three themes, 'Truth and Reconciliation' was privileged in the promotional material and attracted the most media attention, to the extent that the event became known as the 'reconciliation-themed' festival. With this focus, Sellars was not only building on the growing national prominence of indigenous culture but also on its international status, as reflected by events such as the 1997 Festival of the Dreaming and the Olympics Opening and Closing Ceremonies.

This change of direction was enthusiastically supported by the Festival Board and most of the media, at least at the outset, but major problems soon emerged. Among these included poor management of the community consultation process, which left many community and arts organizations disenfranchised from the festival, significant budgetary constraints and instability within the management structure. This led to a smaller festival than was initially planned, running over ten rather than the usual 17 days. By the time the festival was launched in October 2001, there was 'a general feeling of negativity from both the arts community and the media ... because the programme, after all the preceding hype, was very limited in scope and content' (Caust, 2004: 111). Sellars was asked to widen the content but not given additional funds to do so; he resigned as director two weeks later and Nattrass took on his role with the brief to broaden the event's public appeal. To this

end, she scheduled solo performances such as Broadway legend Barbara Cook's *Mostly Sondheim*, B. J. Ward's *Stand Up Opera* and shows by Nick Cave and satirist Max Gillies. Although media reportage was positive, these additions did not prove to be major crowd pullers.

While the presence of indigenous culture had been growing in recent festivals, the 2002 event gave Aboriginal communities their first opportunity to have direct input into the programming of indigenous events via advisory committees and associate festival directors. The opening ceremony, *Kaurna Palti Meyunna*, organized by the local Kaurna people, remains one of the highlights of the festival and exemplifies Sellars's philosophy of promoting reconciliation and community participation. It was the first major Kaurna corroboree in a century and reported to be the first such ceremony in a southern capital city in living memory. The event brought together indigenous communities from around Australia, Aotearoa/New Zealand, South Africa, New Mexico and Tibet. Starting from four city squares in Adelaide, processions of indigenous people, schoolchildren and local residents walked to Tandanyungga (Victoria Square) in the heart of the city, where a huge fire was lit and surrounded by concentric rings of local, distant and overseas Aborigines. The evening concluded with music, dancing and storytelling by Aboriginal elders and performers. Susan Archdall, among other reviewers, registered the ceremony as a celebration of indigeneity and an acknowledgement of colonial history: 'This is a real attempt to get the protocol right, to have the Kaurna people welcome us to their land. In doing so they won't be rewriting or erasing any past wrongs – it's too late for that – but paving the way for reconciliation, understanding and respect' (2002: 8).

Tandanyungga became the symbolic centre of the festival with a programme of free events that explored the theme of home and land. Featured performers included the Gyuto Monks of Tibet, who were accompanied by Aboriginal dancers from Anangu Pitjantjatjara, a Cambodian children's choir, Zuni dancers from New Mexico and African world music star, Toumani Diabate. Among Australian indigenous highlights of the festival's performing arts programme were Black Swan Theatre's *The Career Highlights of Mamu*, Bangarra's *Skin* and Red Dust Theatre's debut production, *Train Dancing*. These productions generally elicited positive reviews and were noted for their significance in raising the profile of indigenous culture in general. The praise mostly focused on the political and moral value of the stories/themes dramatized while the criticisms were largely directed at production values.

The Career Highlights of Mamu, a multimedia performance written by Scott Rankin and Trevor Jamieson, dramatized the Spinifex people's

enforced movement in the 1950s from their traditional country around Maralinga, South Australia, to Kalgoolie in Western Australia because of atomic testing. The production also pointed to an international history of nuclear devastation by paralleling Maralinga with Hiroshima. Performed by three generations from Jamieson's family, who are all Spinifex people and (excepting Jamieson himself) were untrained as actors, the show was praised for its 'anti-theatricality' and the performers' authenticity in rendering 'living history', but criticized for its lack of narrative focus and fluency (Bramwell, 2002: 15; Eccles, 2002a: 5). *Skin* was widely applauded as a compelling drama and eloquent dance exploring the challenges facing indigenous communities in responding to problems brought on by the incursion of modern Western values and practices. Seen as more overtly political and theatrical than Bangarra's earlier works, it was also noted for its ease in navigating different cultures/choreographies. *Train Dancing*, a Nattrass addition to the programme, deployed a blend of metaphor, poetry and song to explore black–white relations in Mparntwe (Alice Springs). Jeremy Eccles described the production as 'a rich brew ... poised to explode' but found the narrative unable to hold the action and felt the cast failed to deliver the complexities of the script (2002b: 6).

The issue of reconciliation implicit in these works also informed an exhibition of Aboriginal visual art[8] and the festival's film programme, which featured four specially commissioned Australian offerings – *Beneath Clouds*, *The Tracker*, *Australian Rules*, and *Kabbarli* – focusing on indigenous themes. The only 'Asian' theatre production featured in the 2002 Festival, William Yang's *Shadows*, explored the legacy of Aboriginal dispossession in Australia alongside aspects of the Jewish holocaust and the internment of German immigrants in South Australia during the World War II. Yang's Chinese-Australian ethnicity was perceived by critics as an important intertext in highlighting a common history of alienation among Aboriginal and migrant Australians; thus, the text was seen to fit 'the Adelaide Festival's reconciliatory theme perfectly', throwing 'new and urgent light on Australia's need for unification' (Thomson, 2002: 6).

The major non-Aboriginal highlight of the festival was the contemporary opera *El Nino*. Composed by American John Adams and directed by Sellars, the production was seen to exemplify Sellars's overall festival concept of community and cultural interaction with an emphasis on reconciliation and storytelling. Community theatre, the other principal focus in 2002, was designed to engage with issues of cultural diversity and develop arts activism. In a direct challenge to the festival's history

of cultural elitism, marginalized communities were encouraged to envision themselves through the arts with the help of professional cultural workers. In contrast to Christopher Hunt's 'top-down' approach to reorienting the festival, which we described earlier as an attempt to democratize culture, the Sellars/Nattrass approach was closer to the concept of cultural democracy, which mobilizes local communities at the grassroots level as both producers and receivers of culture. This form of cultural activism is deployed as an oppositional practice intended to subvert the paradigmatic modes of interaction that render festival audiences as passive consumers of an imposed cultural product.[9] The most impressive work achieved in this programme was Urban Theatre Projects' collaboration with local youths in the Parks Community Centre, which resulted in two productions, *The Cement Garage* and *The Longest Night*, using dynamic performance vocabularies to communicate social disadvantage. Most of the community productions were staged in non-traditional venues in the suburbs where the participants were located. As a result, these projects were not particularly visible to the media, visiting arts enthusiasts or the community at large, which led to accusations that the festival was less substantial than usual (Caust, 2004: 112).

Despite, and because of, the radical political, cultural and structural changes to its programming, the 2002 Festival ran into deficit due to lower than expected ticket sales. The controversy over Sellars's management approach had resulted in some highly adverse publicity that undoubtedly affected audience numbers.[10] Nevertheless, the festival presented a significant challenge to the conventional way of organizing such large-scale multi-arts events and Sellars's desire to embrace the indigenous community in the process and outcomes of the festival succeeded in many ways. The opening ceremony, the performing arts programme and the film showcase contributed substantially to raising the profile of Aboriginal artists and cultures, both nationally and internationally. This increase in visibility coincided with growing interest and support for indigenous arts and culture within the wider community and may have indirectly contributed to the appointment of Stephen Page as the first indigenous artistic director of the Adelaide Festival for 2004.

From the very beginning of his appointment, Stephen Page worked to reassure the festival faithful that he would deliver a 'global party' and that they would not 'get a world indigenous festival' from him (quoted in McDonald, 2002: 6). Page was a particularly apt choice after the so-called 'Peter Sellars Experience' since he was not only Australian but also had an established reputation as an artist with a strong sense of

integrity and community spirit. He admitted that he faced a challenge in coming after Sellars in so far as '[i]t felt like many people had been wounded' (quoted in Strahle, 2003: M11). While he admired Sellars's work and considered the 2002 Festival to be one of the most cutting-edge events he had attended, Page's curatorial strategy was more diplomatic even if he saw his programme as 'complementing what [Sellars] was innocently disturbing' (quoted in Bramwell, 2003). Page used the term 'the medicine of art' repeatedly to describe his approach, which was steeped in Aboriginal culture; his aim was to present a festival that was 'strong and grounded, but with a spirit to heal and inspire' (quoted in Debelle, 2003: 6). In the wake of the Sellars controversy, the 2004 Festival was scrutinized more closely than usual and Page needed to invest considerable time to regain the trust and support of the Festival Board, corporate sponsors and traditional festival-goers. This task was made all the more challenging with major infrastructural change occurring within the organization and a significantly smaller operating budget than that given to previous festivals.

Page made the strategic choice of returning to the traditional formula of showcasing international works supplemented by Australian offerings. By all accounts, the 2004 Festival was a conservative programme that reverted to the customary 17-day run. According to Page, the aim was to 'do everything – Aboriginal content, a bit for the conservatives, a bit for the crazies, a bit of circus. A universal smorgasbord' (quoted in Fitzgerald, 2004: 58). The performing arts segment was dominated by European and North American productions by companies such as CanStage (Toronto), Forced Entertainment (Britain), La Carniceria Teatro (Madrid) and Daredevil Opera Company (New York), to name just a few. Notable non-Aboriginal performances in the Australian selection included the premiere stage adaptation of Robert Dessaix's philosophical meditation on illness, *Night Letters*, and Circus Oz's *The Big, Big Top Show*. Although the indigenous component was small relative to the Western cultural forms represented at the festival, it attracted the most critical attention. In part, the festival's indigeneity was strongly felt because Page had taken the unprecedented step of collaborating with the Fringe Festival to present a joint indigenous programme titled 'Talk'n Up Country', which included major productions such as the Awakening Ceremony, David Gulpilil's eponymous one-man show and Windmill Performing Arts' site-specific work about river ecologies, *RiverlanD*. There were also visual art exhibitions, an Aboriginal film series, performances by the Pitjantjatjara Choir,[11] popular music concerts and free workshops with leading Aboriginal artists. A separate booklet listing

all the Talk'n Up Country events added to the impression of a robust Aboriginal presence at the festival.

Page's 'universal smorgasbord' met with general approval from the media and critics alike as a rounded, if cautious, event with a suitable quotient of international works. The indigenous programme was praised as vibrant, strong and deftly integrated. Eccles remarks: 'despite his efforts to play down the Indigenous core of the festival, Stephen Page has created a fascinatingly non-prescriptive mix. His only agenda seems to be to make an Aboriginal and Torres Strait Islander presence seem entirely normal' (2004: 29). While previous directors such as Hunt and Sellars paved the way by incorporating indigenous arts into the main framework of the festival, Page's achievement was in *normalizing* Aboriginal culture as foundational to Australian culture. Rather than being displayed as exotica, Aboriginal art forms were presented as diverse and dynamic expressions of mainstream contemporary Australia. More significantly, this normalization was achieved through the reterritorialization of the festival's traditional Eurocentric frames of reference. Although the content of the 2004 programme may have been conservative, Page radicalized the significance of the festival by framing it within a distinctly Aboriginal sensibility and spirituality: 'The indigenous content is the serpent that holds the mainstream content in there' (quoted in Plane, 2004: 14). This reterritorialization was not antagonistic or overtly oppositional; rather, Page preferred to work in more 'organic' ways by appealing to common desires for health, wellbeing and communitas. Thus, much of the rhetoric surrounding the festival was couched in terms of healing and nurturing, and promotional material regularly cited Page's belief in the curative potential of the arts for indigenous and non-indigenous peoples alike, and his desire to return a 'sense of spirit' to the nation's leading festival.

To this end, the Awakening Ceremony that marked the festival's beginning was a particularly important event, bringing together 500 members from the three indigenous communities in the region – Kaurna, Narrungga and Ngarrindjeri – to light a fire set along the banks of the Torrens River near the city centre. Symbolically, this ceremony was designed to reawaken the spirit ancestors, ignite the energies of contemporary indigenous groups and cleanse the site to shape a healthier future for generations to come.[12] Among the strengths that Page brought to the festival were protocols developed at Bangarra Dance Theatre for bringing traditional art practices into contemporary domains in ways that promote critical engagement rather than cultural objectification (Fitzgerald, 2004: 58). The Sacred Symposium illustrates

this point. Focused on the question, 'Is art good medicine for recon-
ciliation?', the blurb for the event reads thus: 'As urban, rural, and
remote Indigenous peoples, how do *we* continue to maintain tradi-
tion through contemporary art practice, while retaining ownership
and gaining economic sustainability? How do *we* preserve and protect
our sacred artistic kinship?'[13] It is significant that both the speaking
subject and assumed audience/reader are addressed as Aboriginal even
though the event was open to all and, indeed, attracted a predomin-
antly white audience. This authoritative cultural and racial positioning
of Aboriginal subjects constitutes a marked shift from the festival's
earlier methods of representing indigenous culture and subjectivities
as Other. *Body Dreaming* provides another example of how Page was
able to frame performances in ways that enabled audiences to engage
with Aboriginal culture without fetishizing it. The production, billed
as a 'sacred commission', was conceived and directed by Banduk
Marika and Djakapurra Munyarryun as an expression of the diversity of
their north-west Arnhem Land clans. Body-painting, initiation rituals
and men's ceremonies were enacted as process rather than product
outdoors on a red-dirt stage at dusk. Michael Fitzgerald described the
event as 'a show more organic than organized' requiring the non-
Aboriginal audience to 'leav[e] behind the assumptions of Western
theatre' and simply apprehend the rituals created on their own terms
(2004: 58).

One of the most eagerly anticipated events was the premiere of *Gulpilil*,
performed and co-written[14] by the internationally acclaimed film actor
himself. Directed by Neil Armfield, the production explored Gulpilil's
life between two physical and conceptual spaces: the bush of his Arnhem
Land home and the commercial world of the cinema. For Keith Gallasch,
the production was 'enriched by its improvisational qualities with a
tone that [was] both remarkably relaxed but also curiously volatile'
(2004a: 14). Once again, the performance was designed to heighten
active cross-cultural communication as well as awareness of that
process:

> [Gulpilil] is not an actor who assumes an automatic contract between
> performer and audience: addressing us directly, he wants to make
> that contract, remind us of it, hold us to it with a gentle but firm
> cajoling. ... We have to forget our theatre manners and let him know
> we're ready to go croc hunting with him, read English for him. ... *He
> wants to hear us. We want to hear him, and see him.*
>
> (Gallasch, 2004a: 14; emphasis added)

Gallasch's vivid account of the performance captures the dynamism of the performer–audience interaction; there is no opportunity here for the passive consumption of Otherness. The show drew attention to cultural differences and power asymmetries between performer and spectator, and both parties were required to work towards keeping the perform- ance alive and lively. This form of active engagement seems to have enhanced identification with the indigenous subject. The performances ended with standing ovations and, in Gallasch's view, 'there was the sense that audience and performer were at one' (2004: 27).

Bangarra's triple bill featured Page's choreography in *Rush*, which explored themes of drug dependency, the Stolen Generations and institutionalism; and Frances Ring's creation, *Unaipon*, a celebration of the life of Aboriginal scientist and philosopher, David Unaipon. A common thread in reviews of both works was admiration for Bangarra's ability to reconcile indigenous and Western cultures and worldviews without simplifying or erasing the significant challenges that indigenous communities continue to face. The third section of the bill entailed the performance of *Kabar, Kabur*, an observation of Indonesian political life by dancer and choreographer, Mugiyono Kasido. The only Asian offering in the 2004 Festival, the performance was significant not only for rendering a startling vision of political dystopia but also for forging cross-cultural connections. Critics were keenly aware of the Indonesian context: 'The struggle to stay harmonious rests in brief moments of indi- genous Indonesian stances reminding us of a mature culture subsisting under duress' (Omand, 2004: 30).

By all accounts, the 2004 Festival restored administrative accountab- ility, box-office stability and popular support for the Adelaide Festival organization. For the first time in almost a decade, the incoming director for the next festival, Brett Sheehy, was handed a surplus budget. Despite the conservative move to return to a largely Euro-American repertoire, Page's festival is notable for the ways in which it reinvigorated the event with an Aboriginal sensibility that was not 'tacked on' but rather developed as an intrinsic part of the curatorial vision. In a radical depar- ture from previous practice, the 2004 Festival distinguished itself by making visible its curatorial positioning within a contemporary urban Aboriginal imaginary. This had a major impact not only on the recep- tion of specific indigenous productions, as discussed above, but also on perceptions of the festival as a whole. According to South Australian Premier, Mike Rann, the event was 'a shining example, internation- ally, of reconciliation' (quoted in Plane, 2004: 14). Page's conciliatory 'medicine of art' approach apparently found the right balance in mixing

indigenous culture and politics with art so as not to alienate the mainstream and/or the more conservative sections of the festival community. By strategically placing Aboriginal culture at the core of the festival but retaining its 'internationalism', Page was able to introduce groundbreaking changes to the curatorial imaginary by trading on the growing international interest in indigenous art forms. The comparative absence of Asian performances was also indicative of a larger political and cultural milieu in which Asian engagement was no longer considered a national priority.

While other major Australian arts festivals in Sydney, Perth and Melbourne have a track record of including some Asian and Aboriginal productions in their annual programming since the 1980s, the Adelaide Festival is distinctive for experimenting with the overt marketing of Asian and Aboriginal cultures through its choice of directors and/or curatorial focus. Our study shows that Asian content has been a regular feature of the Adelaide Festival since its inception, reaching a highpoint in 1994. Despite some disquiet from sections of the community about the prominence of Asia that year, Asian art forms continued to feature up to the 2000 Festival. By 2002 however, they took a backseat to Aboriginal works, which, till then, had featured less frequently in the festival's conception of cosmopolitanism. Clearly, there is a close connection between major arts festival programming and wider political, economic and cultural forces. The prominence of Asian productions at the Adelaide Festival, especially in the late 1980s and 1990s, reflects the privileging of Asia enmeshment within official discourse at the time, whereas the emergence of Aboriginal productions from the late 1990s onwards is indicative of the rising market value of Aboriginal culture in the international arts market today. The popularity of Aboriginal performances in recent festivals in Singapore, Tokyo and Europe suggests that indigenous culture will become increasing important as a signifier of Australia's cosmopolitan identity. Analysis of the Adelaide Festival also demonstrates that while market value affects patterns of curatorial display and cross-cultural consumption, the (elite) Australian imaginary is still largely Eurocentric: incursions by Asian and/or Aboriginal cultures appear to be acceptable when the *status quo* is reassured that its interests are protected and enhanced.

5
Crossing Cultures: Case Studies

Thus far, the parallel processes of indigenizing and Asianizing Australian theatre have been broadly delineated in terms of patterns of occurrence and political influences. We have attempted in this survey to identify the key elements of each process as well as some of the motifs and problematics of cross-cultural theatre praxis in the Australasian region. As suggested, these developments must be understood not only with reference to Australian cultural politics but also within the context of a global arts market, the impact of which is refracted and reflected through localized modes and conditions of production and consumption. The following three case studies are designed to provide a more nuanced investigation of selected aspects of this aesthetic 'glocalization'. The first explores indigenous refigurings of European canonical theatre texts that assume metropolitan body cultures and aesthetic systems, while the second analyses the ways in which a 'classic' Australian play has been progressively reinterpreted and stylistically hybridized to reflect changing dynamics in Australian–Japanese relations. The final case study investigates the incorporation of the internationally acclaimed Suzuki Method into the training regimes and performances of two avant-garde theatre groups. Cumulatively, these case studies demonstrate the ways in which global–local forces intersect with cosmopolitanism to produce art forms and practices invested with particular cultural and economic values.

Aboriginal body cultures and the canonical stage

Two evocative colour photographs featuring Aboriginal actors in separate productions of *The Tempest* adorn the covers of John Golder and Richard Madelaine's recently edited critical anthology, *O Brave New*

World: Two Centuries of Shakespeare on the Australian Stage (2001). On the front cover, Rachel Maza as Miranda, dressed in virginal white, sits beside Prospero in a relaxed, intimate pose, perhaps observing the wedding masque; on the back, Margaret Harvey as Ariel attempts to wrest a staff from Prospero's hands as he threatens a kneeling Caliban, played by Glenn Shea. Neither of the pictured productions, the first directed by Jim Sharman for Bell Shakespeare Company in 1997 and the second by Simon Phillips for Queensland Theatre Company in 1999, nor any other productions of Shakespeare's plays that have featured Aboriginal actors, scores more than a one-line mention in the book itself. At its crudest level, this anomaly merely confirms a broader national tendency to cash in on the premium commodity status of Aboriginality, which, in this instance, signals not just Australianness but also the sense of 'innovation within the limits of tradition' that is so often a common selling point for contemporary versions of classical texts worldwide (Bennett, 1996: 19). More elliptically, the gap between what the book's cover promises and what its contents deliver – a rather 'whitewashed' account of the ways in which Australian national identity has been played out in theatrical terms in tension with the mobile cultural apparatus we now call simply 'Shakespeare' – suggests a troubling aporia about the possible functions of indigeneity within local interpretations of the European theatrical canon, itself an important entry point into the international realm of contemporary cosmopolitan arts culture. Elizabeth Schafer has recently canvassed this topic with reference to symbolic relations between Aboriginal and Anglo-Celtic cultures, arguing that 'Shakespeare has provided Australian theatre with a useful space in which to dream of reconciliation' (63), while other scholars have amplified her research via accounts of the rehearsal processes, interpretive choices and critical reception of specific Shakespeare productions (Tweg, 2004; Cox, 2004a and 2004b). Our particular analysis of Shakespeare's indigenization on Australian stages over the last two decades situates this phenomenon within a broader and perhaps more speculative inquiry into the mechanics and effects of casting Aboriginal actors in mainstage productions of canonical texts, whether in racially marked roles or those originally (un)marked as 'white'. We also link this praxis of cross-cultural embodiment to issues of corporeal inscription and bodily mobility within the nation's performing arts industry.

Despite the increasing visibility of indigenous performers in theatre, film and television in recent years, a strictly colour-blind approach to casting remains rare, especially for the 'bread and butter' repertoire of European 'classics' regularly staged in mainstream venues, even though

many companies employ Aboriginal (and other minority) actors in such productions and have explicit policies to ensure their equal access to a range of roles. Most often, when indigenous actors are cast in non-indigenous roles, the purpose is political or interpretive, which, in our view, constitutes a less-conservative practice than colour-blind casting since the latter, used uncritically, can subsume corporeal differences into normative modes of (realist) representation or, alternatively, give the appearance of pluralism without necessarily confronting the hegemony of the dominant culture. As W. B. Worthen argues, '[r]ace-blind casting echoes the antinomies of global capital: it tends to be "blind" only to "raced" actors, since as far as "white" actors are concerned, there is nothing to be blind *to*. In this sense race-blind casting often confirms the structures of race and nation that it claims to transcend' (2003: 119). In so far as such structures inform Australian performance practice, Aboriginal actors in cross-cast roles tend to be caught between ideological and/or artistic imperatives to express their cultural specificities and career aspirations to be recognized as simply artists with skills to match those of their non-indigenous peers, a dilemma complicated by the sense that audiences will likely read markers of indigeneity into the overall stage picture, 'seeking out relevance, resonance and meaning' (Enoch, 2000: 353).

Jon Erikson's explanation of embodiment, as a dynamic theatrical process, helps to unpack the complexities that attach to interpretations of casting choices:

> The problem of the body in performance is a two-fold one: when the intention is to present the body itself as flesh, as corporeality ... it remains a sign nonetheless ... not *enough* of a pure corpus. When the intention is to present the performer's body as primarily a sign, idea, or representation, corporeality always intervenes, and it is *too much* of a body.
>
> (1990: 242)

What this implies for our purposes is that indigenous bodies signify, paradoxically, as both *pre*-formed and *per*formed (Western); while possessed of certain degrees of interpretive mobility on stage, they can seldom be reduced to signs of free connotation. Moreover, as Rustom Bharucha reminds us, '[t]he body culture of any actor cannot be separated from the history in which it is placed and the larger processes of politicization to which it is compelled to submit *and resist*' (1993: 245). In Australia, as outlined in our earlier chapters, these historical and

political processes have included both the abjection of Aboriginal bodies as indubitably Other and their exoticization as commodity capital, as well as more reciprocal – and ethical – cross-cultural transactions. Performance praxis adds another layer to this historical conception of Aboriginal actors' body cultures in so far as it has reflected and refracted broader social processes, leaving its own perdurable legacy of racial and social accretions to be (re)negotiated.

In the hands of non-Aboriginal directors, the incorporation of Aboriginal body cultures into canonical productions via non-traditional casting has mostly been part of a broader effort to localize received texts and their associated performance conventions. Such localization can inhere primarily in performative style, as demonstrated by John Bell's sustained attempts to develop a specifically Australian approach to Shakespeare that emphasizes 'vitality, energy and openness' in performance while remaining close to the 'original' texts (Bell, quoted in Voumard, 1993: 24). Whether intentionally or not, this preoccupation with style has sometimes flattened the potential significations of Aboriginal actors – a case in point is Deborah Mailman as Cordelia in Bell Shakespeare Company's 1998 avant-garde version of *King Lear*, directed by Barrie Kosky – and/or enlisted their energies to the apparently vitalizing force of Australian multiculturalism, on which the company periodically draws. Its 1997 *Tempest*, featuring Maza as mentioned above, seems to have operated in this latter mode, drawing praise from one critic as having given 'lightness, brightness and richness' to Shakespeare 'with a multicultural cast' (Matheson, 1997: 98). The production, which read the play as a carnivalesque tale of revenge and forgiveness laced with intergenerational family conflict, registered favourably among other reviewers as modern, youthful, sexy, comic and palpably physical.

Black Swan Theatre Company has also staged versions of canonical texts that draw on Aboriginal body cultures to localize the production at hand, though such ventures have produced Australianness more through character and setting than through performative style per se. In this respect, Black Swan's casting has been less colour-blind than loosely interpretive and thus more likely to engage critical debate. Andrew Ross's multicultural *Twelfth Night* (1991), the company's inaugural production, seems to have taken this tack, eliciting general approbation for its local colour/atmosphere but a degree of unease about its specific depictions of Aboriginality and Asianness. In conjunction with a stylized set that relocated Illyria to northern Australia by dint of a colour palette of iridescent ochres and blues, corrugated iron architecture with a visible Asian influence, and a bulbous boab tree flanked by tropical water pools,

the production featured Aboriginal actors Stephen Albert as Sir Toby, John Moore as Antonio and Kelton Pell in multiple roles, as well as non-indigenous performers with Polish, Chinese and Anglo-Australian backgrounds. The visual look of this *Twelfth Night*, reminiscent of *Bran Nue Dae* in its iconography (and created by the same designer, Robert Juniper), set the scene for Aboriginality to resonate in familiar ways, notably as the indigenizing element of the multicultural mix interpreted by several reviewers as distinctly Australian *and* cosmopolitan. Interestingly, while most commentators delighted in the visual embodiment of this local cosmopolitanism, several criticized the mixture of accents and verbal styles it seemed to produce, which reminds us of the normative force of the Shakespearean text in delineating the cosmopolitan actor from his/her provincial counterpart, particularly in the erstwhile British colonies. Among the few reviewers who expressed reservations about the approach to characterization, David Williams warned of the dangers of racial stereotypes – as elicited by an 'orientalist "Asian princess" and a brawling Aboriginal drunk' – and called for a more critical approach to non-traditional casting:

> What are the implications of a black Orsino, or of racially mixed lovers? Is the horror of miscegenation alive and kicking? Multicultural theatre must be a forum for undermining received ideas and re-writing the map of difference. If such theatre resists a politicised critical consciousness, it may slither into tokenism.
>
> (1991: 38)

It seems Williams's call for a reflective – and reflexive – multicultural praxis may have been heeded, if Black Swan's 2005 adaptation of *Uncle Vanya* is any indicator. Directed by Tom Gutteridge, this production utilized Ningali Lawford and fellow Noongar actor Heath Bergerson to draw suggestive parallels between the grind of peasant life in pre-revolutionary Russia and Aboriginal pastoral servitude, a theme integral to the larger transposition of Chekhov's restless middle-class landowners to colonial Australia, where they were reimagined as the turn-of-the-century squattocracy bemoaning their distance from the imperial metropolis of London. Reviews confirm that this strategy prompted some spectators to ponder land rights and indigenous sovereignty issues, even though the Aboriginalized roles were relatively minor.

Like Black Swan, Company B has regularly featured Aboriginal actors in non-indigenous roles as well as supporting a range of Aboriginal theatre initiatives. Artistic Director Neil Armfield prefers an interpretive

approach to non-traditional casting, arguing that Aboriginal performers can infuse contemporary productions of classical texts with a 'double reality': 'An actor's aboriginality can inform a story really wonderfully, and in that way no one is neutral and everyone brings a kind of cultural meaning into their presence on stage' (quoted in Holgate, 1999: 12). Armfield's 1999 version of *As You Like It*, which starred Deborah Mailman as Rosalind and Bob Maza as Duke Senior beside other Aboriginal actors in the minor roles of peasants Silvius and Phoebe, invited audiences to read the play's narrative of unjust banishment and eventual restitution through the lens of Australian reconciliation politics. Most reviewers commented on this issue – highlighted by a prominent 'Sorry' sewn on the clown Touchstone's beskirted backside – in terms that suggested a complex rather than stereotypical reading of Aboriginality. Arguably, by transforming the Forest of Arden into a suburban backyard rather than a more iconically 'indigenous' (outback) setting, the production avoided the trap of suturing Aboriginality to landscape, even while drawing on the body cultures of the indigenous actors to suggest their characters' connection with the land and to link the duke and his daughter's exile to the historical dispossession of Aboriginal Australians. Mailman's much lauded rendition of Rosalind cum Ganymede (masquerading as Rosalind) also complicated the text's finely wrought gender ambiguities by introducing cross-racial desire. This black female desire seems unusual in the wider international context of culturally inflected Shakespeare productions if Celia Daileader is correct when she asserts that the casting of black actors is characterized by 'Othellophilia', the foregrounding of the black *male* body in ways that index Othello's destructive lust for whiteness (2000). Cross-racial politics also 'troubled' *As You Like It*'s final reconciliation with an Aboriginal Rosalind positioned as the queer object of a range of desires: male, female, black and white (Schafer, 2003: 70).

These and other productions in which Aboriginal actors have been cast in canonical roles normally considered as white/neutral – Mailman's Katharina in *The Taming of the Shrew*, staged by Brisbane company La Boite in 1994, along with Kelton Pell's Lucky in Black Swan's *Waiting for Godot* (1993) also conformed to this model – have provoked little real controversy, instead being praised for their Australianness and their inclusiveness, as well as for their particular insights into cross-cultural relations. By contrast, the casting of indigenous performers in racialized roles such as Othello or Caliban has been much more contentious, eliciting bouquets from some reviewers for filtering the imperial politics of early modern England through an Australian postcolonial

perspective and brickbats from others for reinscribing racial stereotypes and/or compromising the aesthetics or thematics of the Shakespearean text. One Extra Company's 1989 dance version of *Othello*, directed by Kai Tai Chan and performed at Belvoir Street Theatre as part of Sydney's Carnivale, attracted precisely this range of responses. Chan cast Torres Strait Islander Kim Walker as Othello opposite Chrissie Parrot's white Desdemona, added an Aboriginal mimi spirit that connected Othello to his cultural roots and functioned as a conscience of sorts, and distributed the remaining roles among various members of One Extra's racially mixed ensemble. The narrative, played out in a contemporary corporate setting, was pared down considerably and choreographed to Verdi's music for the opera, *Otello*. Those impressed by Chan's adaptation focused on its complex portrait of multiculturalism, its sensitive probing of racial insecurity, its sustained thread of Aboriginality and its political daring in situating an Aboriginal in a position of power in Australian society (Hoad, 1989: 115; Eccles, 1989: 20). The production's detractors claimed it treated Aboriginal spirituality in a tokenist manner, perpetuated the myth of indigenous primitivity, burdened the text with ideology and faltered aesthetically, presenting 'a jarring symphony of discordant notes' (Shoubridge, 1989: 9; McGillick, 1989: 10). Many reviewers commended Walker for his mastery of European dance styles though one also lamented his lack of 'the ground-rooted power of a tribal dancer' (Eccles, 1989: 21). Collectively, these comments suggest the precariousness of grafting Aboriginality, itself a highly coded performative commodity in Australian theatre, to roles already (over)determined by the weight of imperial canonicity and continuously marked within a modern global culture of racialized Shakespeare production (Worthen, 2003: 121). In this instance, it seems Walker was expected to embody both traditional and contemporary Aboriginality, to portray Othello's (racial) demons without being tainted by them and to somehow evade semiotic capture within the given trajectory of Shakespeare's text.

Chan's experiment, seemingly the first to situate Aboriginal performers on the canonical stage in Australia,[1] may have polarized critics in part because of its novelty, although similarly mixed criticism dogged Simon Phillips's 'Reconciliation *Tempest*', thus far the most prominent Australian attempt to indigenize Shakespeare. This 1999 Brisbane production, remounted (with some cast changes) by Melbourne Theatre Company (MTC) in 2001 for the Centenary of Federation celebrations, presented *The Tempest* as an explicit account of the European colonization of indigenous Australia. As well as casting Koori Glenn Shea and Torres Strait Islander Margaret Harvey in the respective roles

of Caliban and Ariel, both interpreted in ways that enhanced the characters' agency within their enforced servitude, Phillips worked with cultural advisor Cheryl Buchanan and five performers of the Jagera Jarjum Aboriginal Dance Group to model the island spirits as traditional custodians of the land (see Figure 6). To some critics' ire, he also modified the play's final moments to stage a symbolic restitution of Aboriginal sovereignty: instead of closing with Prospero's ambiguous epilogue, the production sent all the colonists back to England and ended with an image of Ariel removing her corset (colonial yoke) and being cleansed of her whiteness by the island spirits. This closure was reviewed variously as a sleight of hand that traduced the text, an annoying inaccuracy in the Australian historical context and, conversely, a brave and satisfying gesture of reconciliation. The popular response to the production, in the immediacy of performance, seems to have been less equivocal since it received standing ovations on a number of occasions. This is undoubtedly linked to the felt urgency of the reconciliation project at that point and the public crisis of conscience engendered by the Howard Government's treatment of the Stolen Generations. In this context, Phillips's adaptation perhaps captured the 'spirit of the times', as James

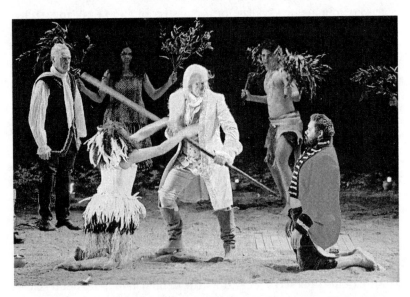

Figure 6 Ariel, Prospero and Caliban with Jagera Jarjum dancers in *The Tempest* directed by Simon Phillips, Queensland Theatre Company, 1999. (Photo: David Kelly)

Harper insists: 'True, Aboriginal magic could not overcome colonial aggression, the colonists never departed and have yet voluntarily to give up significant power. But the production does give a sense of how an act of reconciliation might feel, and of its moral necessity' (1999: 21).

The interpretive nuances of Phillips's production and the cross-cultural negotiations at issue in its rehearsal and performance processes are examined in depth in two scholarly articles that draw markedly different conclusions about the politics and aesthetics of this project. The main point of variance concerns Jagera Jarjum's role in the produc-tion as a choric presence and, particularly, the presentation of the group's ceremonial body culture within the framework of commercial theatre during the masque, enacted as an 'authentic' fire-making ritual. Emma Cox, writing with reference to the Brisbane production (which employed Wesley Enoch in a mediating role as associate director), argues that Jagera Jarjum's dancers 'were not silent functionaries of an Abori-ginal aesthetic' and that their ceremonial performance instantiated a productive 'dialogue with the Shakespearean text, effectively disrupting Eurocentric narrative and theatrical modes' (2004a: 87). Sue Tweg, focusing on the Melbourne version, maintains that the '[c]ompeting demands of a poetic play and a meaningful ritual' ultimately 'led to insuperable aesthetic collisions' (2004: 52) and that, despite all good intentions, Jagera Jarjum's performance was undermined by the 'unexorcisable spectre' of reification because it presented audiences with images of a historically framed rather than living indigenous culture (p. 51). Both critics remark on the reconciliatory ethos of the rehearsals and detail the protocols set up to guard against cultural appropriation, though Cox seems more confident than Tweg that these negotiated rules actually functioned to ensure indigenous authority with respect to representation. Taken in tandem, these assessments reflect the instability of indigenous body cultures on the canonical stage, where their perform-ance may heighten the tension between the body as sign and the body as corpus (in Erikson's formulation). When Aboriginal actors participate in the mimetic structures of Western theatre (here, to play Caliban and Ariel), they can be incorporated, if uncomfortably, into the interpretive repertoires aligned with that praxis. By contrast, indigenous ritual enact-ments performed within a commercial theatre production (as with Jagera Jarjum's fire ceremony) sit on the margins of two epistemologies – the sacred and the secular – that ideally activate different interpretive responses. In this context, it may be difficult to reconcile cross-cultural exchange with commodity consumption.

Whereas non-indigenous directors have generally cast Aboriginal actors to help localize canonical works – a process both nationalist in its endeavour to abrogate the authority of foreign imports and internationalist in its attempt to create distinctive products in a global market that trades in 'tradition + innovation' – indigenous directors seem more concerned with questions of access to power within a performing arts industry where canonical texts, particularly those of Shakespeare, have pronounced regulatory functions, both in terms of work opportunities and cultural profiles. Noel Tovey's 1997 all-Aboriginal *A Midsummer Night's Dream*, produced for the Sydney Theatre Company (STC) as part of the Festival of the Dreaming, demonstrates some of the intricacies of this situation. From the outset, Tovey made no bones about the fact that he intended to show, first and foremost, that 'Aboriginal people can act as well as anyone else' (quoted in McCallum, 1997: 14). This meant engaging with particular corporeal conventions, undergirded by the 'sense of vocal and bodily decorum [that] implicitly racializes Shakespearean acting' as *white* (Worthen, 2003: 119). Not surprisingly, given that he aimed to prove the calibre of Aboriginal performers rather than his own directorial ingenuity, Tovey opted for a conservative staging of the text, transforming the Athenian woods into an Aboriginal dreamtime world with the aid of three-dimensional computer-generated images, but otherwise leaving the production's Aboriginality to speak for itself through the body cultures of the indigenous cast. This approach, together with pre-production publicity citing his determination to successfully stage a 'classic', tacitly invited reviewers to assess the show in normative terms.

On the matter of acting and interpretive standards, *A Midsummer Night's Dream* was not found wanting. James Waites opened his review by declaring that the all-Aboriginal cast had 'come up with as good a production, apart from a handful of world-class landmarks', as could be seen anywhere and that the 'comprehension, delivery [and] characterisation' were 'all finely honed' (1997a: 14). Other critics agreed that Tovey's stated aims had been amply fulfilled and John McCallum, with a nod to subscriber audiences, remarked that the rendition was 'respectful to a fault, with no hint of radical revision or overtly political intent' (1997: 14). In this respect, the Aboriginal actors were admitted to the international circle of cosmopolitan performers who have mastered classical (but not radical) Shakespeare; nevertheless, a number of reviewers expressed disappointment that Tovey had not taken the opportunity to offer a politicized interpretation of the text.[2] This criticism tended to be linked to remarks about authenticity, judged not in Shakespearean but in

'local' terms and focused in particular on the scenography, which some commentators found kitsch in its use of iconic images – the rainbow serpent and native flora and fauna – to indigenize the text.

Such responses possibly say less about the production itself than about the separate regimes of value within which Shakespeare and indigeneity normally circulate as distinct performance commodities. As a canonical work produced for the subscriber season of the state's flagship theatre company, *A Midsummer Night's Dream* needed to embody tradition while also adding value/innovation. Aboriginality, disciplined to fit the contours of the narrow range of bodily styles connected with Shakespearean performance, helped to fit the bill by providing a new face/mask beneath which the 'integrity' of the text and its associated stage traditions would be preserved. The proclamation, 'Shakespeare goes indigenous' (Horsburgh, 1996: 9), neatly captures this process of cultural drag. As a high-profile offering in an indigenous theatre showcase, however, Tovey's production was expected to do more than simply demonstrate the body mobilities of Aboriginal actors, particularly since the Festival of the Dreaming, discussed in Chapter 2, specifically aimed to present complex and contemporary representations of Aboriginality, a brief that conflicted, to some extent, with the recolonizing logic of Shakespeare as a cultural institution.[3] The festival's other indigenized canonical production, *Ngundalelah Godotgai/Waiting for Godot* faced fewer constraints since it was staged in a fringe venue and, in confronting Beckett rather than Shakespeare, was not burdened by the same weight of tradition. Moreover, translated into Bundjalung, the performance text explicitly resisted some of the expressive norms of its English/French counterpart. In this context, Beckett's alienated, homeless tramps were seen to provide more resonant prototypes for an exploration of modern Aboriginality.

If Tovey's all-Aboriginal Shakespeare raised the profile of indigenous practitioners within Australian theatre, it could do little to affect the hierarchies of value that continue to influence what kinds of cultural and political work can be achieved on the canonical stage. Wesley Enoch alludes to this issue in discussing his approach to *Romeo and Juliet*, which he directed for Bell Shakespeare Company in 1999 with a mixed cast of black and white actors representing the feuding Montague and Capulet families respectively.[4] Although he had previously questioned Tovey's motivation in using Shakespeare to prove the mettle of indigenous artists, Enoch accepted the commission, feeling it was something he should do as an Aboriginal director. In his view, although the reviews were largely positive, the project was compromised because

it did not excite his political or cultural interest and, having no clear idea of what he wanted to say, he treated the script – and the racial conflict overlaid on it – superficially. He also notes that the backstage work of cross-cultural negotiation among cast and crew was neglected while he grappled with the complexities of the text (2003). These comments should remind us that canonical works, despite their oft-vaunted universalism, do not necessarily speak to the experiences or interests of indigenous artists but may in fact be sites of estrangement: 'unfamiliar, seemingly unknowable, densely encoded and authored else-where' (Salter, 1996: 114). Moreover, the imbrication of such texts in the domain of global high culture produces certain axiological regularities that can function to normalize – or exclude – indigenous body cultures, not just in Australia but also in other colonized regions. In these circum-stances, the canonical stage remains a highly ambivalent, if productive, space for cross-cultural dialogue.

The Floating World – a cultural barometer

Dubbed an 'unruly masterpiece' by one prescient critic (Hutchinson, 1974: 14), John Romeril's pioneering work, *The Floating World*, hit the raw nerve of Australian xenophobia when it first appeared in 1974 at the Pram Factory in Melbourne. Few observers then could have imagined that more than two decades later this very play, despite (and because of) its controversial treatment of Australian–Japanese postwar relations, would form an integral part of the nation's then most significant cultural exchange with its former military enemy. That a text initially deemed racist in some circles has now distinguished itself as a malleable site for experimenting with racial representation and enacting complex forms of cross-cultural reconciliation suggests a particularly rich production history. We examine this history to determine how race/racism has been performatively coded by different directorial approaches to the play, and how various significations of Australian and Japanese cultures have been interpreted by the critical establishment. At a general level, we hope to establish some of the ways in which the fascinating stage history of *The Floating World* has acted as a barometer of Australian theatre's response to the challenge of representing cultural conflict, during a period marked by intense public debate about the desirability (and inevitability) of Australia's political, economic and cultural enmeshment with Asia.

One of the few local new-wave plays to be restaged periodically after its premiere, *The Floating World*, first produced by the avant-garde Australian Performing Group (APG), had early productions in Sydney,

Perth, Adelaide and Canberra in 1975, as well as in Brisbane in 1976. Most of these performances functioned to disseminate an innovative new work to audiences in the metropolitan centres, and so were styled to varying degrees after the APG's template, emulating its particular brand of boisterous, rough theatre staged in intimate fringe venues. By the early 1980s, however, the play had gained a sufficient reputation to attract more conservative theatre companies and the move from alternative to mainstream stages quickly demonstrated the necessity for genuine rein-terpretations. At this point, *The Floating World* had already received signi-ficant critical attention, was included in school and university curricula in some states, and had also scored a five-week run in Ottawa in 1979 after Romeril won the inaugural Australia–Canada Literary Prize. Major productions by the Melbourne Theatre Company (1982) and the Sydney Theatre Company (1986) subsequently strengthened the play's status as an Australian 'classic', a position confirmed in 1995 by the staging of separate, high-profile, experimental and collaborative versions at the Perth and Melbourne international festivals.

This impressive curriculum vitae in an industry notoriously uninter-ested in revisiting home-grown works suggests not only the perennial relevance of Romeril's script, but also its adaptability. In brief, its fugue-like narrative can be summarized as an epic account of an ex-soldier's mental breakdown some 20 years after his brutalizing experiences as a PoW at Changi during World War II. The context, and catalyst, for Les Harding's breakdown, which culminates in a very public display of personal trauma, is a Cherry Blossom Cruise to Japan that his wife, Irene, has won in a *Women's Weekly* competition. The particular setting of a refitted troopship staffed by various Asian personnel is integral to the play's form in so far as it enables flexible presentation of the shipboard entertainment rituals through which Les's prejudices, fears and delu-sions are revealed. Critical responses to *The Floating World* have tended to fall into one of three categories. Reading Les Harding as an antipodean Woyzeck, some commentators interpret the play as an intense drama about war's effect on the 'human condition'; others have responded more readily to its comic aspects, seen as part of a savage social satire of particular (gendered) forms of nationalist Australian identity. Altern-atively, reviewers who focus on Romeril's treatment of Japanese imper-ialism tend to cast the play as a study of national and regional politics. This tack highlights issues of cultural difference but has sometimes led to accusations that the text is merely a piece of anti-Japanese propaganda.

Notwithstanding its masterful evocation of human suffering, or the laudable critique of war and its characteristic atrocities, *The Floating*

World's longevity within Australian theatre circles rests to a large degree on its self-conscious theatricality. Elizabeth Webby's detailed analysis of the play's structural debt to the popular theatre conventions of vaudeville, music hall, army concerts and Barry Humphries-style sketches demonstrates quite convincingly that the form is a crucial part of the message. In this respect, the question of representation – be it centrally concerned with race or any other attribute – impinges on the ways in which both Asia/Asians *and* Australia/Australians are staged. And if the script seems to demand a performance less concerned with the product than the actual *processes* of representation as played out through specific theatrical devices, then it readily lends itself to differently politicized reinterpretations. Romeril facilitates this kind of interpretive work when he states in the published text that actors and directors are free to reshape his material to suit the particular artistic and social imperatives of their historical moment (1982: xxxiii).

Directed by Lindzee Smith, the 1974 premiere production of *The Floating World* played out some of the popular debates of a post-Vietnam era when official multiculturalism was in its infancy. Tom Burvill maintains that the play, and the APG's work more generally, should be read as 'symptomatic of a key national crisis of the time' in so far as it presented an 'unresolvable negotiation of identity [between] the potentially conflicting discourses of counter-racism, working-class masculinity, radical politics and opposition to economic imperialism' (1993: 91). Given this explosive mix of issues, it is not surprising that a few reviewers interpreted the protagonist's racism as tacitly approving rather than critiquing certain forms of Australian nationalism. Obviously, it is a risky strategy to stage racism, or any other kind of discrimination, on the assumption that audiences will naturally identify and deplore it; however, it seems that a number of the APG's specific production choices made this tactic not only workable but, in fact, appropriate for the times. First, the casting was very much in a non-naturalistic mode with Les Harding played by the young Bruce Spence, cast against age as well as physical type despite the fact that a more 'natural' fit could have been found in fellow APG member Peter Cummins, who played the Comic instead. Spence's own previous comedy work in Melbourne apparently magnified the sense of estrangement effected by this kind of casting since it had given him an 'actor's idiolect' distant from the expected voice/persona of an aging ex-PoW (Burvill, 1993: 89).[5] According to Burvill, the production thus 'foreground[ed] the sense of a Brechtian social "type" – an embodied social *gestus* – being constructed through the figure of Les' (1993: 89). To similar effect, the Malay Waiter,

a male, was played by Carol Porter, presumably raising questions about the performance of gender and sexuality when the Waiter makes a pass at Les's wife, Irene. Here, cross-gender and cross-race casting works against any temptation, on the part of the audience, to adopt Les's homogenizing view of Asia as he progressively mistakes the Waiter for a Japanese soldier.

Taken together, the APG's casting approaches to Les and the Waiter, who are in many senses the play's chief antagonists, facilitates critical engagement not only with Les's racism but also with the play's representations of race itself. The more interesting site of analysis in this respect is possibly not the racialized Asian, who is chiefly constructed through an ironic play of/on Western stereotypes, but rather the unmarked white Australian. That Les, as representative of this particular normative type, could be (self)fashioned – and successfully performed – in much the same manner as the Waiter, albeit using a different set of stereotypes, confirms the constructedness of both identities, which, in turn, begins to make whiteness visible as a racial category. There is evidence to suggest that this Brechtian mode of analytical characterization successfully negotiated the complex issues addressed by Romeril's text, since most reviewers of the APG production were able to read it as a carefully modulated critique of racism, while approving the play's depiction of Australia in a global context, and praising the actors for their vigorous and engaging performances (Robinson, 1974; Kendall, 1974). Perhaps not coincidentally, the following year's Nimrod production in Sydney, which cast Laurence Hodge as a 'better fit' in the leading role, was generally less well received and incited more controversy about its depictions of race/racism.

Second, critical response to the APG production suggests that Peter Corrigan's set design also played an important part in eliciting awareness of the processes of theatrical representation. Within the intimate, makeshift space of the Pram Factory, the stage and auditorium were surrounded by a green chicken-wire enclosure with a boat-like protuberance at one end and a curtained stage for the Comic at the other. This deliberately claustrophobic staging positioned viewers as fellow PoWs within Les's surreal nightmare, while also casting them as the complicit shipboard audience for the crude and often offensive entertainment rituals relished by Les and the Comic. At the functional level, the scenography was seen to brilliantly aid and abet the 'fluid narrative transformations from past to present' (Carroll, 1993: 48), but what many reviewers also stressed was their discomfort at being physically implicated in Les's xenophobic world. By comparison, when the MTC

eventually produced *The Floating World* at its main-stage Russell Street venue in 1982, reviewers complained that the mise-en-scène effectively kept audiences disengaged and that the play seemed dated. Such criticism is surely linked to the inevitable weakening of anti-naturalistic effects in the MTC's rather unimaginative revival. Leonard Glickfield pinpoints this problem in expressing disappointment that Romeril's text did not transpose well to a more conventional venue: 'Arena presupposes a circus. The proscenium predicates a photograph. The first postulates a free-wheeling world of fantasy, the second a world of structured, literal reality' (1982: 19).

The third element of theatricality contributing to the APG production's relatively successful treatment of the complex politics of Australian racism seems to have been the performative idiom. As a collective, the APG had developed a reputation for its strident use of (Anglo-)Australian vernacular language as part of an energetic, improvisational style that well suited *The Floating World*'s considerable reliance on localized popular-theatre routines. Arguably, this trademark style also offered the *only* appropriate way in which to characterize Les at the time, given that he is fashioned in the role of the Ocker, whose creation as the quintessential stage Australian for that historical moment owes no small debt to the work of the APG. Sexist, racist, patriotic, deliberately offensive and forever male, the ocker now seems a soft target for social critique; however, his inherent theatricality and distinctive Australian humour also gave him enormous appeal, especially for audiences tired of a diet of inherited British and American fare. What Romeril's play added to the Ocker figure was a certain depth of character by historicizing the origins of his aggressive nationalism. Understood as partly a response to the atrocities of war, Ockerism could take on grander proportions even while it remained vulgar and parochial. Hence Jim Davidson's comment that Romeril had done the impossible by writing 'a tragedy about an ocker' (1974: 445). In terms of our specific interest in the processes of cultural representation, it is the troubling incongruence between the sense of tragedy and the figure through which that tragedy is played out that maintains the Brechtian dialectic of a pleasurably engaged spectator who is not interpolated into ideology.

By the time Wayne Harrison and Richard Wherrett came to direct STC's production of *The Floating World* at the Opera House in 1986, there had been considerable developments within Australia in social attitudes and theatrical fashions as outlined in the previous chapters. Increasing acceptance of multiculturalism as part of the nation's social fabric coupled with the escalating interest in trade with Asia was seen

to have pushed the nationalist anxieties of the 1970s into the past and given way to a new cosmopolitanism that spoke to Australia's gradual redefinition within the Asia-Pacific region as a postcolonial nation. Fully aware that their work would be assessed by a more sophisticated and culturally literate audience than that of the APG, Harrison and Wherrett recognized the need for a genuine reinterpretation of Romeril's play. They were also keen to meet the challenge of successfully producing a small-scale, free-wheeling piece of rough theatre at a formal proscenium venue, as they felt that *The Floating World* had not yet been given an adequate mainstream staging. Harrison's detailed production notes reveal the mythopoeic impulse behind their project, which is specifically described as 'both an experiment and a search for a classic of the Australian stage' (1986: 1).

Working from the premise that the play is, in effect, 'an eccentric Tivoli variety bill', through which 'facets of Les Harding's social and political environment and mental state are seen' (Harrison, 1987: 505), Harrison and Wherrett sought a production concept that would communicate Romeril's themes while preserving the integrity of his work. They saw their task as 'twofold: a) to enlarge the work where necessary so that it fills its stage and expectations of that stage; and b) to alter the actor–audience relationship when possible to prevent the distancing "sleepy hollow" effect' (Harrison, 1986: 2). Elements of kabuki theatre were chosen to address both issues and, possibly, to work against the negative connotations of the ridiculous dippy birds, the cultural symbols used to signify Japanese economic imperialism in the text as written. Three kabuki demons, doubling as various members of the cruise-ship's staff, were incorporated into the cast of characters, primarily to amplify the reach of Les's madness by providing progressively visible evidence of his distorted reality. Harrison is careful to explain that the intention was not to suggest any historical link between kabuki and the PoW experience, but rather to develop a theatrical conceit whereby the appearance of the demons signalled a narrative transition into Les's private memories (1986: 3). At a more general level, the kabuki characters and performance techniques represented something of an alien number in the variety bill, juxtaposing a highly codified and formal mode of Japanese theatre to the raw, crass and informal entertainment routines that constitute the text's distinctively Australian brand of theatricality. To address the problem of bringing the audience into better proximity with the action than the venue's proxemics would normally allow, Harrison and Wherrett used another kabuki convention, the hanamichi, a walkway extending from the edge of the stage to the back of the auditorium. The primary

function of this walkway was to allow the Comic direct access to the audience, though it also served as an entry/exit passage for the demons at various points. Overall, the kabuki element seems to have been designed to supply a sense of the surreal without divorcing the audience from the spectacle. While the directorial approaches to other aspects of the production are not as clear, the casting to type of actors such as Ron Haddrick as Les and Anthony Wong as the Waiter[6] suggests a preference for some degree of naturalism.

The STC production received many critical plaudits, with particular praise reserved for the ways in which it had made the awkward and unfriendly stage of the Opera House's Drama Theatre work so well. Most commentators approved Harrison and Wherrett's efforts to mainstream the text by reinterpreting it through a more sophisticated performance aesthetic, with only a minority of dissenters complaining that the flashy production 'eviscerated' Romeril's politics (Hoad, 1986: 96; see also Webby, 1990: 38). Interestingly, the issue of Australian racism is never really canvassed in any of the reviews, despite the fact that only the more vulgar of Les's anti-Asian epithets were edited from the original script, nor is there much reference to the complex cultural tensions dramatized through Les's spectacular breakdown. Rather, the play was read as something of a tribute to an old digger whose prejudices did not register as the nation's own. What is troubling about these omissions is the prospect that the kabuki-inspired STC production, while seeming (and apparently being seen) to dilute the text's critique of Japanese culture, may have fallen into the trap of representing difference through precisely the same reductive dichotomy – the demonized versus the exoticized vision of Otherness – that is figured through the respective attitudes of Les and Irene Harding. In this respect, the production situated its Japanese theatre elements 'within the aesthetic exceptionalization of the other' that is recognized as a hallmark of orientalism (Karatani, 1998: 153). There is no evidence in the extensive production records of any significant discussion about the ways in which the kabuki concept impacted on issues of racial or cultural representation. Hence the question remains as to whether Harrison and Wherrett's bold experiment was less an attempt to engage with the conventions of a foreign performance culture than to demonstrate that the real innovators in Australian theatre had indeed taken on the new cosmopolitanism that marked middle-class urban society at the time.

In 1995, the fiftieth anniversary of the end of World War II, *The Floating World* was given two more major productions, both using popular Japanese puppetry forms, among other devices, to reinterpret

Romeril's text for their 1990s audiences. Given that the years since the STC version of the play had seen Australia strengthen its political, economic and cultural embrace of Asia as well as its involvement in cross-cultural performance work within the region, it is not surprising that both 1995 productions set out to assess, in their own ways, the complexities of the nation's enmeshment with Japan, taking the original script as a measure of 'how far we had come'. The first production, directed by Andrew Ross and jointly staged by Black Swan and the State Theatre Company of South Australia, opened at the Perth Festival early in the year and subsequently toured to Adelaide, Melbourne and Sydney, as well as several regional centres. Ross, wanting to heighten the surrealism of the play, assembled a culturally diverse team for his project, collaborating closely with Perth-based puppet master Noriko Nishimoto, Singaporean composer and sound designer Mark Chan, and other practitioners with extensive experience of non-Western perform- ance techniques. Of the production's many 'Oriental' touches, including shadow play and ghostly noh figures used as convenient stage hands, the chief innovation was a range of marionette puppets – a samurai, a Japanese prison camp commander, and miniature versions of the Hard- ings themselves – that served to punctuate Les's haunting memories and comment on various characters and actions. While these embellish- ments also risked presenting Asian performance traditions as a decor- ative foil in the manner of theatrical orientalism, critical responses suggest that, overall, the production was read in much more complex terms than STC's kabuki experiment. If a few reviewers objected to the surfeit of effects, others noted the irony of using Japanese theatre forms to express Australian anti-Japanese anguish, and many positioned the production as part of an ongoing dialogue about Asian–Australian politico-cultural relations.[7] Black Swan was also commended for ampli- fying its multicultural work, which, until that point, had focused on examining relations between white and black Australians. The more sophisticated reception of Ross's work seems to suggest at least two things: first, that the puppetry, extended to include marionettes of Australian types, lent itself more readily to interpretation as a flexible theatrical device rather than an indelible marker of cultural/racial differ- ence; and second, that the historical moment demanded a different kind of critical engagement with Japan and Japanese culture, one based less on remembrance than on postwar reconciliation.

The issue of reconciliation was also integral to the Japanese version of *The Floating World*, staged towards the end of 1995 at Playbox Theatre as part of a bilateral theatre exchange that saw Romeril's play and

an Australian production of Chikao Tanaka's *The Head of Mary*, about the nuclear aftermath in Nagasaki, performed in repertoire in both Melbourne and Tokyo. Directed by Makoto Sato, whose work with the avant-garde Black Tent theatre company has been much lauded in Japan, this *Floating World* adaptation featured a number of high-profile Japanese actors and included extensive puppetry work by the famous Yuki-za troupe drawing on 350-year-old traditions. For the Playbox season the text was performed in Japanese with English surtitles, and the overall exchange was marketed in the promotional flyers as a history-making event that took 'the first cultural step towards real understanding of the impact of World War Two on each particular nation'.

The various textual and interpretive changes in Sato's production are too numerous to detail here except in brief.[8] A new prologue situated a honeymoon couple and two corporate executives as modern-day Japanese visitors attempting to understand Australia through the lens of the tourist industry. This framing device set up an immediate parallel for Les and Irene Harding's adventure, pointing to the ways in which each nation is apt to stereotype the other. The most important adaptation was the use of bunraku puppets to play major characters – the Comic, the Waiter, the Ship's Officer, and straightman/narrator Harry – thereby shifting the focus back to the process of representation. A spectacular refractory effect occurred when these figures were manipulated by puppeteers dressed in exactly the same way and without their faces covered as in traditional bunraku. As a puppet, the Comic could extend his entertainment role by performing routines from Japanese folk theatre in lieu of some of the dirty jokes and limericks that would not translate easily for a Tokyo audience. The puppetry also clarified the Comic's function as ventriloquist for his society, confirming that racism is a communal rather than simply individual practice. In the case of the Waiter, the puppet concept was used primarily to solve the problem of how to differentiate the character racially from Les and Irene so that their anti-Asian stance towards him could be understood. A number of much smaller marionette puppets, used to striking visual effect, illustrated levels of psychological action, especially during the PoW camp sequences. In combination, the different puppet performances not only created unforgettable theatre but also demanded that the audience remain constantly aware of the interplay between the subject and the acts of framing and staging it – or, in other words, on theatricality itself.

The effect of having Japanese actors playing Les, Irene and their fellow Australian passenger, McLeod, equally raised audience engagement with

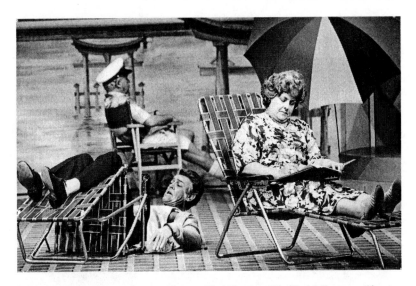

Figure 7 Quintessential Australians, *The Floating World*, Melbourne Theatre Company, 1982. (Photo: David Parker)

issues of representation (see Figures 7 and 8). A number of critics commented on the complex irony elicited by the cross-cultural casting and the unexpected ways in which it perversely highlighted elements of 'Australianness'; many also claimed that Les Harding had never been more moving. Spoken by a Japanese performer, his final harrowing monologue was seen as 'not just the cathartic outpouring of long pent-up horrors' but 'simultaneously a confession of complicity in a historical atrocity' (Thomson, 1995a: 21). Consequently, the overall project could be widely read as an act of atonement, with Les's closing words, 'I was well again', conveying a sense of healing. As one reviewer put it, the production 'is a gesture of breathtaking humanity and heroic nobility. It is worth 10,000 official apologies. The war, at last, is over' (Boyd, 1995: 38). Clearly Sato's approach had taken *The Floating World* well beyond its original polemics to better serve the discourses of rapprochement that have increasingly characterized Australia's relations with Japan over the last few decades. Even those who regarded the production as having limited appeal could still acknowledge its huge political and diplomatic import.

The Playbox production of *The Head of Mary* did not similarly impress Australian reviewers, though it was treated more kindly when considered as part of an effort towards cultural reciprocity rather than as merely

Figure 8 Japanese performers in *The Floating World*, directed by Makoto Sako, Melbourne International Festival of the Arts, 1995. (Photo: Hugh Hamilton)

a local offering in the Melbourne International Festival. Written in shingeki style, itself heavily influenced by modern Western theatre, this poetic, impressionistic play focuses on members of a minority Christian sect struggling to survive and reconcile their faith with the nuclear carnage they have witnessed. Director Aubrey Mellor chose to internationalize the text, filling the roles with a multiracial cast and setting the action in an unspecified landscape designed to evoke both iconic war zones (such as Dresden or Nagasaki) and a bleak post-apocalyptic future. While some critics found the text at best difficult and at worst impenetrable, most reserved their most trenchant criticism for the direction, citing its universalism and confusing multiculturalism as robbing the

story of historicity and specificity. Helen Thomson, in a more probing assessment of the production, also considers the problem of differences in cultural and artistic modelling between source and target partners in this intercultural experiment: 'The failure may be simply one of cultural untranslatability, of a text with a set of meanings unavailable to those unfamiliar with the culture as much as the language' (1995b: 15). It is pertinent to note in this respect that the Playbox version of *The Head of Mary* was well received at the Tokyo International Festival where it won the International Theatre Institute's Uchimura Award for initiatives in Japanese theatre by a foreign company. As enacted by a diverse range of Australians, the play was also embraced as a gesture of Western atonement for the bombing of Japan. By contrast, *The Floating World* proved more mystifying to Tokyo audiences and was not read especially as an admission of guilt on the part of the Japanese but rather a study of the common soldier's impotence to affect the course of political events (see Sawada, 1996: 14–17).

That the performance of each play by its cultural Others instantiated an interpretive discourse of reconciliation in the home country suggests that the intercultural model at the heart of the exchange, which Romeril characterized as being infused with 'justice and equity', was recognized as being part of the message (quoted in Hallett, 1995: 14). Clearly, audiences responded more readily to their own cultural texts rendered 'foreign' via stylistic and interpretive innovations than to foreign texts partially domesticated by translation and familiar modes of enactment. In this respect, Sato's rendition of *The Floating World* was not only the more accessible of the two projects but also the more radical for Australian (re)viewers. In cosmopolitical terms, it broke new artistic and conceptual ground by finally putting race and racialization under the microscope in a way anticipated, albeit obliquely, by the defiant anti-naturalism of the original APG production. Recent theoretical work on race teaches us to pay attention not only to the ways in which Western society's Others have been culturally marked but also to the fact that whiteness gains much of its hegemonic purchase by passing as unmarked, as normative. To 'alienate' whiteness and thus recalibrate the unstable category of race itself, as Sato's production inevitably did by opening up the gap between signifier and signified, is to begin dismantling the epistemological system from which so many of our discriminatory attitudes and practices derive their authority. As for *The Floating World*, it is difficult to imagine that any future reinterpretation could better Sato's magnificent effort and in this respect Romeril's

controversial play may have done its cultural work – at least for the moment.

Australian appropriations of the Suzuki Method

The previous two case studies examined the cosmopolitics of theatricalizing specific body cultures and representing racial difference within and beyond the nation. A different kind of cross-cultural body mobility occurs through the efforts of Australian artists who spend time gaining expertise in Asian theatrical forms and subsequently use them in their own training processes and performance work. Some artists do so with little regard for either the historical context of the borrowed cultural fragments or the dynamics of local reception and, as a result, tend to develop highly formalistic performances, often leaving themselves open to the charge of orientalist reinscription. The criticisms typically view such works as faddish and arising out of a superficial engagement with the source theatre culture, but fail to account for the ways in which this superficiality is sustained and rationalized by companies that are heavily invested in specific Asian techniques and forms. In this case study, we analyse the complex modalities of orientalism discernible within the work of two Brisbane-based fringe companies, Frank Theatre AAPE (Austral Asian Performance Ensemble) and Zen Zen Zo Physical Theatre, that have drawn heavily from Japanese forms for more than a decade. Focusing on each company's uses of the Suzuki Method, we also situate their cross-cultural praxis within specific local and global performance networks.

Arguably, Suzuki Tadashi's work has been the most influential of all recent Asian theatrical imports into Australia, at the levels of both actor training and performance aesthetics. This situation is reflective of a broader international trend marked by intense interest in Suzuki's productions, particularly in avant-garde circles, and a concomitant proliferation of Western access points for training in the Suzuki Method, whether delivered by the master himself or, more often, by one of his apprentices. Suzuki's habit of staging versions of texts drawn from the European canon, his extensive international touring activities and his admittance of various Western performers into SCOT (Suzuki Company of Toga) have combined to increase the perceived portability of his aesthetic system, with its particular training regimes and its underlying philosophical principles. Suzuki, meanwhile, has claimed a certain universalism for his work, arguing that his method, based on a 'grammar of the feet', aims to develop the expressive powers of the 'human' body

and is non-specific in its potential applications: 'Whether in Europe or Japan, stomping or beating the ground with the feet is a universal physical movement necessary for us to become highly conscious of our own body or to create a "fictional" space, which might also be called a ritual space, where we can achieve a personal metamorphosis' (1991: 247–8).

The relative simplicity of the Suzuki Method strengthens its commodity value in the cross-cultural arts market where it offers an 'accessible, feasible alternative current' to those looking beyond the main stream of Western-style naturalism (Allain, 1998: 86). By distilling features of noh and kabuki practice into a training regime that can be taught independently of knowledge about its specific cultural roots, Suzuki provides a shortcut for those wanting to access Japanese performance aesthetics and to emulate the legendary physical presence associated with traditional forms of Japanese theatre. Suzuki's particular position as Japanese, and thus an insider vis-à-vis his country's traditional art forms, has given him street credibility in his adaptations of noh and kabuki as well as protecting him from charges of cultural theft. J. R. Mulryne argues that Suzuki may be seen as a cross-culturalist par excellence in so far as his grammar is 'rooted in a theatre practice that is aesthetically real and available, and so immune to the intercultural anxiety of an adopted and false ritualism' (1998: 85). It should be noted, in this respect, that Suzuki rarely uses the body poses and physical actions that make up his system as the direct substance of a performance. Rather, his grammar functions to negotiate foreign theatrical elements in the Western texts he stages, while embedding each production in a politicized context. A case in point is his production of *The Trojan Women* (1974), which integrated divergent cultural fragments to deliver both a generalized indictment of war and a more specific meditation on the bombing of Hiroshima and Nagasaki.

As mentioned in Chapter 3, the 1992 Suzuki–Playbox project culminating in *The Chronicle of Macbeth*, which premiered at the Adelaide Festival and subsequently showed in Melbourne and Tokyo, was a major catalyst in the Australian uptake of the Suzuki Method (see Figure 9). The project not only offered training opportunities but also showed that local practitioners were capable of presenting a sophisticated yet somewhat mystifying foreign form in a collaboration of considerable magnitude. Publicity generated by this joint endeavour presents the cross-cultural encounter between Australia and Japan in a highly complimentary light. On this level, the project functioned to confirm Playbox's reputation as the most innovative and outward-looking of Australia's major theatre companies and also to secure a position for

Figure 9 The Chronicle of Macbeth, directed by Suzuki Tadashi, Playbox, 1992. (Photo: Jeff Busby)

Australia (and especially Melbourne) in the international arts market via Suzuki's residency. Suzuki's 'stomp of approval' – his involvement in an Australian venture – thus implicitly signalled a maturation of local theatre. Michael Cohen's (1996) and Chris Murphy's (1996) separate accounts of the collaboration point to a far more fractured process and problematic product. What is clear, nonetheless, is that the Suzuki–Playbox project was part of the nation's larger push for alignment with Asia, as well as a litmus test for assessing prevailing Australian–Japanese relations. While *The Chronicle of Macbeth* may have been more success-fully staged for a fringe audience and better envisioned as a tentative exploration of the benefits and limits of Suzuki's system for an innov-ative Australian theatre practice, the imperatives of Asian enmeshment demanded a mainstream production and high-profile marketing.

This example of Suzuki's participation in Australian theatre shows how readily his work can become imbricated in local and regional cosmo-politics precisely because of its internationalism. For those advocates of cross-cultural theatre sensitive to the trap of cultural exploitation,

engagement with the Suzuki Method carries a certain artistic cachet because the form's mixed pedigree in European modernist and Japanese traditionalist performance is seen to provide bridges between nations, cultures and histories while allegedly circumventing the imperialist paradigms discussed by Rustom Bharucha (1993), among others, in recent critiques of cross-cultural experimentation. Yet, Suzuki's work often seems perilously close to being reinscribed within an East–West binary that exerts, in orientalist terms, the relational superiority of the West. For instance, Marie Myerscough, writing about the 'otherworldly' impact of SCOT's production of *The Trojan Women*, asserts that his 'aesthetic may be summarized as Western content, Japanese form' (1986: 9). This assessment not only ignores the extent to which Suzuki inter-rogates and reconfigures texts from the European canon, but also tacitly claims the intellectual aspects of his theatre for the West by separating them from its affective components and relegating the latter to the East as a spectacle befitting the magical setting of Toga.

It is this exoticized version of Suzuki's East–West dynamic that seems to hold Frank Theatre and Zen Zen Zo in its sway, judging by their production work and promotional materials. Over the last decade, both companies have used Suzuki techniques extensively in their training regimes, with the aim of creating energized and visually spectacular theatre geared towards an Australian avant-garde market. Much of their performance work, following Suzuki's example, has involved the aestheticized reworking of classical Greek and Shakespearean texts, which are presented in ways that showcase the formal, sensual surface of the performers' art. This work, unlike that of SCOT or Suzuki's new company at Shizuoka, tends not to confront the politics of its cross-cultural location. In Carl Weber's terms, such work exemplifies 'accul-turation' in so far as it transfers cultural elements from one group to another, using the 'alien component as a spicy sauce to make some old familiar gruel palatable again' (1989: 14). Acculturation inscribes a preserved foreign code, with its attendant ideology, in a native structure, in contrast to 'transculturation', which Weber sees as going beyond a model of appropriation to enact a more analytical, critical displacement of cultural elements (p. 19).

Frank Theatre, co-directed by Jacqui Carroll and John Nobbs, was formed shortly after Nobbs's apprenticeship to the Suzuki Method via *The Chronicle of Macbeth* project.[9] Since then, company members have followed a rigorous training regime and maintained close contact with Suzuki himself, travelling periodically to Japan, as well as the United States, for international masterclasses in his method to 'refresh' and

'replenish' their practice.[10] Frank's stylized and abstracted productions, including *The Romance of Orpheus* (1993), *Tale of Macbeth: Crown of Blood* (1995), *Salome* (1997), *Midsummer Night's Romeos* (2003) and *Oedipus Rex* (2004) have gained it a reputation as the Australian company whose work adheres most closely to a Suzukian aesthetic. Nobbs and Carroll, for their part, stress the authenticity of their work as faithfully disseminating both the principles and practices of Suzuki's system. Hence, they are quick to claim that their training regime follows the Suzuki Method with very few variations, that it has the master's approval and, in particular, that Nobbs is one of Suzuki's special disciples, having been the only Australian to perform with SCOT.[11] Within this discourse of authenticity, the company's visits to Japan enact homage to the master and activate a 'return to source' rhetoric that signals Nobbs and Carroll's investment in maintaining a more or less pure version of their adopted theatrical form. In turn, such signs of authenticity validate the company's difference from other Australian, and even international, practitioners influenced by Suzuki's work.

At the same time, Carroll and Nobbs have often spoken about their work as genuinely hybrid theatre, a new product that combines Japanese and Australian performance elements into a dynamic art form. The emphasis on East–West fusion is implied in the company's extended name as the 'Austral Asian Performance Ensemble' as well as figuring prominently in their mission statement and promotional material. Yet, the curious passivity in Frank's determination to 'remain faithful to the Suzuki Method' (Lim, 1998: 16) seems to militate against real experimentation with the form itself, suggesting a fundamental contradiction in the company's avowed mission to generate a localized, uniquely 'Austral Asian' style of performance. This contradiction is neatly dissolved via a discourse of internationalism that mutes differences between Japanese and Australian cultures. Nobbs reveals, for instance, that he likes Japanese theatre because it is 'not based on political fashions' (quoted in Clarke, 1994: 6) – in other words, not localized – while Frank's promotional material states that the company's work distils from Suzuki's system that which is apparently 'universal'. The theatre is a spiritual arena for Frank, and its mission is not social change but the 'alteration of consciousness' (Pippen, 1998: 26). Within this formulation, physical disciplines such as the Suzuki Method 'unlock the deep unconscious' in order to produce a 'new focused performer, unselfconscious and whole' (Carroll, quoted in Pippen, 1998: 25). The combined discourses of universalism and transcendentalism, which together echo older forms of (ungrounded) cosmopolitanism, enable

Frank to import an Asian performance form into an Australian context while avoiding engagement with the unsettling elements of cultural Otherness located at the level of the sociopolitical. The Asian technique justifies the marketing of Frank under the locally valorized sign of 'Austral Asian hybrid' while enabling the company to position itself as a player in the international arts circuit. Frank's recent training and collaboration with Croatian performers is held as proof of such internationalism: 'we are exporting the hive of Japanese theatre training to Croatia', Nobbs claimed in a media interview about the project (quoted in Aldred, 2001: 42). Carroll's statement that the Suzuki Method is the 'next big movement' of contemporary theatre confirms the globalizing reach of Frank's vision (quoted in Lim, 1998: 16).

The company's emphasis on presenting an authenticated version of Suzukian theatre has led to highly positive reviews, particularly in the early years, from an Australian critical establishment anxious to affirm its culture's ability to absorb and master Asian performance styles. Typically, reviewers praise Frank's productions for their sensual effects and their flawless integration of formal elements. Comments abound on the virtuosity of the performers' techniques, the ritualistic rhythm of their movements, the rich sensuality of the costumes, the evocative crepuscular lighting. Veronica Kelly's review of *Tale of Macbeth: Crown of Blood* conveys the appeal of this kind of theatre: '[It is] the look and feel of the show that impresses. Under formal contrasted lighting, the actors move to percussive sounds in dreamlike controlled movements, like animated friezes from a gothic cathedral whose sculptors had improbably been studying Japanese prints' (1995a: 15). While Kelly does assess the textual content of specific Frank productions, almost all other reviewers confine their comments to matters of style and technique. This trend is significant given that the Suzuki–Playbox version of *Macbeth* generated a good deal of discussion about textual issues – for instance, many critics expressed annoyance at Suzuki's failure to preserve the Shakespearian narrative – but only passing comments about style. Hence, it seems that Suzuki's project was judged largely on his ability (as a 'foreigner') to satisfactorily interpret a canonical Western text for an Australian audience whereas Frank's efforts tend to be evaluated according to the company's mastery of a foreign performance grammar that can enliven Australia's staple theatrical gruel.

In Frank's application, it is the Suzuki technique that is circulated for consumption. The company presents a highly processed product assimilable on the target audience's own terms; cultural dissonance is thus smoothed over leaving only those differences that excite the (Western)

exoticist imagination. Frank's production of *Salome* best exemplifies this approach in so far as it used the Suzukian aesthetic to present an alluring mise-en-scène that drew from nineteenth-century vocabularies of Middle Eastern orientalism, particularly in the use of highly ornate costumes. While the sensory effects of such theatre can be spectacular, as most reviewers noted, the decontextualized display of the Suzuki Method in action suggests a non-reflexive cross-cultural art/artifice in which the seamless merging of performance techniques is matched by an ideology of fusing cultural differences. In Frank's work, questions about the ethics of appropriation never seem to arise and the danger of superficial borrowing likewise slips from consideration. The 2002 restaging of the company's signature work, *The Tale of Macbeth*, also suggests limits to the depth of Frank's cross-cultural engagement. Although the show was advertised in the programme notes as a trilingual, 'genuine international, cross-cultural production' featuring actors from Croatia and Malaysia who had trained in the Suzuki method with Frank's directors, the Malaysian actor had in fact a total of only 18 days to train in this form and rehearse for the production.

In recent years, Frank has extended its adaptations of 'classical' texts beyond the European canon. Its 2000 production of *Rashomon*, based on a Japanese story made famous by Akira Kurasawa's film of the same name, was perceived by some theatre critics as a natural vehicle to showcase the company's Japanese-based aesthetic. According to the programme notes, the production was motivated by Frank's desire to transform the Suzuki training into a 'more contemporary idiom', yet most reviews continued to focus on the exotic look of the production – the lavish costumes and the performers' slow, hypnotic movements, which were accentuated by the technopunk soundtrack (see Galloway, 2000; Brookes, 2004). *Doll Seventeen* (2002) marked the company's first attempt to engage with an Australian text. The production was marketed in the programme notes as 'a right-brained intuitive impression' of Ray Lawler's 1956 play, *The Summer of the Seventeenth Doll*, which is widely regarded as a seminal text in the development of modern Australian drama. Lawler's exploration of mateship and masculinity in the 1950s centres on two Queensland cane cutters who go south to Melbourne each year to spend the layoff season with their long-term 'girlfriends'. That their relationships begin to unravel in the seventeenth season as the characters come to terms with a 'new' Australia suggests that the tough 'bushman' cannot be sustained as an idealized national type in an increasingly urban postcolonial society. Rather than reinterpreting this 'quintessentially Australian' drama through deconstructive lenses,

Frank chose to emphasize the iconic dimensions of the play by focusing on the internal psychological struggles of the major characters. The verbal text was considerably stripped down, while the kewpie doll, a symbol of the fragility – and immaturity – of the love affairs in Lawler's text, took on mythic proportions as animated by actor/dancer Lisa O'Neill. This approach was generally well received, with critics applauding the attempts to dramatize the terrors and fantasies lurking within the human unconscious. There was also general agreement (and approval) that the rigorous Frank physicality had 'softened' as part of the process of engaging with Lawler's realist text and its colloquial language (see Leonard, 2002; Buzacott, 2002). *Doll Seventeen* is arguably the most successful of Frank's attempts to create a Japanese-Australian aesthetic but it is instructive to note the conservative purchase of this kind of cross-cultural experimentation and its buttressing of the status quo. The production aimed to distil the 'essence' of the original text rather than to challenge its canonical status or engage with its difference as a product of a particular social and theatrical context. As one reviewer noted, 'Frank's achievement was to reaffirm *The Summer of the Seventeenth Doll*'s "classic" status' (Leonard, 2002: 35).

Zen Zen Zo (which translates loosely from Japanese as 'Never the Elephant') has also staged productions in which Suzuki's grammar features as formalistic display.[12] The *Cult of Dionysus* (1996) and *Macbeth: As Told by the Weird Sisters* (1998) are cases in point. A promotional video about the latter project clearly reveals this kind of cross-cultural formalism in its singular focus on the ways in which the company's performers have developed their physical expressivity (Roane). In contrast to Frank, however, Zen Zen Zo makes no claim for the authenticity of its Suzukian practices. Artistic directors Simon Woods and Lynne Bradley have both studied other Japanese theatre forms such as butoh, aspects of which they include with yoga practices and a modified version of the Suzuki Method in the company's training regime. Anne Bogart's Viewpoints technique, which heightens the performer's awareness of tempo, duration, gesture and spatial relationships, has also been an important influence.[13] This blending of forms and techniques is designed to create actors capable of delivering high-octane performances that 'recapture the ritualistic power of theatre by combining a striking visual and physical language with raw energy and emotional truth'.[14] In particular, the Suzuki Method is employed for its 'power and energy' while butoh is seen to facilitate 'very strong, intense, pure emotion' (Woods, quoted in Pippen, 1998: 33). Thus, in Zen Zen Zo's praxis, Japanese forms are explored primarily for their

transgressive physical and raw emotional energies rather than their precision mechanics. Advertising material for 'Stomping Ground', the company's annual physical theatre intensive training course, suggests a pragmatic engagement with the cultural contexts from which its models are drawn. Here, the Suzuki Method is positioned as a traditionalist art form while butoh is exoticized for its apparent expression of human-kind's most 'primitive' ritual roots. This eclectic employment of a range of Asian physical training forms to achieve a calculated effect aligns with commercial imperatives, as noted in one 2002 Singaporean review of the company's remounted version of *Macbeth*: 'in this age of fast-paced lifestyles and instant gratification, packaging matters a lot'; Zen Zen Zo 'dress [*Macbeth*] up, bring it up to speed with some snazzy modern effects and adorn it with a few bells and whistles' (Lye, 2002: 20).

Zen Zen Zo's performance work illustrates well the seductiveness of the primitive. The company's signature 'glamorously grotesque' look (Pippen, 1998: 30) features bared teeth, tousled hair and naked pulsating torsos marked with body paint, while variations on the G-string consti-tute the staple costume. In their Suzuki-inspired productions of canon-ical texts, the cast's ritualized movements and choric chants strengthen such primitivist imagery, which stages cultural Otherness as both highly visible but also paradoxically obscure in terms of its erasure of cultural and historical specificity. Zen Zen Zo's performance of oriental savagery is less an assertion of cultural superiority over the Asian Other than a revelation of the oppressive forces operating within Western culture that lead to this need for alterity. In this respect, the company's aesthetic, grounded in disciplined corporeal regimes but foregrounding abandon and excess in performance, illustrates Ali Behdad's thesis that orient-alism exposes 'the split in the western vision of its other, the cleavage of the masked and the exposed, the cut between maximum visibility and total inscrutability, and the division between a desire to indulge in corporality and a profound repression of the body' (1990: 37).

In 2002, in a move to distinguish itself from Frank and as an asser-tion of artistic 'maturity', Zen Zen Zo declared that the Suzuki Method would only be used in training and not in performance. This claim coin-cided with the announcement that the company was shifting its focus towards more text-based work as 'physical theatre [could] no longer rely on the shock of the new to wow audiences'. 'We are very much in love with Australian writing', Bradley added, 'and we want ... to tell our own stories but still using the epic style we have developed over 10 years' (quoted in McLean, 2002: 19). The company's next major work, however, was a version of Homer's *The Odyssey* (2004)

adapted by renowned Brisbane actor Eugene Gilfedder, who also starred in the lead role. The production was facilitated by a company residency at the Queensland Performing Arts Centre and featured Zen Zen Zo performers as a Greek chorus whose physical actions punctuated the epic narrative. This kinetic chorus drew from elements of commedia dell'arte and contemporary Western dance as well as the company's trademark Japanese-inspired movement vocabularies. Reviews praised the production for its visual design and intensity but were less complimentary about Zen Zen Zo's vocal work, with one critic complaining that it threatened his absorption in Ulysses's world (Harper, 2004: 14). Later in the same year, the company did tackle a predominantly text-based project, *Wicked Bodies* (2004), scripted by local playwright Angela Betzien and based on improvisations by the cast, which included independent artists as well as company members. Set in a Parisian brothel, the play explores the ways in which women were coerced into various kinds of wickedness to survive the oppressive social conditions of the late nineteenth century. Again, reviewers generally admired the production's striking visual imagery, reminiscent of the scenography in Baz Lurhman's *Moulin Rouge*, but there was criticism that the performance did not 'live up to the visceral depths of ... earlier shows' (Savige, 2004: 13) and that the script was inadequate and lacked narrative focus (Buzacott, 2004: 7). This lukewarm reception may partly explain why Zen Zen Zo has not presented another text-based work since *Wicked Bodies* and appears, instead, to have returned to its earlier focus on physical theatre. *Those With Lucifer* (2005), a butohesque show billed on the programme as a 'treatise on human life through the paradigm of the Seven Deadly Sins', had a sell-out season. Despite criticisms that it was conceptually thin in terms of 'exploring the consequences of sin' within a contemporary postmodern context, the show confirmed the company's ability to deliver energetic performances that are particularly attractive to its target youth market (Mercer, 2005).

Like Frank, Zen Zen Zo has something of a cult following among Brisbane audiences and has excited reviewers with its wanton physicality and its flagrant subversion of middle-class aesthetics. Commentary about the company's performative uses of the body abounds, with more than one critic delighted in Zen Zen Zo's apparent ability to demonstrate that 'voyeurism can be an art form' (Cotes, 1998: 15).[15] Once again, there is little engagement with the conceptual landscapes set up by the company's particular deployment of butoh and the Suzuki Method, yet local reviewers are eager to claim proxy ownership of whatever product results. 'Brisbane's own Zen Zen Zo' is seen to reinterpret the avant-garde

for a younger audience by meshing Japanese forms with elements of Western popular culture (Eld, 1998: 23). This practice complements the more restrained, high-culture version of the cross-cultural avant-garde presented by Frank, 'Brisbane's best kept secret' (Veronica Kelly, 1995b: 14). Between them, the two companies function to confirm that the city's arts scene is funky, vibrant, young and daring, as well as mature, sophisticated and cultured. Overall, the Brisbane traffic in Japanese theatrical forms suggests that the city has proven its cosmopolitanism and is forward-looking because it is able to successfully renegotiate both tradition and (post)modernity at the Austral–Asian axis. Nevertheless, it could also be argued that what is happening here is a 'willed localism' founded on geographical ownership and communal identification rather than a reading of the local from the performances themselves. In this respect, the work of Frank and Zen Zen Zo is not grounded in the local milieu, but rather gains its purchase and identity from the international network of Suzuki-based practices and their particular location in the global market place of cross-cultural theatre.

Our exploration of the ways in which the Suzuki Method has been incorporated into contemporary Australian performing arts idioms via each company's work reveals cross-cultural practice as a site of aesthetic, political and economic negotiation. This traffic in cultural capital is by no means straightforward, in either practical or ethical terms. While some local applications of Suzukian theatre can be seen to demonstrate, and elicit from audiences, a non-reflexive fascination with cultural difference, such dynamics are complicated by the fact that current Western discourse tends to situate Japan, albeit problematically, as *both* Asian and first-world, oriental and postmodern. This positioning means that cross-cultural commerce with Japan poses less of a moral dilemma for those Australian theatre practitioners anxious to avoid accusations of cultural pillage as they tap into an apparently rich source of Otherness. At the same time, Suzuki's complicity in the dissemination and internationalization of his techniques for a Western arts market begs the question of whether he is implicated in the reification of his own art form. Is he partly responsible for the commoditization of the Suzuki Method under the guise of homage? And if so, what challenges will this pose to charges of orientalism raised by critics of cross-cultural theatre? The argument that Western cultural engagement with Asia cannot be separated from discourses of orientalism is now well recognized; our analysis of networks through which Suzuki's technique has been mobilized in Australia lends weight to the movement to rethink orientalism to take account of complicity and voluntarism.

Behdad's work helps to illuminate the relational character of orientalist formations. He makes the distinction between orientalist desire, which implies observation and representation without any personal participation in the social reality of the Orient, and the desire for the Orient, which 'is the return of a repressed fascination with the Other, through whose differentiating function European subjectivity has often defined itself since the crusades' (1990: 39). Frank's and Zen Zen Zo's works clearly fall into Behdad's second category for, despite differences at the level of praxis, both perceive the Orient as a site of alterity. For Frank, the Suzuki Method offers immersion in the mystical and transcendental while Zen Zen Zo uses the training to evoke and sustain raw, primitive energies. Both positions are, however, coterminous in positing the Orient as the Derridean supplement defining that which is desirable but found lacking in the Self. Behdad's careful unpacking of the relational modes of orientalism complicates the simplistic understanding of orientalist texts as merely racist projections, and draws attention to the corresponding mechanisms of introjection that both limit the signifying horizons of the orientalist text and determine the process of (Western) subject formation. We maintain that one of the key (unacknowledged) orientalist intertexts in the cross-cultural work of Frank and Zen Zen Zo is the legacy of modernist orientalism as Singleton has described it (2004: 14–15). The companies' high-art aestheticism and tribal primitivism owe as much to this Western style of knowing and embodying the Orient, as it does to more recent and localized textualizing of Asia as the site for economic and cultural enmeshment. More work is clearly needed to understand the connections between various disciplinary histories of the Orient and the ways in which such connections are mapped and/or resisted by the performing body. Our aim here has been to initiate the conversation with special regard to the Australasian context of the East–West theatrical encounter.

6
Asian Australian Hybrid Praxis

But how is it to land and not land, my wings rearranging themselves for home and not home?

(Merlinda Bobis, 1996)

Contemporary theorization of cosmopolitanism has struggled to unhinge the concept from its genealogy in early modern European expansionism. In the words of Anthony Pagden, 'it is hard to see how cosmopolitanism can be entirely separated from some kind of "civilizing" mission, or from the more humanizing aspects of the various imperial projects with which it has been so long associated' (2000: 4). One of the central aims in the configuration of a 'new' cosmopolitanism has been to particularize and, following Dipesh Chakrabarty, 'provincialize' cosmopolitan theorizing so as to diminish its privileged Eurocentricism. Homi Bhabha's notion of the 'vernacular' is particularly salient in this regard since it aims to destabilize and decentralize dominant conceptions of cosmopolitanism by bringing it into conversation and collision with minoritarian and subaltern experiences of border-crossings. Vernacular cosmopolitanism is not, therefore,

of the elite variety inspired by universalist patterns of humanistic thought that run gloriously across cultures, establishing an enlightened unity. Vernacular cosmopolitans are compelled to make a tryst with cultural translation as an act of survival. Their specific and local histories, often threatened and repressed, are inserted 'between the lines' of dominant cultural practices.

(Bhabha, 2000: 139)

Citing the social and cultural transformations incurred by colonized societies as a result of their encounter with the West as examples of vernacular cosmopolitanism, Bhabha views the cultural versatility of colonized people as inhering in everyday practices of 'translating between cultures, renegotiating traditions from a position where "locality" insists on its own terms, while entering into larger national and societal conversations' (2000: 139). Such modes of translation and transformation are also characteristic of diasporic cultures that are ambivalently positioned between cultural homelands and current hostlands. These vernacular transactions, which tend to produce and enact signs of cultural hybridity, are often incorporated into artistic practice where they may index the tensions (and pleasures) of diasporic belonging. In this chapter, by examining specific modes of embodying Asian Australian subjectivities on stage, we connect the issue of diasporic identity with the cosmopolitan impulse to Asianize Australian theatre. Thus far, our discussion of this dynamic process has been premised on the assumption of a white performing subject engaging with the theatrical products, styles and practices of Asian cultures; here, we focus on the racially marked bodies of Asian Australian performers, and explore the means by which they impact on, and are in turn transformed by, the prevailing technologies of Asianization.

Corporeal specificities tend to be submerged in attempts to particularize cosmopolitanism by foregrounding its affective dimensions as embodied experience, as 'habits of thought and feeling that have already shaped and been shaped by particular collectivities, that are socially and geographically situated' (Robbins, 1998: 2). Such approaches are inclined to assume the material givenness of the body as the site of affect; there is very little analysis of how specific power/knowledge mechanisms produce different kinds of cosmopolitan bodies and how these bodies respond somatically to such forces. In the few cases where the cosmopolitan body-as-corpus is examined, it is largely conceptualized in spatial terms as a highly mobile entity whose cultural attachments withstand transnational (re)locations and border-crossings (see Appiah, 1998; Ong, 1998). The diasporic body, by comparison, is typically characterized by cultural analysts in terms of corporeality,[1] and specifically as a racialized (and, less often, gendered) body. These apparently separate body discourses can be brought into dialogue through the concept of hybridity in so far as it describes the process and/or product of cultural mixing that is integral to both cosmopolitanism and diasporic experience.

At the risk of simplification, hybridity can be conceived as having at least two distinct applications. In popular usage, it denotes a fusion of disparate cultural elements, as evident, for instance, in world music or the new Australian 'fusion cuisine', which is marketed as an East–West culinary union. Hybridity, in this sense, serves a stabilizing function and works to settle cultural differences. Associated with globalization and the deterritorialization of cultural practices, this understanding of hybridity celebrates the proliferation of cultural difference to the extent that it can produce a sense of *in*difference to underlying issues of political and economic power. The most noxious form of such hybridity is found in naive conceptions of cosmopolitanism, where the term is emptied of its particular histories and politics to invoke instead a model of unbounded culture. In this formulation, which we term 'happy hybridity', there is little sense of tension, conflict or contradiction in cross-cultural encounters. Some academic discourses have duplicated the populist approach to hybridity, ignoring its potential contradictions and specific modes of enunciation; as a result, the concept can be so amorphous as to be emptied of any radical potential or direction. As John Hutnyk puts it, '[t]heorising hybridity becomes, in some cases, an excuse for ignoring sharp organisational questions, enabling a passive and comfortable – if linguistically sophisticated – intellectual quietism' (1997: 122). The other, more carefully differentiated application of the term tends to circulate mostly in postcolonial studies where hybridity potentially unsettles and dismantles hegemonic relations because it is focused on the process of negotiation and contestation between cultures. It is this second, critical approach to hybridity, perceived not as a natural outcome of cultural mixing but rather as a form of political intervention, that we are keen to explore in relation to the cosmopolitics of Asian Australian theatre.

The pioneering work of Mikhail Bakhtin remains one of the most useful points of departure for unpacking the relationship between hybridity's popular and critical strands and outlining its potential for politicization. Bakhtin's concept of hybridity is couched in linguistic terms: 'a hybrid construction is an utterance that belongs, by its grammatical and compositional markers, to a single speaker, but that actually contains mixed within it two utterances, two speech manners, two styles ... two semantic and axiological belief systems' (1981: 304). Bakhtin distinguishes between two kinds of hybridity: unconscious, organic hybridity and intentional hybridity. Organic hybridity is characterized by combination and fusion, 'but in such situations the mixture remains mute and opaque, never making use of the conscious contrasts

and oppositions'. Organic hybrids are also 'profoundly productive historically; they are pregnant with potential for new world views' (Bakhtin, 1981: 360). Transposing this linguistic model to culture and society, it can be argued that organic hybridity describes the historical evolution of all cultures. Despite having the potential to bring about new world views, organic hybridity does not disrupt the normative sense of order and continuity; rather, the movement of culture and the bleeding of boundaries mutates organically (Werbner, 1997: 5). This form of hybridity resembles the happy hybridity model mentioned earlier: it contains neither a sense of self-reflexivity nor a sensitivity to the tensions and contradictions of history. By contrast, intentional hybridity requires the speaker/artist to produce an internal dialogism characterized by contestation and politicization (Young, 1995: 21–2). Intentional hybridity 'is an artistically organized system for bringing different languages in contact with one another, a system having as its goal the illumination of one language by means of another' (Bakhtin, 1981: 361). As Werbner points out, intentional hybrids create an ironic double-consciousness, a collision between different points of view, which creates opportunity for political intervention (1997: 5). Bakhtin's theory provides a useful dialectical model for understanding cultural interaction: 'an organic hybridity, which will tend towards fusion, in conflict with intentional hybridity, which enables a contestatory activity' (Young, 1995: 22).

Asian Australian theatre is an exemplary site through which to examine the possible workings of these two modes of hybridity in the nation's performance culture. As a portmanteau category that could be seen as homogenizing and essentializing, the term 'Asian Australian' is arguably problematic; nevertheless, we maintain that it has political currency within the specific history of postcolonial Australia. Given that Asians were for many decades typecast in the (white) Australian imaginary as threats to the nation's sovereignty and racial purity, it is a strategic move to call attention to the commingling of the two apparently antinomic terms and thereby underscore the long history of cross-cultural and cross-racial relations in the region. Early pictorial images of the 'Asian menace' showing a Japanese octopus with its tentacles reaching out to the Australian land mass and Chinese coolies lasciviously eyeing (feminized) Australia as she sleeps in bed remind us of Robert Young's point that the trope of hybridity is based implicitly on the metaphor of heterosexuality (1995: 5). The term Asian Australian thus foregrounds the suppressed cultural and biological miscegenation that is increasingly demanding recognition as part of the reconfiguring of the national imaginary.

The emergence of Asian Australian as a category of identification also marks a shift away from a more established discourse of migration, which designates 'Asians' as absolute Others. The focus on hybridity emphasizes identity formation as a fluid and provisional process and offers an alternative organizing category for a new politics of representation that is informed by an awareness of diaspora and its contradictory, ambivalent and generative potential. Rather than inscribing Australianized Asians as impure or inauthentic, Ien Ang uses the concept of 'multiperspectival productivity' to describe diasporic identity formations that are characterized by instability and hybridity (2001: 35). Elsewhere, we have located Asian Australian identity within Bhabha's model of the third space, a hyphenated space between categories that draws attention to the ways in which identity is continuously and agonistically reconfigured in relation to the changing political environment (Lo, 1998). This indeterminacy – with all its attendant uncertainties, conflicts, contestation and convergences – highlights the discursive (and hence political) basis of Asian Australianness as an identity category. The position of in-betweenness, of being both Asian and Australian, unsettles dominant expectations of the unproblematic homology between cultural, racial and national identity. Our aim is to explore the political potential of this ambivalence by focusing on the embodied ways by which Asian Australian theatre tests the limits of race as the symbolic marker of alterity in the national imaginary.

Asian Australian writers and performers only emerged as a presence on the nation's stages in the late 1970s after the official demise of the White Australia Policy and the gradual implementation of multiculturalism. Until then, there were no productions of plays by Australians of Asian descent and roles for Asian actors were limited in number and predominantly fashioned as stereotypes. John Lee's *The Propitious Kidnapping of the Cultured Daughter*, staged by Playbox in 1978, was the first Asian Australian play to be mounted. An interpretation of the Patty Hearst story in Chinese opera style, its mixture of Asian and Western elements confused many reviewers who responded with clichéd headlines such as 'A Chinese Puzzle' and 'Never the Twain Should Meet' (Broinowski, 1996: 213). With the exception of Lee's play, early Asian Australian performance was comprised of dance-dramas pioneered by artists such as Kai Tai Chan and his One Extra Dance Company, and Chandrabhanu and his Bharatam Dance Company (see Lo, 1998). It is not surprising that Asian Australian artists should enter the mainstream initially via dance and non-text-based theatre since facility with the English language, and the Anglo-Australian accent in particular,

has functioned as a gate-keeping mechanism for locally scripted texts. While movement-based work remained prominent in Asian Australian performance for some years, increasing numbers of artists were demonstrating a facility with verbal language and multimedia by the 1990s at the height of the Asian turn, which served to counter the stereotype of Asian theatre as essentially spectacular.

The Asia enmeshment campaign from the late 1980s to the mid-1990s was a significant catalyst for the professionalization of the Asian Australian theatre sector due to the increased demand for Asian actors and performance traditions. There is now a growing pool of highly skilled performers, writers and directors in this field, and an increasing diversity of performance forms including text-based realism, physical theatre, monodrama, popular cabaret and standup comedy. As mentioned in Chapter 3, Belvoir Street's Asian theatre festivals – variously titled 'Redefining Australia' (1993), 'Variasians' (1996, see Figure 10), and 'Cultural Revelasians' (1997) – were instrumental in raising the profile of Asian Australian theatre. Playbox's contribution, particularly its Asia-themed playwriting competition, is also significant. The company's acclaimed production of Duong Le Quy's *Meat Party* (2000), directed by Michael Kantor (who is noted for his overtly theatrical sensibility) with leading actors Tam Phan, Tony Yap and Yumi Umiumare, remains one of the high points of mainstream Asian Australian performance. Focusing on a young Australian woman's search for the remains of her father, who was killed during the Vietnam War, this poetic play offers a multilayered, bilingual depiction of cross-cultural conflict and reconciliation. Community theatre companies, notably Sidetrack, Urban Theatre Projects and the Footscray Community Arts Centre, have also supported Asian Australian works, including initiatives by artists such as Chi Vu and Mémé Thorne. The Citymoon Vietnamese Australian Theatre Company, founded by Binh Duy Ta and the late Bruce Keller in 1995, provides a fine example of a community-based Asian Australian company. One of its earliest productions, *Conversations with Charlie* (1996), explored cross-racial desire between an Asian man and an Aboriginal woman, a theme that, hitherto, had remained 'un(re)marked' in the nation's performing arts (see Lo, 1998). The current viability of Asian Australian theatre is demonstrated by the emergence of companies such as A Different Corner Productions Inc. (2000) and Theatre 4a (2002), both run by younger generation artists.

Asian Australian performance has attracted considerable interest in the theatre-going community, yet reviews are often limited in cultural scope and couched in terms of biographical observations that call up the Asian

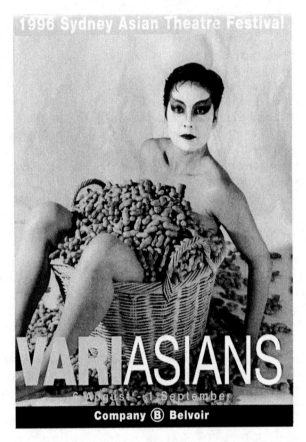

Figure 10 Variasians Poster, Sydney Asian Theatre Festival, Belvoir Street, 1996.
(Photo: Heidrun Löhr)

heritage of the artist, citing it as the originating locus of difference and alterity. While many of the works *are* informed by personal histories, the biographical review format tends to 'traffic in ethnicised strereotyping', as Dean Chan points out: 'At worse, these narratives risk excavating an archaeology of essentialist confirmations to become, in the end, a racialized exercise in "culture spotting": art criticism becomes reduced to the activity of identifying and celebrating the "other" ontological part(s) of the aggregate contemporary whole' (2000: 142). Celebrations of happy hybridity are endemic in this discourse, partly because the visibility of Asianness in the performances encourages a form of visual fetishization – the specular consumption of the Other – that is linked to specific

orientalist and colonialist relations in the region. Critics are frequently unable and/or unwilling to go beyond a 'smells and bells' interpretation of multiculturalism that applauds the so-called innovativeness of border-crossing without critiquing the specific processes of transculturation whereby the foreign culture is incorporated into the host culture (Weber, 1989). Prevailing discourses about 'ethnics' enriching Australian culture undermine the potential for political activism: 'the culinary, with its economy of enrichment and incorporation, signifies the palatable and always aestheticised element of multiculturalism precisely because it still effectively reproduces an assimilationist economy of cultural containment and control' (Perera and Pugliese, 1994: 110). What is missing in the eagerness to embrace and celebrate happy hybridity is an awareness of the complexity of local histories and culture-specific knowledges in all their density, contradiction and contingency. In this respect, mainstream theatre culture perpetuates its privileged position by convincing itself that multiculturalism at the level of folkloric display is desirable provided it does not encroach on the political centre.

Clearly, the embodied specificity of staging Asian Australia underscores crucial questions regarding the relationship between theatrical performance and histories of racialization. Asian Australian performing subjects are already textualized by particular social, political and theatrical discourses that have marked their bodies, first and foremost, in race and gender terms, as indicated in this book's earlier discussions of orientalist representation. A number of recent performances have challenged such textualization specifically and self-consciously, drawing on modes of intentional hybridity to strategically reinscribe Asian Australian subjectivity. The engagement with hybridity has been especially prominent in the one-person show, one of the most popular forms in Asian Australian theatre. This form, which capitalizes on the primacy of the performing body as the most visible and dynamic signifier on stage, not only draws attention to the ways in which bodies carry markings of their particular diasporic histories but also enables the use of bodies as prime sites for political intervention and resignification. As the ensuing analysis suggests, the non-realistic presentational style and reliance on the solo performer as both signifier and sign makes the monodrama an effective vehicle for subverting dominant stereotypes and embodying hybrid subjectivities.

Cantata of the Warrior Woman Daragang Magayon[2] (1994) is a feminist reworking of a traditional Filipino myth about a beautiful maiden, Daragang Magayon, who is captured by an evil warlord and later rescued by her hero-lover. Performed by the author, Merlinda Bobis, this hybrid

text is comprised of storytelling, indigenous chanting, lyric poetry and folk and contemporary dance. Bobis recasts the myth into an epic poem that transforms Daragang into the Warrior Woman who defends her own honour and saves her tribe by going to war. The ambiguities of war are highlighted by having the Warrior Woman fight against those who glorify violence yet condemn the consequences of every battle in which she is involved. Although the text is mythic in scope, the critique of war and violence also functions as a metaphoric reference to contemporary Filipino history. Written in the early 1990s when Bobis was struggling to come to terms with her identity as a newly arrived migrant, the text reflects, in its hybrid structure, the author's own processes of cultural negotiation: 'I ... attempted to unname/rename my Self and my chosen literary form by breaking restrictive traditions. I refused to be "fixed" under absolute definitions of gender and ethnic background' (Bobis, 1994: 118).

Cantata of the Warrior Woman Daragang Magayon not only challenges the masculine epic tradition in Filipino culture but also subverts conventional artistic boundaries by incorporating lyric, dramatic and epic forms into a work that defies easy categorization. In performance, the text's hybridity also reflects Bobis's postcolonial background, which includes Filipino, Spanish/Latino, American and Australian influences. The counter-energies produced from this process of artistic and cultural dialogization results in 'a radical heterogeneity, discontinuity, [and] the perpetual revolution of form' (Young, 1995: 25). Bobis claims for her heroine a partial and provisional identity that is continuously reinvented as Daragang casts off patriarchal ascriptions of feminine subjectivity and becomes 'The Nameless One Who is All Names':

> Woman. Hunter. Warrior.
> Names only of a moment
> As other words rang
> More possibilities. Lover.
> Mother. Earth. Bird. Fish.
>
> (1998: 145)

Like the poetic metaphors of the multiple subjectivities that Daragang chants into being, the shadow sequence in Act 2 is a visual manifestation of this play of provisional selves. Two full-length screens, which form the backdrop, are lit at different times from the rear and the front to create the illusion of multiple body-forms as the performer weaves her way around them. The one-dimensional body-shadow behind the

screen is visually 'neutral', but becomes inscribed as Other through the mesmerizing incantations in Filipino and Asian-accented English languages. At other times, the performer dances with her shadows in a play of embodied alterity that denies fixity. By employing strategies of intentional hybridity at the level of embodiment, through a body that is at once 'real' and representational, *Cantata* challenges the codes of race and gender that essentialize the signifying waywardness of the Filipina Australian as Other.

Bobis is, rightfully, wary that her performance might be interpreted as metonymic of Filipino culture. Sean Maher's review for *Theatre Australasia* exemplifies this tendency. Clearly taken with the text's hybrid form, he writes: 'Categories as a whole are hard to apply to this amorphous performance piece as it slips in and out of so many modes, and perhaps this is one [of] its biggest strengths' (Maher, 1994: 16). The review foregrounds the Filipino origins of the myth of Daragang Magayon and the epic poetic form but makes little attempt to relate these to an Australian context other than claiming that the performance 'successfully reconnects a traditional mode of address and oral history method with the more contemporary concerns of female representation' (p. 16). Maher does not locate the site of contemporaneity; its 'unmarkedness' suggests that Filipinoness can only ever be appended to a non-ethnic centre, rather than infusing or hybridizing that centre in any significant way. The performance is fixed within an Asian/Filipino culture as the review considers neither the Australian context in which the performance was created and staged (on this occasion) nor the impact of Asian Australian cultural processes in its making, beyond acknowledging that such artistic works foreground 'the cultural richness Asia has brought to contemporary performance which flourishes within Australia's own national borders' (p. 16). In short, Maher's response demonstrates how easily the happy hybridity model lends itself to the consolidation of the dominant social structures, in this case, the discourse of hegemonic multiculturalism.

Bobis has attempted to counter this kind of essentializing by insisting that her dancing is a creative synthesis of traditional Filipino and contemporary Western forms and that the epic chanting used in the performance was learnt largely from imported audio tapes of indigenous tribal chants, later supplemented by formal lessons from a traditional chanter in the Philippines (1994: 126). Ironically, the success of the production in Australia was interpreted by a prominent Filipino critic as an indictment of the text's cultural impurity, the assumption being that a 'true' Filipino artform could not be explicable to the West. Bobis

argues that contemporary indigenous modes of performance are hybridized forms: 'It was almost impossible, after three hundred and forty years of Spanish and American colonisation, to find something "truly Other" to the West' (1994: 128). The syncretic forms and corporeal mobilities in the *Cantata* therefore function as specific strategies of intentional hybridity to counter charges of (in)authenticity assumed by both Australian and Asian critics.

Anna Yen's *Chinese Take Away*[3] (1997) also explores issues of cultural authenticity in relation to a history of diasporic movement. Performed by the artist and based on her family history, the multilayered text dramatizes the stories of three generations of women – Anna, her mother and her grandmother – tracing their journey from China to Australia. Along the way we encounter an assortment of characters, including Anna's restaurateur father and a Chinese vaudeville performer, also called Anna Yen, who worked on the British stage at the turn of the twentieth century. All these characters are embodied by the single performer on a minimalist stage in a multiform text consisting of acrobatics, Western mime, dance, Chinese martial arts, storytelling and slapstick comedy. Yen uses a mixture of 'ethnic' Chinese and English languages and incorporates multimedia, including screen projections and soundscapes, into her text. The hybridizing effect of combining such a diverse array of cultural influences, narrative forms and performing styles is not seamless, however, as in Bobis's text; instead, the sutures remain visible as a means of denaturalizing the theatrical experience and unsettling the fixity of the female Asian body as an object of specular desire. This body has been historically overdetermined by orientalism's fetishization of the Asian woman as the passive, receptive and sexualized object of the colonizing gaze. The task for the writer, actor and director is to subvert and transcend the conventional specular relation. In non-realist performance, Brecht's theory of *Verfremdungseffekt* is a practical way of mobilizing intentional hybridity in live performance since it advocates the foregrounding of the gap between the signifier and the signified in order to expose the discursive conditions of representation. The emphasis on representation as *re*-presentation therefore enables the politicization of performance as a means of challenging and dismantling dominant signifying and viewing practices.

The evocative title, *Chinese Take Away*, not only references the exotic consumption of Asian/Chinese diasporic cultures in the West, but also alludes to the commoditization of women's bodies in systems of exchange in both Western and 'native' patriarchies. Yen's staging of a matrilineal history foregrounds the abuse, exploitation and cultural

displacement suffered by women in her family in the name of tradition, colonialism, nationalism and the pursuit of wealth. Her grandmother was sold as a child to work as a servant in China while her mother was tricked by her own parents into leaving Hong Kong as a 17-year-old 'student' to come to Australia, only to be faced with an arranged marriage that led to repeated rape and multiple pregnancies. Her mother's eventual nervous breakdown and suicide perpetuates the legacy of damaged female bodies and the loss of innocence, and young Anna grows up with the burden of not only being born female but also of failing to rescue her mother. Offsetting this history of loss and abuse, however, is the recuperation of agency through the evocation of transgressive female figures such as the marriage resistors from Chinese history and mythology. In particular, Yen calls upon the warrior woman, who has trained in the wu shu martial arts, as a source of physical strength and courage. The performance begins with the figure of the warrior woman furiously striking out at invisible enemies, an image that undermines more established stereotypes in the West of the Asian woman as lotus blossom, dragon lady or mail-order bride. The physical and mental discipline necessary to perform these dangerous martial-arts movements counter the disciplinary techniques (both Western and Chinese) usually exercised on and reproduced through the female body. These contradictory disciplinary histories and ontologies are textualized on/through the solo performing body to effect an embodied hybridity that is not only a locus of power/knowledge but also a site for the articulation of difference and resistance.

Towards the end of the performance, in a highly gestural style, the performer strips naked to symbolize both the emotional laying bare of the protagonist after her mother's suicide and the gradual rebuilding of strength as she learns to embrace life again. The disrobement sequence is juxtaposed to a verbal text and contrapuntal music by composer Charlie Chan. Arguably, the presentation of this naked, racially marked and gendered body on stage could excite the worse kind of orientalist voyeurism but, by this point in the show, the audience has already engaged with multiple subjects whose different embodied histories and capabilities converge in the single performing body. The fluidity and transformative powers of this *performing* body militate against the spectator's impulse to fetishize the *material* (Asian and female) body presented on stage. By stretching the borders of corporeality to embody multiple identities, Yen's performance not only claims a theatrical, and by implication, cultural, space for the Asian Australian subject but also enables the racialized corpus to take on new iconic possibilities beyond

those imposed by the dominant culture. Yen's performance of hybridity asserts a subjectivity that is self-reflexive and regenerative, in continuous dialogic play with its material environment.

We earlier described intentional hybridity as a deliberate strategy to effect an ironic double-consciousness that destabilizes orthodox world views. Intentional hybridity is both a textual effect – a form of aesthetic praxis that works by internal dialogization – *and* a reading strategy informed by doubleness of perspective. The hybridizing effect of *Chinese Take Away* unsettles the 'natural' homology between the historical individual – the performer-writer, Anna Yen – and the theatrical character called Anna whose story and genealogy is dramatized on stage. Unlike some reviews of the production, which praised the 'truthfulness' of Yen's performance by assuming an unmediated relationship between her personal history and her character's story (Veronica Kelly, 1997; Chiang, 1997), a reading informed by intentional hybridity would be alert to the performance's internal dialogizing of its modes of historiography by means of the complex layering of narratives and the body's signifying flexibility. The multiple histories articulated in the show intersect and collide with each other to fracture the authority of 'History' and 'Truth'. In short, the hybridizing effects draw attention to the production's own processes of representation as acts of political intervention into race, gender and class hierarchies within the Asian diaspora in Australia.

William Yang is arguably the best known Asian Australian artist currently working in the theatre. He has consistently explored issues of identity within the nexus of race, gender and class in his performance works, which are presented in the general form of that familiar symbol of Australian suburban life: the slide show. His theatre is a unique artform, a blend of storytelling, documentary photography, family history and social commentary. A third-generation Australian-born Chinese, Yang grew up in Dimbulah, North Queensland, and had, by all accounts, a 'typical' Australian bush childhood; yet, his race and sexuality have always marked him as an outsider. As a gay Chinese man, Yang is conscious of having to work against the double negation of being both non-white and homosexual. Theatre offers him an embodied speaking position to assert that he is both Asian *and* Australian.

Bloodlinks[4] (1999), part of an ongoing series of performances that Yang has created since 1989, continues his preoccupation with his family history. The performance documents some of his attempts to map the movements and experiences of his extended family network. Yet this is more than just an attempt to recuperate some kind of primordial bloodline – indeed, one of the first things Yang's monologue establishes

is that his show is a story about family networks that goes beyond biology. On describing his Sydney family, he says, 'the thing about them is that none of them is, strictly speaking, my blood relative.' Yang is interested in what he calls the 'invisible chains' that link disparate people because of a shared sense of history common to members of a diaspora – in this case, the Chinese in Australia and their descendants who have since moved to other parts of the world. His performance introduces us to a panoply of extended family members; the audience loses sense of the distinction between direct family members and family by marriage as the show progresses. This blurring is a deliberate effect to unsettle and ironize the conventional Western definition of a family.

In a previous performance piece titled *Sadness* (1992), Yang juxtaposed narratives and images of his Chinese family with those of his gay family to create a dialogic experience aimed at dismantling dominant preconceptions of familial structures. In *Bloodlinks*, he extends this focus by problematizing the concept of bloodline. Eschewing the common understanding of the term as denoting a traceable biological ancestry, Yang follows the diasporic movements of both 'blood relations' and relatives by marriage to present us with an intricate and intriguing glimpse of a family network sustained by migration, travel, international study, and cross-racial and cross-cultural marriages. We are introduced to an array of Irish-Chinese-Australian relations, and to Chinese-Japanese, Chinese-Vietnamese and Chinese-Argentine relatives in America. Thus, the very concept of biological determinism invoked by the notion of a common bloodline is hybridized: the term 'bloodlink' takes on a double articulation that extends the idea of family relations even as it dismantles the assumption of a primordial blood link. As Yang says in the performance, '[i]t crosses my mind that many of us are far away from our origins, but we exist in a place that transcends geography, we exist in a place of blood and other bonds.' It is the ironizing tension between 'blood' and 'other bonds' – between biology and the sociopolitical – that emphasizes the diasporic cosmopolitanism of Yang's work.

Bloodlinks is a monologue rather than a monodrama. Unlike Bobis's and Yen's performances, which transform the physical limits of the body as a means of unfixing customary codes of racial and gender representation, Yang's presentational style on stage is relatively subdued and naturalistic. No obvious physical transformation is enacted; his use of the body is less energetic and more iconic. Yet, during performance, Yang's corporeality transcends its physical locus in a kind of double-negation with surprising effects. Positioned stage left beneath the huge screen where the slides are projected, Yang remains an integral part of

the performance even while there are moments when spectators can choose to exclude him from their sightlines to focus solely on the screen images. At such moments, Yang exists as a mediatized presence in the form of a voice relayed through the sound system. This apparent disembodiment does not compromise subjectivity, but rather achieves an altered sense of corporeality. The organizing principle of the theatre is the staging of specular relations. In *Bloodlinks*, the audience becomes aware of not just looking at the visual text and Yang as performing subject, but also of being incorporated into his frame of vision – of looking at other objects/subjects through his photographic eye/I. The text's particular dramaturgy draws attention to the circulation of the gaze in the performance: the audience looking at Yang and his slide projections, Yang looking at the audience looking at him, and Yang looking at the projections. This relay of looks and shifting subject positions is further strengthened by Yang's different relationships with people projected on the screen – brother, son, cousin-in-law twice removed and so forth.

This network of (subjective) specular relations dismantles the calculus that limits the performing subject's identity solely to his racially designated position as Other. The blurring of the boundaries between the subject and object of the gaze results in an altered power dynamic characterized by negotiation rather than essentialism, thereby opening up possibilities for new kinds of subjectivities that are partial and provisional. Although race as an embodied marker of difference remains a strong element in Yang's performance, it is presented as socially constructed rather than biologically determined. The 'bloodlink' of Chineseness is not visible through corporeal inscriptions (this is particularly true of relatives who are bi/multiracial); it is only through our discursive engagement with Yang's performance that these family resemblances and relations can be asserted. Thus, racial identity is not shown as merely given but rather has to be expressed through discourse, within a social context. Although Yang is related by 'blood' to his relatives, the bloodlink is no guarantee of either racial purity or cultural absolutism. Migration and intermarriage have resulted in a family tree characterized by a form of difference underscored by contingency, plurality and particularity. In this way, the very concept of 'Chineseness' as a 'categorical difference' comes under erasure in the performance of a hybridized diasporic identity.

Georgina Naidu's *Yellowfeather*[5] (2005) explores the cultural politics of racial hybridity through references to film, television, music and popular culture. The autobiographical performance traces Naidu's struggle

growing up as an Anglo-Indian in the rural township of Mt Eliza on the outskirts of Melbourne, and her subsequent career in the performing arts industry. The story unfolds as an episodic narrative in which the performer presents vignettes of her life interspersed with direct audience address and sundry impersonations. An important feature of the production, which also includes screen projections of family photographs, is the incorporation of a live, hybrid soundtrack of Bollywood and 1980s popular music by the Fijian-Indian disc-jockey, DJ Schmidti, who remains on stage throughout the show. As a young child, Naidu identifies her 'poo-coloured' skin with the only cultural referent available at the time, the 'Indians' in the popular *Daniel Boone* television series. Calling herself 'Yellowfeather', 4-year-old Naidu wears a spectacular American Indian headdress and fantasizes about being an extra on the show. Later, as a teenager, her 'exotic' ethnicity becomes increasingly attractive to the opposite sex and she is perceived as a 'cross' between Black American and Asian Australian popular entertainers such as Janet Jackson, Lisa Bonet and Kate Ceberano. The performance also highlights some painful experiences of racism: Naidu talks about being called a 'boong' and told to go back to where she came from, to which she retorts, 'I'm not a boong and if I was, this would be my land so why don't *you* go back to where you came from!' This exchange points to an acknowledgement of, if not affinity with, the marginalized and dispossessed indigenous Australians, and suggests the flexible nature of 'blackness' as a floating signifier of alterity.

It was not until she read Hanif Kureishi's novel, *The Buddha of Suburbia*, that Naidu came into contact with popular representations of her culture. Relating this event, the performer shrieks and prances around the stage exclaiming, 'That's me, that's me!' This important moment in Naidu's interpellation as an Anglo-Indian foregrounds cultural difference at the same time as it underlines diasporic connectivity. Within the racial economy of their London locale at the time, Kureishi's Anglo-Indians were categorized as Black British whereas, in Australia, such individuals have been ambiguously situated within, outside and sometimes alongside, the emerging category of Asian Australian.[6] While there have been significant moves to include South Asians in the establishment of contemporary Asian Australian cultural coalitions, performances such as *Yellowfeather* vividly enact the provisionality of identity categories based on phenotype. Naidu's 'poo-colour' inscribes her, at various times, as American Indian, African American, Anglo-Indian, Aboriginal, Black British and Asian Australian, but rather than merely compounding her Otherness, this performance of excessive alterity functions to question

whiteness as a system of power and privilege. The denaturalization of whiteness is largely achieved through the use of comedy. Naidu's comic talents are well known in Australia, having first come to the attention of the general public through her role as the Indian character, Phrani Gupta, in the highly popular television series, *Sea Change*, broadcast in the late 1990s. *Sea Change* both celebrates and parodies Australian life in a small coastal village, and Naidu's character plays a key role in locating this performance of Australiana within a multicultural and cosmopolitan context. Phrani presents as a stereotypical, sari-wearing Indian woman who speaks with a marked accent. Forced to flee India to avoid persecution for bridal dowry by her husband's family, she is noted for her 'Asian' entrepreneurial skills, which enable her to survive and thrive in her adopted community alongside other idiosyncratic characters. Very few members of the audience at *Yellowfeather* would not be familiar with Naidu's television character, so her stage appearance, to a certain extent, was already overdetermined by specific inscriptions of Indianness. However, these codifications are dialogized with her other performances of self, most notably as the 'cultural insider' who speaks impeccable Australian English and effortlessly negotiates the maze of Western popular cultural references.

The tightly scripted and self-consciously embodied performance of various stereotypes and personae contribute significantly to the comedy in the show. Scholars are generally in agreement that humour serves to enforce social norms and consolidate a sense of collective identity. According to Christie Davies, ethnic and racist jokes project traits that the tellers 'wish to remain on the moral periphery of their culture onto groups who inhabit the social or geographical periphery of their society' (1982: 386). *Yellowfeather* provides an interesting challenge to conventional theories about the function of humour by making the enunciator of the joke simultaneously its target. This doubleness (or hybridity) problematizes the notion of a common 'we' in the face of the Other. It would be simplistic to assume that a racial stereotype is automatically subverted or parodied when performed by a racialized actor; much depends on the circumstances and execution of the performance. Moreover, its location is an important determinant of the audience's constitution, which, in turn, impacts on the modes of interpretation. *Yellowfeather* played to a mainstream audience in the Studio of what is arguably *the* flagship Australian venue, the Sydney Opera House. Despite the obvious multicultural constitution of the audience, we maintain that its collective imagination was predominantly aligned with that of the white cosmopolite. Although there were many occasions during the

show when Naidu's mixture of parodic and slapstick comedy confirmed the position of this dominant culture, moments of strategic and simultaneous play *at* and *with* stereotypes were also evident, resulting in what John McCallum calls 'doubled irony'. Commercial performers such as Naidu, he argues,

> operate within the discourses of power but they also mockingly embrace a self-deprecating style: it is never quite clear how confident that mockery is. Any attempt to read the level of irony that they are employing inevitably implicates the reader: the more you read their jokes ironically the more the aggression in them is turned back on you.
>
> (1998: 215)

An example of this doubled irony occurs when Naidu narrates her audition process for the role of Phrani in *Sea Change*. Her Australian English quickly shifts into a parodic Indian English à la Peter Sellers as she critiques the typecasting practices of the entertainment industry. Naidu makes much fun of being required to wear a sari for the audition: having never worn one before, she nearly strangles herself with it before finally resorting to spreading the material on the floor and rolling into it. While she appears to be mimicking a recognizable stereotype and celebrating her lack of authenticity as one of 'those' Indians, a move that aligns her (albeit in a self-deprecating way) with the dominant culture, she is also, at the same time, mocking the very processes of typecasting and racist (and sexist) ascription operating within the industry that continues to position her as Other. Towards the end of the scene, Naidu makes the ironic observation that she has found fame and success as a performer on the coat-tails of the same kind of categorizing that she faced as a mixed-race child. At such moments, she is identifying as the vernacular cosmopolitan who speaks back to the white imaginary and makes visible, and visceral, the unequal relations of power inherent in multicultural Australia. This intentional hybridizing of two different world views and subject positions as conveyed by the single performing body can result in powerful deconstructive performances.

Some of the political potency of *Yellowfeather* is neutralized, however, by the high-energy finale, which sees Naidu and DJ Schmidti dance in what one audience member described most aptly as 'a triumphant, euphoric dancefloor epiphany that attempts to inscribe a newly comfortable politics of identity, under which all is reconcilable'.[7] The performance comes closest to happy hybridity at this point, when the panoply

of cultural and ethnic references are indiscriminately fused in a celeb-ratory 'masala mix'. Such a triumphant ending supports a reading of the text as a 'coming out as ethnic in a White world' narrative, which might explain why the show was so well received by reviewers, who commended its honesty and sincerity as well as its levity. In the final analysis, this autobiographical story of a well-known Asian Australian could not escape from its confessional mode and subject positioning as Other. In this sense, the happy hybridity finale marks/masks a polit-ical aporia because the logic of the performance ultimately perpetuates an unequal relationship between the white cosmopolitan and its Other even as it attempts to critique the status quo.

What distinguishes intentional hybridity from happy hybridity is its motivation and location within an identified field of contesting power relations. Whereas the happy hybridity model is based on a harmonious fusion that reabsorbs difference into the dominant culture, intentional hybridity stresses the strategic use of ambivalence as a mode of interven-tion and politicization. Our discussion of intentional hybridity in Asian Australian performance has been designed to reconceptualize cosmopol-itan formations through the lens of what Scott Malcomson calls 'actually existing cosmopolitanism' (1998: 240), that is, from the perspectives of the racialized and gendered vernacular cultures that are implicated in the process of Asianizing Australia. The conception of Asian Australian identity explored in this chapter does not preclude other forms of identification and allegiance, nor does it overlook the heterogeneity of personal and collective histories and cultures within the nation's Asian communities. As a mode of identification, Asian Australianness lends itself to the consolidation of a coalition of minority knowledges and subjectivities in opposition to a deepening political conservatism that increasingly perceives domestic cultural diversity as a threat even as it embraces the commercial value of cosmopolitanism and some of its aesthetic correlatives. The political objectives of an Asian Australian coalition also encompass the possibility of extending vernacular cosmo-politanism outwards by forging solidarity with others in the global Asian diaspora, and with disenfranchised groups within the nation, such as indigenous communities and asylum seekers. The Victorian Vietnamese community has already shown a lead in this respect by offering a formal apology to members of the Stolen Generations.[8]

The category of Asian Australianness offers sufficient flexibility for a comopolitics that 'proceeds from the legitimacy of difference, in and despite the need for unity' (Werbner, 1997: 21). Despite its portmanteau nature, this category has proven valuable because it has strategic

capabilities; the potential for the term Asian Australian to act as a rallying point for solidarity is not grounded, however, in any fixed ontology but rather stems from an understanding of difference that is 'positional, conditional and conjunctural' (Hall, 1996: 447). Indeed, it could be said that an Asian Australian identity is itself a hybridized performative category that can only be realized at the moment of articulation. In this respect, Asian Australian cosmopolitanism mobilizes race discursively and provisionally while disavowing its specific historical accretions.

7
Performance and Asylum: Ethics, Embodiment, Efficacy

We are the innocents who have kissed
the noose of Australian Democracy.
<div align="right">(Mohsen Soltany-Zand, 2002: 10)</div>

In their attempts to conceptualize non-elitist versions of transnational belonging and political community that are not bound by Western privilege or the capitalist ideologies of globalization, some proponents of new cosmopolitanism have taken pains to position forced migrants and refugees as potential – and even exemplary – cosmopolitan subjects. These deterritorialized (non-)citizens are thus seen to participate in the uneven affiliations and 'discrepant' cultural engagements of mobile communities (Clifford, 1992), the survivalist, 'vernacular' cultural translations of postcolonial societies (Bhabha, 2000) and the practical, 'actually existing' cosmopolitanisms of situated collectivities (Malcomson, 1998). In such inclusive formulations, refugees and forced migrants share with other globally mobile subjects the propensity for cosmopolitan 'thinking and feeling' and the ability to negotiate new sociocultural and political attachments. What is taken for granted in this discourse is that refugees and forced migrants are necessarily accorded the ancient right of universal hospitality that underpins Kantian cosmopolitanism, 'the right of a stranger not to be treated with hostility when he [*sic*] arrives on someone else's territory' (Kant, 1970: 105). While this right is enshrined in the 1951 United Nations Convention on Refugees and respected in many regions, refugees and asylum seekers are all too often divested of political status, targeted for exclusion/expulsion from specific sovereign territories and/or forced to live in camps or liminal zones where the conditions of existence are reduced to what philosopher Giorgio Agamben terms 'bare life' (life exposed to death) (1998).

In such circumstances, which are becoming more common with the recent, widespread, and often aggressive securitization and racialization of national borders, particularly between the West and the rest, the world's violently uprooted underclassses can be incorporated into notions of the ideal cosmopolitan subject only as its abject Others (Nyers, 2003: 1073).

Cast out from their natal communities and denied full access to viable alternative forms of cultural citizenship, refugees and asylum seekers might be conceived as testing the ontological limits of (new) cosmopolitan subjectivity, particularly within nations, such as Australia, that have adopted punitive asylum systems. If the issue of asylum has played a key part in revitalizing local and international debates about cosmopolitan hospitality, and human rights more generally, new cosmopolitanism has not yet offered a way to account for external impediments to the 'worldly' subjectivity it advocates or for the partial and even oppositional modes of belonging that may result from traumatic attempts to forge new sociopolitical relations. It is not enough to claim, as some theorists do, that refugees and exiles 'represent the spirit of cosmopolitical community' even while they are 'often the victims of modernity, failed by capitalism's upward mobility, and bereft of those comforts and customs of national belonging' (Pollock *et al.*, 2000: 582). Such proclamations seem not only utopian but also curiously indifferent in so far as they demand no redress of capitalism's structural inequalities and no commitment on the part of its beneficiaries to enter *into* cosmopolitical community with those whose experiences of exclusion stand as historical witness to the system's failures. To celebrate the 'spirit' of cosmopolitanism in this way is to occult the lived history of refugees and asylum seekers and to downplay the corporeal aspects – the body-to-body engagements – of cosmopolitical community as cross-cultural *process*.

Given the physical and bureaucratic impediments that prevent refugees and asylum seekers from claiming/exercising any meaningful kind of global citizenship, it may be necessary to bracket questions of their subjectivity vis-à-vis cosmopolitanism from analyses of the degree to which requests for asylum activate an ethics of cosmopolitan openness in any given community. This openness differs from Hannerz's concept of a willingness to engage intellectually and aesthetically with Others (1996: 103), and it is not predicated on intercultural competencies but rather acceptance of unassimilable cultural differences. More specifically, an ethics of openness foregrounds the issue of hospitality that has preoccupied some of the more philosophical (as

distinct from culturalist) strands of new cosmopolitan thinking. In this context, performances about asylum and the experiences of those who seek it may reveal more about *affective* transactions between and within cultures than about theatrical exchange per se. Such transactions are no less corporeal than the other modes of cosmopolitanism we have discussed thus far, though they are entangled in the processes of theatrical representation and reception in distinct ways. By examining recent productions about Australia's treatment of refugees and asylum seekers, this final chapter aims to expand the ethical and political dimensions of cosmopolitan performance. We also locate such productions within a range of discourses about the nation's responses to those proximal 'strangers' habitually positioned (just) outside its collective imaginary.

That recent requests for asylum by Iraqi, Afghani and Iranian refugees, typically arriving by boat at Australia's shores, have been met with decidedly inhospitable responses from authorities marks a revanchist, anti-cosmopolitan turn in the nation's political culture. It has been federal policy since the early 1990s to incarcerate such asylum seekers, mainly in remote camps enclosed by razor wire, until their claims for refugee status have been fully assessed, which can take many months and even years in some cases. Since late 2001, when John Howard won his third federal election (held just after the terrorist attacks on the United States) essentially on (anti-)asylum issues, these so-called boat people have acquired a certain iconicity that crystallizes concerns about national security, sovereignty and identity, which the Howard Government continues to manipulate with much explicit (or tacit) public support. In the process, asylum seekers are cast, at best, as economic migrants and, at worst, as terrorists, even though, according to most figures, more than 85 per cent of those 'processed' have been found to be bona fide refugees fleeing persecution and human rights abuses in their home regions. Relentlessly demonized by government functionaries and sectors of the mainstream media alike, these 'non-citizens', whose Otherness is managed in and through an inflexible system of detention centres, refugee tribunals and temporary protection visas, have had few opportunities to represent themselves to the public. Government restrictions on access to detainees and directives to the media not to show humanizing images of asylum seekers – this means no close-up shots unless of riots or otherwise 'uncivil' behaviour – have further thwarted their efforts to enter into public representation other than as objects of scorn.

The Australian government's instrumentalization of stateless subjects, especially through detention and the (sanitized) imagery of detention,

amounts to a spectacular performance of state sovereignty in Prem Kumar Rajaram's view: 'This is the state asserting itself, asserting its moral and political limits and the ... spatio-temporal relations within. From the performance comes the re-assertion of particular logics of humanity, security, community and responsibility' (2003: 2). We would add that such performances, by troping asylum seekers as physical and moral threats, empty the state's responsibilities to the stranger/outsider of their humanitarian underpinnings so that rejecting the request for refuge becomes ethically acceptable. In response to the frustration of being treated like criminals, of not being granted basic human rights in a country that is signatory to the UN Convention on Refugees, detainees have periodically performed their own spectacular acts of self-assertion – or what Joseph Pugliese calls 'tortured gesture[s] of agency' (2002: par. 12) – by going on hunger strikes, throwing themselves on razor-wire fences, or sewing their lips together to draw attention to their corporeal experiences of state power. Such protests have been incorporated, in turn, into the state logics of exclusion/abjection, re-presented by government ministers and elements of the media circus as further evidence of these particular (Islamic) outsiders' monstrous depravity, their invalid claim to cosmopolitan hospitality.

In mounting a trenchant critique of Australia's asylum system, the performing arts, along with other cultural sectors, have thus faced the particular challenge of finding ways to engage with Others whose presence at the borders of the nation has been marked by both hypervisibility and invisibility and whose access to cross-cultural dialogue has been severely limited. Some brief examples of site-based performance and culture jamming[1] suggest a range of politically-driven responses. Mireille Astore's *Tampa* (2003), mounted in the sand at Sydney's famed Bondi Beach, consisted of daily eight-hour performances of 'relentless waiting' enacted in all weather within a stylized, prison-like sculpture built with poles as a scaled version of the Norwegian freighter that rescued 434 asylum seekers from a sinking Indonesian vessel near Australian waters in August 2001. Foregrounding themes of Otherness and what Ghassan Hage terms 'ethnic caging',[2] the performance examined the nation's shores as sites of *in*hospitality and critiqued the government's refusal to allow the rescued asylum seekers to land on Australian territory.[3] Astore also explored the perspective of the 'caged' by taking photographs, through the bars of her prison, of onlookers and the iconic beach landscape at specific times of day and posting them on a website, which also contained transcribed comments by passers-by.

We Are All Boat People, a loose coalition of activists including artist Deborah Kelly, has orchestrated a number of events similarly dramatizing Australia's 'border panic' and the results of its cruel asylum policies. To commemorate the first anniversary of the sinking of the *SIEV-X* (Suspected Illegal Entry Vessel X) in which 353 asylum seekers, mostly women and children, drowned en route to Australia, the group collaborated with relatives of some of the dead to project their names and faces on a human screen assembled on the banks of the Yarra River. This performance of remembrance and solidarity, staged during the 2002 Melbourne Festival, acted as both a public acknowledgement of the *human* cost of border protection and a public indictment of the government for its attempts to downplay the *SIEV-X* tragedy. Kelly and her collaborators are also known for their culture-jamming activities, including the projection on major public buildings of a large-scale tall ships image with the simple caption, 'Boat People', which links recent refugee migrations with Australia's colonial history and implicitly recognizes Aboriginal sovereignty.

A number of silent vigils staged by protestors with their mouths taped shut to reference lip-sewing protests by detainees – and the general muffling of opposition to asylum policies – have featured among activist performances designed to raise public awareness of the state's failure to embrace its humanitarian responsibilities. The most controversial of these occurred in front of an audience of well over a million viewers during the 'live eviction' sequence of the popular reality television show, *Big Brother*, on 13 June 2004. Merlin Luck, that night's evictee, refused to participate in the standard post-eviction discussion, instead sitting in silence with black masking-tape over his mouth and holding a sign, 'Free th[e] Refugees', that he had smuggled into the studio. His protest prompted the show's flustered host to abandon the live telecast and cut to an advertising break, during which Luck was first counselled by the resident psychologist and then escorted from the stage as he declined to break his silence. Labelled variously as a cheap stunt and a courageous political act, Luck's performance figured in the headline pages of Australian newspapers and generated vigorous debate about asylum issues on *Big Brother*'s fan website as well as capturing the attention of overseas media. Despite their ephemerality, such events, like the *Tampa* and *SIEV-X* performances, contribute to a growing archive of corporeal acts/inscriptions that serve to witness and support refugee rights to cosmopolitan community.

Circus Oz took up this specific issue with a new, human cannonball stunt for its 2003 touring show. In a quirky, symbolic demonstration

of cosmopolitan hospitality, a performer was shot over the 'the barbed wire of bigotry', past the 'border gate of brutality' and 'under the storm clouds of suppression' to land on the 'crash mat of human kindness' (programme note). The company, which lists social justice as part of its artistic mission, has also undertaken outreach work in refugee communities and raised considerable funds for asylum-seeker resource centres. This effort is part of a broader, activist response by the performing arts industry that has coupled theatrical explorations of asylum issues with practical support initiatives and information dissemination. At the artistic level, one of the key projects has been to counter the pernicious dehumanization of asylum seekers in government and media discourses. Against a bureaucratic language of easily imprinted acronyms and images of faceless ciphers for the projection of sundry fears, groups such as Actors for Refugees, who count among their members some of the luminaries of the Australian theatre establishment, explicitly state in promotional material that their mission is to 'humanize the plight of asylum seekers by giving faces and voices to the unseen and unheard'. This project has generated numerous and diverse theatrical productions over the last five years, while also raising some thorny questions about the ethics and politics of cross-cultural representation.

The growing corpus of theatre about asylum includes fictional dramas, stand-up comedy shows, autobiographical monologues, agit-prop performance and physical theatre, but by far the most common type of 'play' in this field has been the verbatim text constructed from letters, interviews and other documented accounts of refugee experiences, often in collaboration with former detainees or members of their ethnic communities. These verbatim dramas typically confront government propaganda and public misinformation with the 'truth' of personal testimony. Presenting the 'back-stories' behind individual requests for asylum, they variously describe experiences of persecution, torture and subjugation, along with the emotional anguish of being forced into exile. Many detail gruelling journeys to Australia and express incomprehension and outrage at the nation's determination to repel the blameless and the vulnerable. Most of the texts also convey the abject humiliation of detention: the constant surveillance, the boredom of the endless wait for processing, the visceral hatred that emanates from some guards and officials, the flies, the heat, the loss of hope, the denial of community. In this context of overriding trauma, the process of performing (auto)biographical narratives can be fraught with problems, as Julie Salverson's analysis of her arts work in refugee communities in

Canada reminds us. Salverson warns of the risk of performing testimony 'caught in an aesthetic of injury' that reproduces configurations of hegemonic power in identifying the oppressed as victims (1999: 37). Such an aesthetic, often inhering in mimetic enactments, excites superficial empathy – an imagined stepping into the refugee's shoes – which incorporates the Other's difference into a form of knowledge that positions the traumatized refugee as an object of spectacle (p. 41). To address this risk, Salverson calls for a theatre praxis that remains sensitive to the intimacy of testimony – where intimate means both deeply personal and communicated through a warm, close relationship – and that accounts for the 'translative, performative moment' in which testimony is enacted (p. 38).[4] This praxis would aim to articulate the nature of the connection between the performer and the life histories being dramatized (whether by refugees themselves or by other actors) and to implicate the audience in that self-reflexive process so that 'reality' is located not in the historical evidence presented, but in the social relationships thereby activated. Salverson also challenges theatre practitioners (and spectators) to recognize multiple, and contradictory, refugee subjectivities and to listen/look as much for resistance as for injury and violation in witnessing trauma (p. 48).

At the heart of Salverson's theorizing is a vision of ethical theatre that 'does not dismiss empathy, but rather challenges the terms on which it is negotiated' (p. 49). While her work suggests the perils of performing refugee histories, it also leaves a space for cross-cultural representation – and reception – by focusing on the encounter between 'animator', text and audience, rather than on the ontological status of the material performed. In this potentially ethical space, it may be possible to stand in for (but not as) Others who are denied access to public representation, to embody their stories in ways that engender and rehearse cosmopolitan community. This is a critical issue for verbatim theatre about asylum in Australia, given that most of the recent projects have been driven by the sense of an urgent need among refugees and asylum seekers to address *mis*representation by publicly telling their own stories (if only by proxy) and an equally strong imperative among audiences to bear witness to such testimony.

Citizen X, one of the first verbatim productions to dramatize the specific plight of Middle-Eastern detainees, uses an epistolary mode with multiple voices and viewpoints to build a composite picture of the gross injustice of the asylum system. Developed by Sidetrack Performance Group in 2001, the text collates fragments of letters sent by asylum seekers incarcerated in the Woomera, Port Hedland, Villawood

and Curtin detention centres to a network of correspondents across Australia. Careful protocols were followed in obtaining permission to stage the letters' contents and ensuring their authors' anonymity to avoid possible reprisals. Some scenes in the fragmented play consist of mere snippets: passing observations, reminiscences, pointed questions, a personal thank you; others detail shocking human rights violations and the culture of contempt that detainees face on a daily basis. Such stories are staged with deliberate irony in a suburban home where the gap between the verbal text and the gestural language of comfortable, everyday living reinforces the exceptional cruelty of detention without reifying images of those it produces as absolute Others. Animated in this manner by three actors (chosen partly for their language groups and ethnicities in the original production),[5] the many texts of the asylum seekers are preserved as communications between speakers/writers and active (cor)respondents in a testimonial transaction. Spectators are interpellated into this dynamic process from the very beginning when the actors take on their roles as vehicles through which the stories will be conveyed and tell their audience: 'We hear the voice of conscience through your mouths only' (Sidetrack Performance Group, 2003: 31). Periodic salutations and farewells maintain this interrelatedness – 'Dear Brother', 'Hello', 'Salam yours', 'Heil Australians' – while the drama's centrepiece, devised from a public letter by a nurse who worked at Woomera, invites viewers, as fellow Australians, to consider their possible positions within, rather than merely as onlookers to, the nation's asylum system. Delivered by Georgina Naidu, not as an ethnic stranger/outsider but as a citizen/insider, the nurse's testimonial is less important in corroborating the stories told than in modelling the openness necessary to cosmopolitan community that the source letters for this theatre project implicitly request.

Something to Declare, first staged in Brisbane in 2003 by Actors for Refugees, delivers a similarly kaleidoscopic portrait of refugee life but intersperses testimonial fragments with a range of documentary material designed to inform and, crucially, unsettle audiences, thereby interrupting the uncomplicated empathy that Salverson warns against. Interleaved with the intimate stories of the asylum seekers are clinical texts such as headcounts of male, female and child detainees; statistics detailing Australia's refugee intake compared to that of other nations; summaries of per capita detention costs; medical and legal reports; and excerpts of official documents, including sections of a 1996 parliamentary bill reaffirming the government's commitment to non-discriminatory immigration policy. The narrative is book-ended by two specific discursive

examples of the intimate and the clinical, set in juxtaposition. It opens with testimony from Amal Hassan Basry, one of the few survivors of the *SIEV-X* tragedy, detailing the moment of the boat's sinking, then cuts to brief, factual descriptions of each of Australia's immigration detention centres. Towards the end, the focus returns to Amal Basry's story, which then segues from the site of unbearable trauma to a childhood memory, before the whole performance closes with a log of the times of day at the various detention centres. The particular narrative structure, with its amplification of just one testimony among the many, also works metonymically to suggest (unspecified) back-stories for the other lives dramatized. Although *Something to Declare* does not foreground its modes of address so directly as *Citizen X*, it creates an overall impression of a vast web of interconnected discourses and practices in which actors and audiences are implicated as both witnesses and citizen advocates. Well-known writer/director Michael Gurr, who compiled the script, alludes to this point when he asserts that the performance is 'not a play but a reading'; the actors are 'giving evidence on behalf of those who cannot', and therefore should avoid 'detailed characterization' (2003: 1–2). While these verbatim projects, and others of their ilk, typically authenticate their texts as 'real' with programme notes and/or advertisements that stress their presentation of 'true' or 'real-life' or 'actual' accounts of detainees' experiences, the dramaturgical approaches to the source material insist that its truth – and historicity – is not simply given, but rather negotiated at the moment of performance.

In line with the aim to 'humanize' asylum seekers' experiences, various verbatim pieces have been described in terms that acknowledge the visceral power of (re)embodied testimony; reviews assert, for instance, that a particular performance 'gives voice to the voiceless' (Dunne, 2002: 18) or 'puts emotional flesh on the bones of abstraction' (Gallasch, 2002: 36). For many theatre critics, and presumably audiences, the affective value of embodiment in communicating asylum requests has been enhanced by the inclusion of actual refugees in the cast. Most prominent among productions using this technique is *Through the Wire*, devised by Ros Horin from the testimonies of four refugees who spent between 22 months and four years in detention centres across Australia. The play premiered in Sydney at the Opera House Studio in 2004 and subsequently had a limited interstate run after its application for a federal government touring subsidy was unexpectedly refused, apparently due to intervention by the Arts Ministry. This censorship resonates uncannily with the story of the actual refugee performing in the show, writer and actor Shahin Shafaei, whose involvement in political theatre

in Iran led to his persecution and exile. At the time of the production, unlike the other refugees whose stories were dramatized by Australian actors, Shafaei had not been granted permanent asylum, but rather a temporary protection visa and could have been deported at any time.

Through the Wire focuses on relationships between the four refugees and the Australian women who helped them through their incarceration. Minimalist but evocative staging literalizes the metaphor of the wire fence suggested by the play's title as the ambiguous site of both communication (through/via barriers) and refusal of cosmopolitan community (see Figure 11). Along with scenes from the detention

Figure 11 Shahin Shafaei in *Through the Wire*, Sydney Opera House Studio, 2004. (Photo: Heidrun Löhr)

centres, the discontinuous narrative features extended monologues in which each refugee character, seated in front of a microphone, tells his real-life equivalent's back-story, with a massive, live-feed video image of his testimony projected simultaneously onto an up-stage screen. The events that put their lives at risk and caused them to seek asylum are various: Farshid discovered a government plot to poison a prominent Iranian; Mohsen blew the whistle on judicial corruption in a court case involving an intelligence officer; Rami was tortured after offering hospitality to a Westerner during a UN weapons inspection of Iraq. Shahin, playing himself, reveals that he first ran afoul of Iran's ruling Ayatollahs for challenging religious dogma and exploring feminist perspectives in his work. Forced to forego his career as a playwright, he took up acting, but was banned from the theatre altogether when he allegedly shook hands with a woman on leaving the stage after winning a major award. He fled his country when a subsequent secret rehearsal of one of his plays was raided by authorities and the director, a close friend, disappeared without a trace. While the particular staging of Shahin's testimonial, in character, risks reproducing the refugee as spectacle – indeed, there is a certain chilling frisson for spectators in the veracity of the witnessing – the mediatization of this process works to provide the necessary critical distance (or double consciousness) that can bring the translative, performative aspects of the testimony into visibility. The projected video image speaks powerfully to government attempts to proscribe media close-ups of detainees; symbolically, it also inverts the surveillance mechanisms, the 'panoptic modality of power' (Foucault, 1977: 218), inherent in the detention system and thematized elsewhere in the text. At this point, the spectator's gaze is split between the apparently vulnerable refugee/actor and his imposing – even accusing – screen 'double', which ideally prevents unproblematic identification of/with the performer as victim. Without precluding compassion, such theatricality challenges audiences to recognize their implication in asylum abuses; as one reviewer put it, '[t]here's no place to hide' (Krauth, 2005: 28).

Media interviews with Shahin Shafaei point to the complexity of his role in the creation and execution of this testimonial performance. He reveals the initial difficulty of laying bare his life for scrutiny in rehearsals and the pain of reiteration each time he performs. Tactfully, he also points to the incommensurability between outsider and insider perspectives in such contexts: 'to act yourself is a very bizarre experience. Also there's a director who says "Walk in this way" or "Tell this line in this way" and you know that in your real life it was done another way' (quoted in Gill, 2005: 100). How Shafaei worked through/with personal

trauma and negotiated the frictions between interpretive and autobiographical frames in this project can only be guessed. Nevertheless, Kirsten Krauth's observation that he 'tells his story with the distance of a writer/actor through necessity' (2005: 28) suggests his successful insertion of a critical caesura between the related subjectivities of performer and refugee.

If embodying the histories of those subjected to trauma needs to be approached within a relational context that posits the possibility of ethical cross-cultural transactions, finding ways to represent the corporeal 'wounds' of refugees and asylum seekers – the (in)visible inscriptions of state violence etched in their flesh – presents even greater challenges for theatre practitioners, especially when such wounds are perceived by the public to be self-inflicted. Lip-sewing is the paradigmatic example of this kind of wound and has become a particular topic of focus in the many theatre projects that aim to expose the visceral harm instantiated by Australia's detention system and to endorse the cosmopolitan right to ethical community. The most publicized instance of lip-sewing occurred in Woomera in 2002 and involved approximately 70 asylum seekers who were part of a larger hunger strike staged to draw attention to the government's refusal to process Afghani applications for refugee status following the ousting of the Taliban regime. The immigration minister, Phillip Ruddock, responded to the protest with an extensively telecast statement designating lip-sewing as a heinous practice performed by the nation's Others, in ways that violated the protocols of rational and reasonable behaviour: 'Lip-sewing is a practice unknown in our culture. It's something that offends the sensitivities of Australians. The protestors believe it might influence the way we might respond. It can't and it won't' (quoted in West, 2002: 7). This callous response to the asylum seekers' desperate political gesture, itself embodied in a stunningly literal *and* powerfully symbolic way, surely gives lie to the efficacy of a cosmopolitics founded only in *imagined* community. Ironically, it was precisely at the very visceral moment when the asylum seekers insisted on being granted Kant's universal right to hospitality that they were most decisively marked as non-cosmopolitan, even non-human.

Pugliese has written cogently and passionately about lip-sewing, arguing that 'by intextuating the organ of speech literally with thread, [detainees] symbolically magnify the acts of censure and prohibition that reduce [them] to silence' (2002: par. 17). Lip suturing, he maintains, 'also signals despair at the very possibility of ethical dialogue' and bears testimony to 'the failure of the nation to speak a language of ethical hospitality' or to offer nourishment or sustenance to the traumatized

refugee seeking asylum (par. 18). In his formulation, lip-sewing and other kinds of self-mutilation practised by detainees 'must be located at the level of *the corpus of the nation*' in so far as they reflect 'back to the nation the gestures of refusal and rejection that it violently deploys in the detention, imprisonment and expulsion of refugees and asylum seekers' (par. 7). This 'penal exercise of state power ... produce[s] a body that does not simply and self-identically belong to the individual subject' since its significations are 'shaped and invested' by the forces that detain it and, simultaneously, by those that represent it (par. 8).

For our purposes, the significance of Pugliese's argument lies in its suggestion that asylum seekers' bodies, under Australia's 'deterrence' regime, circulate within a national economy of representation that demands the production of spectacle, not so much as entertainment but as abjection or revulsion (2002: par. 32). Pugliese calls this economy a 'theatre of cruelty' in which the 'decency' of the nation and its citizens is constantly violated by the detainees' apparent barbarity, allowing Australians to 'disown complicity' in its violent (re)production (par. 34). His points about the spectacularization of violence through representation raise urgent questions about how performance, as embodied praxis, might engage with the highly visual and deeply sensory wound of lip-sewing. If, among actual detainees, the act of suturing lips together fuses the literal and metaphorical in a process of violent intextuation (in Pugliese's terms), what can it mean to re-present lip-sewing in an aesthetic context to a particular audience gathered together for the express purpose of seeing images of refugee life? How can theatricalized citations of lip-sewing in Australian detention centres address the lack of an ethical response to asylum seekers and the gestures of rejection and refusal that these incidents initially highlighted?

One of the earliest and most controversial presentations of this wound as an embodied trope was staged by well-known performance artist Mike Parr at the Monash University Museum of Art in 2002. To publicize the conditions in detention centres, Parr sewed up his lips, cheeks, nose and eyelids and sat motionless with the word 'alien' branded on his thigh in a five-hour protest titled *Close the Concentration Camps*, which was simulcast on the web. Other parts of his installation included projected slides and framed letters about the politics and context of his work, which he presented as an act of solidarity with asylum seekers. Parr has since repeated versions of this performance at other venues, notably at Sydney's Artspace in 2003, where it was renamed *Aussie, Aussie, Aussie, Oi, Oi, Oi: Democratic Torture* and expanded in reference to critique Australia's participation in the war on Iraq. On this occa-

sion, Internet viewers could deliver a shock to his exhausted face at any time during the 30-hour performance by activating a hotspot on their screens. Not surprisingly, Parr's work has met with fascination and disgust (as intended) and accusations of sensationalism, along with some plaudits as a confronting political intervention (see Heinrich, 2002: 3). Such 'art' does seem to play on the aesthetics of injury in its grotesque re-enactment of the horrors of self-harm; in this sense, it functions as an abreactive performance that ritually reinscribes, and thus purges, the national blight of lip-sewing. At the same time, Parr's protest captures the anguished literality of the asylum seekers' actions, adding political complexity – and perhaps an ethical dimension – to his performance. This literality, indexing the original wounds of the asylum seekers, elicits an affective residue, an excess, in Rebecca Schneider's terms, that seeps into the complicit space between performer and audience and 'repeat[s] across our social nervous system' as a form of embodied knowledge (1997: 174): a collective recognition of the trauma erased in government representations of lip-sewing as an affront to common decency.[6]

The themes of non-entry and closure of communication magnified by Parr's sutured face are echoed in other performances that evoke or enact lip-sewing. Though the narrative and dramaturgical functions of this trope vary in the texts concerned, it is most often used to indict the nation in verbal or visual communiqués addressed directly to the audience as citizen representatives of an unjust regime. For instance, *Citizen X* features a poem by a detainee that explicitly metaphorizes lip-sewing as staging the graphic failure of the social contract by which requests for asylum should at least be heard. The poem is recited early in the performance and reiterated as its closing piece:

> Will you please observe through the wire
> I am sewing my feet together
> They have walked about as far
> As they ever need to go
>
> Will you further observe
> Through the wire
> I am sewing my heart together
> It is now so full of
> The ashes of my days
> It will not hold
> Any more

> Through the wire
> One last time
> Please observe
> I am sewing my lips together
> That which you are denying us
> We should never have
> Had to ask for.

> (Sidetrack Performance Group, 2003: 32)

Another 2002 play, *The Waiting Room*, devised in agit-prop style by Sydney's Platform 27 in collaboration with Melbourne Workers Theatre, featured what one reviewer describes as a 'profound moment of quiet horror' when the spotlight fell on a performer cuddling a teddy bear and sewing its mouth shut (Harris, 2002). This functions as a more elliptical condemnation of the government's stance towards asylum seekers, aspects of which are thematized in the play by an allegorical, Kafkaesque character who wanders in and out of the action; he is stranded in an unspecified place/space not knowing his crime, who is persecuting him, what laws he has unknowingly broken or how to secure his release. In a different manoeuvre, *There is Nothing Here* (2003) by Afshin Nikouseresht and Dave Kelman depicts lip-sewing as the only viable response to the kind of interrogation (Islamic) asylum seekers routinely experience when they enter Australian territory. The young Afghani protagonist, Mohammed, humiliated and terrified, sews his lips together in the last moments of the play to avoid further dialogue after unwittingly incriminating himself in response to leading questions by a security officer determined to cast him as a terrorist. As he sits in his cell, back to the audience and lit in silhouette so only the pulling of the thread is visible, the gratuitous cruelty of the asylum system is underscored while the guard casually listens to a translated Farsi poem about hope and justice.[7] Performed before the implementation of upgraded anti-terrorist measures in Australia and elsewhere, this fictional drama now seems prophetic in its vision of the state silencing of political opposition.

In all of these plays, the matter of embodiment is critical to the ethico-political effects we want to claim for theatrical representations of lip-sewing. This is not to suggest that particular value should be attached to fleshly *enactments* of this wound – in fact, only Parr's installation has done this – but that visceral, affective communication between performers and spectators is necessary for the (re)generation of cosmopolitan community. We see this process as beginning when

spectators enter into a testimonial transaction, of the kind we discussed in Chapter 2's analysis of the Stolen Generations' narratives, to engage with shame as a civic response to their complicity in the brutalization of refugees and asylum seekers. *In Our Name* (2004), devised by Nigel Jamieson from extensive interviews with the deported Al Abaddi family describing their 1000-day ordeal in Australian detention centres,[8] sets up precisely this kind of testimonial contract through reference to lip-sewing. The incident is introduced as a desperate response to months of isolation, denigration, physical abuse and broken promises as the Iraqi detainees wait in vain for news about their request for asylum. Initially, members of the family deliver a collective account of the strike, their memories condensed into single-line sentences spoken in sequence, then Humam, the 15-year-old son explains the actual process of lip-suturing in starkly graphic terms:

> It's not a difficult thing to do. You need cotton, ice and a needle. You put ice on the lips for a few minutes to numb them, then you tense the muscles and push the needle in through and out again. The needle doesn't hurt so much but the dragging cotton through hurts a lot. Then you take the cotton over and force the needle through the bottom lip then cross over to the other side. It doesn't bleed much, but you can't speak, eat or drink properly. Some detainees just put the needle through the skin of the lips, but we put it through the full thickness to make sure we had done it properly. It made our bodies shake.
>
> (Jamieson, 2004: 16)

This scene implicitly asks viewers to occupy the position of the second person, the responsive listener who is the necessary complement to the first-person narrator in the generic form of testimony (Whitlock, 2001: 209). The sense of national shame invoked here is more explicitly exhorted later in the play when Humam's father, Jasim, addresses spectators in the accusative voice, demanding they acknowledge their complicity in the torment carried out by *their* government in *their* name: 'Mr Ruddock ... MR Howard ... fine people of Australia ... did you have to ... do this to my beautiful boy?' (Jamieson, 2004: 35) In such socio-corporeal contexts, lip-sewing is not a form of self-mutilation that emphasizes the gulf between Australians and aliens (as the government insists), but an act that urges ethical engagement with, and responsibility toward, the Other. Spoken directly to the audience in a form of body-to-body contact where emotional affect comes into play, Humam's

dialogue, like the poem cited earlier from *Citizen X*, asks audiences to admit that lip-sewing is generated out of Australian soil, as Pugliese argues, that it is produced by Australian culture, 'legislatively, juridically and penally' (2002: par. 40). The temporal and spatial locatedness of such asylum wounds is also stressed in Jamieson's pre-show media interview: 'I'm sad to say that the Tampa and detention centres are the defining icons of the beginning of the 21st century in Australia' (quoted in Morgan, 2004: 21). This is a particularly significant statement coming from an artist widely recognized as one of Australia's leading iconographers following his role in staging the nation, to itself and the world, in segments of the Sydney Olympic Opening Ceremony.

The 'civic archaeology' being undertaken through the performance of asylum testimony is amplified in the work of Sydney's version 1.0, self-styled as an edgy, visceral ensemble that makes 'human scale interventions into the body politic'.[9] Rather than dramatizing the specific experiences of asylum seekers, version 1.0 has turned its anatomizing gaze on the political processes that inhibit cosmopolitan community. The group's most provocative work to date, *CMI (A Certain Maritime Incident)* (2004), uses self-reflexive verbatim techniques meshed with physical theatre to investigate the workings of Australia's maritime border protection regime, Operation Relex. The play focuses primarily on the 2002 Senate Select Committee inquiry into the scandalous 'children overboard affair', in which the Howard Government maliciously claimed that asylum seekers approaching Australian waters had thrown their children into the sea in an effort to force a naval rescue. Most of the dialogue is distilled from Hansard transcripts of the testimony voiced by government and naval personnel; no asylum seeker was permitted to give evidence at this inquiry though witness accounts of the *SIEV-X* sinking, which occurred less than two weeks after the earlier boat was intercepted, were submitted in written form. Powerful evocations of the victims of this particular disaster, presented as the real (occulted) 'incident' that haunts the margins of the farcical hearing, frame the performers' satirical representation of the Committee's processes.

In what the publicity material calls 'an act of public outrage', *CMI* stages the inquiry as a series of violent speech acts 'remaking matters of ethical weight and importance ... into a stupid and stupefying language of nonsensical procedure' (David Williams, 2004: 9). The text attacks the crisis euphemisms and clinical acronyms – SUNC (suspected unauthorized non-citizen), UA (unauthorized arrival), PII (potential illegal immigrant) – used to erase the bodies, the humanity, of the asylum seekers,

and suggests that the inquiry could only ever deliver an appearance of democracy at work. Revolving footage of the parliament buildings underscores the endless obfuscations inherent in the committee present-ations. Juxtaposed to this verbiage at the very end of the proceedings is a computerized voice that reads factual statements from the survivors of the sunken *SIEV-X*. The words are projected on up-stage screens as if being typed simultaneously by an unseen hand, while a naked 'corpse' is ritually laid out and tagged in anonymity. This technologized witness testimony, devoid of emotion and devastating in its simplicity, suggests the silencing, the suturing, of the lips/wounds of the living and the dead whose embodied (hi)stories should have been publicly heard. With this finale, *CMI* also captures the insidious workings of 'necropolitics', the state's arrogation of the right to determine under what practical condi-tions Other(ed) human beings become disposable, allowed to live or exposed to death at the behest of sovereign power (Mbembe, 2003: 11).

While most critics have welcomed the political turn in Australian theatre evinced by *CMI* and the other asylum texts discussed here, some have expressed concerns that such works may be preaching to the converted. We want to challenge this assumption, one so often made of political theatre, by arguing that ideological persuasion is not the most important cultural work being achieved in these performances. Their significance resides, rather, in their potential to elicit shame and outrage as a prelude to ethical community, and it seems they have been highly effective in this activist project if responses such as the following are any measure: 'We the audience were left with a deep sense of national shame' (Mockett, 2003); 'I think looking back, we will be shocked that we actually went so low ... that so many values that should sit at the centre of a democracy were thrown away' (Jaivin, 2004: 62); '[H]ow could we squander our self respect, our human dignity and sense of justice so easily?' (Felicity Harrison, 2004). The silent vigils and remem-brance ceremonies mentioned earlier are also expressions of shame as the defining connection between the citizen, the asylum seeker and the nation.

As affective responses, shame and outrage address the 'strategic deployment of rationality and the criticism of emotion' that has func-tioned so powerfully in Australia to marginalize sympathy for asylum seekers (Robert Dixon, 2002: 20). If, as Rosalyn Diprose argues, affective response is the prerequisite for an ethical rather than merely polit-ical, relation with the Other (2003: 41), then shame and outrage in this context also potentially set up the conditions for cosmopolitan community. While this ethico-political project connects with the philo-

sophical strands of cosmopolitanism, it demands a richer notion of cosmopolitan hospitality than Kant's theorizing entails. Derrida has recently explored the concept of a cosmopolitics of refuge where the right to hospitality is seen not in Kantian terms as an imperative to global commerce and world peace, but as a by-product of globalization to which we must respond. Derrida makes the distinction between unconditional and conditional hospitality and notes fundamental antimony between the two types; unconditional hospitality (the Law) dictates that any stranger should be welcomed to a territory regardless of his/her origins while conditional hospitality (the laws) is determined and regulated by the state and its legal apparatus and draws particular limits to hospitality as a right of visitation, not residence (2001: 16–23). To begin to conceive a way through the apparent impasse inherent in negotiating between these two concepts, Derrida argues the need for a new ethics of hospitality based on receptiveness and responsiveness (that is, affective states) and suggests that this reorientation of cosmopolitan rights would require rethinking questions of statehood and sovereignty (2001: 4–5). In the context of asylum, the concept of hospitality also needs to be extended to account for a continuing interaction with the Other as well as an initial response.

In their particular kinds of affective engagement, performances about asylum potentially activate the states of receptiveness and responsiveness that Derrida stresses as the bases for a new (as yet unrealized) cosmopolitan hospitality. It seems that Australian audiences attend such performances less to affirm their support for detainees (thought this is part of the equation) than to publicly enact their shame (the shame their government has thus far denied) as a civic action performed in and to and on behalf of their communities. This is not the same as catharsis, however similar it may look and feel, but rather a differently embodied response we want to claim as potentially efficacious. Baz Kershaw argues that the concept of community is the key to efficacy in performance since community is 'the concrete medium of face-to-face interactions through which we enact ideological [and, we would add, corporeal] business with the wider social structure' (1992: 29). In his view, efficacy is possible when the immediate and local effects of a particular performance change, however minutely, not just the future action of its audience members but also the structure of their community (Kershaw, 1992: 1). Cumulatively, the texts discussed here do precisely this kind of communal and cultural work in their treatment of the wounds of asylum, and in so doing, they reduce, however infinitesimally, the spectacularization of violence that Pugliese so deplores of the

image economy in which representations of asylum seekers in Australia circulate.

A brief analysis of Théâtre du Soleil's two-part epic, *Le Dernier Caravansérail*, and its particular reception in Australia at the 2005 Melbourne Festival further illuminates the connections between representation, community and spectacle. While this breathtaking drama about the odysseys of the globally dispossessed no doubt deserves the international recognition it has enjoyed, the aesthetics of the production and, perhaps more critically, its circulation as a 'masterpiece' in the global arts market, circumscribes its potential for efficacy in the terms we have outlined. The show's visual appeal, much lauded by critics, turns on a collocation of images that infuse the harrowing traumas communicated by the refugee stories with the aesthetic pleasures of orientalism. Particularly resonant in this respect are the snapshots of Afghanistan: elusive women in full, pale-blue burqas; a starkly beautiful burnt-out hut; the cruel Taliban, both mysterious and immediately recognizable beneath black beards and turbans. Visually condensed on small mobile platforms dwarfed by the vast stage, such images conjure a generic Middle East positioned as the Other of European modernity. The asylum seekers' experiences, as Judith Miller observes, are set off 'in quotation marks', visually registered and 'often deeply felt, but only partially understood' (2006: 217). The audience as collective witness to the verbatim testimonies – often projected in exquisite (foreign) handwriting – thus recedes from visibility while the conditions of ethical responsiveness are subordinated to the imperatives of voyeurism. This dynamic, which foregrounds the (beautiful) vulnerability of the body as a testimonial site, seems to capture precisely Salverson's notion of 'an aesthetic of injury' that codifies the very powerlessness the performance seeks to address (1999: 35).

Le Dernier Caravansérail created a definite buzz at the festival where critics made much of its Australian connections. Many claimed, erroneously, that the initial idea for the play was inspired by director Ariane Mnouchkine's interviews with Villawood detainees, and most took the opportunity to highlight the iconically Australian scenes. These featured boat-people being repelled by the coastguard and a detainee facing a refugee tribunal, set in a remote camp to the background strains of didgeridoo music. Beyond these superficial observations, which position the antipodean gulag as interchangeable with refugee camps at Sangatte and other places, reviews did not register the play as speaking to local asylum practices but rather as staging the ubiquity of human suffering in our times. The sense of shame that has permeated responses to most asylum theatre in Australia was noticeably absent. In this respect, the

production functioned quite differently in relation to its interpretive community, seeming to confirm the nation's visibility in the global (dis)order dramatized and, simultaneously, in the international arts world. That the doyenne of intercultural theatre could be persuaded to bring her show to Melbourne was clearly cause for great local pride and supposedly confirmed Australians' 'desire to see aesthetically mature work' (Coslovich, 2005: 8). Critics stressed the production's massive scale and the immense effort required to stage it, along with the fact that the state government had funded extra performances, one attended by the premier himself. Whereas outside of Australia *Le Dernier Cara-vansérail* has sometimes been charged with exoticism (see Stefanova), on this occasion there were no discordant notes in a uniform symphony of praise. For Martin Ball, among others, Mnouchkine's legendary work, compared to local performances about asylum, even had the effect of making 'the politics irrelevant' (2005: 16).

While we have argued that the act of representing refugee stories in the flesh, in public, is central to the processes by which an edifying national shame might be produced, the example of *Le Dernier Caravansérail* reiterates the connectivity of local and global inflections. Critics such as James Goodman have positioned such local activist projects as part of a global refugee solidarity movement based on cosmopolitan anti-nationalism. This conception would be in keeping with claims that cosmopolitanism (in both its new and old forms) is necessarily the antithesis of nationalism. In Australia, as this book has demonstrated, the two cannot be opposed so easily. If refugee solidarity is driven by the demand for an ethical response to the Other who seeks protection and hospitality in the nation-space, then such solidarity, and its practical manifestations, must be seen as deeply imbricated in nationalist formations. Ironically, this is confirmed by the prime minister's habit of labelling as 'un-Australian' those people who refuse to celebrate the nation's colonial history or who critique its racialized immigration practices. Some artists and intellectuals have gladly occupied the space of the un-Australian, not as part of a process of disinterested separation from the nation but in an attempt to claim back that basic decency they feel has been shamefully put aside by the resurgent fortress Australia mentality. In this respect, the cultural work Australian theatre is doing in relation to national policies about asylum is not so much to think and feel beyond the nation but to think and feel *for* a nation that has thus far failed to include some of the world's most vulnerable people in its humanitarian embrace.

Conclusion: Cosmopolitics in the New Millennium

Australia's increasing openness to the globalization of market capitalism has been accompanied, ironically, by a progressive narrowing of the state's vision of global social justice, particular as it informs domestic matters relating to the management of the cultural matrix. This anti-cosmopolitan turn is encapsulated by John Howard's repeated assertion of the nation's authority to determine the parameters of asylum seekers' (human) rights: '*We* will decide who comes into the country and the circumstances in which they come.' Here, the sovereign power of the nation-state is used to validate a legalistic stance that admits no overriding ethical or moral claim to hospitality. The government's retreat from humanitarian responsibility is matched by the literal shrinking of the nation-space through the redefinition of its borders in an effort to prevent valid asylum applications.[1] This (white) arrogation of sovereignty has been challenged by several indigenous leaders who point to the constitutive violence of colonialism, now being revisited in the regime of mandatory detention, as undermining the validity of government determinations of land rights/rights of landing. The presence of indigenous participants at arts events, public rallies and vigils in support of refugees confirm that there is strong feeling on this matter within sections of the Aboriginal community.

Aboriginal leaders such as Wadjularbinna, a Gungalidda elder from the Gulf of Carpentaria, not only challenge the white establishment's claim to sovereignty by insisting on prior rights of custodianship – 'this is not John Howard's country, it has been stolen ... taken over by the first fleet of illegal boat people' (2002: par. 17) – but also underscore the fundamental ethics of hospitality that has been obfuscated by the juridical processes of what Ghassan Hage calls 'paranoid nationalism'

(2003). Wadjularbinna insists on an autochthonous form of cosmopolitanism that preceded European colonization:

> [W]e were all different, speaking different languages, but we all had the same kinship system for all human beings, in a spiritual way. Our religion and cultural beliefs teach us that everyone is a part of us and we should care about them ... it's a duty. ... People can come here, if they respect our land, and treat our land as it should be treated ... and if they respect our differences.
>
> (2002: pars 6–7)

Such expressions of hospitality, from people who have themselves suffered dispossession, serve as powerful reminders of our fundamental ethical responsibility as human(e) beings to care for others in need. It should be noted that this indigenous welcome to country is not assimilative, but instead emphasizes cohabitation as a process of practical negotiation founded on an ethos of mutual respect.

This stance of openness to difference contrasts markedly to the insularity nurtured in mainstream society by the decade-long Howard regime, which has produced an aggressively nationalist and exclusivist notion of Australianness typified by resistance to reconciliation, cultural pluralism and republicanism. The threat of global terrorism provides an alibi for such anti-cosmopolitanism, leading to further erosions of social equity principles. Hage acerbically describes this mode of governance as phallic:

> Phallic democracy is the democracy that one has, rather than the democracy one lives. It's the democracy of those who say 'we have got democracy', rather than those who say 'we *live* democratically'. ... The phallic democrat says to his other: 'My democracy is really big! As opposed to you who have a very little democracy! Likewise my tolerance and my freedom of speech – look at them!'
>
> (2005: 29)

It occurs to us that phallic democracy is not unlike thin cosmopolitanism in that both are staged for political effect and economic expediency in response to global/local forces, rather than conceived as materially grounded, everyday, embodied practices of living *together in difference* in ways that necessitate exchange and mutual accommodation.

Notwithstanding its commercial tendencies, theatre offers a rare opportunity to instantiate an ethical and politicized cultural dialogue

that destabilizes the shrinking borders of our imagined community. Building on performances that expose and address the shameful aspects of nation-building, new cultural scripts in Australasia are also challenging dominant racial triangulations that assume whiteness as the mediating element in cross-cultural exchange. There is an emerging alliance between indigenous and Asian artists that by-passes white brokerage, as exemplified by Ningali Lawford and Hung Le's *Black and Tran*, which premiered at the 2000 Melbourne International Comedy Festival. Billed as a 'comedy that laughs in the face of racism', the show features Lawford, an Aboriginal woman from the Kimberley region, and Le, a refugee from Vietnam, sharing common experiences of racial discrimination and cultural dispossession from White Australia (see Figure 12). Using racial stereotypes to undermine cultural (mis)conceptions, their 'Aborasian' partnership made a strong impression on critics, many of whom noted its pertinence in the light of continuing debates about indigenous land rights, Asian immigration and the mandatory detention of refugees.[2] Another Aboriginal–Asian alliance is explored in Lucy Dann and Mayu Kanamori's *Heart of the Journey* (2000), a slideshow that traces Dann's journey from Broome to Japan in search of her

Figure 12 Ningali Lawford and Hung Le in *Black and Tran*, Melbourne International Comedy Festival, 2000. (Photo: Michael O'Brian, courtesy West Australian newspapers)

Japanese father. The performance not only celebrates Dann's newly discovered mixed-race identity and an extended family network in Japan, but also excavates the subaltern history of voluntary miscegenation between indigenous and Asian communities at the height of the White Australia era.

Such efforts to recalibrate the prevailing racial model are also found in cross-cultural productions foregrounding alternative cosmopolitan histories of contact between Aboriginals and Asians that preceded European incursions into the continent. Among notable Top End shows in this mode is the multilingual opera, *Trepang*, which dramatized encounters between Macassan seafarers from the Indonesian islands and the Yolngu people from northeast Arnhem Land, who were partners in the trepang (sea cucumber) trade between the late seventeenth and early nineteenth centuries. Directed by Andrish Saint Claire, a migrant from Hungary, the show was first performed in 1996 as part of a Yolngu community celebration on Elcho Island; subsequent development led to a full-scale production in Darwin and the Sulawesi capital of Ujung Pandang (the old city of Macassar) in 1999. Conceived as a demotic re-enactment of history, *Trepang* was based on a traditional indigenous ceremonial song cycle and included Macassan and Yolngu performers, many of whom were related by a kinship system established from their early contact. Significantly, the project did not shy away from confronting the violence and bloodshed that was part of this encounter, even as it celebrated the resultant blood ties, shared lexicon and strong trade and cultural connections between the two groups. More recent collaborations such as Marrugeku's *Burning Daylight* (2006) also embrace the project of revisioning contact histories to highlight cross-cultural exchanges that unsettle the hegemony of colonial cosmopolitanism. This multimedia and multilingual production, which was developed in Broome, explores the interactions between Aboriginals, Asians and Caucasians that have resulted in the town's distinctive hybrid culture today. The production employs a mixture of indigenous contemporary and traditional dance styles textured with silat, a Malay martial art form, and features a series of projected images drawn from interracial melodramas, set against a historical backdrop of brutal assimilation policies, deportation of Asians and the internment of Japanese locals during World War II.

On a similar trajectory, Caucasian playwrights such as Stephen Carleton are also reconfiguring the tripartite racial calculus in mainstage works. His award-winning gothic drama, *Constance Drinkwater and the Final Days of Somerset* (2006), is set in a fictional 1890s colonial

settlement in the multiracial far north, and depicts the struggles of the recently widowed wife of a Government Resident to sustain the illusion of absolute whiteness necessary for colonial rule. The arrival of two shipwrecked visitors, one of whom is a Chinese trader, exposes the dirty secrets of colonial desire. The text's invasion narrative, which explicitly dramatizes the colonial society's fears of racial and cultural miscegenation with Aboriginals and Asians, is consciously framed to critique contemporary Australian anxieties about border security, refugees and ethnic diversity. By underscoring the racial/racist foundations of the nation, Carleton suggests that White Australia's violent appropriation of indigenous land and its continuing failure to accept moral responsibility for this history will lead to self-destruction, as dramatically portrayed by Constance's systematic murder of her family with the poisoned flour used by the authorities to 'manage' the indigenous population. The impossibility of sustaining whiteness as a regime of power is stressed at the end of the play when Constance's only surviving daughter steps away from the Residency towards a miscegenated future with the Chinese trader and the local indigenous community.

While these new trajectories in Australasian theatre rehearse alternative visions of cosmopolitan community, they also acknowledge the impediments to its realization at a time when the notion of common humanity is increasingly under threat. As our study demonstrates, (new) cosmopolitanism does not offer any easy solutions to the racial tensions, border phobias or exploitative practices that tend to characterize cross-cultural commerce, though it does suggest the urgency of addressing underlying structural asymmetries between the communities and cultures at issue. The usefulness of cosmopolitanism as a theoretical model for performance analysis lies in its provocation to examine the political and aesthetic aspects of cross-cultural exchange, positioned within the broader transnational flows of people and commodities associated with globalization. Critically, the philosophical strands of cosmopolitanism also foreground the ethics of cross-cultural interaction. As an idea/ideal of engagement with alterity, cosmopolitanism goes beyond notions of empathy and tolerance (which, arguably, proceed from unequal power relations between Self and Other), towards a recognition of intersubjectivity in which individuals and cultures are 'conjoined in an act of affirmation without obliterating difference' (Pugliese, 2002: par. 48). Applied to theatre, such an ethical and mutually constitutive model of cosmopolitan community would go some way towards stemming the trade in exotica that typifies many contemporary cross-cultural experiments.

In the context of cosmopolitanism as a field of study, perhaps the most significant aspect of this book lies in its stress on the practical elements of crossing cultures. Despite its recent attempts to take into account discrepant practices and subaltern experiences, cosmopolitanism as a knowledge formation has largely circulated at elite levels, in the arena of academia, social policy, media and commerce. We have endeavoured to explore the mechanics of cosmopolitanism as material praxis and, in stressing theatre's specific conditions of embodiment, to complicate some of the foundational principles of cosmopolitan theory, especially its abstract idealization of global citizenship. This book's emphasis on the *realpolitik* of cross-cultural performance underscores the need for a more nuanced theory of cosmopolitanism that takes into account the impact of bodily inscriptions as well as body mobilities and embodied consciousness. In its analysis of the Australasian performing arts sector, our study also opens up new spaces for a specifically Australian inflection of, and extension to, the current Euro-American theorizations of cosmopolitanism. By focusing on indigenous and other minoritarian experiences and cultural practices *within* the nation that might be considered cosmopolitan, we challenge prevailing thinking about cosmopolitanism as a transnational phenomenon characterized by an encounter with Otherness *beyond* the nation. As the first comprehensive study of Aboriginal and Asian cross-cultural theatre practice positioned within a global arts marketplace, *Performance and Cosmopolitics* troubles the sleek and shiny populism of cosmopolitan-talk. To quote Scott Malcomson, 'the cosmopolitan's challenges are not in theory but in practice' (1998: 238).

Notes

Introduction: performing cosmopolitics

1 Unattributed feature article, *Australian*, 16 September 2000, p. 6.
2 Although the riots resulted directly from a series of locally staged tensions revolving around beach territoriality and male youth culture, the anti-Arab sentiments expressed by demonstrators and circulated by the media tapped into a much wider context of racism provoked by Australia's participation in the US-led anti-terrorism alliance, the bombings of Australian tourists in Bali by Islamic militants, and a high-profile case of the rape of Caucasian girls by a gang of Lebanese youths in 2002.
3 Federal Government of Australia. (1994) *Creative Nation: Commonwealth Cultural Policy*. <http://www.nla.gov.au/creative.nation/intro.html> (accessed 19 July 2005).
4 The Immigration Restriction Act of 1901 was the cornerstone of the 'White Australia Policy' aimed at excluding all non-European migration. The Act was enforced through the use of a dictation test, similar to the one used in South Africa, which enabled authorities to deny entry to any person who was not able to transcribe a passage dictated in a designated European language. The Act remained in force until 1958.
5 Many Australians who voted 'no' in fact supported the idea of a republic but did not agree with the only model offered by the ballot. For detailed analysis of the referendum's results, see *Australian Journal of Political Science*, 36:2 (2001).
6 See Veronica Kelly (1998a: 9–10) for a succinct overview of significant studies in contemporary Australian theatre to 1997. More recent additions to this list include Kelly's edited collection assessing the field's state of play in the late 1990s (1998b); Helen Gilbert's study of race, gender and the nation (1998a); Peta Tait's edited book on physical theatre (2000); Alan Filewod and David Watt's analysis of workers' theatre in Australia, Canada and Britain (2001); Maryrose Casey's chronicle of Aboriginal theatre (2004); Geoffrey Milne's account of industry and funding structures (2004); and Rachel Fensham and Denise Varney's study of women writers and directors (2005).
7 By contrast, the indigenizing processes analysed are not closely connected with multiculturalism, which has been dominated by the discourse of immigration in ways that effectively sideline the key indigenous issues of land rights and sovereignty. Moreover, cultural policies concerning Aboriginals are typically conceived and administered as separate from designated multicultural programmes.

Chapter 1 (Anti-)cosmopolitan encounters

1 Untitled review of Chinese opera at the Prince of Wales Theatre, Melbourne, *Argus*, 2 November 1860, p. 5.
2 Untitled review of *Foiled* by W. C. Cooper, *Table Talk*, 10 January 1896, p. 6.

3 In this play, the heroine also makes the claim (unusual for its time) that she would prefer to marry an Aboriginal than her unwelcome suitor and have 'a man for a husband' rather than 'be chained for life to some senseless noodle' (quoted in Margaret Williams, 1983: 202).

4 A review of *The Mikado*'s 1885 Australian premiere praises the 'gorgeous' costumes and general look of the production, relating it to a growing interest in Japanese cultural artefacts. 'The Mikado; or the Town of Titipu', *Sydney Morning Herald*, 16 November 1885, p. 7.

5 Henry Parkes, Premier of New South Wales five times between 1872 and 1891, famously declared in 1890 that a federated Australian nation would be united by the 'crimson thread of kinship'. The phrase soon became the buzzword for the federation movement (McGrath, 2003: 37).

6 Untitled review of *White Australia, or the Empty North* by Randolph Bedford, *Bulletin*, 1 July 1909, pp. 8–9.

Chapter 2 Indigenizing Australian theatre

1 Although citizenship and voting rights had already been granted to indigenous groups, what was significant about these amendments is that an overwhelming proportion of the population voted in a referendum to approve them, thus symbolically casting aside notions that Aboriginals simply did not count.

2 On the same day in the erstwhile imperial centre, Koori elder Burnum Burnum planted an Aboriginal flag at Dover to symbolically claim Britain for his people.

3 See Gilbert (1998a: 51–95 passim) for a detailed discussion of the ways in which the three plays – *The Dreamers* (1982), *No Sugar* (1985) and *Barungin* (1988) – and Davis's earlier work, *Kullark* (1979), engage with the effects of European colonization in Australia.

4 Sidetrack was similarly in the minority of 'multicultural' companies to tackle the subject of Aboriginality in ways that complicated the general black–white framework for discussing race-relations between indigenous and non-indigenous communities. Its experimental performance piece, *Whispers in the Heart*, a self-reflexive take on constructions of black Australians in historical and anthropological discourses, was developed specifically as a bicentennial 'intervention' by the company's multiethnic ensemble (see Burvill, 1998).

5 This inquiry was initiated in 1987 to investigate why a disproportionate number of Aboriginals had been dying in police custody and in prisons. Despite some evidence of systematic harassment and abuse by law enforcement personnel, no charges were ever laid. The Commission's final report made numerous recommendations, some of which were implemented, but mortality rates have not significantly improved to date.

6 The Native Title Act did not actually grant land rights, but rather set up mechanisms for dealing with Aboriginal demands for ownership over traditional land and sea resources. In 1998, the Act was subjected to a series of amendments, including a sunset clause, to restrict such claims.

7 Council for Aboriginal Reconciliation. (2000) 'The Council – Charting the Way', *Reconciliation: Australia's Challenge*. <http://138.25.65.50/au/other/IndigLRes/car/2000/16/text02.htm> (accessed 24 March 2006).

8 These include *The Sunshine Club* (1999), Wesley Enoch and John Rodgers's musical about mixed-race dance clubs in the 1950s; and *Magpie* (2005), Richard Frankland and Melissa Reeves's exploration of black–white contact in urban Australia.

9 Human Rights and Equal Opportunity Commission. (1997) *Bringing Them Home*. <http://www.austlii.edu.au/au/special/rsjproject/rsjlibrary/hreoc/stolen/> (accessed 28 January 2006).

10 Examples include Dallas Winmar's *Aliwa* (2000), Tammy Anderson's *I Don't Wanna Play House* (2001) and *King Hit* by Geoffrey Narkle and David Milroy (1997).

11 The other Olympic festivals were as follows: A Sea Change (1998), a celebration of Australia's migration cultures, comprising events across the nation over a nine-month period; Reaching the World, which showcased Australian culture on a global scale in five continents throughout 1999; and Harbour of Life, the official cultural programme for the 2000 Games, focused in Sydney and including the Olympic Opening Ceremony. Aboriginal arts/cultural events were included in all of these festivals to some degree.

12 Sydney Organising Committee for the Olympic Games. (2001) *Official Report of the XXVII Olympiad*. <http://www.gamesinfo.com.au/postgames/en/pg000679.htm> (accessed 28 February 2006).

13 Sydney Organising Committee for the Olympic Games (2001), *Official Report of the XXVII Olympiad*. <http://www.gamesinfo.com.au/postgames/en/pg000680.htm> (accessed 28 February 2006).

14 The Bridge Walk (and others like it across the country) symbolized crossing the gulf between indigenous and non-indigenous Australians and was deliberately scheduled to lead into Corroboree 2000, held the next day, when the Council for Aboriginal Reconciliation would present its recommendations (many of which had already been rejected by the government) to the nation.

15 Australian Performing Arts Market 2002: <http://www.performingartsmarket.com.au/2002.htm> path: briefing session transcripts; indigenous arts (accessed 1 February 2006).

16 We wish to acknowledge Robert Clarke's contribution to this discussion of Olympism.

17 This information is synthesized from Page's 2003 lecture (pp. 124–5) and comments included on Bangarra Dance Theatre's web page: <http://www.bangarra.com.au/diary/oaf.html> (accessed 1 February 2006).

18 Department of Foreign Affairs and Trade Annual Report 2003–04: <http://www.dfat.gov.au/dept/annual_reports/03_04/performance/3/3.1.2.html> (accessed 3 February 2006).

19 Toni Janke's comments, quoted here, along with several other speeches can be found at <http://www.performingartsmarket.com.au/2002.htm> path: briefing session transcripts; indigenous arts (accessed 23 November 2005).

20 Australian Performing Arts Market 2006: <http://www.performingartsmarket.com.au/2006/apam06.htm> path: spot light and pitch sessions; Nerrpu Dhawu Rrurrambuwuy (accessed 12 March 2006).

21 Australian Performing Arts Market 2006: <http://www.performingartsmarket.com.au/2006/apam06.htm> (accessed 23 November 2005).

22 Perth International Arts Festival 2003: <http://www.perthfestival.com.au/ 2003_archive/IndigenousArtsShowcase2.html> (accessed 21 January 2006).
23 Interestingly, reviews of the HeadsUp plays admitted no culpability on Britain's part for the historical disenfranchisement of Aboriginal Australians; nor did they acknowledge colonial ties between the two countries.

Chapter 3 Asianizing Australian theatre

1 Federal Government of Australia. (1994) *Creative Nation: Commonwealth Cultural Policy.* <http://www.nla.gov.au/creative.nation/internat.html> (accessed 19 July 2005).
2 Playbox was renamed the Malthouse Theatre in 2005 under the leadership of its new artistic director, Michael Kantor. The revamped company does not privilege Asia in its policy.
3 The festival has its precedent in the Celebration of Australian Asian Artists in 1992 and 1993.
4 The Asialink Centre was established in 1990 by the Myer Foundation, in partnership with the University of Melbourne, the Mazda Foundation and the Australian government, with sponsorships from a variety of business corporations.
5 Performances by Asian Australians at local multicultural festivals may similarly privilege 'folk' or 'traditional' elements as signifiers of difference, resulting in the reinforcement of national and/or ethnic stereotypes.
6 A hanamichi is a raised platform running through the audience space, used for characters' entrances and exits.
7 Female roles in kabuki plays are performed by specialist male actors called onnagata.
8 *Cho Cho San* was first produced in 1984 by Handspan Theatre. The 1987 production was staged by Playbox and toured China and Japan with Geoff Hooke as the director and Peter J. Wilson as lead puppeteer.
9 Austrade is a federally funded export facilitation agency that provides information on the market conditions and cultural practices of export destinations, as well as financial assistance for promotional activities. <http://www.austrade.gov.au> (accessed 14 January 2006).
10 Department of Foreign Affairs and Trade: <http://www.dfat.gov.au/aicc/> (accessed 20 October 2005).
11 The Confederation comprises the Adelaide, Brisbane, Darwin, Melbourne, Perth, Sydney and Tasmanian festival organizations.

Chapter 4 Marketing difference at the Adelaide Festival

1 Adelaide Festival of Arts, 'How It Started.' <http://www.adelaidefestival. com.au/about/history/started.aspx> (accessed 15 March 2006).
2 Adelaide Festival 1970, programme brochure, Adelaide Festival archive, pp. 37, 40; emphases added.
3 At the festival's launch, the 1994 theme was apparently announced as 'Portrait of Diversity: Australia in Asia'. The subsequent focus on the

Asia-Pacific region instead suggests that the concept of Australia as Asian was too controversial.

4 This connection between culture, trade and politics is also demonstrated by the fact that Hunt addressed government and business leaders from Japan, Indonesia and Australia at various meetings in the lead-up to the festival and during some of its special programmes.

5 Aside from Yang's work, the 1994 Festival also featured dance by Chin Kham Yoke, and an Asian-Aboriginal intercultural musical performance by shakuhachi player Riley Lee with Matthew Doyle on didgeridoo.

6 In the lead up to the festival, Hunt is reported to have blamed slow ticket sales on the public's 'unconscious racism'. Overt racism was also articulated by a small segment of the press, with one critic apparently saying that she had seen plenty of this 'incomprehensible' 'Asian stuff' in Europe (quoted in Bunbury, 1994: 13).

7 In addition to the usual festival administration, Sellars brought in nine Australian associate directors who represented a broad platform of interests including indigenous art, food, architecture, community arts, film and performing arts. Assisted by advisory committees, the associate directors were responsible for executing the process of community consultation and participation as both art producers and audiences.

8 The festival helped to facilitate a community project with Maralinga Tjaratjura people, who had no previous history of painting with acrylic on canvas. The community produced 25 artworks that were exhibited to coincide with the stage production of *The Career Highlights of Mamu*.

9 Unlike Hunt, Nattrass worked with local communities using 'multicultural ambassadors' from many different nationalities to talk with residents and develop audience participation in the festival (Owens, 2002: 41).

10 Other possible factors include disruptions to the programme development phases of the festival and late programme announcements, the destabilizing effect of terrorist attacks on New York and negative sentiment among traditional festival audiences. Adelaide Festival of Arts. 'History.' <http://www.adelaidefestival.org.au/history/2002.asp> (accessed 12 June 2005).

11 Since the Pitjantjatjara Choir had been barred from performing at the 1966 Adelaide Festival, its 2004 appearance was in many ways an act of historical reclamation. The Choir also opened the premiere of Peter Sculthorpe's *Requiem*, performed by the Adelaide Symphony with William Barton on didgeridoo. That this cross-cultural performance was included in the indigenous arts programme even though it was initiated by a non-indigenous artist is another indicator of Page's non-essentialist and conciliatory curatorial approach.

12 Talk'n Up Country 2004, programme brochure, Adelaide Festival archive, p. 2.

13 Talk'n Up Country 2004, programme brochure, Adelaide Festival archive, p. 9; emphasis added.

14 The other co-writer was Reg Cribb. Gulpilil is unable to read English; he narrated his stories to Cribb and Armfield, who arranged them into a script that was read back to Gulpilil, who then performed the stories (Gallasch, 2004: 14).

Chapter 5 Crossing cultures: case studies

1 The term 'canonical stage' is used to suggest productions of canonical texts that have been mounted in major venues; we do not include amateur, student or fringe productions of such texts.

2 Initially, Tovey had planned a more political project, a pastiche in which Aboriginal actors in Elizabethan costume would present a version of the play to colonial troops (see Cox, 2004b). Whether his decision to abandon this approach had anything to do with STC norms remains a matter for speculation.

3 In this respect, Denis Salter argues that 'the appropriative gaze of Shakespeare as cultural institution' can 'never be entirely deflected'. Rather it 'continues to be reflected through mimesis as a form of subtle but tyrannical aesthetic discipline' that 'recolonize[s] the times and places to which the Shakespearean text was supposed to have been adapted' (1996: 128).

4 Incidentally, a similarly racialized *Romeo and Juliet* with indigenous Capulets and white Montagues was jointly staged in the same year in Brisbane by Kooemba Jdarra and La Boite (see Cox, 2004a). This general approach to the play is by no means new in international terms, though in Australia it was explicitly linked to reconciliation politics in both productions.

5 Here Burvill is working through Denise Varney's account of the processual poetics of the APG in her unpublished MA thesis.

6 Wong is not Malay, but, like many other non-Anglo actors, he has functioned as the generic Asian in a number of Australian productions.

7 For instance, *West Magazine*'s feature article, titled 'Asia: How Do We Fit In?', 18 February 1995, pp. 8–13, carefully historicized the play's critique of war while stressing that the imperatives of immigration and globalization had radically changed the Australian political landscape.

8 For a detailed discussion of this issue, see Sawada (1996).

9 Nobbs travelled to Melbourne in 1991 to participate in the preliminary workshops for the production and was included among the cast.

10 Frank Productions: Austral Asian Performance Ensemble, promotional folder, 1999: n.p. The company has been variously called Frank Productions, Frank Ensemble and Frank Theatre over the years.

11 These claims are scattered about interview material, promotional brochures and reviews of Frank's work.

12 The company, founded in 1992 by Simon Woods and Lynne Bradley, was based in Japan from 1993–95.

13 There is already an established relationship between Viewpoints and the Suzuki Method: Bogart and Suzuki established the Saratoga International Theatre Institute in New York in 1992 to develop international cultural exchange and collaboration.

14 Zen Zen Zo Physical Theatre. 'Company History.'
 <http://www.zenzenzo. com/pages/frames.htm> (accessed 4 March 2006).

15 Versions of this sentiment permeated critical responses to Zen Zen Zo's work in the early years; more recently, some reviewers have commented on weaknesses in vocal projection and dramaturgy in both new and remounted shows.

Chapter 6 Asian Australian Hybrid Praxis

1 In this respect, white diasporic populations (deriving from European settlers in various parts of the colonial world) are rarely labelled as such. The recognized Irish diaspora does not contradict this pattern since the Irish were regarded as coloured in some historical instances.
2 Written, performed and directed by Merlinda Bobis, Belvoir Street Theatre, Sydney, 22 September 1994.
3 Created by Anna Yen, Therese Collie and Hilary Beaton, directed by Therese Collie and performed by Yen, Cremorne Theatre, Brisbane, 26 August 1997. All cited quotations refer to this production.
4 Devised and performed by William Yang, with music by Stephen Rae, Performance Space, Sydney, 6 October 1999. All cited quotations refer to this production.
5 Written and performed by Georgina Naidu, directed by Sally Sussman and produced by Theatre 4a at The Studio, Sydney Opera House, 21 September 2005. All cited quotations refer to this production.
6 South Asian Australians have historically been categorized as 'Indian' rather than 'Asian' within the popular imaginary; the latter term is reserved for so-called 'Orientals' from East and Southeast Asia.
7 Jebni. 'Breed or Bleed.' Weblog, 25 September 2004. <http://www.antipopper. com/blog/archives/2004_09_25_0357hrs.html> (accessed 20 March 2006).
8 This apology was communicated in a letter to *The Age* to mark 'Sorry Day': '[W]e understand about the loss of home, family and cultural values, and we too would like to express our deep sorrow to all Indigenous Australians for their suffering and offer our support for genuine reconciliation' (Le and Nguyen, 1998: 14).

Chapter 7 Performance and asylum: ethics, embodiment, efficacy

1 Culture jamming is used here to describe subversive transformations of popular culture icons and every day images/discourses to critique their original message or implication.
2 Hage describes the detention of refugees as 'ethnic caging' in a polemical attempt to evoke connections between this human rights abuse and the genocidal practices of 'ethnic cleansing'. Using the trope of 'caging', he also draws parallels between the nation's treatment of refugees and Aboriginals (Hage, 1998: 105–16).
3 The so-called 'Tampa crisis', which caused a diplomatic row with Norway, was resolved with the 'Pacific solution' when the Australian government transferred the rescued asylum seekers to navy vessels and transported them to Nauru and Papua New Guinea for offshore processing.
4 Here, Salverson is working through the theories of Roger Simon and Claudia Eppert in relation to the witnessing of historical traumas through testimony.
5 Other productions have also used strategically racialized casting to invoke the various ethnic communities represented, though most of these performances

have been carefully framed to prevent the fixing of racial identities or the mimetic fusion of performer and character.

6 The fleshly reality of Parr's performance contrasts with other images of lip-sewing circulating at the time, notably in an issue of the fashion magazine, *Australian Style*, which earlier that year had featured photographs of sultry models with (cosmetically) stitched lips in a gauche support gesture. Images of lip-sewing among asylum seekers themselves have not appeared in print or visual media, despite extensive coverage of hunger strikes at Woomera and elsewhere.

7 Information supplied via email communication with Dave Kelman, 31 March 2006.

8 The Al Abaddi family became something of a cause célèbre for refugee activists after their extensive legal battle to remain in Australia. *In Our Name*, the first subscriber-season refugee play to grace the nation's stages, also featured an ex-detainee (previously untrained as a performer) in one of the leading roles.

9 version 1.0: <http://www.versiononepointzero.com/> (accessed 31 March 2006). The term 'civic archaeology' is borrowed from descriptions of the company's work in advertising material.

Conclusion: cosmopolitics in the new millennium

1 In 2001, the federal parliament passed a bill that excised specific northern Australian islands from the Migration Zone, effectively invalidating claims for asylum made from those territories. The government has attempted to add further areas, mostly occupied by Aboriginals, to this excised zone but has thus far been blocked by the Senate.

2 Hung Le and John Harding premiered *Black and Tran II – The Two Marketeers* at the 2004 Melbourne International Comedy Festival. The second production extended the critique of racial stereotypes to include issues of cultural and artistic ownership.

Bibliography

Abbas, Ackbar. (2000). 'De-scriptions: Shanghai and Hong Kong.' *Public Culture*, 12.3: 769–86.

Agamben, Giorgio. (1998). *Homo Sacer: Sovereign Power and Bare Life*. Trans. Daniel Heller-Roazen. Stanford: Stanford University Press.

Aldred, Debra. (2001). 'Frank Returns to Croatia.' *Courier-Mail*, 20 June: 42.

Allain, Paul. (1998). 'Suzuki Training.' *The Drama Review*, 42.1: 66–89.

Anderson, Amanda. (2001). *The Powers of Distance: Cosmopolitanism and the Cultivation of Detachment*. Princeton: Princeton University Press.

Anderson, Benedict. (1998). 'Nationalism, Identity, and the World-in-Motion: On the Logics of Seriality.' *Cosmopolitics: Thinking and Feeling Beyond the Nation*. Ed. Pheng Cheah and Bruce Robbins. Minneapolis: University of Minnesota Press, pp. 117–33.

Anderson, Ian. (1995). 'Reclaiming Tru-ger-nan-ner: De-colonising the Symbol.' *Speaking Positions: Aboriginality, Gender and Ethnicity in Australian Cultural Studies*. Ed. Penny van Toorn and David English. Melbourne: Department of Humanities, Victoria University of Technology, pp. 31–42.

Ang, Ien. (2001). *On Not Speaking Chinese: Living Between Asia and the West*. London: Routledge.

——. (2003). 'From White Australia to Fortress Australia: The Anxious Nation in the New Century.' *Legacies of White Australia: Race, Culture and Nation*. Ed. Laksiri Jayasuriya, David Walker and Jan Gothard. Perth: University of Western Australia Press, pp. 51–69.

Ang, Ien, and Jon Stratton. (1996). 'Asianising Australia: Notes Towards a Critical Transnationalism in Cultural Studies.' *Cultural Studies*, 10.1: 16–36.

Ang, Ien, Sharon Chalmers, Lisa Law and Mandy Thomas, eds. (2000). *Alter/Asians: Asian-Australian Identities in Art, Media and Popular Culture*. Sydney: Pluto.

Appadurai, Arjun. (1986). 'Introduction: Commodities and the Politics of Value.' *The Social Life of Things: Commodities in Cultural Perspective*. Ed. Arjun Appadurai. Cambridge: Cambridge University Press, pp. 3–63.

——. (1996). *Modernity at Large: Cultural Dimensions of Globalization*. Minneapolis: University of Minnesota Press.

Appiah, Kwame Anthony. (1998). 'Cosmopolitan Patriots.' *Cosmopolitics: Thinking and Feeling Beyond the Nation*. Ed. Pheng Cheah and Bruce Robbins. Minneapolis: University of Minnesota Press, pp. 91–114.

——. (2001). 'Cosmopolitan Reading.' *Cosmopolitan Geographies: New Locations in Literature and Culture*. Ed. Vinay Dharwadker. New York and London: Routledge, pp. 197–227.

Archdall, Susan. (2002). 'Indigenous Parade Paves Way for Respect.' *Adelaide Advertiser*, 2 March: 28.

Attwood, Bain. (2005). 'Unsettling Pasts: Reconciliation and History in Settler Australia.' *Postcolonial Studies*, 8.3: 243–59.

Australia Council. (2002). *Review and Evaluation of the Australian Performing Arts Market, 1994–2002*. Sydney.

Bakhtin, Mikhail. (1981). *The Dialogic Imagination: Four Essays*. Trans. Caryl Emerson and Michael Holquist. Austin: University of Texas Press.

Ball, Martin. (2005). 'Odysseys of Pain and Poetry.' *Australian*, 14 October: 16.

Banks, Ron. (2004). 'Death March to Music.' *West Australian*, 30 June: 2.

Barnes, Mick. (1987). Review of *Cho Cho San* by Daniel Keene. *Sun-Herald*, 26 April: 112.

Batty, Philip. (1998). 'Saluting the Dot-spangled Banner: Aboriginal Culture, National Identity and the Australian Republic.' *Australian Humanities Review*, 11: <http://www.lib.latrobe.edu.au/AHR//archive/Issue-September-1998/batty.html> (accessed 24 December 2005).

Bedford, Randolph. (1909). *White Australia, or The Empty North*. Unpublished mss. University of Queensland, Fryer Collection.

Behdad, Ali. (1990). 'Orientalist Desire, Desire of the Orient.' *French Forum*, 15.1: 37–51.

Bennett, Susan. (1996). *Performing Nostalgia: Shifting Shakespeare and the Contemporary Past*. London: Routledge.

Betts, Katharine. (1999). 'The Cosmopolitan Social Agenda and the Referendum on the Republic.' *People and Place*, 7.4: 32–41.

Bhabha, Homi. (2000). 'The Vernacular Cosmopolitan.' *Voices of the Crossing: The Impact of Britain on Writers from Asia, the Caribbean and Africa*. Ed. Ferdinand Dennis and Naseem Khan. London: Serpent's Tail, pp. 133–42.

Bharucha, Rustom. (1993). *Theatre and the World: Performance and the Politics of Culture*. London: Routledge.

Billington, Michael. (2000). 'Dirty Tricks Down Under.' *Guardian*, 8 July: 6.

Bisazza, A. J. (1994). Letter. *Adelaide Advertiser*, 11 March: 14.

Black, Ollie. (2001). 'Circus and Physical Theatre in Australia: An Introduction.' *In Repertoire: A Guide to Contemporary Australian Performance*. Sydney: Australia Council and RealTime, pp. 41–3.

Bobis, Merlinda. (1994). 'Redreaming the Voice: From Translation to Bilingualism.' *Rubicon*, 1.2: 24–36.

——. (1996). *Border Lover*. Unpublished mss.

——. (1998). *Cantata of the Warrior Woman Daragang Magayon*. In *Summer Was a Fast Train Without Terminals*. Melbourne: Spinifex, pp. 67–200.

Bott, Jennifer. (2001). 'Introduction.' *In Repertoire: A Guide to Contemporary Australian Performance*. Sydney: Australia Council and RealTime, p. 2.

Boyd, Chris. (1995). 'Cultural Salve for War Scars.' *Herald Sun*, 4 November: 38.

——. (1996). 'Descent Hits Heady Heights.' *Herald Sun*, 16 February: 92.

Bradley Smith, Susan. (2003). 'Rhetoric, Reconciliation and Other National Pastimes: Showcasing Contemporary Australian Theatre in London.' *Playing Australia: Australian Theatre and the International Stage*. Ed. Elizabeth Schafer and Susan Bradley Smith. Amsterdam: Rodopi, pp. 195–211.

Bramwell, Murray. (2002). 'Devilish Toll of Nuclear Testing.' *Australian*, 4 March: 15.

——. (2003). 'Page Opens a New Chapter.' *Adelaide Review* (November): <http://www.adelaidereview.com.au/archives/2003_11/issuesandopinion_story6.shtml> (accessed 21 March 2005).

Brand, Mona. (1999). *Here Under Heaven*. *Tremendous Worlds: Australian Women's Drama 1890–1960*. Ed. Susan Pfisterer. Sydney: Currency, pp. 143–208.

Brennan, Timothy. (1997). *At Home in the World: Cosmopolitanism Now*. Cambridge, MA: Harvard University Press.

Brickhill, Eleanor. (2001). Review of *Nerve 9: A Body Called Flesh* by Tess de Quincey. *RealTime*, 44: 35.

Brisbane, Katharine. (1973). 'Complexity and Simplicity.' *Australian*, 13 October: 17.

———. (1995). 'The Future in Black and White: Aboriginality in Recent Australian Drama.' <http://www.currency.com.au/preview/b_and_w.htm> (accessed 9 January 2006).

Broinowski, Alison. (1994). 'A Slow Drift Towards Asia.' *Sydney Morning Herald*, 17 August: 24.

Broinowski, Alison. (1996). *The Yellow Lady: Australian Impressions of Asia*. 2nd edn. Melbourne: Oxford University Press.

Brookes, Darren. (2004). Review of *Rashomon* by Frank Theatre. *M/C Reviews*: <http://reviews.media-culture.org.au/article.php?sid=1036> (accessed 4 March 2006).

Brown, Karilyn. (2002). 'The Australian Arts Sector and Asia – Key Issues and Opportunities.' <http://www.asialink.unimelb.edu.au/arts/projects/forum2002/brown.htm> (accessed 2 January 2006).

Bunbury, Stephanie. (1994). 'Art of Surprise Wins Audiences' Attention.' *Age*, 14 March: 13.

Burchall, Greg. (1997). 'Celebrating in a Big Black Way.' *Age*, 2 June: C5.

Burvill, Tom. (1993). 'Romeril's Work with Race, Class and Ethnicity.' *John Romeril*. Ed. Gareth Griffiths. Amsterdam: Rodopi, pp. 86–102.

———. (1998). 'Playing the Faultlines: Two Political Theater Interventions in the Australian Bicentenary Year 1988.' *Staging Resistance: Essays on Political Theater*. Ed. Jeanne Colleran and Jenny S. Spencer. Ann Arbor: University of Michigan Press, pp. 229–46.

Buzacott, Martin. (2002). 'Saved by a Classic Cut and a Cartoon.' *Australian*, 27 September: 18.

———. (2004). 'Courtroom Classic from the '50s Parable for Our Times.' *Australian*, 25 October: 7.

Carroll, Dennis. (1993). 'John Romeril and the APG.' *John Romeril*. Ed. Gareth Griffiths. Amsterdam: Rodopi, pp. 35–54.

Carruthers, Ian. (1995a). 'The Renovation of Traditional Theatre: Zeami and Shakespeare.' *The Japan Foundation Newsletter*, 12.6: 12–14, 19.

———. (1995b). *Theatre East and West: Problems of Difference or Problems of Perception? Suzuki Tadashi's Australian Macbeth, 1992*. Melbourne: La Trobe University Asian Studies Papers Research Series 5.

Casey, Maryrose. (2004). *Creating Frames: Contemporary Indigenous Theatre*. St Lucia, QLD: University of Queensland Press.

Caust, Jo. (2004). 'A Festival in Disarray: The 2002 Adelaide Festival: A Debacle or Another Model of Arts Organization and Leadership?' *Journal of Arts Management, Law, and Society*, 34.2: 103–17.

Chan, Dean. (2000). 'The Dim Sum vs the Meat Pie: On the Rhetoric of Becoming an In-between Asian-Australian Artist.' *Alter/Asians: Asian-Australian Identities in Art, Media and Popular Culture*. Ed. Ien Ang, Sharon Chalmers, Lisa Law and Mandy Thomas. Sydney: Pluto, pp. 141–51.

Cheah, Pheng. (1998). 'Rethinking Cosmopolitical Freedom in Transnationalism.' *Cosmopolitics: Thinking and Feeling Beyond the Nation*. Ed. Pheng Cheah and Bruce Robbins. Minneapolis: University of Minnesota Press, pp. 290–328.

Cheah, Pheng, and Bruce Robbins, eds. (1998). *Cosmopolitics: Thinking and Feeling Beyond the Nation*. Minneapolis: University of Minnesota Press.

Chi, Jimmy, and Kuckles. (1991). *Bran Nue Dae*. Sydney: Currency; Broome: Magabala Books.

Chiang, Jerome. (1997). Review of *Chinese Take Away* by Anna Yen. *World Weekly News*, August: n.p.

Chow, Clara, and Clarissa Oon. (2004). 'NAC Renews MOU with Arts Victoria.' *Straits Times*, 19 June: L16.

Clark, Geoff. (2000). 'A Flame Is Lit for the Future.' *Daily Telegraph*, 27 September: 36.

Clarke, Rebecca. (1994). 'Australians Develop their Skills in Japan.' *Theatre Australasia*, 12 (December): 2, 6.

Clifford, James. (1992). 'Travelling Cultures.' *Cultural Studies*. Ed. Lawrence Grossberg, Cary Nelson and Paula A. Treichler. New York: Routledge, pp. 96–116.

Cohen, Michael. (1996). 'Seventeen Stories about Interculturalism and Tadashi Suzuki.' *About Performance 2: Performances East/West*. Ed. Tony Day and Paul Dowsey-Magog. Sydney: Centre for Performance Studies, University of Sydney, pp. 51–8.

Cohen, Mitchell. (1992). 'Rooted Cosmopolitanism: Thoughts on the Left, Nationalism, and Multiculturalism.' *Dissent*, 39: 478–83.

Collins, Carolyn. (2000). 'Black Play May Upstage Howard's London Visit.' *Australian*, 6 April: 4.

Coslovich, Gabriella. (2005). 'Epic Refugee Play Eclipses Esoteric Offerings.' *Sunday Age*, 23 October: 8.

Cotes, Alison. (1998). 'Steel Yourself for Flesh.' *Courier-Mail*, 3 September: 15.

Cox, Emma. (2004a). 'Reconciling Shakespeare and Indigeneity in Australia: Star-crossed Communities and Racial *Tempests*.' *Australasian Drama Studies*, 44: 78–95.

——. (2004b). 'Negotiating Cultural Narratives: All-Aboriginal Shakespearean Dreaming.' *Southerly*, 64.3: 15–27.

Craik, Jennifer, Glyn Davis and Naomi Sunderland. (2000). 'Cultural Policy and National Identity.' *The Future of Governance*. Ed. Glyn Davis and Michael Keating. Sydney: Allen & Unwin, pp. 177–202.

Crawford, Jim. (1947). *Rocket Range*. Unpublished mss. University of Queensland, Fryer Collection.

Curthoys, Ann. (2003). 'Liberalism and Exclusionism: A Prehistory of the White Australia Policy.' *Legacies of White Australia: Race, Culture and Nation*. Ed. Laksiri Jayasuriya, David Walker and Jan Gothard. Perth: University of Western Australia Press, pp. 8–32.

Daileader, Celia R. (2000). 'Casting Black Actors: Beyond Othellophilia.' *Shakespeare and Race*. Ed. Catherine M. S. Alexander and Stanley Wells. Cambridge: Cambridge University Press, pp. 177–202.

Dann, George Landen. (1949). *Fountains Beyond*. Sydney: Australasian Publishing.

Davidson, Jim. (1974). 'The Babe Among the Gladdies Is Perambulating Nicely, Thankyou.' *Meanjin Quarterly*, 33.4: 443–5.

Davies, Christie. (1982). 'Ethnic Jokes, Moral Values and Social Boundaries.' *The British Journal of Sociology*, 33.3: 383–403.

de Quincey, Tess. (n.d.). 'Sites of Multiplicity and Permeation.' <http://www. bodyweather.net/siteforum.pdf> (accessed 14 October 2005).

Debelle, Penelope. (2003). 'The Dead, White Male is Back.' *Age*, 15 October: 6.

Derrida, Jacques. (2001). *On Cosmopolitanism and Forgiveness*. London: Routledge.

Diprose, Rosalyn. (2003). 'The Hand that Writes the Community in Blood.' *Cultural Studies Review*, 9.1: 35–49.

Dixon, Kay. (1997). 'Water Puppet Magic.' *Muse*, 158 (February): 2–3.

Dixon, Robert. (2002). 'Citizens and Asylum Seekers: Emotional Literacy, Rhetorical Leadership and Human Rights.' *Cultural Studies Review*, 8.2: 11–26.

Duffy, Rosemary. (2004). Review of *Sandakan Threnody*. *State of the Arts Review*, 20 September 2004: <http://www.stateart.com.au/sota/Reviews/default.asp?fid=2944> (accessed 6 January 2006).

Dunne, Stephen. (1997). 'Written on the Body.' *Sydney Morning Herald*, 12 September: 8.

——. (2002). 'The Voiceless Speak, with Varying Success.' *Sydney Morning Herald*, 3 October: 18.

Dyer, Richard. (1997). *White*. London: Routledge.

Eccles, Jeremy. (1989). 'Othello in Ochre.' *Sydney Review*, 17: 20–1.

——. (2002a). 'Maralinga Revisited.' *RealTime*, 48: 5.

——. (2002b). 'Poised to Explode.' *RealTime*, 48: 6.

——. (2004). Review of *Stories from Australia*. *RealTime*, 60: 29.

Eckersall, Peter. (2004). 'Trendiness and Appropriation? On Australia–Japan Contemporary Theatre Exchange.' *Alternatives: Debating Theatre Culture in an Age of Con-fusion*. Ed. Peter Eckersall, Moriyama Naoto and Uchino Tadashi. Brussels: Peter Lang, pp. 23–54.

Edwards, Penny, and Shen Yuanfang. (2003). 'Something More: Towards Reconfiguring Australian History.' *Lost in the Whitewash: Aboriginal–Asian Encounters in Australia, 1901–2001*. Ed. Penny Edwards and Shen Yuanfang. Canberra: Humanities Research Centre, Australian National University, pp. 1–22.

Eld, Mark. (1998). Review of *Macbeth: As Told by the Weird Sisters* by Zen Zen Zo. *Rave Magazine*, 29 April: 23.

Enoch, Wesley. (2000). 'Performance.' *The Oxford Companion to Aboriginal Art and Culture*. Ed. Sylvia Kleinert and Margo Neale. Melbourne: Oxford University Press, pp. 349–54.

——. (2001). ' "We Want Hope": The Power of Indigenous Arts in Australia Today.' *Australasian Drama Studies*, 38: 4–15.

——. (2003). Personal interview by Emma Cox. 14 August.

——. (2004). 'The Politics of Skin.' Interview by Susan Bradley Smith. *Contemporary Theatre Review*, 14.3: 39–44.

Enoch, Wesley, and Deborah Mailman. (1996). *The 7 Stages of Grieving* (1994). Brisbane: Playlab.

Erikson, Jon. (1990). 'The Body as Object of Modern Performance.' *Journal of Dramatic Theory and Criticism*, 5.1: 231–43.

Evans, Bob. (1993). 'Adelaide Festivals Share a Stage in Pledge of Excellence.' *Sydney Morning Herald*, 19 November: 19.

Evans, Gareth. (1994). 'Australia in Asia.' *Adelaide Festival 1994 Guide*, p. 6. Adelaide Festival Archive.

Fantasia, Josephine. (1996). 'Entrepreneurs, Empires and Pantomimes: J. C. Williamson's Pantomime Productions as a Site to Review the Cultural Construction of an Australian Theatre Industry, 1882 to 1914.' Unpublished PhD Thesis. University of Sydney.

Farrell, Rosemary. (2005). ' "Sweat from the Bones": Inventing Tradition in New Circus.' Unpublished paper presented at the 2005 Australasian Drama Studies Association Conference, 4–7 July, Charles Sturt University, Wagga Wagga.

Fensham, Rachel, and Denise Varney. (2005). *The Dolls' Revolution: Australian Theatre and the Cultural Imagination*. Melbourne: Australian Scholarly Publishing.

Filewod, Alan, and David Watt. (2001). *Workers' Playtime: Theatre and the Labour Movement since 1970*. Sydney: Currency.

Fitzgerald, Michael. (2004). 'In Leaps and Bounds: The Adelaide Festival's First Aboriginal Director Injects Some Spirit and Vaults Cultural Divides.' *Times International* (South Pacific Edition), 15 March: 58.

Fitzpatrick, Peter. (1985). 'Asian Stereotypes in Recent Australian Plays.' *Australian Literary Studies*, 12.1: 35–46.

Foucault, Michel. (1977). *Discipline and Punish: The Birth of the Prison*. Trans. Alan Sheridan Smith. London: Tavistock.

Frost, Stephen. (1994). 'Broinowski Versus Passmore: A Dialogue of Our Times.' *Continuum: Journal of Media & Cultural Studies*, 8.2: 20–48.

Gallasch, Keith. (2001). 'Australian Contemporary Performance: An Introduction.' In *Repertoire: A Guide to Australian Contemporary Performance*. Sydney: Australia Council and RealTime, pp. 38–40.

——. (2002). 'Bodies at Work.' *RealTime*, 50: 36.

——. (2004a). 'Black, White and Beyond.' *RealTime*, 60: 14, 27.

——. (2004b). 'Singapore Plays Its Own Tune.' *RealTime*, 62: 46–7.

Galloway, Paul. (2000). 'Searching for Truth.' *Brisbane News*, 13–19 December: 8.

Gandhi, Leela. (2000). 'Affective Cosmopolitanism: A Path of Multiculturalism.' *The Paths of Multiculturalism: Travel Writing and Multiculturalism*. Ed. Maria Alzira Seixo, John Noyes, Graca Abreu, and Isabel Moutinho. Lisbon: Cosmos, 2000, pp. 31–47.

Gantner, Carrillo. (1999). 'Looking Closer Afield: Carrillo Gantner on Australian Theatre and Asia.' Interviewed by Peter Copeman. *Australasian Drama Studies*, 34: 25–45.

Gilbert, Helen. (1998a). *Sightlines: Race, Gender and Nation in Contemporary Australian Theatre*. Ann Arbor: Michigan University Press.

——. (1998b). 'Reconciliation? Aboriginality and Australian Theatre in the 1990s.' *Our Australian Theatre in the 1990s*. Ed. Veronica Kelly. Amsterdam: Rodopi, pp. 71–88.

——. (2003). 'Black and White and Re(a)d All Over Again: Indigenous Minstrelsy in Australian and Canadian Theatre.' *Theatre Journal*, 55.4: 679–98.

Gill, Harbant. (2005). 'Wired for Sound.' *Herald Sun*, 2 May: 100.

Glickfield, Leonard. (1982). 'Drifting World.' *Australian Jewish News*, 7 May: 19.

Goers, Peter. (1994a). 'Festival, or a Fringe Benefit?' *Sunday Mail*, 27 February: 143.

——. (1994b). 'The Critics Sum Up.' *Adelaide Advertiser*, 14 March: 11.

Golder, John, and Richard Madelaine, eds. (2001). *O Brave New World: Two Centuries of Shakespeare on the Australian Stage*. Sydney: Currency.

Gooder, Haydie, and Jane M. Jacobs. (2000). ' "On the Border of the Unsayable": The Apology in Postcolonizing Australia.' *Interventions*, 2.2: 229–47.

Goodman, James. (2004). 'Refugee Solidarity: Dilemmas of Transnational Mobilisation.' *Education Links*, 68: 11–16.

Gordon, Harry. (2000). 'Cavalry Arrives to Break the Mould.' *Weekend Australian*, 16–17 September: 4.

Gough, Sue. (1995). 'Exploring the Landscape of Pain.' *Bulletin*, 3 October: 93.

Graham, Duncan. (1990). 'Tears and Full Houses.' *Age*, 5 March: 14.

Gurr, Michael, compiler. (2003). *Something to Declare* by Actors for Refugees. Unpublished manuscript.

Hage, Ghassan. (1998). *White Nation: Fantasies of White Supremacy in a Multicultural Society.* Sydney: Pluto.

———. (2003). *Against Paranoid Nationalism: Searching for Hope in a Shrinking Society.* Sydney: Pluto.

———. (2005). 'Warring Societies.' *Arena Magazine*, 75: 26–31.

Hall, Stuart. (1996). 'New Ethnicities.' *Stuart Hall: Critical Dialogues in Cultural Studies.* Ed. David Morley and Kuan-Hsing Chen. London: Routledge, pp. 441–9.

———. (2002). 'Political Belonging in a World of Multiple Identities.' *Conceiving Cosmopolitanism: Theory, Context, and Practice.* Ed. Steven Vertovec and Robin Cohen. Oxford: Oxford University Press, pp. 25–31.

Hallett, Bryce. (1995). 'The Head of Mary, The Floating World.' *Australian*, 3 November: 14.

Hamilton, Annette. (1990). 'Fear and Desire: Aborigines, Asians and the National Imaginary.' *Australian Cultural History*, 9: 14–35.

Hannerz, Ulf. (1996). *Transnational Connections: Culture, People, Places.* London: Routledge.

Harper, James. (1999). 'In Spirit of the Times.' *Courier-Mail*, 27 September: Features 21.

———. (2004). 'Odyssey Is Visually Intense.' *Courier- Mail*, 26 April: 14.

Harris, Narrelle. (2002). Review of *The Waiting Room. Stage Left Review*: <http://pandora.nla.gov.au/pan/20542/20020714/www.stageleft.com.au/waitroom.html> (accessed 4 March 2005).

Harrison, Felicity. (2004). 'What's Done in Our Name.' *Backbench*, p. 6: <http://www.thebackbench.com/view.php?id=42> (accessed 4 March 2006).

Harrison, Jane. (1998). *Stolen.* Sydney: Currency.

Harrison, Wayne. (1986). Director's Notes to *The Floating World*. Sydney Theatre Company Archive.

———. (1987). 'Maintaining the Rage.' *Contemporary Australian Drama.* Review edn. Ed. Peter Holloway. Sydney: Currency, pp. 504–18.

Hart, Jonathan. (2000). 'Act of Healing.' *Advertiser*, 31 March: 67.

Harvey, David. (2000). 'Cosmopolitanism and the Banality of Geographical Evils.' *Public Culture*, 12.2: 529–64

Healy, Chris. (2001). ' "Race Portraits" and Vernacular Possibilities: Heritage and Culture.' *Culture in Australia: Policies, Publics and Programs.* Ed. Tony Bennett and David Carter. Cambridge: Cambridge University Press, pp. 278–98.

Healy, Connie. (2000). *Defiance: Political Theatre in Brisbane, 1930–1962.* Mt Nebo, Queensland: Boombana.

Heinrich, Karen. (2002). 'Flinch Art.' *Age*, 12 June: 3.

Held, David. (2003). 'Cosmopolitanism: Globalisation Tamed?' *Review of International Studies*, 29.4: 465–80.

Himmelfarb, Gertrude. (1996). 'The Illusions of Cosmopolitanism.' *For Love of Country: Debating the Limits of Patriotism.* Ed. Martha C. Nussbaum and Joshua Cohen. Boston: Beacon, pp. 72–7.

Hoad, Brian. (1986). 'At Sea in a Wealth of Colorful Detail.' *Bulletin*, 12 August: 96.

———. (1989). 'Futuristic Shakespeare.' *Bulletin*, 19 September: 115.

Hodge, Bob, and Vijay Mishra. (1991). *Dark Side of the Dream: Literature and the Postcolonial Mind.* Sydney: Allen & Unwin.

Holgate, Ben. (1999). 'Actors Hurdle the Colour Bar.' *Australian*, 21 May: 12.

Hollinger, David. (1995). *Postethnic America: Beyond Multiculturalism*. New York: Basic Books.

Horsburgh, Susan. (1996). 'Black Actors Tackle the Dream.' *Weekend Australian*, 21 December: Local 9.

Hunt, Christopher. (1994). 'A Festival for Australia's Future.' *Adelaide Festival 1994 Guide*, p. 1. Adelaide Festival Archive.

Hutchinson, Garrie. (1974). '*The Floating World*: Unruly Masterpiece.' *Australian*, 14 August: 14.

Hutnyk, John. (1997). 'Adorno at Womad: South Asian Crossovers and the Limits of Hybridity-talk.' *Debating Cultural Identity: Multi-Cultural Identities and the Politics of Anti-Racism*. Ed. Pnina Werbner and Tariq Modood. London: Zed Books, pp. 106–36.

Jaivin, Linda. (2004). 'Theatre of the Displaced.' *Bulletin*, 20 April: 60–2.

Jamieson, Nigel. (2000). '*The Theft of Sita*.' <http://performinglines.org.au/15881.html> (accessed 27 October 2005; site dismantled).

Jamieson, Nigel, in association with the Al Abaddi family. (2004). *In Our Name*. Unpublished manuscript.

Jefferson, Joseph. (1889). *The Autobiography of Joseph Jefferson*. New York: Century.

Johnston, Peter Wyllie. (2004). ' "Australian-ness" in Musical Theatre: A Bran Nue Dae for Australia?' *Australasian Drama Studies*, 45: 157–79.

Jose, Nicholas. (1992). 'Sensitive New Asian Country.' *Island*, 53: 43–7.

Kant, Immanuel. (1970). *Political Writings*. Trans. H. B. Nisbet. Ed. Hans Reiss. Cambridge: Cambridge University Press.

Karatani, Kojin. (1998). 'Uses of Aesthetics: After Orientalism.' *Boundary 2*, 25.2: 125–60.

Kelly, Martin. (1988). 'Circus Pulls No Punches.' *Daily Telegraph*, 11 January: 23.

Kelly, Paul. (1997). 'The Curse of the M-Word.' *Weekend Australian*, 30–1 August: 21.

Kelly, Veronica. (1993). 'Orientalism in Early Australian Theatre.' *New Literatures Review*, 26: 32–45.

——. (1995a). 'Macbeth, Mill Fire.' *Australian*, 13 April: 15.

——. (1995b). 'Changing Time, *The Tragedy of Oedipus*.' *Australian*, 7 July: 14.

——. (1997). 'A Satisfying Romp Across Boundaries.' *Australian*, 2 September: 12.

——. (1998a). 'Old Patterns, New Energies.' *Our Australian Theatre in the 1990s*. Ed. Veronica Kelly. Amsterdam: Rodopi, pp. 1–19.

——. (2001). 'The Global and the Local: Theatre in Australia and Aotearoa/New Zealand Enters the New Millennium.' *Theatre Research International*, 26.1: 1–14.

Kelly, Veronica, ed. (1998b). *Our Australian Theatre in the 1990s*. Amsterdam: Rodopi.

Kendall, David. (1974). 'A Study of Madness.' *Bulletin*, 31 August: 50–1.

Kershaw, Baz. (1992). *The Politics of Performance: Radical Theatre as Cultural Intervention*. London: Routledge.

Knowles, Ric. (2004). *Reading the Material Theatre*. Cambridge: Cambridge University Press.

Koh, Buck Song. (1994). 'More Asian Arts Shows Staged This Year.' *Straits Times*, 22 February: L5.

Krauth, Kirsten. (2005). 'Refugees: Between Reality and Performance.' *RealTime*, 67: 28.

Lawe Davies, Chris. (1993). 'Black Rock and Broome: Musical and Cultural Specificities.' *Perfect Beat*, 1.2: 48–59.

Le, Thanh Van and Thang Manh Nguyen. (1998). 'Vietnamese and Aborigines.' Letter. *Age*, 3 April: 14.

Leonard, Douglas. (2002–03). 'Doll Madness.' *RealTime*, 52: 35.

Lim, Annie. (1998). 'Master Act for Suzuki Disciples.' *Australian*, 31 July: 16.

Litson, Jo. (2000). 'White Heat Black Stories.' *Australian*, 20 May: R16.

Lo, Jacqueline. (1998). 'Dis/orientations: Contemporary Asian-Australian Theatre.' *Our Australian Theatre*. Ed. Veronica Kelly. Amsterdam: Rodopi, pp, 53–70.

——. (2000). 'Beyond Happy Hybridity: Performing Asian-Australian Identities.' *Alter/Asians: Asian-Australian Identities in Art, Media and Popular Culture*. Ed. Ien Ang, Sharon Chalmers, Lisa Law and Mandy Thomas. Sydney: Pluto, pp. 152–68.

——. (2005). 'Tropes of Ambivalence in *Bran Nue Dae*.' *Altitude* 5: <http://www.altitude21c.com/> path: contents; Issue 5: Reading Indigenous Australian Texts Part 1; view (accessed 25 November 2005).

Love, Harold. (1985). 'Chinese Theatre on the Victorian Goldfields 1858–1870.' *Australasian Drama Studies*, 3.2: 46–86.

Lowe, Lisa. (1991). *Critical Terrains: French and British Orientalism*. Ithaca, NY: Cornell University Press.

Lucashenko, Melissa. (2000). 'Black on Black.' *Meanjin*, 59.3: 112–18.

Lye, Aaron. (2002). 'Zen Zen Zo Delivers Engaging Take on *Macbeth*.' *Business Times*, 15 March: 20.

Maher, Sean. (1994). 'Festival Highlights Our Diversity.' *Theatre Australasia*, 11 (November): 16.

Malcomson, Scott L. (1998). 'The Varieties of Cosmopolitan Experience.' *Cosmopolitics: Thinking and Feeling Beyond the Nation*. Ed. Pheng Cheah and Bruce Robbins. Minneapolis: University of Minnesota Press, pp. 233–45.

Maravillas, Francis. (2004). 'Cartographies of the Future: The Asia-Pacific Triennials and the Curatorial Imaginary.' Paper presented at 'Our Modernities: Positioning Asian Art Now' Conference, National University of Singapore, 19–22 February. <http://www.ari.nus.edu.sg/conf2004/asianart.htm> (accessed 23 June 2005).

Matheson, Veronica. (1997). 'Storm's New Light.' *Sunday Herald Sun*, 23 November: 98.

Mbembe, Achille. (2003). 'Necropolitics.' Trans. Libby Meintjes. *Public Culture*, 15.1: 11–40.

McCallum, John. (1997). 'Smoking Ceremony Ignites Festival's Magical Fire.' *Australian*, 18 September: 14.

——. (1998). 'Cringe and Strut: Comedy and National Identity in Post-War Australia.' *Because I Tell a Joke or Two: Comedy, Politics and Social Difference*. Ed. Stephen Wagg. London: Routledge, pp. 203–20.

McDonald, Patrick. (2002). 'Director Aims for Youth, Fun and Popular Culture.' *Adelaide Advertiser*, 25 April: 6.

McGillick, Paul. (1989). Review of *Othello* by One Extra Dance Company. *Financial Review*, 8 September: Weekend 10.

McGrath, Ann. (2003). 'The Golden Thread of Kinship: Mixed Marriages Between Asians and Aboriginal Women During Australia's Federation Era.'

Lost in the Whitewash: Aboriginal–Asian Encounters in Australia, 1901–2001. Ed. Penny Edwards and Shen Yuanfang. Canberra: Humanities Research Centre, Australian National University, pp. 37–58.

McLean, Sandra. (2002). 'Zen Zen Zo on the Go.' *Courier-Mail*, 21 March: 19.

Meekison, Lisa. (2000a). 'Can You See What I Hear? Music in Indigenous Theatre.' *Meanjin*, 59.2: 85–94.

——. (2000b). 'Whose Ceremony Is It Anyway? Indigenous and Olympic Interests in the Festival of the Dreaming.' *The Olympics at the Millennium: Power, Politics and the Games.* Ed. Kay Schaffer and Sidonie Smith. New Brunswick, NJ: Rutgers University Press, pp. 182–96.

Mercer, Leah. (2005). 'The Ambiguities of Sin.' *RealTime*, 69: 35.

Mignolo, Walter. (2000). 'The Many Faces of Cosmo-polis: Border Thinking and Critical Cosmopolitanism.' *Public Culture*, 12.3: 721–48.

Miller, Judith. (2006). 'New Forms for New Conflicts: Thinking about Tony Kushner's *Homebody/Kabul* and Théâtre du Soleil's *Le Dernier Caravaransérail*.' *Contemporary Theatre Review*, 16.2: 212–19.

Milne, Geoffrey. (1988). '*Cho Cho San* – "A Triumph of Collaboration".' *Australasian Drama Studies*, 12–13: 85–101.

——. (2004). *Theatre Australia (Un)limited: Australian Theatre since the 1950s.* Sydney: Currency.

Mockett, Colin. (2003). Review of *Refugitive* by Shahin Shafaei. <http://www.comicgenius.com/thats_entertainment/reviews_archive.htm> (accessed 3 November 2005).

Morgan, Joyce. (1997). Review of *Water Stories* by Canberra Youth Theatre. *Australian*, 17 January: 9.

——. (2004). 'Behind the Wiring of an Easy Lifestyle.' *Sydney Morning Herald*, 21 April: 21.

Morley, Michael. (1992). 'Images Fade in the Shadows.' *Australian Financial Review*, 20 March: 35.

Muecke, Stephen. (1994). 'Indigenous Australian Philosophies in an Asia-Pacific Context.' *Communal/Plural*, 3: 1–14.

Mulryne, J. R. (1998). 'The Perils and Profits of Interculturalism and the Theatre Art of Tadashi Suzuki.' *Shakespeare and the Japanese Stage.* Ed. Takashi Sasayama, J. R. Mulryne, and Margaret Shewring. Cambridge: Cambridge University Press, pp. 71–93.

Murphy, Chris. (1996). 'Operation Hypothesis: Tadashi Suzuki's "Toil and Trouble" Tour, Australia 1992.' *About Performance 2: Performances East/West.* Ed. Tony Day and Paul Dowsey-Magog. Sydney: Centre for Performance Studies, University of Sydney, pp. 41–9.

Musa, Helen. (1995). 'Are the Asian Arts Winning Too Many Australian Hearts?' *Theatre Australasia*, 17 (May): 1–2.

Myerscough, Marie. (1986). 'East Meets West in the Art of Tadashi Suzuki.' *American Theatre*, 2.10: 4–10.

Neilson, Brett. (1999). 'On the New Cosmopolitanism.' *Communal/Plural*, 7.1: 111–24.

——. (2002). 'Bodies of Protest: Performing Citizenship at the 2000 Olympic Games.' *Continuum: Journal of Media & Cultural Studies*, 16.1: 13–25.

Nicoll, Fiona. (1998). 'Backlash: Reconciliation after Wik.' *Meanjin*, 57.1: 167–83.

Nochlin, Linda. (1983). 'The Imaginary Orient.' *Art in America*, 71.5: 118–31, 187–91.

Nowra, Louis. (1988). *Capricornia*. Sydney: Currency.

Nussbaum, Martha C. (1997). 'Kant and Stoic Cosmopolitanism.' *Journal of Political Philosophy*, 5.1: 1–25.

Nussbaum, Martha C., and Joshua Cohen, eds. (1996). *For Love of Country: Debating the Limits of Patriotism*. Boston: Beacon.

Nyers, Peter. (2003). 'Abject Cosmopolitanism: The Politics of Protection in the Anti-deportation Movement.' *Third World Quarterly*, 24.6: 1069–93.

O'Brien, Angela. (1997). 'Jim Crawford's *Rocket Range*.' *Dis/Orientations Conference Proceedings*. Ed. Rachel Fensham and Chris Worth. Melbourne: Centre for Drama and Theatre Studies, Monash University, pp. 217–23.

Omand, Helen. (2004). Review of *Triple Bill* by Bangarra Dance Theatre. *RealTime*, 60: 30.

Ong, Aihwa. (1998). 'Flexible Citizenship among Chinese Cosmopolitans.' *Cosmopolitics: Thinking and Feeling Beyond the Nation*. Ed. Pheng Cheah and Bruce Robbins. Minneapolis: University of Minnesota Press, pp. 134–62.

Owens, Susan. (2002). 'Adelaide Confronts Home Truths.' *Australian Financial Review*, 2 March: 41.

Pagden, Anthony. (2000). 'Stoicism, Cosmopolitanism, and the Legacy of European Imperialism.' *Constellations*, 7.1: 3–22.

Page, Stephen. (2003). 'Kinship and Creativity.' *The Parsons Lectures: The Philip Parsons Memorial Lectures on the Performing Arts 1993–2003*. Ed. Katharine Brisbane. Sydney: Currency House, pp. 113–29.

Pang, Khee Teik. (2004). 'Abusing Prisoners of War.' *Kakiseni*: <http://www.kakiseni.com/articles/reviews/MDUzMA.html> (accessed 6 January 2006).

Parry, Benita. (1992). 'Overlapping Territories and Intertwined Histories: Edward Said's Postcolonial Cosmopolitanism.' *Edward Said: A Critical Reader*. Ed. Michael Sprinker. Oxford and Cambridge, MA: Blackwell, pp.18–47.

Payne, Pamela. (1994). 'All the World's a Kyogen Farce.' *Sun-Herald*, 13 March: 19.

Perera, Suvendrini, and Joseph Pugliese. (1994). 'The Limits of Multicultural Representation.' *Communal/Plural*, 4: 91–113.

Perkins, Elizabeth. (1998). 'Plays about the Vietnam War: The Agony of the Young.' *Our Australian Theatre in the 1990s*. Ed. Veronica Kelly. Amsterdam: Rodopi, pp. 38–52.

Pfisterer, Susan. (1999). 'Introduction.' *Tremendous Worlds: Australian Women's Drama, 1890–1960*. Ed. Susan Pfisterer. Sydney: Currency, pp. v–xxvi.

Phelan, Peggy. (1993). *Unmarked: The Politics of Performance*. London: Routledge.

Pippen, Judy. (1998). 'Ranged Between Heaven and Hades: Actors' Bodies in Cross-Cultural Theatre Forms.' *Australasian Drama Studies*, 32: 22–34.

Plane, Terry. (2004). 'Page's Guiding Heart.' *Australian*, 30 January: 14.

Pollock, Sheldon, Homi K. Bhabha, Carol A. Breckenridge and Dipesh Chakrabarty. (2000). 'Cosmopolitanisms.' *Public Culture*, 12.3: 577–89.

Prichard, Katharine Susannah. (1974). *Brumby Innes and Bid Me to Love*. Sydney: Currency.

Pugliese, Joseph. (2002). 'Penal Asylum: Refugees, Ethics, Hospitality.' *borderlands e-journal*, 1.1: 53 pars. <http://www.borderlandsejournal.adelaide.edu.au/vol1no1_2002/pugliese.html> (accessed 5 January 2005).

Rabinow, Paul. (1986). 'Representations are Social Facts: Modernity and Postmodernity in Anthropology.' *Writing Culture: The Poetics and Politics of Ethnography*. Ed. James Clifford and George E. Marcus. Berkeley: University of California Press, pp. 234–61.

Radbourne, Jennifer, and Margaret Fraser. (1996). *Arts Management: A Practical Guide*. Sydney: Allen & Unwin.

Radic, Leonard. (1988). 'Australia Seen Through Black Eyes.' *Age*, 10 May: 14.

Rajaram, Prem Kumar. (2003). 'The Spectacle of Detention: Theatre, Poetry and Imagery in the Contest over Identity, Security and Responsibility in Contemporary Australia.' Singapore: Asia Research Institute Working Paper No. 7: <http://www.ari.nus.edu.sg/docs/wps/wps03_007.pdf> (accessed 7 March 2006).

Rees, Leslie. (1978). *The Making of Australian Drama from the 1830s to the Late 1960s*. Sydney: Angus & Robertson.

Reyburn, Bruce. (1997). 'Festival of Dreaming?' Letter. *Koori Mail*, 13 August: 6.

Roane, Tim, writer and director. (1998). *Toil: The Making of Zen Zen Zo's Macbeth: As Told by the Weird Sisters*. Tim Roane Films in Association with Zen Zen Zo.

Robbins, Bruce. (1998). 'Introduction Part 1: Actually Existing Cosmopolitanism.' *Cosmopolitics: Thinking and Feeling Beyond the Nation*. Ed. Pheng Cheah and Bruce Robbins. Minneapolis: University of Minnesota Press, pp. 1–19.

Roberts, Rhoda. (1998). 'A Passion for Ideas: Black Stage.' *Australasian Drama Studies*, 32: 3–20.

——. (2002). Keynote Address, Australian Performing Arts Market. <http://www.performingartsmarket.com.au/2002.htm> path: briefing session transcripts; welcome and keynote (accessed 9 February 2006).

Robinson, Ian. (1974). 'When an Old PoW' *National Times*, 19–24 August: 27.

Romeril, John. (1982). *The Floating World* (1974), 2nd edn. Sydney: Currency.

Romney, Jason. (1993). 'A Message in Music.' *Herald Sun*, 5 July: 61.

Rowell, Vanessa. (2002). 'Untamed and Trapped.' *RealTime*, 48: <http://www.realtimearts.net/nextwave/rowell_confusion.html>(accessed 20 February 2006).

Said, Edward. (1978). *Orientalism*. New York: Vintage.

Salter, Denis. (1996). 'Acting Shakespeare in Postcolonial Space.' *Shakespeare, Theory, and Performance*. Ed. James C. Bulman. London: Routledge, pp. 113–32.

Salverson, Julie. (1999). 'Transgressive Storytelling or an Aesthetic of Injury: Performance, Pedagogy and Ethics.' *Theatre Research in Canada*, 20.1: 35–51.

Sanders, Vicki. (1988). 'Dancing and the Dark Soul of Japan: An Aesthetic Analysis of Butō.' *Asian Theatre Journal*, 5.2: 132–47.

Savige, Jaya. (2004). 'The Excitement Is Missing.' *Courier-Mail*, 18 October: 13.

Sawada, Keiji. (1996). 'The Japanese Version of *The Floating World*: A Cross-cultural Event between Japan and Australia.' *Australasian Drama Studies*, 28: 4–19.

——. (2005). 'From *The Floating World* to *The 7 Stages of Grieving*: The Presentation of Contemporary Australian Plays in Japan.' Unpublished PhD Thesis, Macquarie University.

Schafer, Elizabeth. (2003). 'Reconciliation Shakespeare? Aboriginal Presence in Australian Shakespeare Production.' *Playing Australia: Australian Theatre and the International Stage*. Ed. Elizabeth Schafer and Bradley Smith. Amsterdam: Rodopi, pp. 63–78.

Schafer, Elizabeth, and Susan Bradley Smith, eds. (2003). *Playing Australia: Australian Theatre and the International Stage*. Amsterdam: Rodopi.

Scheer, Edward. (2004). 'Dissident Vectors: Surrealist Ethnography and Ecological Performance.' *Alternatives: Debating Theatre Culture in an Age of Con-fusion*.

Ed. Peter Eckersall, Moriyama Naoto and Uchino Tadashi. Brussels: Peter Lang, pp. 55–61.

Schneider, Rebecca. (1997). *The Explicit Body in Performance*. London: Routledge.

Sexton, Jared. (2003). 'The Consequence of Race Mixture: Racialised Barriers and the Politics of Desire.' *Social Identities*, 9.2: 241–75.

Shoubridge, William. (1989). 'A Whistle-stop Blueprint.' *Australian*, 4 September: 9.

Sidetrack Performance Group. (2003). *Citizen X*. Australasian Drama Studies, 42: 31–56.

Singleton, Brian. (2004). *Oscar Asche, Orientalism, and British Musical Comedy*. Westport, CT, and London: Praeger.

Sissons, David C. S. (1999). 'Japanese Acrobatic Troupes Touring Australasia 1867–1900.' *Australasian Drama Studies*, 35: 73–107.

Slavin, John. (2004). 'Horror of Sandakan March Brought Movingly to Stage.' *Age*, 16 October: 13.

Smith, Anthony D. (1995). *Nations and Nationalism in a Global Era*. Cambridge: Polity.

Smith, Jo. (1912). *Girl of the Never Never*. Unpublished mss. Mitchell Library, Sydney, William Anderson Collection.

Smith, Naomi. (2004). 'Investigating the Consumption of "Asianness" in Australia: Culture, Class and Capital.' *Asia Examined: Proceedings of the 15th Biennial Conference of the Asian Studies Association of Australia*. Ed. Robert Cribb. Canberra: Australian National University, pp. 1–21.<http://coombs.anu. edu.au/ASAA/conference/proceedings/Smith-N-ASAA2004.pdf> (accessed 10 December 2005).

Soltany-Zand, Mohsen. (2002). 'If One Person Dies.' 'Quest for Freedom – A Tale of Poetry and Passion.' By Tony Stephens. *Sydney Morning Herald*, 9 October: 10.

Stefanova, Kalina. (2004). 'Along the Roads with Ariane Mnouchkine.' *European Cultural Review*, 16: <http://www.c3.hu/~eufuzetek/en/eng/16/index.php?mit =mnouchkine> (accessed 21 January 2005).

Stenberg, Maryann. (1993). 'Dance Coup Boosts Festival Excitement.' *Sydney Morning Herald*, 13 November: 12.

Stevenson, Deborah. (2000). *Art and Organisation: Making Australian Cultural Policy*. St Lucia, Queensland: University of Queensland Press.

Strahle, Graham. (2003). 'Adelaide Plays It Safe.' *Courier-Mail*, 8 November: M11.

Stratton, Jon. (1998). *Race Daze: Australia in Identity Crisis*. Sydney: Pluto.

Sussman, Sally, and Tony Day. (1997). '*Orientalia*, Orientalism, and the Peking Opera Artist as "Subject" in Contemporary Australian Performance.' *Theatre Research International*, 22.2: 130–49.

Suzuki, Tadashi. (1991). 'Culture Is the Body.' *Interculturalism and Performance: Writings from PAJ*. Ed. Bonnie Marranca and Gautam Dasgupta. New York: PAJ Publications, pp. 241–8.

Swain, Rachael. (2006). 'The Marrugeku Company's Creative Process in Western Arnhem Land.' *About Performance*, 6: 14–37.

Sykes, Jill. (1997). 'From Fish to Funk.' *Sydney Morning Herald*, 19 September: 18.

Tait, Peta. (1998). 'Performing Sexed Bodies in Physical Theatre.' *Our Australian Theatre in the 1990s*. Ed. Veronica Kelly. Amsterdam: Rodopi, pp. 213–28.

——. (2000). *Body Shows: Australian Viewings of Live Performance*. Amsterdam: Rodopi.

Taylor, Yana. (1998). 'About Time in Performance and Analysis: Streams of Time in *Burying Mother.' About Performance 4: Performance Analysis.* Ed. Gay McAuley. Sydney: Centre for Performance Studies, University of Sydney, pp. 43–55.

Theroux, Paul. (1986). *Sunrise with Seamonsters.* Harmondsworth: Penguin.

Thomson, Helen. (1995a). 'A Moving Refraction.' *Age,* 2 November: 21.

——. (1995b). 'Bold Idea Does Not Translate Well.' *Age,* 30 October: 15.

——. (2002). 'Throwing Light on Reconciliation.' *Age,* 6 March: 6.

Timms, Peter. (2003). 'Woodchips are Down.' *Australian,* March 28: 19.

Tweg, Sue. (2004). 'Dream On: A "Reconciliation" *Tempest* in 2001.' *Contemporary Theatre Review,* 14.3: 45–52.

Vertovec, Steven, and Robin Cohen. (2002a). 'Introduction: Conceiving Cosmopolitanism.' *Conceiving Cosmopolitanism: Theory, Context, and Practice.* Ed. Steven Vertovec and Robin Cohen. Oxford: Oxford University Press, pp. 1–22.

Vertovec, Steven, and Robin Cohen, eds. (2002b). *Conceiving Cosmopolitanism: Theory, Context, and Practice.* Oxford: Oxford University Press.

Voumard, Sonya. (1993). 'Shakespearean Fashions.' *Sydney Morning Herald,* 7 July: 24, 23.

Wadjularbinna. (2002). 'A Gungalidda Grassroots Perspective on Refugees and the Recent Events in the US.' *Borderlands,* 1.1: <http://www.border landsejournal.adelaide.edu.au/vol1no1_2002/wadjularbinna.html> (accessed 3 March 2006).

Waites, James. (1987). 'Trick or Treat – '88 Festival Programs Announced.' *New Theatre: Australia,* 2: 2–3.

——. (1997a). 'Forest Fantasy a Fresh Success.' *Sydney Morning Herald,* 17 September: 14.

——. (1997b). 'The Power of Great Storytelling.' *Sydney Morning Herald,* 25 September: 15.

Walker, David. (1997). 'Cultural Change and the Response to Asia: 1945 to the Present.' *Australia and Asia.* Ed. Mark McGillivray and Gary Smith. Melbourne: Oxford University Press, pp. 11–27.

Wallerstein, Immanuel. (1996). 'Neither Patriotism nor Cosmopolitanism.' *For Love of Country: Debating the Limits of Patriotism.* Ed. Martha C. Nussbaum and Joshua Cohen. Boston: Beacon, pp. 122–4.

Waterhouse, Richard. (1999). 'Travelling Shows in Rural Australia 1850–1914.' *Australasian Drama Studies,* 35: 19–31.

Webby, Elizabeth. (1990). *Modern Australian Plays.* Sydney: Sydney University Press; Melbourne: Oxford University Press, pp. 34–44.

Weber, Carl. (1989). 'AC/TC: Currents of Theatrical Exchange.' *Performing Arts Journal,* 11.3: 11–21.

Werbner, Pnina. (1997). 'Introduction: The Dialectics of Cultural Hybridity.' *Debating Cultural Identity: Multi-Cultural Identities and the Politics of Anti-Racism.* Ed. Pnina Werbner and Tariq Modood. London: Zed Books, pp. 1–26.

——. (1999). 'Global Pathways: Working Class Cosmopolitans and the Creation of Transnational Ethnic Worlds.' *Social Anthropology,* 7.1: 17–35.

West, Andrew. (2002). 'Asylum-seeker Teenagers Join Lip Sewing Protest.' *Sun Herald,* 20 January: 7.

Western, Melissa. (1999). 'Performed or Pre-formed: An Interrogation of the "Racially Marked Body" as Seen on Contemporary Brisbane Theatre Stages.' Paper delivered in the English Department Thesis Prospectus Series, University of Queensland, 15 July.

Whitelock, Derek. (1980). *Festival! The Story of the Adelaide Festival of Arts.* Adelaide: published by the author.

Whitlock, Gillian. (2001). 'In the Second Person: Narrative Transactions in Stolen Generations Testimony.' *Biography,* 24.1: 197–214.

Williams, David. (1991). 'Black Swan Theatre Debut Displays Spark of Greatness.' *West Australian,* 21 September: 38.

——. (2004). 'Resisting State Stupidity and Its Theatre of Nonsense.' Paper delivered at the Australasian Association for Theatre, Drama and Performance Studies Annual Conference, 30 June–3 July, Wellington, New Zealand, pp. 1–18.

Williams, Margaret. (1983). *Australia on the Popular Stage, 1829–1929.* Melbourne: Oxford University Press.

Willox, Innes. (1995). 'Republic Vital to Asia Trade, Says PM.' *Age,* 16 February: 8.

Wilson, Peter J., and Geoffrey Milne. (2004). *The Space Between: The Art of Puppetry and Visual Theatre.* Sydney: Currency.

Worthen, W. B. (2003). *Shakespeare and the Force of Modern Performance.* Cambridge: Cambridge University Press.

Yan, Haiping. (2005). 'Other Transnationals: An Introductory Essay.' *Modern Drama,* 48.2: 225–48.

Yeĝenoĝlu, Meyda. (2005). 'Cosmopolitanism and Nationalism in a Globalized World.' *Ethnic and Racial Studies,* 28.1: 103–31.

Yen, Anna. (2000). *Chinese Take Away. Three Plays by Asian Australians.* Ed. Don Batchelor. Brisbane: Playlab.

Young, Robert J. C. (1995). *Colonial Desire: Hybridity in Theory, Culture and Race.* London: Routledge.

Index